Blood on

The Social Construction of Women, Sexuality, and Murder

Frankie Y. Bailey
University at Albany

Donna C. Hale
Shippensburg University

COPYRIGHT © 2004 by Wadsworth Group. Wadsworth is an imprint of the Wadsworth Group, a division of Thomson Learning Inc. Thomson Learning™ is a trademark used herein under license.

Printed in the United States of America

Wadsworth/Thomson Learning
10 Davis Drive
Belmont, CA 94002-3098
USA

For information about our products, contact us:
Thomson Learning Academic Resource Center
1-800-423-0563
http://www.wadsworth.com

International Headquarters
Thomson Learning
International Division
290 Harbor Drive, 2nd Floor
Stamford, CT 06902-7477
USA

UK/Europe/Middle East/South Africa
Thomson Learning
Berkshire House
168-173 High Holborn
London WC1V 7AA

Asia
Thomson Learning
60 Albert Street, #15-01
Albert Complex
Singapore 189969

Canada
Nelson Thomson Learning
1120 Birchmount Road
Toronto, Ontario M1K 5G4
Canada
United Kingdom

ALL RIGHTS RESERVED. No part of this work covered by the copyright hereon may be reproduced or used in any form or by any means—graphic, electronic, or mechanical, including photocopying, recording, taping, Web distribution, or information storage and retrieval systems—without the written permission of the publisher.

ISBN 0-534-19775-2

The Adaptable Courseware Program consists of products and additions to existing Wadsworth Group products that are produced from camera-ready copy. Peer review, class testing, and accuracy are primarily the responsibility of the author(s).

For permission to use material from this text or product, submit a request online at
http://www.thomsonrights.com
Any additional questions about permissions can be submitted by email to thomsonrights@thomson.com

Acknowledgments

The authors would like to thank the anonymous reviewers who read early drafts of this work. The book is much improved because of your constructive criticism and helpful suggestions. The authors thank four graduate assistants at Shippensburg University: Charity Brallier, Matthew Fetzer, Amanda Poust, and Michelle Weller. A special thank you to Pauline Clinkenbeard for her newspaper clipping services. We also would like to express our appreciation to Professor Victor Streib, who gave us permission to use his data on women on death row and provided his most recent report.

This book would never have reached completion without the support of the editorial staff at Thomson Learning. We want to thank our former editor, Sabra Horne, for seeing us through this long process, and we want to wish her much happiness in her new undertaking. We also want to express our sincere thanks to Michele Baird and Christina Smith, who exercised great patience through our many revisions.

To everyone who contributed to this book, including all the other scholars, the female professionals who responded to our survey, and the librarians in Shippensburg and in Albany, we thank you.

Contents

Introduction ...iii

PART I
History, Narrative, & the Social Construction of Women Who Kill1

Chapter 1
Women in Greek Mythology: Medea and Her Sisters2

Chapter 2
The Anatomy of Difference: On the Status of Women
 in Ancient Greece and Rome ..17

Chapter 3
Virgin, Whore, Witch: Images of Medieval and Renaissance Women30

Chapter 4
A Punishment to Fit Her Crime: From Settlement to Antebellum Era57

Chapter 5
A Proper Lady: Victorian Women ..83

Chapter 6
Modern Life and Primitive Woman: Women in the Early 20th Century107

Chapter 7
Domestic Tranquility? Women in the Post-World War II Era141

Chapter 8
Contemporary Images of Women ..165

PART II
Constructing the Women Who Kill in Popular Culture195

Chapter 9
Women and Murder in True Crime ...197

Chapter 10
Women & Homicide in Literature, Music, & Films215

Chapter 11
Of Women, Sexuality, & Murder: Concluding Thoughts233

Appendix A
Suggested Reading & Viewing Lists ...255

Appendix B
Great Women in Criminology/Criminal Justice ..277

Appendix C
Survey Responses of Women Professionals/Practitioners280

Bibliography ..295

Index ..335

Introduction

Constructing Women Killers

The Oxford English Dictionary (1989) defines a "resource" as "a stock or reserve upon which one can draw when necessary." This book is about the resources that various cultures from the ancient Greeks and Romans to contemporary Americans have drawn upon in constructing narratives about women who kill. Social constructionists assert that what we know as reality is created in the context of human interactions (Berger and Luckmann, 1966). In the case of men and women, gender differences have been constructed and maintained in a variety of ways, including myth and religion, language, science and medicine, and the legal system (Levit, 1998). What this has meant is that women—defined by their biology and by their status as different from men—have been seen as the sometimes dangerous "other."

In a *Psychology Today* article, the author refers to women's "killer instinct" as one possible explanation of an alleged increase in violent behavior:

> Violence by women has skyrocketed in the latter part of this century. Have they taken "women's liberation" one step too far—or are they just showing their natural killer instinct? (Yeoman, 1999: 54).

Violence by women has not "skyrocketed." It has been the "war on drugs" rather than their "killer instinct" that has led to the incarceration of many women now in prison (see Belknap, 2001: 80-118; Muraskin, 2000). However, as this quote illustrates, two themes have tended to characterize male responses to female criminality: (1) fascination with female "instincts" and (2) concern that women are getting "out of control."

In her study of female criminality in late 19th century France, Shapiro (1996: 4) observes that contemporaries wrote "extensively about the problem of the female criminal in the absence of statistically important criminal behavior by women." Shapiro argues female criminality served as a "code" for the discussion of other societal concerns. This book provides support for that argument, finding the same coded focus on female criminality in other times and places. This is particularly evident with regard to the low rate of offending but often alarmed attention given to homicides committed by women. This response to homicides by women provides a window on societal concerns about women and their status.

Looking at female criminality in 19th century France, Shapiro questions how the stories told about women's crimes were related to "broader debates about marriage reform, depopulation, sexuality, and women's roles in the public sphere?" (Shapiro, 4). What was "the role of expert commentary" (i.e., from professionals such as legal scholars) "in producing a normative code for criminal behavior"? Shapiro finds that the discourse about female criminality

revealed the tensions within a republican ideology about mass culture; and that narratives about female defendants and female criminals made "compelling theater" as real life and fictional dramas (Shapiro, 4). This book poses questions similar to those of Shapiro about female criminality—specifically homicides—in other places and during other historical periods.

The argument made here is that although women who kill are atypical of female criminals, reaction to them is at the extreme end of a continuum of societal responses to female behavior. A society's response to women who kill reveals much about how all women are perceived with regard to actual and potential deviance. This book traces the history of these perceptions in Western discourse about women, focusing on the social construction of women as killers.

Explanations and Models

When a homicide occurs, whoever is the alleged perpetrator, an act has occurred that requires an explanation and an assessment of the nature of the act. In some cases, homicides are deemed justifiable (e.g., in defense of one's own life or that of others). In other cases, homicides fall into a gray area of controversy (e.g., physician-assisted euthanasia), and in still other cases, homicides are clearly wrongful deaths (manslaughter or murder). But what is relevant here is that much about a homicide depends on perception. Since the prerogative to use violence historically has been male, men (from soldiers on battlefields to husbands discovering illicit liaisons in bedrooms) have been given much more leeway in the killing of others. Men who kill, including serial killers, have been portrayed as heroes. Male outlaws have been described as "good badmen." It has only been in special circumstances that equivalent leniency or/and approval has been displayed toward women who kill. Instead, there seems always to have been a drive by men to contain female violence, to bring it under control, to tame it as a dangerous force of nature. Therefore, when a woman kills, the explanation for her action must be made in social space that is far from gender neutral.

With regard to women and homicide, Rasche (1990: 48–50), in her review of the social science literature published between 1895 and 1970, identifies six distinct etiological perspectives that have prevailed about women who kill:
1. *The "deadlier species" model*—depicts women in terms of a dichotomy as either the "gentler sex" or "the more deadly species"; women who kill described as especially wicked, even monstrous
2. *The "biological defect" model*—depicts women as biologically defective or physically impaired in comparison to men; violent behavior linked to menstruation and/or hormonal changes
3. *The psychopathology model*—depicts women who kill as severely mentally ill or psychologically incapacitated
4. *The "crime of passion" model*—assumes that women like men might kill when moved by extremely strong emotions

5. *The "women's role in society" model*—assumes that both men and women are capable of murder, but that women's roles in society affect their choice of victims; women more likely to kill intimates than strangers
6. *The self-defense model*—recognizes that women sometimes kill to defend themselves against male violence

These models offer explanations not only of female homicide behavior but implicitly of female behavior in general. These explanations are grounded in perceptions of gender relations, women's roles in society, and the biological nature of women. These explanations are incorporated into narratives.

Narratives of Abuse and Weakness

In *Fiction in the Archives* (1987), Davis offers an example of one 16th century woman's narrative about a homicide:

Without saying a word, the said Toussaint slapped her twice so hard that she fell to the floor. As she got up, the chickens tumbled down, and she had the knife all bloody in her hand, and she said once again that he did ill to beat her when she had done no wrong. . . . (Davis, 1987: 93).

The narrative of this domestic drama that ends in the death of the husband at his wife's hand comes from a letter of remission (request for pardon), submitted to a French court in 1540. In the letter, the woman argued that she had acted in self-defense. She was in her kitchen preparing that night's dinner when her husband attacked her. She responded with lethal violence because she feared for her life (Davis, 1987). This sixteenth-century narrative has modern counterparts in the contemporary legal narratives of battered women who kill abusive spouses.

In her book, Davis (1987) argues that to be effective the stories told by sixteenth-century women seeking pardon had to be cast in a language and style that portrayed them as the blameless victims of violent men. In modern courtrooms, the narratives presented by attorneys defending women who killed spouses or lovers who allegedly battered, threatened and/or tried to kill them, often cast these women in the role of terrorized victims of male violence. In the same vein, Francus (1997) finds that women in early eighteenth-century England who were accused of infanticide needed to present "narratives of female weaknesses, ignorance, fallibility, and repentant virtue" in order to be acquitted (134). Similar narratives about women who kill their children—presenting them as "docile" rather than "rebellious" mothers (Francus, 134)—are still offered today.

In fact, modern courtrooms provide a site for discourse about social issues such as domestic violence. In *Popular Trials,* Hariman (1990: 5) writes: "Trials function. . .as forums for debate, as symbols of larger constellations of belief and action, and as social dramas used to manage emotional responses to troubling situations." He observes that such "public discourse" occurs not only in the courtroom, but in other public domains, "especially in the news media"

(Hariman, 18). It is in these settings—during "issue-oriented trials"—that social concerns are indirectly examined and debated (Cuklanz, 1996). In the courtroom and in the media, such cases become an occasion for examining and defining/redefining social boundaries. In these arenas, narratives about women who kill are told and retold to various audiences.

Crafting Trial Narratives and Framing the News

During the past decade, the topic of narration has entered the discussions of legal scholars,[1] anthropologists, social workers, psychologists, and other social scientists.[2] Narration can assume a variety of forms, from short story to courtroom argument. In its most basic structure, a narrative "begins with an introduction that supplies some background information, continues with a chronological sequence of events, builds to a crisis or problem, and ends by offering a resolution" (Tiersma, 1994:148).

With regard to trial narratives, Gewirtz (1996) reminds us that the rules of jurisprudence ensure that the boundary is maintained between the "courtroom and ordinary life." However, "there is always a struggle between this idealized vision of law -- which proclaims that law is and must be separate from politics, passion, and public resistance -- and the relentless incursion of the tumult of ordinary life" (Gerwirtz, 135). Cuklanz (1996) asserts that in "issue-oriented trials," the courtroom becomes a forum "for explicating or 'hashing out' the conflicting perspectives" that have developed around topics that have generated controversy.

> These types of trials are selected for prolonged national news coverage for two primary reasons. First, they offer an opportunity for mainstream discourse to take up the issues for which social change movements have demanded public attention. . . .Second, the discussion of these trials is played out as a nationally visible power struggle on an issue where the criteria for innocence and guilt are known to be in flux. On a nationwide level, readers and observers witness how power is wielded in a system of changing values and definitions. Both the trial itself and the news coverage that accompanies it are evidence of social change in progress (Cuklanz, 39).

However, as Bird notes, "News does not exist until it is written, until it becomes a story, and what is deemed newsworthy owes as much to our cultural conceptions of what makes a good story as it does to ideas of importance or significance" (1996: 47). For this reason, stories such as teenager Amy Fisher's non-lethal shooting of her older lover's wife or Lorena Bobbitt's non-lethal castration of her husband after an alleged beating/rape became front-page news, and in the case of Amy Fisher inspired several books and made-for-television movies. Of particular interest is the "framing" of these events as news.

As used here a media frame "is a particular way in which journalists

compose a news story to optimize audience accessibility" (Valkenburg, et al., 1999: 550). Frames both give meaning to and simplify events. A news story might be presented in a "conflict frame," a "human interest frame," or in another frame (such as "economics" or "responsibility") that makes the story interesting for and accessible to the audience (Valkenburg et. al, 550-552).

While journalists seek out frames for their narratives, in the courtroom attorneys engage in an adversarial contest in which each side attempts to sway the judge and/or jury with the content and the quality of its legal narratives. Attorneys must take into account that jurors come to the courtroom with images of crime and criminals that have little to do with the penal code and the legalese of lawyers. Jurors bring preconceived notions about why people commit violent crimes and about who is capable of such violence. Successful trial lawyers craft narratives that are both believable based on the evidence in the present case and familiar based on the stories that the jurors have heard about crime. Such is the nature of courtroom storytelling by legal advocates.

In this book, the authors argue that modern lawyers and journalists draw on very old tales in constructing narratives about women who kill. The authors examine these depictions, tracking their evolution from the ancient Greeks and Romans to the present.

Methodology and Organization of the Book

For the reasons outlined above much of the analysis in this book will focus on cases that entered the public domain and became the subject of popular discussion and debate. However, many cases from a variety of sources, including "encyclopedias of murder" and books about specific cases, have been examined by the authors. Key words searches were done in the LexisNexis Academic database using terms such as *women and murder* and *infanticide*. Particularly with cases in the modern era (such as Karla Faye Tucker, Andrea Yates, or, more recently, Clara Harris), a search for all available newspaper articles was done using LexisNexis. For historical cases, two indexes, *America: History and Life* and *Historical Abstracts* were searched using key words such as *women who kill, murderess,* and *infanticide. The New York Times Index* and that newspaper on microfilm also were used. The cases that have been selected for inclusion in this book are those that provide examples of issues relevant to narratives about women who kill. As would be expected from the discussion above, these were often also the cases that received significant popular attention during a trial and/or later during the death penalty process. Therefore, these cases provide important insights into perceptions of female deviance, gender relations, and "gender politics" (see Connell's (1990) discussion of theoretical perspectives regarding sexual or gender politics).

A basic argument put forth here is that in spite of historical changes and cultural differences, it is possible to detect recurring themes in narratives about women from ancient times to the present. It seems that men have always found women a mystery to the extent that women are different from them-

selves. Narratives told by men have aimed to explain the nature of woman and the mystery of the female. One of the themes this book will return to in each chapter is how the people who lived during a given period described gender differences that they perceived between men and women.

In the field of semiotics, social scientists focus on opposites in discourse (e.g., Danesi, 2002). In narratives from myriad cultures, images recur of women in polarly opposite categories (the good woman/the bad woman; the creator/the destroyer). For as much as men have desired, sought out, and described the virtues of women, they have in equal (if not greater) proportion mistrusted and feared women and sought to avoid falling under their spells. In gender relations, sex is described as a weapon. Historically, men have feared this weapon when wielded by women. The sexually autonomous female has been perceived as a dangerous female who can seduce and destroy. At the same time, lethal violence has been seen as alien to the nature of the "good woman." Historically, explanations offered of female homicides has reflected this sense of aberration, of deviation from the norm. Yet, at the same time, these narratives have located these "deviant women" within the sisterhood of womankind. These narratives have reflected certain perceptions and age-old stereotypes about the nature of human females and their capacities for destruction.

For example, one aspect of the physical nature of woman—menstruation—has puzzled and often frightened men. Because primitive people did not understand the reason for the female menstrual cycle, certain taboos became associated with this process. Harding (1971: 56) writes that the word taboo means something "unclean, holy, or set apart." Deemed unclean, menstruating women were expected to remain apart from other people during their period of "sickness" (Harding, 56). Yet, even in advanced Western societies where the biology of menstruation is taught to school children and generally understood, this perception of menstruation as something unclean—and similar to bodily processes such as defecation and urination—seems to remain.

This is relevant to the topic of this book because this particular aspect of a woman's physical nature often has been described as accounting for her emotional or mental state. In modern narratives about women and crime, premenstrual stress (PMS) and postpartum depression have figured into accounts of violent behavior by women. As early as 1846, in a case tried at the Old Bailey in England, Mary Ann Hunt, a 30 year old woman who had killed her elderly neighbor, Mary Sowell, was said to suffer with "women's problems." According to the defense, she routinely experienced "suppressed menstruation" which made her prone to hysterical fits. As her neighbors testified, she was usually a quiet, gentle woman, but doing these fits she would become violent and strike out at those around her. Expert medical witnesses were called to testify. The court rejected Mary Ann Hunt's claim of temporary insanity caused by her menstrual cycle (Eigen, 1999: 442-446), but the matter of menstrual irregularities which caused aberrant behavior would be raised during other trials of women for homicide.

This book also examines the connection made in various narratives

between physical attributes, dress, and sexuality. Feminists have argued that women have been and still are defined by their sexuality. In the following chapters, views on sexuality during each era are examined. This matter of sexuality prompts a number of questions. One of the more important is under what circumstances female sexuality is viewed as disruptive or deviant.[3] For example, in the modern era, there are narratives—both real and fictional—in which lesbianism is depicted as deviant and this deviant sexuality is linked to female criminality (particularly to violent crimes normally associated with male perpetrators). Therefore, in each era, this book considers what the boundaries of "appropriate" sexuality are for "good" women and how some women come to be labeled as "bad."

A third theme (related to the first two) is that of the punishment of women who commit (or who are alleged to have committed) criminal homicide. The controversy during the days leading up to the 1998 execution of Karla Faye Tucker in Texas illustrates the debate that has occurred at various times about executing women.[4] An earlier example occurred in New York State in 1859, when Mary Koehler Hartung was sentenced to death for her role in the murder of her husband Emil. Like the case of Karla Faye Tucker, the Hartung case became the focus of a discussion about gender and punishment within the larger context of the death penalty debate.

A fourth theme pursued throughout this book is that of women's roles, particularly their status within the home and in relation to intimates. Historically, in every society, assumptions have been made about how a woman should relate to her children and to her male partner. The home has been described as the female sphere. In this setting, women have been depicted as nurturers, care givers, and the "moral center" of the family. Expectations about how much time a woman should spend in her home and the activities she should engage in within that setting have differed, affected by factors such as social class and race/ethnicity. However what has been true is that women have been expected not to betray the trust placed in them by husband, children, and other intimates. In crime narratives, women who engage in "malice domestic," who kill those closest to them, are described as especially wicked.

In an article about the "self-psychology" of mothers who kill, Crimmins, et al. (1997: 66) assert, "Women who kill children are still somewhat of an enigma in the latter part of the 20th century. Whereas reasons and motives are complex, the literature still tends to focus upon these women as mad or bad." In recent years, the media have given a great deal of attention to several cases involving women who killed their children. This attention has included cases of neonaticide in which well-to-do white teenagers disposed of their infants following concealed pregnancies and unaided births.

Related to this topic of women as mothers is the concept now described as "fetal protection." The discourse about this issue concerns the obligation (if any) of a pregnant woman to ensure the welfare of her unborn child (see Bauer, 1999). If she decides not to terminate her pregnancy, does a woman

then have a duty to forego behavior that might place the fetus in jeopardy? Causing even more controversy is the question of whether or not women who engage in endangering behavior should be subject to criminal prosecution. This issue is examined here because of contemporary efforts to criminalize the behavior of some mothers who are perceived as taking less than adequate care of their fetuses. As Gomez (1997), Roberts (1997), and others have noted these prosecutions have been directed mainly at poor and racial minority women. As this concept of "fetal protection" has evolved women who used drugs while pregnant have been charged with child abuse, or in rare cases even manslaughter or homicide (if the fetus is still-born). As Roberts (1997) finds regarding African American slave women and as will be discussed regarding women in other times and places, the "policing" of female maternity has often worked to the disadvantage of women and sometimes brought them into the criminal justice system.

This book is divided into two parts. Part I provides a generally chronological examination of the status of women and the cultural roots of modern narratives about women who kill. Chapters 1 and 2 should be read as companion pieces, separated only for the ease of the reader in focusing on important concepts that will be discussed throughout the rest of the book. Chapter 1 examines the depiction of women in the mythologies of ancient cultures. This introduction to the ancient myths provides necessary groundwork for later chapters. In modern narratives women are sometimes described in mythological terms (e.g., Susan Smith, a woman who killed her two children, as a "Medea"). This chapter provides the readers with the necessary references to follow the argument made throughout the book about the recurrence of these myths about violence women as cultural archetypes. Chapter 2 examines the theories of female biology offered by ancient Greek and Roman physicians and philosophers and begins the discussion of the roles of women as wives and mothers. Male wariness with regard to female practitioners involved in the process of childbirth and infant care (i.e., midwives and wet nurses) is explored. The matter of midwives and wet nurses is developed in later chapters in the context of the witch trials in Europe, baby farming, and infanticide. Chapter 2 provides the starting point for a discussion that culminates in Chapter 7 with modern criminal justice responses to women who are perceived as "bad mothers" (e.g., "crack moms") or dangerous childcare practitioners (e.g., the Louise Woodward "nanny" case). Chapter 2 concludes with a discussion of Roman women and male responses to female displays of power. This is an essential background for the discussion of how women who deviate from gender prescribed roles—for example, Cleopatra as warrior queen—are responded to and depicted. Chapter 3 examines the transformations that take place from the Middle Ages to the Renaissance as Christianity challenges paganism and the mythologies of the Greeks and Romans are supplemented by biblical depictions of women. Again, as in Chapter 2, findings about the everyday lives of real women during this period provide the context for understanding perceptions of women and responses to perceived

deviance by them. These three chapters lay the groundwork for Chapter 4, which focuses on women in the cultural space of America from Puritan New England through the antebellum era. Entrenched images of women, of their biology, their nature, and their capacity for violence shape narratives about women during these formative years in American history. The chapter examines the narratives told during trials of women for heresy, witchcraft, and infanticide. The chapter also looks at the roots of American crime reporting as it began to develop during this era with gallows confessions and other narratives. Finally, the chapter moves through the 18th and into the 19th centuries, looking at the intersections of race, class and gender, and bringing issues such as the use of wet nurses into the American context. The chapter begins to focus on race/class bias and unequal justice. These themes are picked up again in Chapter 5, which focuses on Victorian sensibilities and gendered perceptions. Chapter 5 discusses the ways in which these perceptions continued to structure both female behavior and societal responses in the 19th century. The Victorian white middle-class woman was both protected and restricted by the "cult of true womanhood." The working class woman, particularly poor, minority women, were generally not the recipients of male "chivalry." For all women, displays of female weakness and vulnerability in the face of accusations continued to be a more successful strategy than self-presentation as an "unruly" woman. The moral panic about female poisoners, illustrated in several high-profile British cases, is also discussed in this chapter. Chapter 6 moves into the 20th century when waves of immigration from Eastern European countries to the United States and the presence of African American and other non-white migrants in the cities led to concerns about racial purity and fears of white "race suicide." Perceptions of the good (i.e., white middle-class) woman as child-bearer and the bad (i.e., immigrant or non-white) woman as threat to civilized society appeared in both social science literature and in popular culture. Leaving behind the vamps and the flappers of the early 20th century, Chapter 7 looks at the myth of the American dream of suburban domesticity and societal responses to those women who disrupted these idyllic fantasies with their violent acts. Several high profile cases such as that of Barbara Graham are discussed here. In this chapter, the cases of several juvenile female offenders are discussed because of the concern prevalent in the 1950s about the breakdown of the family—and hence the domesticity of women. Chapter 8 focuses on the modern period. This chapter offers analysis of a number of representative high profile cases and argues that the narratives about women in the late 20th and early 21st centuries have much in common with the narratives of earlier eras. The mythology of gender, the images of women in their roles relative to men and children, continue to shape the stories told about modern women who kill. Building on the discussion in earlier chapters, Chapter 8 examines differential responses to women, varying by race and class, and shaped by the ability and the willingness of women to conform to gender expectations.

Part II of this book focuses on popular culture/mass media. Scholars of crime and culture have noted the intersection in the modern era between

crime, criminal justice, and mass media. Surette (1998) uses the term "info-tainment" to describe the blurring of the line between news and entertainment. The audience that turns to the media for news about crime finds it, not only in newspapers and on television newscasts, but on TV newsmagazines that present stories about high profile crimes in info-tainment formats. By the same token, mass media consumers can turn to TV cop shows, cable network programs about crime investigation, movies, novels, and true-crime books as additional sources of information. It is now common for high profile crime to move from the news media into the entertainment media. This is not a new phenomenon, but the capacity of modern mass media producers to reach millions of consumers, makes it important to consider the creation of popular culture narratives. This is the focus of Part II of this book. Chapter 9 examines true crime books about women because these books are one of the literary descendants of the gallows sermons and broadsheets discussed in an earlier chapter. True crimes books are one source that general readers turn to for narratives about women who kill. Thus, they play a part in the social construction process. Because the marketing strategy for true crime books often involves the use of classifications (e.g., serial killer or "black widow"), the authors include in this chapter a discussion of the typologies used to classify killers. The authors point out that earlier typologies developed for male serial killers are problematic when applied to women. They look at more recent typologies developed for women killers and offer their own modifications. This chapter and the chapter that follows examine genre-based narratives about women who kill. While Chapter 9 focuses on "non-fiction" accounts of true crimes, Chapter 10 examines fictional narratives. Beginning with early popular literature, the chapter considers images of women and violence in music, literature, and films. These images include sinister stepmothers, femme fatales, women in jeopardy, and more recently "tough gals" with "hard bodies" who may be heroes or villains. The authors raise the issue of the impact of these images on the social construction of violent women and women who kill.

Finally, Chapter 11 offers the authors' conclusions about women, sexuality, and murder. This chapter provides a synthesis of the discussion throughout the book about the roles of women and the social construction of women and murder. Following this chapter, the reader will find three Appendices containing material that will allow the reader to further explore ideas discussed in the book.

This concludes the general overview of this book. For the sake of clarity, the authors state again that although women killers make up only a small percentage of the women criminals to be found in any historical era, this book argues that it is in narratives about women who kill that the status of women and societal attitudes toward women are laid bare. Because the roles of women have been so important in determining their status and in shaping perceptions about appropriate behavior, this book examines homicide within the context of women's everyday lives. Homicide is examined as one aspect of a few women's lives that affects the ways in which all women in a society are viewed.

This book takes the perspective that it is impossible to understand the

courtroom dramas in which women are defendants without examining the themes found in the diverse narratives which deal with the "nature" of women and their status in society. These narratives have taken many forms from biological theories about female aggression to sociological theories about the role of socialization in determining female behavior; from fairy tales to film noir; from the Bible to feminist tracts. Sometimes women tell their own stories. More often, women are discussed and described by men. Whatever their source, these narratives provide cultural information about how the use of violence by women is viewed.[5]

The goal of this book is not only to present and analyze narratives about women who kill, but also to encourage readers to become actively involved in the process of examining these narratives and discussing their possible impact on the treatment of women in the criminal justice system and on the lives of all women. Therefore, throughout the book, the authors have included profiles, tables, discussion questions, exercises, and other material to encourage reader interaction with the material.

Finally, the authors would like to note that the primary focus of this book is on Western cultures. This is not intended to ignore the richness or the interest of the narratives about women or the scholarship on Asian and African cultures. However, because of limited space available to the authors to provide a synthesis of the works of many scholars and then extend the discussion with their own arguments, the authors have been forced to exclude this body of literature. The authors encourage the reader to pursue this literature as additional reading.

Discussion Questions

1. What is a narrative? What roles do narratives play in our lives? What is the role of narratives in the courtroom?

2. Why is it important to examine narratives about women who kill?

Notes

[1] The matter of the use of "narrative" in law is somewhat more complicated than in some other fields because of the challenges being offered to "traditional" approaches to law by those in the legal profession (particularly prominent in this group are women and people of color) who advocate an approach to the law that involves a broader and more subjective form of "storytelling." In this approach to legal narrative, the use of personal experience is acceptable when deemed relevant (e.g., when writing about rape shield laws, a female attorney might introduce the topic with a description of her own experience as a rape victim). Advocates of this approach also argue that the law must be viewed in historical context (e.g., hate crime legislation must be considered in the context of crimes of racial violence against people of color). This "new school of narrative jurisprudence" is controversial (see for example, "Introduction to Narrative Jurisprudence," 1990). It is not what the authors refer to in this chapter when they state that lawyers use narratives. The authors are simply saying here that lawyers find storytelling, i.e., relating what happened and why, a natural way of communicating that juries understand and to which they respond. However, in Chapter 8, which looks at modern cases involving women who kill, some attention will be given to stories that some lawyers of the "new school" argue should be told about women and their experiences (e.g., Bauer, 1999).

[2] See, for example, Brown's *Society as Text* (1987) in which he describes narrative as "an emblem of a larger social text" (144). Brown, a sociologist, goes on to make three claims: "that narrative logic is universal and that hence other logics are derivative of it; that epistemological crises in the philosophic tradition of positivist science are conflicts of narrative traditions; and that paradigm shifts in science itself are reformulations of cognitive traditions in terms of narrative logic" (164). Also see Mumby (1993); West (1993); Martin (1995); La Rue (1995); Hall (1997); and deMarrais (1998).

[3] Regarding the association between female sexuality and death, Bassein (1984: 37) finds: "It was once believed that so much vital strength was spent when semen was lost to a woman that death would come sooner. This is the origin of the notion found in medieval and Renaissance literature that each session of intercourse takes one day off a person's life."

[4] Following the recent execution of 28-year old Christina Marie Riggs for the murders of her two young children, one observer commented on "intense public soul-searching and beating of breasts" about executing a woman (the first in Arkansas in 150 years). According to this writer: "The thought of a woman in the death chamber makes people cringe—even those who have no problem with sending a man to his death for his crimes. It appears that chivalry still lives when a woman must die" (Young, 2000).

[5] For example, both *Little Red Riding Hood* and *The Wizard of Oz* offer narratives about young girls coping with difficult situations and their own emotions. The fairy tale about Little Red Riding Hood has gone through many versions, including modern retellings. In a 1939 version by James Thurber, the 'no-nonsense' little girl shoots the wolf with her automatic. The moral of Thurber's story is: "It's not so easy to fool little girls nowadays as it used to be" (Zipes, 1983: 37). Regarding Dorothy's final encounter with the wicked witch in the Land of Oz, Katz writes in *Seductions of Crime* (1988) that "Dorothy's lethal attack, launched in rage after the witch had snatched one of her silver shoes [silver in the book, ruby in the film], consists of throwing on the witch a bucket of water. This is a moral attack, a status-reducing expression of disgust by the young girl from a self-confident stance. . ." (Katz, 29).

Part I
History, Narrative, & the Social Construction of Women Who Kill

Chapter 1

Women in Greek Mythology
Medea and Her Sisters

Timeline of Early Greek and Roman History

c.2000 B.C.E.	Minoan worship of the Mother Goddess
c.2000–1500	Height of Minoan civilization
c.1500–800	Dark Ages of Greek history
c.1250	Trojan War
c.800	Beginning of city states in Greece
c.753	Rome founded
c.750	*The Iliad* and *The Odyssey*
594	Reforms of Solon in Athens
c.500	Establishment of Roman Republic
496–406	Sophocles
490–479	Greco-Persian War
c.484–420	Herodotus
c.480–406	Euripides
469–399	Socrates
460–c.377	Hippocrates
c.450	Law of the Twelve Tables, Rome
431–404	Peloponnesian War
429–347	Plato
384–322	Aristotle
334–323	Conquests of Alexander the Great
146	Destruction of Carthage by Rome
c.146–60	Introduction of Greek philosophy to Rome
46–44	Dictatorship of Caesar in Rome

End B.C.E., Begin C.E.

27 B.C.E. to 14 C.E.	Principate of Augustus Caesar in Rome
34–65	Seneca
c.80	The Colosseum in Rome
121–180	Marcus Aurelius
200	Completion of Roman Jurisprudence by Great Jurists
235–284	Civil War in the Roman Empire
306–337	Constantine I
311	Beginning of toleration of Christians in Roman Empire
354–430	St. Augustine
379–395	Theodosius I
380	Christianity becomes the official Roman religion
410	Visigoths sack Rome
c.500–700	Decline of towns and trade in west
527–564	Justinian
c.550	*Corpus* of Roman law
590–604	Pope Gregory I
711	Muslims conquer Spain
c.750	*Beowulf*
768–814	Charlemagne
c.800–1000	Height of Byzantine commerce and industry

Source: Compiled from www.wwnorton.com/college/history/worldciv/reference/eurotime.htm

Introduction

In *Theogony,* the ancient Greek writer Hesiod offered an account of the cosmos, from the birth of the gods to the establishment of the rule of Zeus. Written in the 8th century B.C., Hesiod's work is the earliest known book of Greek mythology. But Hesiod himself was probably influenced by Babylonian tales of the gods and the universe. In fact, there is much overlap in the mythologies of ancient cultures. These myths provided the basis for religious worship in the ancient world. These myths influenced the works of Greek and Roman philosophers and dramatists. Because of the impact of these civilizations on the Western world, these myths are important as sources of some of the earliest images of women.

Art and Myth

In *Art and the Western World,* the companion book to the PBS television series, Cole and Gealt (1989: 5) write, "[The] Greeks asked themselves fundamental questions about their origins, about their destiny, about morality, and government; and they used art in their quest." In the introduction to that book, Wood (1989: x) writes, regarding the "spiritual content" of Greek art, "Its religious and mythic dimension, and the archetypal power of the Greek myths themselves, created themes that have continued to be a rich source of meaning." Wood adds that the gods and goddesses of Greek mythology "had an emotional force that purely allegorical figures could never have" (Wood, x).

The ancient Greeks did not worship a single god or goddess. They worshiped many. In the temples and other sacred places, the Greeks performed the rituals of the cults devoted to their deities. In their art and literature, the Greeks told stories of interactions between gods, goddesses, and humans. This art and literature and the myths that spawned them has been the subject of on-going scholarship.

One aspect of this scholarship has to do with the extent to which these stories reflect life in ancient Greece. For example, did Hesiod, a man of his times, duplicate elements of the patriarchal system that existed in his own contemporary Greece in his *Theogony?* Is this why the old female goddesses lose much of their power as Zeus become ruler of the universe? Do the relationships between these divine gods and goddesses reflect those of humans?

Myth: A fable or legend embodying the convictions of a people as to their gods or other divine personages, their own origin and early history and the heroes connected with it, or the origin of the world; in a looser sense, any invented story.

Mythology: The study of myths; myths collectively, often, a body of myths relating to a particular person, or describing the legendary deeds of gods and men.

Source: New Webster Dictionary of the English Language, College Edition (1981)

Of Goddesses and Gods

Ironically, in light of the advise Greek physicians gave to mortal females regarding the health benefits to be derived from regular sexual intercourse (see Chapter 2), the patron goddess of the city of Athens was Athena Polias (Pallas Athena), one of the "virgin goddesses". In Greek mythology, Athena was associated with both female handicrafts and male warfare. She was the goddess of wisdom who had sprung full-grown from the forehead of her father, Zeus. Athena was her father's favorite child, entrusted with his aegis, buckler, and thunderbolt (Hamilton, 1942, 30).

Athena's unorthodox birth occurred after Zeus swallowed Athena's pregnant mother, Metis. Zeus had married Metis "hoping to domesticate her"(Lincoln, 1999: 7). But when oracles predicted that Metis would bear a daughter and then a son, and the son would overthrow his father, Zeus resolved the problem by swallowing his wife.

As the ruler of Olympus, Zeus was powerful, sometimes wise and benevolent. But like the other gods and goddesses, he was not without flaws. In Zeus's case, his weakness was women. During his later marriage to his sister/consort, Hera, he actively pursued and seduced or raped (in various guises) mortal women. Hera responded with rage aimed often at the women and their offspring. About this, Gilmore (2001) writes:

> By the time of Homer's *Iliad,* women were already being shoe-horned into the "bad-wife" stereotype even among the gods. The blind poet's portrayal of the bossy Hera who persecutes her husband Zeus is typical. Nagging wives populate supernumerary Greek myths and stories; they drive their husbands to distraction, culminating in calamity (72).

Much in a Name?

In March 2002, Marjorie Knoller was convicted of second-degree murder* in the mauling death of her neighbor, Diane Whipple. The dogs who killed Whipple were owned by Knoller and her husband, Robert Noel, both attorneys.

In a letter to the editor, one reader of a news magazine observed that the claims made by the couple that they did not know that their dogs were dangerous was belied by the names that they had given the dogs— "Hera, the vengeful wife/sister of Zeus, and Bane (definition: 'poisonous, murderous, destructive')" (*Newsweek,* Letters, p. 13).

*A Superior Court judge overturned this verdict, substituting a finding of involuntary manslaughter. Noel had originally been found guilty of involuntary manslaughter. Knoller was released from prison on parole in January 2004 after serving more than half of her four-year sentence.

As for Zeus, although his behavior toward women was often less than chivalrous, women had played an important part in his rise to power. Rhea, Zeus's mother, had protected her son by deceiving Cronus, his father. Because Cronus feared being overthrown, he made a practice of consuming his offspring. But when Zeus was born, Rhea, concocted a plan to save him. Knowing her husband intended to swallow the infant, she substituted a stone wrapped in swaddling clothing. Later, Zeus, full-grown, did indeed overthrow his father, just as Cronus, in response to his mother's plea,[1] had overthrown his own sire. But, as Loraux (1992) observes, such conspiracies between mothers and sons ended with Zeus. Zeus prevents his own predicted overthrow by swallowing the pregnant Metis. In doing so, as Lincoln (1999:8) observes, he "brought her under control in definitive fashion by fully encompassing her power. . .with this, at last his sovereignty [was] secure." Zeus's second wife, Hera, ruled with him, but was also subordinate to him.

Having cast many of the old gods into oblivion, Zeus developed a strategy for shared rule of the universe among the new generation of gods and goddesses. From one perspective, Zeus brought order to the universe. From another, it was he, the "Father of all gods and men" who established a patriarchal universe.

The Gods and Goddesses of Mt. Olympus

In Greek mythology, Mt. Olympus is the spiritual home of the deities. The mountain has no exact geographical location, but it has been associated with peaks in Greece, Turkey, and Cyprus. The multifaceted gods and goddesses who are associated with Olympus are:

Zeus...	king of the gods
Hera...	his sister/wife
Poseidon and Hades	Zeus's brothers
Demeter* and Hestia	Zeus's sisters
Apollo, Artemis, Ares, Aphrodite, Athena, Hermes, and Hephaestus...........	Zeus's children

In their worship of The Olympians, the Greeks associated these aspects with the individual god or goddess:

Zeus (Jupiter**)...................................	lord of the sky, the rain god, god of mind and intellect
Hera (Juno) ...	protector of marriage, goddess of fertility and stages of a woman's life
Poseidon (Neptune).............................	lord of the sea
Hades (Pluto)	lord of the underworld, ruling over the dead

> **The Gods and Goddesses of Mt. Olympus** *Continued*
>
> Hestia (Vesta) goddess of the hearth
> Apollo (the same) god of music, healing, truth, light
> Aphrodite (Venus) goddess of love, desire, and beauty
> Ares (Mars) god of war
> Artemis (Diane) lady of the wild things, protector of the young, the goddess of chastity
> Athena (Minerva goddess of the city, embodiment of wisdom, reason, and purity
> Hermes (Mercury) Zeus's messenger and the guide of the dead to the underworld
> Hephaestus (Vulcan) god of fire and the forge
>
> **Demeter (Ceres) is sometimes not included on the list of The Olympians because she came down to wander the earth when her daughter Persephone was kidnaped and carried to the underworld. However, she is the goddess of the harvest (or grain). She is sometimes referred to, along with the god of wine Dionysus (Bacchus), as the two "gods of Earth" (Hamilton, 1942: 48).*
>
> ***These names in parentheses reflect the influence of Greek art and literature on the Romans. These are the names the Romans called these gods and goddesses when they adopted them (Hamilton, 44-45).*
>
> *Other Sources: www.sacredsites and Hellas On Line.*

In evaluating this cultural material, some feminists scholars have argued that in these stories of the overthrow of the old gods and the displacement of the mother goddesses, we see the mythological depiction of the real life vanquishing of the "prepatriarchal" societies that had once existed among humans.

In the Beginning was the Goddess?

Feminist scholar, Adele Getty (1990: 5) writes:

> The Goddess has always been recognized in a variety of forms. She is the Mother of the World, Giver of Life, the great nurturer, sustainer, and healer. Yet she is also the Bringer of Death, the one who grants immortality and liberation. . . She is time -- past, present and future; she is form and formlessness. She has been virgin, lover, mother and crone. She has ten thousand names and has been called 'Queen of Heaven', 'Mistress of Darkness,' 'Lady of Wild Things', the 'Weaver of the Web'. . . .

Getty asserts that this narrative of an Earth Mother, an omnipotent female being, who reigned supreme in a prepatriarchal past is not simply an interesting myth. In the modern ideological struggles that whirl around gender issues, "The mythological perspective is but one thread in the story; the

political repercussions for women and our changing attitudes toward life and Nature are also inextricably tied up with her fate" (Getty, 5). Narratives of The Goddess have played a significant role in the work of some contemporary feminist scholars. The Goddess has become a symbol of empowerment for some women who reject the values of what they describe as "male-dominated" societies. For these women (and perhaps some males), the myth of The Goddess has both spiritual and political meaning. The Goddess represents a mechanism for reshaping the relationship between men and women and between humans and Nature.

Fooling with Mother Nature

In margarine commercial that is now considered a classic, "Mother Nature" - attired in flowing gown with a flowered wreath in her hair and surrounded by the creatures of the forest -- is told that she has mistaken margarine for real butter. Her response to this trickery: a wave of her hand that produces a clash of thunder and a flash of lightning, and the warning, "It's not nice to fool with Mother Nature."

In human cultures, Mother Nature (as mother-goddess) is portrayed as both nurturing and destructive. A report on the devastation wrought by AIDS on the continent of Africa is headlined, "Genocide Perpetrated by Mother Nature" (www.allafrica.com). A weather report about the impact of hurricanes on homeowners along the Atlantic and Gulf coasts reads, "Facing Mother Nature's Fury" (Ullman, 2002). But in her more nurturing persona, "Mother Nature Loves Breastmilk" (Michels, 1996). Mother Nature has been portrayed as both the "good" (nurturing) mother and the "bad" (destructive) mother.

However, in the more ecologically-aware 20th century, environmentalists began to portray Mother Nature as the victim of her careless children, who have ravaged the Earth. The message has been that her good children should come to her aid and help her to heal (e.g., Fitzmaurice and Bankston, "Helping Mother Nature With Her Own Remedies") because as environmentalists also note, an abused Mother Nature exacts her revenge.

This Mother Goddess has been associated with Ishtar of Babylon; Isis of Egypt; Cybele of Phrygia; Anu or Annis of prehistoric Western Europe; and with the goddesses of Greek mythology, Aphrodite, Rhea, Ge, and Demeter; and the Roman goddesses Tellus, Ceres, and Maia (Harding, 98-99; also Leeming and Page, 1994: 19-83). However, in the case of the goddesses of ancient Greece and Rome, they were not solitary female beings. They shared power with male gods. The question becomes then whether there is evidence that there was a time when The Goddess might actually have existed as the symbol of matriarchal societies in which females ruled independent of males.

> ### Isis: The Winged Goddess
>
> In Egyptian mythology, Isis is the mother-goddess, mother of Horus, the infant she is often depicted suckling. She is also the devoted wife/sister of Osiris. In the Isis–Osiris legend, the two rule together over Egypt until Set, their brother, tricks Osiris and brings about his death. The box containing his body is thrown into the Nile. The grief-stricken Isis finds her husband in Byblos and brings him back to life long enough to conceive a child with him. Then she hides until their son, Horus, is born. But one day, Set finds Osiris's body, cuts it into fourteen pieces, and scatters it throughout Egypt. Isis searches for and finds all of Osiris's body except his penis which have been eaten by a crab. Aided by other deities, Isis magically rejoins her husband's body parts. Then with the Rite of Rebirth, she gives him eternal life, and he ascends to the world of the immortals. Isis then turns her attention to the rearing of her son, Horus (with help from Osiris, who comes down to assist in his son's training). When Horus is old enough he challenges Set for the throne of Egypt. During the combat between the two, Isis steps in to save her son. Furious at her interference, he strikes out and beheads her with a sword. But the god Thoth replaces Isis's head with that of a cow, and eventually Horus is named heir to the throne.
>
> Among her titles, Isis is known as the Lady of Heaven, the Giver of Life, Queen of the Gods, and Goddess of Marriage and Protection.
>
> *Source: Harris, C. C. (August 1, 2001) "Exploring Isis."*

Although he finds the notion of goddess cultures appealing, Kinsley (1989) points out the reasons he and other scholars hesitate to embrace the theory. First, there is limited physical evidence. Archaeologists have found artifacts that support the assertion that in prehistoric times, female-centered religions existed. However, in these cultures, men might still have dominated women. Moreover, there is little information about the geographical extent of such cultures if they did exist (Kinsley, xvi–xviii, also see Pomeroy, 1976). Whether or not women were indeed once dominant, these narratives provide alternative and competing stories and offer new images of women that challenge the mythologies of Western cultures.

It would be useful now to have a closer look at some of the other stories about women in Greek myths and the alternative readings some scholars have proposed.

Dangerous Females in Greek Myths

In the Greek myth, **Medusa** was a human maiden whose beauty vied with that of the goddess Athena. When Medusa dallied with the sea god, Poseidon, in Athena's temple, Athena blamed Medusa for the sacrilege. She turned Medusa's lovely hair into serpents and made her face so terrible that anyone

who beheld it (or upon whom Medusa gazed) turned to stone. Medusa, the chief Gorgon, is later killed by Perseus, a hero of ancient Greece, with a sword given him by the god Hermes. To avoid being turned to stone, Perseus looked only at Medusa's reflection in a shield provided by the goddess Athena. Perseus used Medusa's severed head to rescue Andromeda, a beautiful maiden who had been chained to a rock ledge by the sea (because her mother angered the gods with her arrogance). After the rescue, Perseus married Andromeda and gave Medusa's head to Athena in gratitude for her protection. Athena wore Medusa's head on her shield (aegis).

But, in the beginning, when she was a beautiful maiden, was Medusa a willing partner in the encounter with Poseidon or was she raped? Was Athena's rage at Medusa spurred more by her resentment of Medusa's beauty than by her concern about the desecration of her temple? Was Medusa really a horrible monster or was she instead a young woman who had been horribly wronged?

Walker (1985) finds that the myth of Medusa was not Greek in origin. She traces Medusa to Libya, where she was worshiped by the Libyan Amazons as the Serpent Goddess (representing female wisdom). She was the Destroyer aspect of the Triple Goddess (Neith in Egypt, Athene or Ath-enna in North Africa). Walker (1985:57) writes:

> Many myths present the idea that the Crone could kill with a straight look from her unveiled eye. It was a logical corollary to the theory that she revealed the mystery of herself only to the dying. Perhaps the best known of these evil-eye myths was that of Medusa, third of the trinity of Gorgons, whose petrifying look have symbolized the "turning to stone" of the dead, in the form of a grave pillar, or funerary portrait statue.

The Medusa of Greek myth seems to be descended from the ancient Goddess's "trinitarian character" of "Virgin, Mother, Crone." Walker (1985) argues that Medusa, like the other goddesses of Greek myth, owes much of her origin to the Oriental (Indian) Kali Ma, "the archetypal Crone," "the Terrible Mother" who creates and destroys.

> In her typical pose, Kali Ma squats on top of her consort Shiva, who lies dead under her feet. She rips open his belly, and drags his entrails into her mouth. . . Around her neck she wears a necklace of human skulls. . .She is lean and wrinkled like a mummy. . .(Walker, 71).

This is Kali, the Crone. But she is also capable of giving life even as she takes it. She is a "multiform Goddess" who is "both ugly and beautiful, Virgin and Crone, darkness and light" (Walker, 72). These multiple faces of Kali reflected her worshipers perception of the natural world as having its own cycle of birth and death, growth and decay. The world for these worshipers was not divided into "good" and "evil" (Walker, 72). As the Goddess entered Western culture, her aspects were splintered off to multiple goddesses. Medusa is an example of the fracturing of the Goddess's power, but Medusa, the

destroyer, also bore aspects of the wisdom embodied by the Crone in the form of her "wise blood."

> ### Kali and the Thugs
>
> Although worshiped as the Divine Mother, the goddess Kali is also associated with "disease, death, and destruction." Kali was honored as the patroness of the Thugs, a former sect in India, which preyed upon wealthy travelers, robbing and murdering their victims. A pickax, representing Kali's tooth, was consecrated after being used to dig the victim's grave. The Thugs were active from the 13th century until the 19th century when they were repressed during the British rule of India.
>
> *Source: The Columbia Encyclopedia, 6th edition, 2001. Entries: Kali and Thugs.*
>
> *Note: In a recent news story from Bangladesh, a police superintendent reported that a woman who had hacked her two children, ages 5 and 7, to death said she had done so "to satisfy the goddess Kali in order to achieve divine blessings." The woman said she had dreamed that the goddess asked her to make the "sacrifices" (Reuters, Nov. 21, 2000).*

Whatever her links to other ancient myths, the Medusa who comes down through the ages from the Greeks is a monstrous creature who turns men to stone and is finally herself beheaded. In the 17th century, Rubens rendered this scene in a grisly painting he titled "The Head of Medusa." Leonardo da Vinci and Caravaggio also did paintings dealing with the myth. But it was Sigmund Freud, the father of psychoanalysis, who helped to introduce Medusa into the discourse of social science with an essay in which he discussed the symbolism of Medusa in relation to male castration anxiety (Freud, 1922). More recently the fiery image of Medusa has been adopted as a symbol of power and female rage by some feminists (e.g., Valentis and Devane, 1994).

> ### Marketing the Power of Myth
>
> **Example 1:**
> A commercial recently seen on network television features a vignette in which a visor clad warrior (perhaps Mars) dances with a beautiful woman. Her hair—coiling snakes—is tamed by the heat from his torch.
>
> Moral: Even Medusa-like locks will be smoothed by these heat-activated hair products—and the user can also capture the heart of the handsome and slightly dangerous warrior.

Marketing the Power of Myth *Continued*

Example 2:

A January 2002 item in *Brandweek* reported that the California Milk Processor Board had hired a group of Latino students from the Art Center College of Design along with the agency of Goodby, Silverstein & Partners to create a "Got Milk?" ad aimed at the Latin market. The ad they produced featured *La Llorona*. *Brandweek* noted that this selection of a mythical figure famous for having drowned her children might seem an unusual choice. However, *La Llorona* ("the Weeping Woman") has long had the status of a cultural myth used to tease naughty children. In the ad, the ghostly figure wanders through a house, passing through a wall. She opens the refrigerator and exclaims "Leche!" (Milk), However, the carton is empty. *La Llorona* has no milk with which to wash down the pastry in her hand. She begins to weep again and the tag line "Got Milk?" appears (*Brandweek*, 01/21/2002).

To paraphrase another commercial, "Oh, the power of myth!"

The Sorceress Circe

Less frightening than Medusa in appearance, in fact, beautiful and seductive, she lives on the island of Aeaea. When Odysseus and his men land there during their voyage home from the Trojan War,[2] Circe practices her magic on them. She turns Odysseus's companions into swine. But, the hero, is saved from her trickery by the herb given him by Hermes. He conquers her:

> When Circe had used on Odysseus the magic which had always hitherto been successful and to her amazement saw him stand unchanged before her, she so marveled at the man who could resist her enchantment that she loved him. She was ready to do whatever he asked and she turned his companions at once back into men again. She treated them all with such kindness, feasting them sumptuously in her house, that for a whole year they stayed happily with her (Hamilton, 1942: 221, 223).

When Odysseus is ready to continue his journey home, Circe uses her magic to find out what he should do next to reach home safely. It is Circe who gives Odysseus the wax to put in his ears when he passes the island inhabited by the Sirens (part woman, part bird). The Sirens lure men in passing ships to death upon the rocks with their singing (Hamilton, 223-224). Like Circe, the Sirens destroy even while enchanting. But, as Odysseus proves, a Greek hero with a god on his side, can conquer a witch (Circe) who turns men to swine. Once conquered by her passion for him, the witch's power can be used for good, to aid the hero on his journey (and back to the arms of Penelope, a wife

so loyal that she has held her suitors at bay for twenty years while she awaited her husband's return).

Finally, no discussion of destructive women in Greek mythology is complete without mention of **the Amazons.** These ancient women warriors resurface later in explorers' tales of Africa and the New World. In the myths of the Greeks, they were fearless and fearsome. Lefkowitz (1986: 19) writes, "Whatever we now might think of the positive values of Amazon society, the Greeks treated them as negative illustrations of what might happen if warrior women were in control." In Greek mythology, the Amazons lived in a female-governed society. They mated with men only to produce children. Male offspring were returned to their fathers or crippled and kept as slaves.

In the myths, the Amazons became a symbolic enemy that Greek heroes, one after another, matched their skills against. Lefkowitz (1986: 20) observes, "For all their strength and skill, the Amazons always lose their battles against male heroes, especially if they are Greeks." But these untamed women who rode horses and cauterized (or cut off) their right breast to make it easier to use their weapons (see Yalom, 1997: 21-24) were deemed worthy opponents. Their downfall was linked to the rise of Greek civilization.

> The mythical defeat of the Amazons became in the rhetoric of Classical Athenian funeral orations one of the achievements of the Attic past, which symbolized the rescue of the Greeks from slavery at the hands of the foreign conquerors. . . .Amazons played a central role in the art and ideology of Archaic and Classical Athens, but they were continually reimagined to serve a changing culture and politics. . . (Fantham, et al., 1994: 128-129).

In these evolving myths, the man-hating Amazons were linked to the real life enemies of Greece. For example, one Attic vase (ca. 440-430 B.C.E.) shows a Greek warrior between two Amazons, who are clad in Persian garments (in Fantham, et al., 132).

Aside from the myths, enduring images of women are also introduced into Western culture through the works of Greeks playwrights such as Euripides and Sophocles. These women include **Clytemnestra,** who conspires with her lover to kill her husband, and **Electra,** who with her brother's aid, avenges her father's murder. In this myth, Clytemnestra is enraged by her husband Agamemnon's sacrifice of their daughter Iphigenia to ensure fair winds for the Greek armies as they sail for Troy. When he returns from war with Cassandra, the Trojan princess as his captive concubine, Clytemnestra kills him. Their father's avengers, Electra and her brother, Orestes, kill their mother and her lover.

And there is **Medea,** who kills her two children when her husband, Jason, casts her aside in favor of another woman.

Medea's Crime of Passion

In a play by the Greek dramatist Euripides, Medea emerges from her house

to address the Corinthian women. She tells them of the pain that she feels because of Jason's desertion of her and their children:

> My whole life was bound up in him, as he well knows; yet my husband has proved to be the worst of men. Of all beings who breath and have intelligence, we women are the most miserable creatures (Euripides, *Medea* (431 B.C.E)).

According to Greek mythology, Medea – Princess Medea of Colchis -- betrayed her father for love of Jason.[3] Medea helped Jason to steal the Golden Fleece and then fled with him on his ship. In the process, she killed or caused to be killed her own brother. His dismembered body was flung into the sea to slow the pursuit by her father who stopped to collect his son's body parts. Having made good their escape, Medea and Jason were married. They returned to his homeland, Greece, where Jason learned that his own father had been forced to commit suicide by the usurper Pelias. Jason turned to Medea for help in avenging this wrong. For her husband's sake, Medea tricked Pelias's daughters into killing their father (by telling them she knew a secret to restore his youth). Forced into exile after Pelias's death, Jason and Medea went to Corinth. There Jason decided to cast Medea aside and marry the king's daughter. Heart-broken and enraged, Medea sent a gift, a robe, to Jason's bride. This beautiful but poisonous robe burned the Corinthian princess's flesh when she put it on. In her anguish, the young woman flung herself into a well and drowned (or, in another version of the tale, dropped dead). As a final act of vengeance, Medea, the woman scorned, killed her two sons that Jason had fathered. As Jason, came after her in his fury, she flew off over the roof tops in a chariot drawn by dragons. Medea, the niece of Circe, was an enchantress, a witch. She was also a woman who had killed her own children.

Or was she? Euripides, the ancient Greek playwright, found Medea guilty of the allegations against her, but in his drama he gave her the opportunity to accuse Jason of betrayal and to describe her plight as both woman and alien in a strange land. Christa Wolf, the late twentieth-century novelist, goes further. She clears Medea of all of the charges against her (from the betrayal of her father and murder of her brother to the murder of the Corinthian princess and her own children). Wolf's *Medea* (1998) tells the reader how she stumbled upon a secret buried beneath the Corinthian royal palace. Because of this, those in power considered her dangerous and plotted to destroy her. Wolf's Medea is a scapegoat not a murderess. She is deserted or betrayed by those she trusts and finally forced to go into hiding after her children are stoned to death by a mob.

But in spite of such modern reconstructions of her story, the name Medea echoes through the centuries as that of a wicked woman (see Corti, 1998; also Hall et al., 2000). Bloody Medea, lacking all maternal feeling, slays her children to avenge herself against their father. Like the other mythical women discussed above, Medea descends through history as an archetype of the dangerous woman. Modern feminist scholars and others have retold their

stories, offering alternative perspectives, but it is the stories as they were first told by the ancient Greeks that resonate in our psyches.[4]

Summary

In this chapter, we have discussed some of the depictions of women in the mythology of ancient Greece. We have focused on Greek mythology because of its impact on Western thought and imagination. The reader should note several points: (1) that the roles occupied by mortal women as wives, mothers, daughters, sisters are replicated in the Greeks myths; (2) that there is a continuing debate about the existence of "prepatriarchal" cultures in which The Goddess rather than a male god ruled supreme; (3) that some feminist scholars have made use of these myths in their work.

The point of this chapter is that Greek mythology is one of the cultural resources used in the social construction of women who kill. Mythical images of women as seductresses, destroyers, harpies, and avengers are a part of contemporary gender discourse. In this regard, the negative images of violent women that emerge from Greek mythology and that are evoked in contemporary descriptions of women who kill are an area of contention.

In the next chapter, the focus is on the status of Greek and Roman women in the legal system and in the thoughts of men. The anatomy of difference described by the physicians and philosophers is discussed. The next chapter also begins the process of tracing the surveillance of maternity and of healthcare/care-giving roles (i.e., midwives and wet nurses) by men.

Discussion Questions

1. In Greek mythology, with the coming of Zeus, the male god becomes dominant. How do you think the mythology of the Greeks would be different if they had imagined a universe in which The Goddess ruled supreme? What might this alternative mythology have reflected about their lives?

2. How do you think the mythical Amazons are perceived in modern popular culture? Is it a slur to refer to a woman as "an Amazon"?

Notes

[1] In Greek mythology the first beings are Mother Earth (Gaea) and Father Heaven (Ouranos). They are gigantic creatures. The Cyclopes and the Titans are their children. Outraged at Ouranos's treatment of her other monstrous children, Gaea appeals to the Cyclopes and the Titans for help in avenging them. The Titan Cronus hears his mother appeal. He wounds his father terribly and the Giants and the Furies are born from Ouranos's blood (Hamilton, 1942: 66-67).

[2] We should note here the role of the beautiful Helen, wife of Menelaus, King of Sparta, in starting the Trojan War, when she either eloped with or was kidnaped by Paris, a prince of Troy. Helen's culpability in the slaughter that follows has been much debated. However, Aphrodite also played a role, when in order to win a beauty contest that Paris was judging, she promised him he would have the fairest woman in the world—Helen.

[3] The goddess Aphrodite sends Cupid to shoot a shaft into the maiden's heart with his bow, making her fall in love with Jason at first sight. Hera has asked Aphrodite to help the courageous Jason in his quest for the Golden Fleece (Hamilton, 1942: 128).

[4] Psyche was the beautiful mortal maiden, a princess, with whom Cupid (the God of Love) fell in love—much to the displeasure of his mother, Venus. After much interference by her own sisters (who make Psyche distrust the husband she has never seen by light of day) and Venus (who gives her a series of tasks to perform), Psyche triumphs. Cupid forgives her for doubting him, an assembly of gods make her immortal, and she and Cupid are formally married. Venus relents.

Chapter 2

The Anatomy of Difference
On the Status of Women in Ancient Greece and Rome

The Roles of Women in Archaic and Classical Greece[1]

In ancient Greece, the status of women was subordinate to that of men. With the exceptions of prostitutes and servants, women spent much of their time in their homes.[2] Earlier scholars suggested that upper class Greek women were generally restricted to the women's quarters of their homes and rarely ventured out of doors. However, more recent scholarship leans toward the perspective that although in theory upper class women were confined to the private spaces of their homes, these women did in fact venture out to participate in religious rituals, festivals,[3] weddings, and funerals. They also visited the homes of female neighbors and relatives. However, women of child-bearing age who were married to male citizens were expected to observe certain rules of conduct. They were to avoid any situation that might give the appearance of impropriety.

The concern among Athenians about the behavior of wives and unmarried women was rooted not so much in concern about female chastity but rather in concern about the integrity of the family bloodline. After marriage, free Athenian women were expected to produce the male heirs who would carry on their husband's *oikos* (family or household).[4] This heir would take his place as an Athenian citizen, a status both socially and economically valuable. Therefore, it was important to the husband that he be certain that the infant presented to him by his wife as his heir was indeed a child that he had sired.

However, the information available about the experience of marriage and motherhood from the perspectives of Greek women is limited. With a few scattered exceptions, such as the poetry of Sappho, women's voices are not heard. Most of what is known about Greek women is filtered through the lens of Greek men (Pomeroy, 1997: 14). Scholars have searched for information about women and their lives in the visual arts and poetry of the period and in fragments of archaeological remains (Fantham, et. al., 1994: 10).

Based on the evidence available, it seems that although the public appearances of upper-class women were restricted, one area in which women were active was in religious ceremonies and rituals. They were central to the "sacrificial community" of the polis (Katz, 2000: 514). In fact, women were often the chief mourners at funerals. One reason women seem to have played such an important role in funeral rites was because of the belief that women "were less threatened by the ritual pollution (miasma) of contact with a corpse, especially women who had given birth and thus already incurred pollution" (Fantham, et al., 48).[5]

Mourning the dead was also an activity for which Greek men considered women emotionally better suited than themselves. Free male citizens (as opposed to dependent slaves) were expected to be rational and in control of their emotions. In contrast, women were expected to be irrational, emotional, and at the mercy of their senses (i.e., prone to gluttony, drunkenness, and sexual insatiability). Therefore, women were ideally suited to the weeping and the renting of the hair that became a part of the funeral ritual. Women could freely express their emotions. Men were expected to show more restraint.[6]

By the seventh century, "the role of mourner must have fallen increasingly to women, for at the beginning of the sixth century, Solon reportedly drafted laws regulating the conduct of female mourners at funerals" (Fantham, et. al., 46). Apparently intended to curb the practice of hiring women as mourners, the new law forbade women, except those over 60, to mourn for anyone other than a blood relative (Fantham, et al., 47). This restriction on hired mourners seems to have been aimed less at the women themselves than at ostentatious displays by the wealthy.

Aside from their role in the rituals of death, the other roles played by women were also regulated by law. In the sixth century B.C., Solon, an Athenian lawgiver "institutionalized the distinction between good women and whores." While abolishing self-sale and the slavery of children, he affirmed the right of a male guardian "to sell an unmarried woman who had lost her virginity." He also regulated other aspects of the lives of citizen women, including "the walks, the feasts, the mourning, the trousseaux, and the food and drink" (Pomeroy, 1995: 57).

From the Bronze Age to the Classical Period in Greece history, there appears have been continuity in the roles of Athenian women because these roles were "biologically determined" (Pomeroy, 1995: 33). That is, in Athenian society, certain roles—wife and childbearer—were ascribed to women based on their gender. When poor women went out to work they pursued occupations that "were an extension of women's work in the home" (Pomeroy, 1995: 73). The daughters of upper class families were given into arranged marriages that were intended to strengthen political and economic bonds. During the Bronze Age and through the pre-Classical era, marriage was less a matter of individual fulfillment than "the strengthening of the *polis*" (Pomeroy, 1995: 34).

However, in neighboring Sparta, girls and women seem to have enjoyed relatively more freedom because Spartan society had a somewhat different (i.e., more warlike) focus than that of Athens. Girls were encouraged to exercise vigorously because of their special role as future mothers. Spartan marriages also differed from those of the Athenians in that after marriage, husband and wife often lived apart. The husband often continued to live in military barracks with his comrades, visiting the woman to whom he was married. Since the custom was to keep such unions secret, the marriage could later be nullified if the bride failed to become pregnant. In fact, the Spartan approach provided both partners an opportunity for a "trial marriage" of sorts (Pomeroy, 1995: 38-39).

But their marital ties aside, Greek men in both Sparta and Athens, shared strong bonds with other men. Much has been written about the male homosexual relationships in Greek culture that flourished openly and as an accepted part of male life. Just (1989: 145-151) theorizes that these relationships provided free male citizens with their only real opportunity to experience a relationship with another person who could be both sexual partner and companion. Because of her subordinate status and the restrictions placed upon her, a man could not have such a relationship—a relationship

between equals—with his wife. Moreover, marriage was not based on romance, but a same sex relationship could be. If the relationship were with a younger man or boy, the older partner could also think of himself as involved not only in a physical (or erotic) union but as serving as a mentor to his lover.

At the same time, practices such as homosexuality, the male's use of prostitutes and slave women, and limited sexual activity between husband and wife offered mechanisms for population control. During times of war, it was necessary to replenish the population. At other times there might have been few incentives to have additional children. The natural mortality rate for infants was high, but abortion still seems to have been practiced. Infanticide, particularly of daughters, might sometimes have occurred (Pomeroy, 1995: 69).

The husband and wife were guided in their choices by the laws promulgated by Solon. The father, guardian, or husband of the woman exercised control over her and had the right to punish what he perceived as misbehavior. When adultery occurred, the male was assumed to have been the aggressor, but both parties were punished. Aside from the impact of an illicit affair on a marriage, such an affair might produce a child.[7] This was a matter of particular concern if the father was a non-citizen male because the child would be introduced into the cuckolded husband's home, kinship-group cults, and, even more disturbing, added to the rolls of Athenian citizens (Pomeroy, 1995: 86). In cases of both rape and adultery, the law compelled the husband to seek divorce from his wife. The accused woman was not allowed to "proclaim her own innocence, though, with difficulty, her guardian might do so on her behalf." A woman punished for sexual misbehavior might be banned from participation in public ceremonies, from the wearing of jewelry, and might in the extreme be made a social outcast who would never be able to find another husband (Pomeroy, 1995: 86).

But aside from the law, which governed the behavior of women, there was the medical profession that ministered to their needs and the male doctors who gave them advice.

Doctors, Midwives, and Female Anatomy

Demand (1994) is among those scholars who argue that over time, doctors sought to exercise more control over their female patients, supplanting the women who had once been the primary advisers and caregivers.[8] According to this argument, the concern on the part of husbands that their wives provide them with legitimate male heirs led to male distrust of female midwives who might conspire with wives to deceive husbands (e.g., by substituting a male child born of a slave for the wife's female child). But a male doctor provided some reassurance for the husband. This Hippocratic physician was able to relieve some of the anxieties of the husband by asserting his authority as a man of medicine.

> He [the doctor] was in a good position to prevent the connivance of the midwife in the introduction of a supposititious infant, and possibly even to prevent unauthorized female resort to abortion. And

he could rely upon his professional assessment of the risks of female sexual and reproductive abstinence in order to reinforce social norms of early marriage of adolescent daughters and the remarriage of divorcees and widows of childbearing age (Demand, 69).

In the gynecological treatises that they produced, doctors discussed a condition that they described as **"the wandering womb."** It was a condition found among virgins of marriageable age (about fourteen) and in older women, married or unmarried who were not sexually active. Deprived of the moisture produced by sexual intercourse and pregnancy, the womb -- that according to Hippocratic anatomy was free to move about the body -- would migrate to other areas (the head, heart, stomach, bladder, etc), causing a variety of unpleasant symptoms:

> The symptoms suffered by the victim of wandering womb varied according to the site to which it moved: suffocation, chills and fever, headache, pains in various other locations, vomiting, loss of speech, strangury, and effects of consciousness ranging from lethargy to delirium. . . . (Demand, 1994: 55).

The doctor's prescription for women suffering from wandering womb was intercourse and pregnancy. This provided encouragement for a young woman (who might be reluctant to leave her home and family) to marry, and encouragement for a married woman to bear children. At the same time, as with other maladies that will be discussed, this diagnosis was a part of the social construction of a uniquely female illness. The diagnosis of wandering womb could be used by doctors, patients, and others to explain certain behaviors by women, and it provided a mechanism for directing female behavior in the desired direction (i.e., marriage and childbearing).

As male doctors became more involved with treating female patients, Demand (1994) argues that these medical men provided support for the gender status quo. Reflecting an "androcentric bias," Greek medical theory appeared to offer a rational basis for believing that women were inferior to men in their anatomy. According to this theory, women were "weaker, moister, softer, more porous, and warmer than men. . . .slower to develop in the womb but faster to age and decline in their lifetimes. . . ."(Demand, 32).

When the female womb did not receive the moisture and weight provided by semen or a fetus, the womb wandered about causing symptoms that could be not only distressing for the woman but alarming and potentially dangerous for others. A woman was at her best -- and most tractable -- when she was married and involved in a sexual relationship with her husband who would get her with child.

If the tractability of women was a matter of concern for Greek men, it was perhaps more of a concern for the Romans conquerors who wanted to build and hold an empire. Women who held or tried to seize power became the subjects of the narratives that the Romans told.

Queens and Warrior Women in the Roman Empire

Among the ancient Romans, Cleopatra was both notorious and legendary. To the Romans of her day, Cleopatra VII, queen of Egypt, was a woman who captured if not the hearts at least the lust of two noble Roman generals, Julius Caesar and Marc Antony. Her liaison with Julius Caesar produced a son, Caesarion (Ptolemy Caesar) born on June 23, 47 B.C. Following Caesar's assassination, she turned to Marc Antony. She bore him two sons and a daughter. Together the two of them, challenged the army of Octavius. When Antony was defeated, he killed himself. Taken captive by Octavius, Cleopatra, too, committed suicide by (according to legend) holding an asp to her breast.

Regarding her relationships, Clarke (1988) describes Cleopatra's alliance with Julius Caesar as a "political and sexual relationship" that was "a maneuver to save Egypt from the worst aspects of Roman domination." After Caesar was assassinated, Cleopatra, still in her early twenties, met Marc Antony and began yet another love affair motivated by politics (Clarke, 127). In this scenario put forth by Clarke and others (e.g., Ackerman, 1994: 6), Cleopatra's suicide after Antony's death was not so much (or completely) an act in response to lost love as it was to the fact that she no longer had "a protector or champion and faced humiliation at the hands of Octavius." Clarke (1988: 128) asserts that she "committed suicide because she lost control of Egypt." It was her country that was her "great love."

Which image of Cleopatra is the true one? The scheming seductress? The beautiful woman who falls in love with two strong men? The queen doing what she must to save her country and killing herself when it is lost? In *A Natural History of Love* (1994), Diane Ackerman writes:

> We don't remember her [Cleopatra] in Egyptian terms, as a powerful and able monarch, whose people valued and even worshipped her. Instead, we accept the Roman propaganda of her as a depraved seductress, the ruin of great men. This should not surprise us. Rome was her enemy, and it was in Rome's best interest to vilify her during wartime. If she wasn't depicted as a beautiful, debauched, hot-blooded enchantress, how could one explain Roman generals joining forces with her? (Ackerman, 5).

But what of the story that Cleopatra murdered—or had murdered—her own brother-consort in order to gain sole control of the throne of Egypt? What of the other murders she is said to have commanded carried out? Of this Ackerman writes:

> Was she depraved? Apparently she did contrive to kill her siblings in order to be queen. Did she have many lovers? She is reported to have taxed some men dearly for spending a single night with her. After lovemaking she sometimes had a man killed (Ackerman, 5).

Cleopatra as a female "black widow" killing the men with whom she mated? Perhaps. Or perhaps this is only a part of the legend of a woman who challenged an empire. Millan (1982) argues that Cleopatra's reign should be

evaluated as one in what would be a long line of "women rulers in men's worlds," extending from the antiquity to the present. As a woman, Cleopatra was "a political victim of the ancient tragedians' stereotype of women" (Millan,15). As Ackerman observes, in her own lifetime, Cleopatra assumed the status of legend, of "invention." Her enemies "mythologized her as an evil enchantress; she mythologized herself as a beneficent goddess" (Ackerman, 5).[9] Cleopatra thought herself the embodiment of the goddess Isis (Ackerman, 6). In linking herself to the myths of the goddess, Cleopatra followed the tradition of dynastic Egypt, the land of the pharaohs.

Cleopatra's Allure

Shakespeare's *Antony and Cleopatra* was first published in the folio of 1623. In the play, Shakespeare has Antony's friend, Domitius Enobarbus, offer this famous description of the Egyptian queen. He is explaining to a friend of Caesar's why Antony will not leave her:

> Age cannot wither her, nor custom stale
> Her infinite variety; other women cloy
> The appetites they feed, but she makes hungry
> Where most she satisfies. For vilest things
> Become themselves in her, that the holy priests
> Bless her when she is riggish [lewd]. —Act II, ii, 235-241

In fact, such claims to immortality were not limited to Egyptian queens. Later in Rome, the emperor Nero would declare his own descent from the gods. Known for his excesses, sexual and otherwise, Nero is said to have ordered the murder of his own mother, Agrippina Minor. But the horror of Nero's matricide is diluted by the allegation that Agrippina had aided her son's youthful rise to power by feeding her husband Claudius poison mushrooms on October 13, 54 A.D. Claudius himself had earlier ordered the execution of a prior wife, Valeria Messalina, after she conspired with C. Silius and after his discovery that she had organized and taken part in sexual orgies.

Regarding Agrippina, Ferrero (1993) asserts there is reason to doubt that she was guilty of her alleged crime (i.e., the murder of her husband):

> This accusation of poisoning…seems to be precisely the same sort as, and not a whit more serious than, all those other similar accusations which were brought against the members of the Augustan family. Claudius, who was already sixty-four, in all probability died a sudden but natural death, and from the point of view of the interests of the house of Augustus, which Agrippina had strongly at heart, he died much too soon… (Ferrero, 218).

In his examination of the roles assumed by women in the politics of ancient Roman, Bauman (1992) describes this period as one in which

intelligent and determined elite women used their skills to protect their own positions and those of their family members. In this world of intrigues and betrayals, some of these women were as devious and treacherous as the most villainous of the men with whom they dealt. Other women were more admirable. But as a group, they reflected the opportunities during this era for the "rise of the great political matron" (211).

Whatever the activities of the "women of the Caesars" (Ferrero, 1993), elsewhere in the Roman Empire, women sometimes led spirited resistance movements against Roman forces. In Ethiopia, the oldest country in Africa for which records exist, dating back to 3000 B.C., there is evidence that tribal relations were matriarchal in pre-Christian times. When the Napata Empire (later Meroe) was conquered by the Romans in 22 B.C., the Roman historian Strabo reported that the leader of the African army was Queen Kundake. She lead her troops against the forces of Augustus Caesar (Loth, 1987: 35). Kundake was one of the warrior queens that appeared at various times during this period. Another was the British queen Boudicca (Bodecia) of Iceni. When her husband was killed, her daughters raped, and she herself beaten, Boudicca led a revolt against Roman rule in 61 A.D. When she was defeated by Suetonius Paulinus in 62 A.D., she committed suicide by taking poison. Other warrior queens included Zenobia of Palmrya who invaded Rome's eastern territories in the 3rd century C. E.

Like their male counterparts, these non-Roman women were seen as the "Other" by the Romans. They were perceived as "barbarians," subject to conquest and enslavement. As Fantham et al. (1994) observe, the stories in which these women figured as warriors, as barbarian queens, leading their troops against Roman forces bear some resemblance to the Greek tales of battles with Amazon women. These tales "grant a certain misguided heroism to the Amazon-like women even as they go down in defeat" (Fantham et al., 386).

But what of the lives of those women who stayed at home as their men went off to fight and who bore the sons that would become a part of the Roman military/political machine?

Roman Wives and Mothers

Historian Paul Veyne observes:

> The birth of a Roman was not merely a biological fact. Infants came into the world, or at any rate were received into society, only as the head of the family willed. Contraception, abortion, the exposure of freeborn infants, and infanticide of slaves' children were common and perfectly legal practices (Veyne, 1987: 9).

It was up to the Roman father to determine the fate of the new-born child—life or death, acceptance into the family or rejection. As Veyne (1987: 9) writes: "Immediately after the birth it was the father's prerogative to raise the child from the earth where the midwife had placed it, thus indicating that he recognized the infant as his own and declined to expose it [to the elements]."[10] If he suspected his wife of adultery, a husband might chose to

reject the child. However, special privileges were granted to women who had fulfilled their maternal duty by producing three accepted children for their husbands (Veyne, 13). At the same time, Romans were aware of the burden placed on families by too many children—whether in terms of daily survival or with regard to shared inheritance. For these reasons, both poor people and those better off might decide not to raise a child. Sometimes these children who were abandoned were taken in by other families. Roman law allowed for the process of adopting—and reclaiming—a child (Veyne, 10).

With regard to the care of mother and infant, in Rome as in Greece, women played an important role in assisting other women. Some peasant women relied on their practical experience in offering themselves as midwives (*opstetrices*), but increasingly women who had received their training in wealthy households came to dominate the profession (Evans, 1991: 123). There is also evidence that a "small group of female physicians (*medicae/iatromeae*)," generally either slaves or freed-born women, did practice medicine in the provinces and in Rome (Evans, 125-126).

However, the majority of the women who provided services were wet-nurses (*nutrices*). As they would in later centuries, working class women found a demand for the milk that their bodies could provide to nurse infants. Evans relates this description of the ideal wet-nurse found in the teachings of the Greek physician Soranus:

>a woman in her 20s or 30s who has given birth to two or three children of her own. She should, he says, be healthy, and have a large frame and ruddy complexion; more to the point, her breasts should be of medium size, soft and unwrinkled, and yield an overabundance of milk. With regard to her temperament, she should have sufficient self-control to refrain from, inter alia, intercourse and alcohol: it was commonly believed that these temptations reduced lactation, and caused the milk to spoil in the process. In addition, she should be even-tempered, tidy, and of a sympathetic nature—qualities that would serve to protect the infant from abuse or neglect... (Evans, 128).

Although Soranus expressed a marked preference for Greek wet-nurses, his pronouncements on the subject seem to have reflected common opinion in the Roman world as well about qualities desirable in a wet-nurse (Evans, 128). The underlying concern was not only to insure the survival of the infant by providing the food (milk) that he or she required, but also to avoid the contamination or the abuse/neglect of the child. In his *Gynecology*, written in the second half of the first century C.E., Soranus writes:

> Besides, angry women are like maniacs and sometimes when the newborn cries from fear and they are unable to restrain it, they let it drop from their hands or overturn it dangerously... (quoted in Fantham et al., 1994: 379).

Clearly there was a concern among those who instructed in the selection of wet-nurses and the parents who employed them that an ill-chosen wet-nurse might prove more of a danger to the child than a blessing. But, at the same time, in Greek and Roman societies, because of the death of women in childbirth and because of the preferences of well-to-do women regarding nurses, wet-nurses—as they would continue to do in future centuries—had an important role to play. In actuality, the wet-nurse's own family might suffer negative consequences because of her employment. Her children might be neglected or even abandoned as she carried out her duties as a nurse to other infants.

But there was another group of women in the Roman world who by their actions risked even graver consequences to themselves and their families.

Women and Christian Martyrdom

Fantham et al. (1994) observe of Christian women in the Roman world that prior to 311-12 C.E., when Constantine made Christianity legal, women who were practicing Christians risked their positions, their families, and possibly the loss of their lives.

> Whether because of overt persecution or simply through the loathing of Christianity that came about from stories about cannibalism and incest, only the lowliest or the most privileged in Roman society could openly and with impunity admit to being a Christian. . . (Fantham et al., 383).

Archibald (1997: 134) finds:

> The Christian practices of emphasizing love, addressing one another as "brother" and "sister," and meeting regularly for communal meals in celebration of Christ's sacrifice was creatively and maliciously interpreted to produce bizarre accounts of cannibalism and incestuous orgies in the dark.

Such narratives as that of St. Perpetua of her captivity in third-century Carthage provide vivid accounts of the beliefs of Christian women and the responses of their persecutors (Fantham et al., 383). Early Christian women seemed to have behaved in ways that non-Christian Romans perceived as both provocative and defiant. As Ide (1998) describes, Christian women (and men) were accused of being atheists (*a-theos*) "since they followed the what seemed irrational, and at times contradictory teaching of a mortal man who his followers claimed to be immortal" (Ide, 20). Moreover, women were most vulnerable to the charge of atheism because of their traditional duties of caring for and tending the gardens, pools, and temples of the Olympian deities.

> When Christian women refused to honor the gods and goddesses of their particular locality in the same manner, they were shunned as being against motherhood and the expected role of women that

included motherhood either in giving actual birth to a mortal child or being the 'vessel for a god'. . . . (Ide, 25).

In fact, the early Christians did believe chastity to be the preferred state for both men and women. When sex occurred within marriage it was to be for the purpose of procreation. Therefore, Christian women who had defied Roman laws with their proselytizing and other activities were often punished by being placed in a brothel or given to an individual or to a group of men for gang rape. They were also "farmed out" for entertainment and sport, "any form of sexuality from bestial to serial" (Ide, 54). These women sometimes committed suicide, preferring death to the loss of their chastity. However, rape and sexual abuse was not the only punishment suffered by these early Christian women for their defiance of the law. Some were executed.

These women who refused to experience (or at least to acknowledge) sexual pleasure, who refused to engage in the civic activities that were expected of them, and who took part in ceremonies which were rumored to involve the sacrifice of children and/or the eating of human flesh and drinking of blood (the language used by the Christians in describing their sacred rituals), were deemed disruptive and dangerous. Especially unsettling was the way in which Christian women (and men) seemed to embrace death and to welcome martyrdom. Contributing to their stigmatized status was the fact that many of the Christian women began to dress like men and to crop their hair. This issue of female dress and its meaning would appear again in Christian history with the warrior maiden, Joan of Arc.

But as the Roman empire fell into decline, one of the images to emerge from and define Christianity was that of the Virgin Mary, the Madonna. This image was juxtaposed against that of woman as whore and seductress.

Summary

This chapter has introduced the reader to three important themes that will be developed throughout this book: (1) the social and legal status of women and their ascribed roles; (2) the descriptions of the nature of women—their anatomical makeup and psychological predispositions—that appear in medical and other narratives; and (3) the male anxieties inspired by maternity and by the involvement of women as caregivers. In subsequent chapters, the language of the discourse will change, but the themes will not. These themes are at the heart of narratives about female virtue and depravity, and thus essential in the discussion of the social construction of women as killers.

The next chapter looks at women and narratives about them from the Middle Ages to the Renaissance. The chapter moves from biblical narratives of wicked women to Shakespeare's Lady Macbeth. As in this chapter, these narratives are examined in the context of the conditions of women's lives during these centuries.

Discussion Questions

1. Discuss the concept of the "wandering womb" as a disorder of the female body identified by ancient physicians. How were this disorder related to perceptions about female sexuality and the roles of women?

2. Recently the media reported on a traveling exhibition from the British Museum, "Cleopatra of Egypt: From History to Myth". Articles in *The New York Times* (Stanley, 01/20/2001, Section B, p. 9) and *The Christian Science Monitor* (Mason, 01/25/2002, Features, p. 13) described the artifacts in the exhibition and the new perspectives on Cleopatra that are being offered by historians and others. Read these two articles and discuss this modern reconstruction of history, myth, and the image of this woman.

Notes

[1] The Archaic period extends from late eighth-early fifth centuries B.C.E. The Classical period extends from early fifth-late fourth centuries B.C.E.

[2] The focus here is on upper class women not because the lives of other women were unimportant but because, as in all eras, the best historical evidence available is about the lives of the elite. Moreover, the attitudes of upper class Greek men toward women of the same rank reveal much about what they believed about all women and their nature.

[3] Perhaps the most famous festival for women in classical Athens was the Thesmophoria. During this fertility rite, married women spent three days living in a hilltop sanctuary dedicated to the goddess Demeter. They symbolically recreated the mourning of Demeter for her daughter Persephone, who was carried away in a rape/marriage by Hades, the god of the underworld. The festival ended with a feast in honor of fertility and birth (Fantham, et al., 86-87).

[4] See Pomeroy (1997) for her chapter on "Defining the Family" in which she deals with the complexity of the family and inheritance. Included in this chapter is discussion of marriage between blood relatives in instances in which a young woman was left an orphan. See also Just (1989) on women and Athenian law.

[5] Pomeroy (1995: 44) writes: "Women's association with rituals concerning death is still customary in Greece. Women have always been freer than men to indulge in displays of emotion, and are therefore more impressive participants at funerals. The washing and dressing of the corpse has certain analogies to the caring for infants; the cycle of life takes us from the care of women and returns us to the care of women."

[6] Here we should note the association of women with the cults of Dionysus, the God of the Vine (Wine). The Maenads or Bacchantes, his followers, were women who when frenzied with wine were said to tear wild creatures to pieces with their bare hands (Hamilton, 1942: 58). Orpheus, the musician, was torn apart by a band of Maenads. Pentheus, the King of Thebes, was also killed by followers of Dionysus, including his own mother and sister, who (made mad by Dionysus) saw Pentheus as a mountain lion and tore him from limb to limb (Hamilton, 59-61).

[7] Just (1989: 70) cites the conclusion of scholars who assert that adultery was not simply a private offense but an offense against the polis (city-state) as well because of the importance of citizenship.

[8] We will return to the matter of midwives and male doctors at various points, particularly in the United States in the 19th-century as medicine undergoes professionalization.

[9] One aspect of the legend of (and the debate about) Cleopatra concerns her race. Historian John Henrik Clarke, in an essay on "African warrior queens" (in Van Sertima, 1988: 126) asserts:

> She was not a white woman, she was not Greek...Until the emergenceof the doctrine of white superiority, Cleopatra was generally pictured as a distinctly African woman, dark in color. Shakespeare in the opening line of Antony and Cleopatra calls her 'tawny'...

[10] According to Veyne (1987) in ancient Greece it was "more common to expose female infants than males." The Romans seem not to have discriminated by gender, but to have "exposed or have drowned malformed infants" (Veyne, 9).

Chapter 3

Virgin, Whore, Witch
Images of Medieval and Renaissance Women

Timeline of Middle Ages and Renaissance

871-899	Alfred the Great of England
c.880 – 911	High point of Viking raids in Europe
1046	Beginning of Reform Papacy
1066	Norman Conquest of England
1067	Work begins on Tower of London
1086	Domesday Book completed in England
1095-1099	First Crusade
1099	Crusaders capture Jerusalem
c.1100 –1300	Origins of university in the west
1204	Crusaders sack Constantinople
1215	*Magna Carta* in England
1225-1274	St. Thomas Acquinas
1290	Edward I expels all Jews from England
c.1310	Dante's *Divine Comedy*
1337-1453	Hundred Years War
1347-1350	Black Death
1381	Peasants' Revolt in England
c.1390	Chaucer's *Canterbury Tales*
1403	Ghiberti sculpts human bodies in realistic style for bronze doors of Florence baptistry, one marker of beginning of Renaissance
1431	Joan of Arc (Jeanne d'Arc) burned as witch at Rouen
c.1450	Printing with movable type
1453	Hundred Years War ends
1455-1485	War of the Roses in England
1469	Marriage of Ferdinand and Isabella
1469-1492	Lorenzo de' Medici rules Florence
1485-1603	Strong Tudor dynasty in England
1478	The Spanish Inquisition
1492	Christopher Columbus reaches West Indies
1503	Leonardo da Vinci paints *Mona Lisa*
1510	First African slaves taken to America
1508-1512	Michelangelo paints ceiling of Sistine Chapel
1558-1603	Reign of Elizabeth I of England
1564	William Shakespeare born
1587	Mary, Queen of Scots executed
1588	Spanish Armada defeated
1607	John Smith founds colony of Virginia at Jamestown
1611	King James authorized version of the Bible published
1619	First African Americans arrive in Virginia aboard Dutch ship
1620	Pilgrims land Plymouth Bay, Massachusetts
1625	Dutch found New Amsterdam (later New York)
1628	John Endecott founds Puritan settlement in Salem, Massachusetts
1632	Birth of John Locke
1633	Galileo taken before the Inquisition in Rome

Biblical Wicked Women

In a volume on the history of women in the Middle Ages, editor Christiane Klapisch-Zuber discusses the images purveyed in the Bible and "patristic tradition." Women are described as "creatures dominated by their sex," beings who embody "death, suffering, and toil," and it is up to men to "control and punish" this "dangerous, disruptive sexuality." In this regard:

> Masculine philosophy and science showed little reluctance to shoulder the task. Proverb, maxims, medical treatises, works of theology, textbooks, and manuals of ethics had been honing an arsenal for the purpose ever since antiquity. Scientific, ethical, and political thought converged in the notion that woman must either remain chaste or devote herself entirely to procreation (Klapisch-Zuber, 13).

In his guide to reading the Old Testament, Bandstra (1999) points out the complexity of the text as a source. Composed over a period of a thousand years, the Old Testament (or Hebrew Bible) is the work of various authors, writing at different times and influenced not only by their own oral tradition but by contacts with other cultures. Frymer-Kensky (1992) makes this point even more strongly in her examination of the biblical transformation of pagan myths about goddesses. She argues that "misogynistic and anti-erotic themes" enter Christian thought because of the influence of Hellenic culture on Judaism and the emerging Church (213-215).

Whatever their original sources, the negative images of women ascribed to the Bible are said to have contributed to the false dichotomy of woman as virgin or whore. Exum (1996) describes the women of biblical narratives as being "plotted, shot, and painted" in cultural representations. For example, **Delilah** is a "relatively minor biblical character but one whose action has serious consequences" (Exum, 180). The minimal information about her in the Bible is ambiguous enough to allow for reading of Delilah as prostitute or as seductive foreign woman (Exum, 186-187). She uses her sexuality to bewitch Samson, and then betrays him to the Philistines by cutting off the hair that is the source of his great strength. Bach (1997) describes Delilah as one of the women in the Bible who appear in

> ... a series of stories ... in which a woman is responsible for the death and decollation of a narratively significant male figure. Haman is hanged at Esther's request, Judith severs Holofernes' head with his own sword, Jael smashes in the head of Sisera, Delilah is responsible for the haircutting and subsequent blinding of Samson. Food and drink are two of the temptations that lead to sexual desire and death in each of these stories ... (Bach, 213).

One of these women, the widow **Judith,** is acclaimed as a heroine after she uses her sexuality to entrap and then kill the enemy of her people. With

"the hand of a woman" she delivers her people from the threat of Holofernes. It should be noted that her woman's hand carries out a bloody task that has the approval of the male elders. No word of censure is spoken regarding her treachery toward the man she kills (see Harrington, 1999).

Another alluring female, the young **Salome,** so delights her stepfather's guests with her dance that he offers to reward her by granting a request. After conferring with her mother, Herodias, Salome asks for the head of John the Baptist on a platter (Bach, 212-213). Artists and composers of later periods were fascinated with the story of Salome. Her dance became increasingly eroticized in re-tellings of the tale. Bach (1997) observes:

> In spite of her shadowy appearance in the Gospels of Mark and Matthew, one can create a full-bodied dangerous Salome through the examination of these fin de siecle and popular cinematic representations of the mysterious dancing girl who became an icon of seduction (Bach, 212).

As Bach (1997: 9) observes, the "vixens" of the Bible, such as Delilah and Salome, are the women who destroy the man who is presented as the idealized hero of the story rather than destroying the "right" man (i.e., the villain).

As a biblical example of a female villain, **Jezebel,** the daughter of a Phoenician king, is portrayed as both dangerous and evil. Married to King Ahab of Israel, Jezebel is said to have persuaded her husband to build altars and sanctuaries to a pagan god and goddess, Baal and Ashtart. When she is finally defeated by her enemies, Jezebel appears at the window as they approach. Of that appearance, Aschkenasy (1998: 15) writes:

> At the end of her life, widowed and having learned that her son, the king, was assassinated, she welcomes the usurper by appearing at the window, eyes painted and hair stylishly coiffed (2 Kings 9: 30). It is hard to imagine that Jezebel means to flaunt her sexuality at this moment in her life. Rather, as the priestess of Ashtart, daughter of a king who was probably priest of Baal or even deemed half-god (Etbaal), Jezebel means to die in all her glory...

But Jezebel comes down to us in legend as "the epitome of evil." She kills both her enemies and innocent citizens. She oversteps her bounds as a woman. Aschkenasy (1998) describes Jezebel as "the biblical precursor of Lady Macbeth," seizing control when her weak husband fails to act "and [she] never expresses any regrets or pricks of conscience" (Aschkenasy, 15).

But if Jezebel is presented as brazen in her wickedness, the story of **Bathsheba,** wife of Uriah, is more ambiguous. Bathsheba, too, captured the imagination of visual artists from the Middle Ages to the 20th century. But, in the biblical story, what is not clear is the degree of Bathsheba's complicity (i.e., willingness) in her adulterous affair with King David. She, as with Salome, does not have a significant speaking role in her story. King David looks down from his rooftop and sees her bathing. She is the object of his male gaze, and then

she is his lover. She informs him when she finds herself with child. She becomes his wife and the mother of a son, Solomon, who will himself become a king. As Aschkenasy (1998) observes Bathsheba remains an ambiguous figure because she "lacks the malice and deadliness of other 'lethal' women" (116). Her story can be interpreted in at least two ways — as that of an innocent women coerced into a relationship with a king, or, on the "flip side" as a woman of "cunning and calculation" who plans her every move to entrap a king (Aschkenasy, 117).

Completely unambiguous is the story of **Lilith,** Adam's mythical first wife. **Eve**, Adam's second wife, is credited — like **Pandora** — with bringing trouble into the world. In Greek mythology, sickness and disease afflicted the human race

> when Pandora, the first woman, released these troubles from a large jar. According to the myth, only hope remained to console mankind (Time-Life Books, 1997: 43).

According to one version of the myth, Zeus created Pandora specifically for that purpose. He, a male god, uses a woman as his instrument of vengeance. In the biblical narrative, Eve is created from Adam's rib to be his helpmate. But Eve allows herself to be tempted by the serpent and the fruit of the forbidden tree. Because of Eve, humans are cast from the Garden of Eden.

But Eve, although weak, is not depicted as evil. Not so Lilith. Lilith is portrayed as both powerful and evil. According to Hebrew folklore (Goldenberg, 1979; Lacks, 1980, cited in McDermott and Blackstone, 2001), Lilith's wickedness begins when she and Adam quarrel because she insists on questioning Adam's right to be dominant (the "missionary position") during sex. She leaves, and left without a mate, Adam complains to God. God sends three angels to fetch Lilith back. McDermott and Blackstone (2001: 88-89) relate the story of what happens after the angels find Lilith, who has taken up with demons in a cave by the Red Sea. She apparently has found sexual satisfaction with the demons and

> produced many thousands of demon children. The angels ordered Lilith to return to God, warning her that they would slay one hundred of her demon children every day until she did, but she refused. Lilith told the angels that in exchange for having her demon children slain, she would kill newborn children and attack sleeping men, stealing their semen to produce her own demon children. Because she left Eden before the Fall, Lilith is immortal (see also Gilbert and Gubar, 1979: 35-36; Graves and Patai, 1964: 65-69).

Following popular convention, the Renaissance artist Michelangelo depicted the serpent in his Sistine Chapel panel as female. It has been suggested the serpent is Lilith. At any rate, both Lilith and Eve are "creatures of male imagination" who have inspired "enduring impressions of the nature of women's personality and moral character" (McDermott and Blackstone, 4). Concerning the origins of these two mythic women, Ide (1993) finds:

Eve, herself, is a series of refined legends. She had been the goddess Heba, wife of a Hittite Storm-god, who rode naked on a lion's back while the Hittites marched into Canaan, destroying many ancient Semitic holy places and shrines. She was also Hebe, Hercules' bride. And when she returns to Semitic mythology she is a refined (less sexual) version of Lilith, her alleged predecessor who has been exorcised from Scripture but not Hebrew lore and fantasy since she was originally a fertility goddess . . . (Ide, 108).

In these stories, both Eve and Lilith are destructive. Eve is punished for her woman's weakness and susceptibility to seduction with the curse of painful childbearing, to be bore not only by Eve but by all her female descendants. Immortal Lilith, escapes punishment. But the angels do extract a promise from her:

She would never harm a child who wore an amulet which carried the image of an angel. When she came towards a child protected by the amulet she screamed like the wind enraged and seeing that the child was protected by an "angelic amulet" she spitefully turned against her own with murderous excitement (Ide, 1993: 422).

Lilith is a mother who kills her own (demonic) off-spring when she cannot kill human children. In modern works, feminists scholars have offered counter-narratives to these stories of Lilith and the other biblical women whose names are by-words for seductiveness and wickedness. But the ancient stories are so much a part of secular culture and of Western religious heritage that redeeming the reputations of the "bad women" of the Bible is a formidable task.

The Women of Camelot

The women of the Bible were not the only women whose characters were subjected to examination and discussion by members of the clergy during the medieval era. During the Middle Ages, the lore of the Arthurian romances (i.e., of King Arthur and the Knights of the Round Table) was transformed as the Cistercian monks composed their own versions of these tales. The women of the Arthurian romances, particularly **Morgan Le Fay,** did not fare well in these new narratives. Day (1995: 64-65) writes:

Although the bookish Cistercian scribes were more subtle in their approach to semi-pagan literature than were their iron-fisted brothers in their approach to heretic cities, they were nonetheless determined to convert the Arthurian Romances into religious allegories in order to convey the superiority of the spirit over all earthly concerns. Above all, matters of the flesh were despised.

Unfortunately for Morgan and her sisters, in the eyes of the churchmen "matters of the flesh" included anything female.

Because the Cistercian scribes believed that it was blasphemy to

"attribute healing or prophetic powers to a female who was not a member of the religious order and that such powers undermined the authority of the priesthood and the church," they held in disgust mythical women such as Morgan Le Fay of the Arthurian romances (Day, 65). In their retelling of the tales, Morgan was transformed, her powers "twisted," and charges of "demonic possession, adultery, and incest" added for good measure (Day, 65).

Morgan Le Fay had first appeared in a 12th century narrative, *Life of Merlin,* by Geoffrey of Monmouth. She was depicted as a healer, the leader of the holy order of women from Avalon who tended King Arthur's wounds after the Battle of Camlaun. By the end of the 12th century, other chroniclers of the romances had introduced a twist in the relationship between Arthur and Morgan. Even though she was still portrayed as a kindly healer, she was now presented as Arthur's sister (Day, 63-64). It was in the narrative of the Cistercian scribes (the *Prose Lancelot* or the *Vulgate Cycle,* written between 1230 and 1250) that Morgan Le Fay assumed her now familiar incarnation of evil seductress/enchantress, Merlin's rival, and the instrument of Arthur's downfall through Mordred, the son of their incestuous union. Phillips and Keatman (1992: 31) write that aside from the fact that the *Vulgate Cycle* was "something of a religious propaganda exercise":

> There may have been even greater reason to denigrate her [Morgan Le Fay's] character.... Geoffrey of Monmouth appears to have taken a variety of mythical characters and woven them into Arthur's life. This certainly seems to be the case with Morgan, for not only her name but also her prophetic and healing powers identify her with the Celtic deity Morrigan, the Earth Mother and goddess of health and healing (Phillips and Keatman, 31-32).

Day (1995) puts it somewhat differently. He suggests that aside from any misogyny that might have motivated the Cistercian monks in their destruction of Morgan Le Fay's reputation, the monks might have drawn from earlier sources (folklore and myths) in their creation of an evil Morgan. The female figures in Camelot show the influence of narratives about "pagan queens, sibyls, priestesses and goddesses who throughout the pre-Christian world had been reputed to possess supernatural powers." Among these earlier myths were stories of Celtic and Germanic priestesses "widely known as the Angels of Death — who practiced the black arts and human sacrifice" (Day, 67). Therefore, the monks might have seized on and used for their own purposes these stories of female demonism as opposed to female healing.

There is also the possibility of the existence of a historical model for Morgan Le Fay. **Queen Brunhilda,** the Visigoth (born 540 A.D.) was the wife, then the widow, of Sigebert of the Eastern Franks. She was executed in 613 by a group of noblemen. Her punishment — being torn apart by wild horses and then burned in a pyre — was considered appropriate for her crimes, which were said to include the murders of at least ten kings and princes over a thirty year period (Day, 67).

Summing up the transformation of the fictional Morgan Le Fay, Fries (1992) concludes:

> In spite of her murderous and adulterous career, Morgan retains her nurturing function as Arthur's conductress to Avalon after his wounding. But this "good" Morgan is overshadowed by the ubiquitous "bad" woman. She is the most extreme villain of Arthurian romance ... Her gradual change ... from connector of life with healing, as mistress of Avalon, into a connector of death with illicit sex indicates the inability of Arthurian authors to cope with the image of a woman of power in positive terms (Fries, 14).[1]

Of course, it is **Guinevere,** Arthur's queen, who appears in the legend of Camelot as the adulterous wife who betrays a noble husband. Her affair with Launcelot, Arthur's friend and trusted knight, leads to discord and death in Camelot. In Sir Thomas Malory's 15th century epic, *The Morte d'Arthur,* this tale of Guinevere and Launcelot, the star-crossed lovers, takes center stage (Day, 108). Phillips and Keatman (1992) find:

> Guinevere also appears to have been based on a Celtic goddess. In a number of Welsh poems of the Middle Ages ... she appears under the name Gwenhwyfar, meaning "White Spirit." This suggests that she may have been derived from the Celtic goddess Epona, depicted as a white horse or white lady and worshipped widely throughout northern Europe in pre-Christian times ... (Phillips and Keatman, 32).

Although Geoffrey in his narrative calls Arthur's queen Ganhumara and describes her as coming from a noble Roman family, there is no historical record (as with much Arthurian legend) of such a person existing during the fifth or sixth centuries (Phillips and Keatman, 32). Whatever her name, Arthur's queen is remembered for her role in destroying Camelot, the perfect kingdom. While Morgan is eventually presented as an evil and powerful sorceress, a destroyer of her brother's peace of mind and eventually his life, Guinevere is portrayed as assisting in the destruction of Arthur by her failure to be a "good wife."[2]

However, in the real world of the medieval era, "courtly love" between a married woman and her admirer was a game that a man and woman of noble birth might play.

> During the twelfth century, French troubadours were developing a poetic love-cult. Courtly love became a literary convention bound up (if on somewhat uneasy terms) with chivalry. Amours were supposed to obey rules ... (Ashe, 1990: 15).

According to these rules, the knight was "utterly devoted to his lady," ready to sacrifice all at her biding. The lady in turn "would be domineering, able to throw her lover into the wildest distress, yet, after her fashion be faithful to him" (Ashe, 15-16).

Among the nobles, one real life queen "might almost have invented" the game of courtly love (Duby, 1997: 7). She was also one of the powerful women who challenged male authority and, thereby, became notorious.

Queens and Controversy

Eleanor, heiress of the duchy of Aquitaine, was considered outrageous during her lifetime and has continued to be the subject of stories that focus as much on her sexual exploits as on her strong will. Married off at age thirteen to Louis VII, king of France, she was rumored during this marriage to have been unfaithful to Louis with several men, including a romance with Saladin, "an infidel" with whom she tried to elope. After divorcing the king of France, she married Henry Plantagenet, king of England. Although Eleanor and her duchy were considered matrimonial prizes, sought after by many suitors, Eleanor herself has been vilified by her detractors because of her spirited defiance of the roles assigned to her. In 1173, after years of tumultuous marriage to Henry, she sided with her sons, against their father (in the fashion perhaps of the old goddesses of Greek mythology). As Duby (1997) writes:

> Rebellions of this type, pitting sons against a father who was slow to die, were common enough at this period, but it was rare for the mother of the troublemakers to take their side and betray her husband. Eleanor's attitude was regarded as scandalous. She seemed for the second time to be breaking the basic rules of matrimony. (Duby, 14).

After Henry had put down the uprising, he captured Eleanor. She was wearing male clothing at the time "another serious breach of the rules" and she was on her way to seek refuge with her ex-husband, the king of Frances (Duby, 15). Henry imprisoned his wife in his castle at Chinon. She remained a prisoner there or in another fortress until just before his death in 1189. Eleanor was notorious in her day, offering "a vivid demonstration of the terrifying powers with which nature had endowed women, who were lustful and treacherous. It had showed how the devil used them to spread discord and sin" (Duby, 15). These tales of Eleanor of Aquitaine were seemed as giving support to the argument that women were best kept under the strict supervision of a father or a husband, or, in the case of widows, dispatched to nunneries. Duby concludes, "At the end of the twelfth century, every man who knew how the duchess of Aquitaine had behaved saw in her the exemplar of what both tempted and disturbed him in femininity" (Duby, 15).

However, as Labarge (1986) observes, Eleanor of Aquitaine was not the only strong queen of the Middle Ages. Others included **Isabella of France,** queen of Edward II. Isabella was not well thought of by her contemporaries. Her own grandson, Louis XI, is supposed to have called her *"La gran putana"* (the great whore). The source of her bad reputation lies in the accusation that she was responsible for the factional warfare in England in the fifteenth century

because of her domination of her husband and her determination to keep him on the throne (Labarge, 66). In *Henry VI* (Pt. 3, Act I, scene 4), Shakespeare has the Duke of York describe Isabella as "She-Wolf of France but worse than wolves of France, whose tongue more poisons than the adder's tooth."

Of such medieval queens as Eleanor and Isabella, Labarge (1986: 70) writes:

> Medieval queens were a collection of vivid personalities who could often exercise considerable power. It was usually unfortunate for the kingdom when weak kings were married to ambitious and dominant women....A queen was a woman and thus theoretically submissive, but the king had to be able and willing to exercise his authority over her lest she create her own party and supporters and split the reign.

Those kings unable or unwilling to exercise this control would presumably have shared the feelings of less noble males who found themselves dealing with strong-willed women. While Church doctrine said that women were to be submissive to their husbands and fathers, contemporary narratives and the historical evidence indicate that women sometimes assumed prerogatives that challenged gender stereotypes. This was true not only of queens and noblewomen but of women of lesser stations.

But it was the **Virgin Mary** who symbolized the feminine ideal.

Mary and the Salvation of Women

During the Middle Ages, "[f]eminine virtue was, in a word, virginity" (Betzig, 1995: 196). Paradoxically, for medieval Christians the image of the perfect virgin was captured in Mary, the Mother of Jesus, who was also the perfect mother (the Madonna). In achieving a virgin birth, she had avoided the more sinful aspects of male-female relationships and had preserved her chastity. In becoming the mother of the savior of mankind, she also achieved the status of motherhood personified. During the Middle Ages, a cult developed around Mary. She was worshiped even by those male members of the Church who believed women flawed and treacherous creatures. McLean (1980: 129) writes:

> The desert fathers and early monastic communities found the femininity and comfort they needed to sustain them in devotion to Mary, and satisfied their asceticism by emphasizing her personal excellence and the purity of her motherhood. She became the protectress of penitents. . .According to the Christian poets, Mary's motherhood enclosed the whole of heaven and earth within her womb, within the space of a single round rose. The all-in-one, one-in-all rose of love, once praised in pagan poems, became a Christian rose.

Although the rose (sacred to the goddess Venus) was rehabilitated from pagan to Christian, in the lore of the Church pagan women did not fare as

well. The flesh-and-blood women of the medieval era were presented with mixed messages about the characteristics of their gender. In the Church, **Mary Magdalene,** the female apostle who was present when Jesus arose from his tomb after his crucifixion, became the amalgamation of several different Biblical women, including a former prostitute (Stammer, 1999: E-1/E-2). Dalarun (1992) finds that the Mary Magdalene "venerated in western Christendom does not exist as such in the Bible." Her creation occurs at the hands of Gregory the Great who "was responsible for merging the trio into the single figure of Mary Magdalene" (Dalarun, 32). What Mary Magdalene offered was hope to women who, as a gender, labored (metaphorically and literally) under the curse placed on Eve. As crafted by Gregory from earlier works and a sermon by Odo of Cluny (c. 1000), Mary Magdalene assumed a role in "the economy of salvation." In his sermon, Odo wrote:

> This was done so that woman, who brought death into the world need not remain in disgrace. Death came into the world through the hand of woman [Eve], but news of the Resurrection came through her [Magdalene's] mouth. Just as Mary, always a virgin, opens for us the gates of Heaven from which we were excluded by the curse of Eve, so, too, is the female sex saved from disgrace by Magdalene (quoted in Dalarun, 34).

But for medieval women much depended on assuming a proper attitude in their relationship to God and men. Ordinary women were perceived as having aspects of all three women of the Bible, Eve, the Virgin Mary, and Mary Magdalene, in their make-up. At times, they also were perceived as the spawn — or consort — of the Devil.

Poisonous Blood and Demonic Lice

Regarding female physical characteristics, in the Middle Ages male physicians, clergy, and others who pondered the nature of women continued to accept many of the theories put forth by the Greeks and Romans. For example, although menstrual blood was thought to provide essential nourishment to the embryo in the womb, it was also believed "to have harmful effects on people forced to live in proximity to a menstruating woman" (Thomasset, 1992: 54).

> It was commonly believed that menstruation was a process that started in the head and continued throughout the body to remove digestive wastes and purge the blood of poisonous humors. Rooted in the Bible, another widely held view was that women were unclean during the menstrual period; the blood itself was regarded as dangerous or as having magical properties (Williams and Echols, 1994:38).

Some experts believed that menstrual blood killed semen, making procreation impossible. Others held that "menstrual blood poisoned semen and thereby produced terribly handicapped offspring" (Williams and Echols, 38).

Women continued to be a mystery to men, especially to the clergy, "who held a monopoly on learning and the ability to write in the feudal age" (Dalarun, 1992: 15). This clerical monopoly of the written word, was unfortunate for the gender images of women because the clergy were the men who had the least contact with women. Since the eleventh century, clerics had been "enjoined to remain celibate." As a consequence, by the thirteenth century, the most devout had shut themselves away in exclusively male settings, living and working as monks. Although they felt called upon to think and write about "the nature of humankind and human society, and the Church, to point the way to salvation, and to assign women to their proper place," the fact was they "knew nothing about women, or, rather about Woman, other than what they imagined" (Dalarun, 15). What they imagined about Woman and presented in their writings was a "distant, strange, and frightening figure of profoundly contradictory nature" (Dalarun, 16). For example, women's hair was thought to contain demons. St. Paul warned about demons leaping like sparks from female hair. It seems that "[t]he tradition of a woman covering her head in church originated with this belief that any mild-mannered woman could poison the church building with her licelike demons" (Ackerman, 1995: 193).[3]

Yet there was a legend, that at least one woman had reached the highest echelon in the Church hierarchy.

Pope Joan and Medieval Motherhood

According to a ninth-century legend, a young English woman named Joan fell in love with a traveling student. Because the student was a monk, they could not marry. To be with her lover, Joan dressed in clerical clothes. Attired as a male, she traveled with him around Europe, joining him in his studies. When her lover died, Joan made her way to Rome. Armed with the vast knowledge she had acquired in her travels, Joan was eventually elected to the papal throne. According to this story, Pope Joan "ruled the Church of Rome for a few years in the middle of the ninth century" (Atkinson, 1991: 1). But Pope Joan's downfall came when she took another lover and became pregnant. She was able to conceal her condition until, during a procession through the streets of Rome, she went into labor. Joan, the pope, "gave birth and died in shameful agony" (Atkinson, 2). The legend of Pope Joan appeared in eleventh century sources and was elaborated on during the Renaissance. As Atkinson (1991: 4) observes:

> At first sight, the legend of Joan and the cult of Mary have no common characteristic except that each sheds light on the imagination of medieval Christians, who produced images of "mother" and notions of motherhood that ranged from tender and sacred to vulgar and blasphemous . . .

The image of Pope Joan was of the vulgar and blasphemous. She, a woman, had risen to the status of pope by pretending to be male. But her

womanhood and her shame were revealed when she gave birth to an out-of-wedlock child in a very public spectacle.

> Joan was not betrayed by a lover or discovered by an enemy; she was brought down by her own body, which was inherently and catastrophically unfit for ecclesiastical dignity. The literary and artistic images that surround the birth of her child display a range of responses from hysterical laughter to horrified disgust. The notion of a female pope was scandalous; of a pregnant pope, ludicrous; of a pope giving birth, disastrous (Atkinson, 3).

Real women in the medieval era continued to have babies. As in past eras, having children satisfied a number of social and personal needs (e.g., civic duty and lineage survival). For peasant families, children were "assets" because they could provide the family with much needed help in working the land or in caring for younger siblings (Williams and Echols, 1994: 77). But, at the same time, each child was an additional mouth to feed. However, the plague and its devastation acted as a spur to reproduction. Itnyre (1996) finds that in medieval Florence, Italy because of the periodic occurrences of the Black Death, a family could be wiped out in a matter of weeks (Itnyre, 88). Those who survived such calamities, were expected to contribute to the population of the state. Florentine tax policy provided an exemption for each child in the household to encourage population increase. Moreover, "[h]aving children was also a Christian duty. A woman who became pregnant acquired a soul for Christ, so Niccolo Machiavelli observed" (Itnyre, 88). Because some couples were infertile, there were many "remedies" available for childless couples.

> Florence, in fact, was filled with fertility devices. Witches and sorcerers provided women and men with amulets for having children...Thus Christian and other supernatural beliefs existed side by side and even intermingled in the attempts to have children (Itnyre, 90).

In Florence, midwives and wet nurses played important roles in the "female-centered birthing room" and in the process of caring for the mothers and their infants (Itnyre, 91-95). Male physicians played a very limited role. They seem to have rarely attended a birth and to have been called in most often when the mother and/or child were in grave danger or had died (Itnyre, 93). In Florence, as elsewhere in Europe, conception and childbirth was still a mysterious process about which there was much superstition and lore. Women still preferred to place their faith in other women to see them through the process of giving birth.

But at the same time, as in past eras, concern was expressed about the women — midwives and wet nurses — who played such essential roles in childbirth and the care of mother and child. For example, looking at Florence during the last medieval period, Gavitt (1990) finds:

> The malfeasance of wet nurses was a staple of contemporary writ-

ing as well, and fifteenth-century parents were so convinced that babies sent to a wet nurse were vulnerable to accidental or deliberate smothering that Tuscans invented the *arcuccio,* a basinet with an arched rib so that it would be impossible for a nurse to roll over and accidentally smother a child (Gavitt, 136).

The clergy, theologians and bishops, also warned parents about taking infants into their beds with them, "and doing so made parents (or wet nurses) automatically culpable" (Gavitt, 137; also see Williams and Echols, 77).

However, in medieval Florence, plague and malnutrition seem to have been more common causes of infant death than smothering. But in the case of malnutrition, wet nurses were often held culpable. Wet nurses in Florence and elsewhere would often take the children in their charge into the country away from the perceived dangers of an urban environment. The failure of wet nurses to provide adequate nutrition for these infants sometimes led to their deaths. The problem seems to have been either the quality of the breast milk given to the infant, the substitution of animal milk (goat or cow) for breast milk, or the substitution of soggy bread or other food for any kind of milk. It was generally thought that "pregnant milk" was not nutritious, could even be dangerous for an infant. Therefore, wet nurses were expected not to become pregnant while feeding. On other occasions, the wet nurses' milk might dry up or become inadequate for the task of nursing.

These concerns were a part of the discourse about the dangers of turning to a mother substitute to provide the breast that the nursing child required. But, at the same time, women who could not nurse their own children and women who chose not to nurse (or whose husbands made the decision for them) turned to wet nurses. Sometimes they were considered less than ideal as an alternative.

Equally vulnerable to charges of misbehavior, and in significantly more danger with regard to punishment, were the midwives who cared for pregnant women and delivered their children. Because of the superstitions that would feed the witch crazes that swept Europe, midwives — who seemed to have some special knowledge of life and death — found themselves among those suspected of dabbling in magic and the occult and of consorting with the Devil. We will turn now to this matter of women and witchcraft, examining the gender roles of women and how these roles and beliefs about female sexuality were related to accusations of witchcraft.

Lady Macbeth and the Witch Craze

In Shakespeare's early 17th century tragedy, *Macbeth,* the title character, and his wife conspire to kill Duncan, the king, so that Macbeth can rise to power. However, Harbage (1969), the editor of a collected works of Shakespeare, observes: "Lady Macbeth's own behavior is not totally alienating. In a perverted way she is doing what all loyal wives are expected to do, urging her

husband on to what she deems his own good. . . ." (1107). But Lady Macbeth often has been described as more "monstrous" than her spouse because it is she who urges him on when he shows reluctance to carry out their murderous plan. She tells him:

> . . . I have given suck, and know
> How tender 'tis to love the babe that milks me:
> I would, while it was smiling in my face,
> Have plucked my nipple from his boneless gums
> And dashed the brains out, had I so sworn as you
> Have done to this (Act I, vii).

Proser (1965: 60) observes of this speech that it "gives us a picture of nature completely inverted. Motherhood, instead of nursing the babe, destroys it. Womanliness, normally tender, apprehensive, and compassionate, transforms itself to cruelty . . . " Proser asserts that Lady Macbeth's "resolution, daring, and ingenuity act as a challenge to her husband" (Proser, 61). When Macbeth asks, "If we should fail?" she urges him to "screw your courage to the sticking place" (Act I, vii). Having heard her plan to kill Duncan and frame the king's drunken servants, Macbeth tells his wife, half in admiration, half in awe:

> Bring forth men-children only;
> For thy undaunted mettle should compose
> Nothing but males (Act I, vii).

Lady Macbeth displays traits generally identified with the "masculine," she has "unsexed" herself (Proser, 61). This speech is often quoted as proof of how Lady Macbeth, by displaying these traits, plays a pivotal role in her husband's downfall. She is as ambitious for him as he is for himself. In other circumstances, this would be considered an attribute of a good wife. In this case, it is the makings of a tragedy, with Macbeth as the tragic hero. But if Macbeth later regrets his crimes, so does his lady. In perhaps the most famous scene in the play, Lady Macbeth, haunted by their deeds — including the slaughter of Macduff's family — sleepwalks as the doctor and her servant observe her. She speaks these lines as she tries to wash the imaginary blood from her hands:

> The Thane of Fife had a wife. Where is she now?
> What will these hands ne'er be clean (Act V, i).

Lady Macbeth concludes regretfully:
Here's the smell of blood still. All the perfumes of
Arabia will not sweeten this little hand (Act V, i).

Overwhelmed by guilt and remorse and the isolation from her husband created by his reaction to their crimes, Lady Macbeth eventually commits suicide. Her husband lives to meet his enemies. He dies at the hands of the

vengeful Macduff — who true to the three Weird Sisters (witches') prophecy was not of woman born, but "torn untimely" from his mother's womb.

In fact, it is these three witches who Macbeth encounters at the beginning of the play, after his victory in battle, who set him on the path that will lead to his downfall. It is they who predict that he will be king. Macbeth and his wife then conspire to make their words true. Later, when Macbeth returns to them to seek information, one of the witches tells the others of his approach with these words, "By the pricking of my thumbs, Something wicked this way comes" (Act IV, i). The question the audience might ask is whether or not Macbeth was always wicked, always evil. Or did the witches seduce him into crime with their words — their wicked words? Macbeth greets the witches in this way: "How now, you secret, black, and midnight hags, What is't you do? "To this they reply "A deed without a name" (Act IV, i). Regarding the witches in *Macbeth,* Dolan (1994) describes Lady Macbeth, herself as "the drama's most vivid manifestation of the witch as dangerous familiar and her witchcraft as 'malice domestic,' as an invasion of the household and its daily life" (Dolan, 226).

A Witch's Curse

In Shakespeare's *Macbeth,* the three weird sisters (witches) gather prior to their encounter with Macbeth. The first witch relates to the others how she'll take revenge on a woman who slighted her by giving the woman's husband a rough journey:

> A sailor's wife had chestnuts in her lap
> And mounched and mounched and mounched.
> 'Give me,' quoth I.
> "Anoint thee, witch!' the rump-fed ronyon
> cries.
> Her husband's to Aleppo gone, master o' th'
> Tiger:
> But in a sieve I'll thither sail
> And, like a rat without a tail,
> I'll do, I'll do, and I'll do.

The other witches join in, and the first witch concludes:

> I'll drain him dry as hay.
> Sleep shall neither night nor day
> Hang upon his penthouse lid.
> He shall live a man forbid.
> Weary sev'nights, nine times nine,

> **A Witch's Curse** *Continued*
>
> > Shall he dwindle, peak, and pine.
> >
> > Though his bark cannot be lost,
> >
> > Yet he shall be tempest-tost.
> >
> > Look what I have.
>
> What she has, and displays to the other witches, is "a pilot's thumb, Wracked as homeward he did come."
>
> —*Macbeth*, Act I, ii, 4-30

When Shakespeare wrote this play, he did so at a time when in the world beyond the stage, real people still believed in witchcraft and the existence of witches. However, as Salgado (1977: 86) notes, "The witches in Macbeth could cause tempests and help to murder a king, but real life 'witches' of Elizabethan England rarely claimed to perform or were accused of performing such spectacular deeds . . . " Yet Barstow (1995: 21) identifies the years of "major persecution" of European women accused of witchcraft as 1560-1760. A popular belief in witches — in men and women with special, supernatural powers — had existed long before the 16th century and would continue to exist in the minds of Europeans and later in the minds of the European colonists who came to North America. During the period identified by Barstow, this belief became the basic for widespread official response. Regarding this, Zipes (1983), in his discussion of the role of popular belief in witches and werewolves in the creation of European fairy tales, observes about this response to those suspected of witchcraft:

> In the 16th and 17th centuries women more than men were declared witches and burned because they were associated with untamed nature and potential heresy. The actions of the church which lasted well over 200 years in Western Europe and spread to America, were not simply police measures that affected social structures. They had a profound effect on social consciousness, customs, and habits in Western society. . .In particular, the witch and werewolf crazes were aimed at regulating sexual practices and sex roles for the benefit of male-dominated social orders . . . (Zipes, 1983: 50).

One woman who challenged those sex roles by leading men into battle was described by her detractors as both heretic and witch.

The Trial and Punishment of Joan of Arc

In 1431, **Joan of Arc** was executed by her captors. She had been accused of heresy because she claimed to hear "voices" (of angels and saints), wore men's

clothing, and led soldiers into battle. In a History Channel documentary, the narrator described Joan of Arc as a "teenage girl so dangerous she had to be burned at the stake" (In Search of History, 11/18/98). Since the fifteen century, the story of Joan of Arc's life and her death has stirred religious, political, and philosophical debates. Who was this unlettered girl who believed that she had been given a divine mission "to raise the siege of Orleans, conduct the Dauphin Charles to Reims for his crowning and to drive the English from the land?" (Saint Joan of Arc Center, online). She was successful in gaining the ear of Charles. He allowed her to lead his army into battle. Dressed in armor especially designed for her, Joan of Arc, liberated the city of Orleans. After her Loire campaign, she witnessed the crowning of Charles as King of France in the cathedral of Reims. But then Joan of Arc's fortune turned. She was captured at the town of Compiegne on May 23, 1430. After a year in captivity, apparently abandoned by Charles, she was executed — burned at the stake — on May 30, 1431.

The matter of Joan's captivity — the accusations, the demand that she confess, the confession and then the retraction — has intrigued historians and others, including feminists scholars. She did confess after being held in a dungeon, chained, isolated, half-starved, and interrogated twice a day. But, why, after confessing and saving her life, did she then forfeit it by defying her captors to again wear male attire? Some scholars have maintained that she was raped after she displayed her vulnerability by confessing and discarding her male clothing. This rape, they argue, spurred her to resume her former persona — Joan of Arc, the warrior, with the right to dress as a man.[4] Whatever occurred, her captors responded with anger. She was condemned to death. Prior to her execution, her head was shaved as a mark of her shame. Joan of Arc met her fate calmly, with her last breath she called out the name of Jesus— something heretics were not believed capable of doing. Five centuries later in 1920, the Church declared Joan of Arc a saint (see Dworkin, 1987, 83-104; In Search of History; Joan of Arc Center; Edwards, 1999; Williams and Echols, 147-148).

As a cross-dresser (a sin in itself, according to her prosecutors), a heretic, and possibly a witch, Joan of Arc was dangerous because she took onto herself not only masculine attributes but attributes that seemed supernatural. She stood in defiance of her accusers. Even as she died, she refused to repent or admit any wrong-doing. She was a larger than life example of the women that Zipes (1983: 50) asserts "the male-dominated social orders" felt they needed to control. Of the legend of Joan of Arc, Edwards (1999: 133) writes:

> Throughout the centuries, the historical figure that is Joan of Arc has appeared in many guises, reflecting the interests and concerns of many people and eras. A female heroine or French patriot, heretic or saint, witch or visionary, androgyne or freak, Joan has played a diversity of roles.[5]

One of Joan of Arc's roles was that of witch. However, after examining the history of the Inquisition and the witch trials in Europe, Klaits (1985: 19)

points out that the witch trials "were virtually unknown until the final centuries of the Middle Ages."Prior to that period, the clergy "generally held that anyone who believed women went flying about at night was a victim of superstition" (Klaits, 19). But, gradually social changes, including an increasing awareness of death as an individual fate and belief in the Devil as an actual force in the world, as well as changing demographics and social relations, contributed to an intensification of clerical concern about heretics in the form of witches. What also occurred was an increasing association of witchcraft with women — as the consorts of the Devil in perverse sexual rituals and orgies. Female sexuality became linked to witchcraft and witchcraft became linked to Satan.

Witchery and Midwives

Reviewing the research on the accused in witch trials, Klaits (1985) finds that the "sexually powerful and menacing witch figure was nearly always portrayed as female." The two Dominican churchmen, Heinrich Kramer and James Sprenger, who wrote the *Malleus Maleficarum* (1486), which would become the handbook of witch-hunting, described the majority of witches as women. Given this it was in fact, "like a self-fulfilling diagnosis" that women would be the majority of those accused during the witch craze. Examining the evidence from about 7,500 witch trials in Europe and North America, Klaits finds that during the sixteenth and seventeenth centuries "nearly 80 percent of accused witches were female, and in parts of England, Switzerland, and what is now Belgium, women accounted for over nine out of ten victims" (Klaits, 51-52).

This perception of women as evil and perverse was reflected in the literary and artistic works produced just prior to and during the period of the witch craze. For example, as mentioned above, it was common for artists to portray the serpent who tempted Eve as a creature with female breasts and face. Klaits asserts, "Women were regularly depicted as predators, with sexuality as their weapon" (Klaits, 73). But it has been asserted by some scholars that the women who were most vulnerable to charges of witchcraft were not women who were young and beautiful, and thus obvious in their sexuality. Instead, old women, poor women, marginal women, hags, and crones were the targets of these charges.

This seems to have been true in some settings. In others, all women seem to have been vulnerable as whole villages and towns were caught up in accusations, trials, and executions. Women healers and midwives were particularly vulnerable to accusations of witchcraft.[6] Of women healers, in general, Barstow (1994) writes:

> Through healing, by both spells and portions, delivering babies, performing abortions, predicting the future, advising the lovelorn, cursing, removing curses, making peace between neighbors — the work of the village healer and her urban counterpart covered what we call magic as well as medicine. This work overlapped dangerously with the priest's job as well (Barstow, 109).

By the 16th century, this "role of healer, long respected and even seen as essential, became suspect" (Barstow, 109; see also Rivers, 1996: 45). The midwives, who brought all their practical experience of female anatomy and childbirth as well as their knowledge of folk medicine and folk beliefs to their work of delivering babies, were particularly subject to scrutiny. The mere fact that a midwife used a herbal concoction to ease a woman's labor might link her to the Devil in the mind of a churchman who believed in the biblical edict that women, the "daughters of Eve," should suffer the pains of childbirth. But there was another aspect of her work which increased the risk for a woman who served as a midwife. As noted in Chapter 2, since Greek and Roman antiquity, there had been concern on the part of men that women might deceive them during childbirth — that a wife in collusion with a midwife might substitute one child for another, a living child for a dead one, or a male for a female.

During the witch craze, there was also the accusation that at the time of delivery, midwives sometimes killed newborn infants. This was less a suspicion of collusion with the mother than that these midwives with their esoteric knowledge of birth and death, might be witches. Witches was supposed to need "flying ointment" to rub on their bodies so that they could fly off to their midnight orgies with the other worshipers in their covens. The base ingredient for this ointment was said to be fat, the fat of slain and unbaptised infants. It was also said that the placenta and the umblical cords from infants were used in unholy rituals. One set of regulations governing the conduct of midwives, the Bradenburg regulations issued in 1711, specifically forbade midwives to give away or sell the fetal membranes, placenta, or umbilical cord from infants they had delivered (Forbes, 1966: 118). But the worst fear was that a midwife/witch might actually murder an infant.

> Such accusations were recorded as early as about 1460 . . . Part I, Question XI, of the *Malleus maleficarum* charges that witch-midwives destroy the child *in utero,* causing an abortion, or find a moment of privacy in which to offer the newborn infant to Satan. In Strasburg, the book relates a mother who refused the services of a certain midwife, was subsequently bewitched and suffered greatly. A Swiss midwife was said to have confessed the murder of over forty infants by piercing their heads with a needle during delivery. (Forbes, 127).

These alleged examples of infanticide by midwives were seen as particularly heinous because the unbaptised child would be lost to Satan: "The child was not a Christian until it was properly baptized. Until this protection was conferred, the infant was considered to be in deadly peril from the powers of evil" (Forbes, 129).

But, in spite of the suspicions about them, midwives were sometimes charged with the obligation to see that an infant who was not likely to survive was either taken to the priest, or if there was no time, that she herself baptized the baby according to the laws of the Church, in which she would have

received instruction (Forbes, 129-131). Unable to eliminate midwives from the social order, those in authority, instead attempted to control their behavior with ordinances and regulations, including those which forbade midwives to engage in, quoting a Wurtemburg statute of 1552, "superstitious sayings or other ungodliness" during the delivery (Forbes, 131).

But in spite of such mandates, midwives and other women continued to face accusations of witchcraft during this era. These accusations had a lasting impact — not the least of which was the linking of the word "witch" with images of unruly, unattractive, and/or socially marginal women:

> The dramatic events of the witch persecutions reinforced the received traditions of misogyny and patriarchal control, narrowing women's status and demonizing the image of women in a damaging way . . . Not until the mid-nineteenth century did the status of Western women begin to recover from the witch hunts (Barstow, 12).

Radical Witches

During the 1960s, many women were questioning and/or challenging the status quo. In 1968, the New York Radical Women, formed an "action wing," which they called WITCH — an acronym for Women's International Terrorist Conspiracy from Hell. Purkiss (1996: 9) writes:

> 'Woman' names the witch as gendered, while 'international' asserts the ubiquity of witches, and 'terrorist' marks witches as violent. 'Conspiracy' deliberately flirts with fears of a secret organization of subversive women, while 'from Hell' draws attention to the origin of witches' otherness while pointing to women's oppression. This adds up to an image of the witch as violent and empowered woman. WITCH's members hexed the Chase Manhattan bank, and invaded the Bride Fair at Madison Square Gardens dressed as witches.

Purkiss notes the role of the women of WITCH in introducing other women to the myths of witchcraft that became "central to many radical feminists and most modern witches" (9).

Women and the Law

The fact of the persecution (and prosecution) of women as witches, requires historians to examine women's lives. In Europe, this was a period during which women were both empowered and oppressed. As Barstow observes:

> Women were more than sex objects in sixteenth-century society; they served as midwives, healers, counselors, farmers, alewives, spinners, domestic servants, assistants to their husbands in craft

work, and so on, and their productive as well as reproductive roles made them potentially threatening to men . . . (Barstow, 10).

In their roles of wives and mothers, women also were seen as potentially threatening to men. Dolan (1994: 1) finds that in early modern England, 1500-1700, "the home could function as a locus of conflict, an arena in which the most fundamental ideas about social order, identity and intimacy were contested." Although husbands appear to have been at least twice as likely to kill their wives as wives were to kill their husbands (Dolan, 25), the law after 1352 recognized by statute the crime of "petty treason" by women. In effect, when a woman killed her husband, she engaged in an act "analogous to high treason — any threat to or assault on the monarch and his or her government" (Dolan, 21). In narratives about petty treason, the wife who killed her husband was often portrayed as acting in consort with a lover (Dolan, 24-25). These dramas were played out in the "central locations of marital life — the dining table and the bed" in a clear "violation of domesticity and marital intimacy" (Dolan, 29). However, some 16th and 17th century texts did offer self-defense as a possible explanation of the wife's crime.

Petit Treason: The Slaying of a Husband

In England under the Statute of Treasons of 1352, a wife who killed her husband was guilty of petit treason defined as, "another sort of treason than high treason. . .the slaying of a master by his servant; the slaying of a husband by his wife." Until 1790, the most common punishment for husband-slaying was burning at the stake. Finally, in 1828, the crime of petty treason was abolished. As the wording of the statute would suggest, men who killed their wives were not subject to the charge of petty treason, nor were they burned at the stake for their offense. *Source: Chan (2001: 10-11).*

During this period, there were two high profile cases involving allegedly murderous noblewomen.

Royal Intrigue and Murder

In 1567, **Mary Queen of Scots** was suspected of complicity in the murder of her husband who had died — of strangulation — following an explosion in his house. Mary had been disappointed in her marriage to Henry Stuart, Lord Darnley, her cousin. When she developed a close friendship with David Riccio, an Italian singer who she made her secretary, Darnley responded by killing Riccio in front of her during a drunken rage. Then he himself was killed. A few months later, Mary married the Earl of Bothwell. This was a political move that did not sit well with many of her Protestant nobles who rose up against her. She was held captive, but later escaped to England. But, in

England, Queen Elizabeth, considered her too dangerous to have at liberty. Mary was held under house arrest until Elizabeth, having long suspected her of treasonous activities, finally signed the warrant for Mary's death by beheading in 1587.

In the early seventeenth century, another noblewoman, **Frances Howard, Countess of Essex,** was involved in an adulterous affair, with Robert Carr, Viscount Rochester. With the support of King James I, she obtained an annulment of her marriage on the grounds that her husband was impotent. But Sir Thomas Overbury, a talented literary man and erstwhile friend of Carr's, opposed Carr's marriage to Lady Frances. When Overbury declined the suggestion that he leave London, the king had him thrown into the Tower of London. There, he weakened and eventually died. Regarding his death, it was alleged that Lady Frances had used Mrs. Anne Turner as her intermediary in her dealings with Simon Forman, an astrologer and unlicensed physician who supplied the noblewoman with both love potions and poison (Salgado, 1977, 108; The Encyclopedia of Murder). Mrs. Turner and two other co-conspirators, were hanged for their role in the Overbury affair. Rochester and Lady Frances were tried, found guilty, but eventually pardoned.

But even though women, noble or common, were obviously capable of murder and might sometimes engage in this crime and others, Hull (1987: 23) notes that felony law allowed women "special avenues of escape not given to men."

Feme Covert and Pleading the Belly

These avenues of escape rested solidly on a woman's role as wife and mother. She could claim *feme covert* status, "a civil law concept derived from the property and inheritance of marriage" which for certain felonies exempted a woman from prosecution under the assumption that she was under the guidance and direction of her husband. However, murder, treason, and burglary were exempt from this rule (Hull, 24). In the case of murder, a woman in her role of mother — or more precisely, mother to be — might "plea her belly," asking for a stay of execution of her sentence until her child was born. This claim of pregnancy had to be substantiated by an examination by midwives or medical men. As will be discussed in the next chapter, this examination could sometimes go awry. But if "quickening," the movement of the fetus, could be detected the woman might live until she had given birth.

At the same time, in the 17th century, unwed mothers who attempted to conceal their pregnancy and delivery found themselves the subject of legislation. The Stuart infanticide statute of 1624 made concealment of the deaths of illegitimate infants presumptive evidence of murder. This statute did not apply to men or to married women and their legitimate children (Hull, 27-28). It was unmarried women, who might have greater reason to conceal their pregnancy and to wish to be free of their newborns, who were subjected by this law to special scrutiny and prosecution.

Summary

The biblical images of wicked women that were inscribed into Christianity by male authors reflected misogynic anxieties about women and their sexuality. Women were said to be more susceptible than men to the seduction of evil. During the Renaissance, dramatists such as Shakespeare created female characters that reflected both contemporary thinking and the archetypes of women that by then existed.

When Shakespeare wrote his play, *Macbeth,* his depiction of Lady Macbeth may have been influenced by secondary sources such as the English translations of Seneca's tragedies, *Medea, Agamemnon,* and *Hercules Furens* (Shaheem, 1999:621). Because the patron of Shakespeare's acting company was King James, "some of the biblical references in Macbeth may have been inspired by the king's use of the same references in his works" (Shaheem, 621).

In Shakespeare's play, Lady Macbeth emerges as a political figure in the style of the women of ancient Rome. In the real world of 17th century England, people were "fascinated by the question of women's political capacity" because of such "notorious female sovereigns" as Mary Tudor, Catherine de Medici, Mary Queen of Scots, and Elizabeth I (Dusinberre, 1996: 272). But there was also wariness. Although the society valued action, in the case of women there was "no middle position between monstrosity and womanishness" (Dusinberre, 277).

This was also the dilemma of the real women who in the mid-sixteenth and early 17th century began to write and publish in significant numbers. Because the Bible seemed to require both silence and submission from women, they were seen as seizing a male "prerogative." Satirists called them Amazons and monsters, and equated them to whores (Pearson, 1988).

This literary slander would seem at first glance to be irrelevant to the exploration of the themes that inform the modern social construction of women as killers. However, as will be discussed in the next chapter, this mandate of female silence in certain spheres was an important aspect of the response of the Puritan justice system to some women in colonial America.

Discussion Questions

1. Although people accused of being "witches" are no longer persecuted (or prosecuted) in most societies, do you think many people still hold strong negative associations with the word "witch"?

2. How would you react if a new neighbor you knew only slightly were accused by another neighbor of being a witch? What questions would you ask?

Exercises

1. Read Shakespeare's *Macbeth* and discuss the role Lady Macbeth plays as co-conspirator with her husband in his crimes. Also consider the role played by The Weird Sisters (the three witches). In your opinion, who emerges as most blameworthy for the murders and other crimes that occur? Macbeth? His wife? The witches? What does the play suggest to you about Shakespeare and his times?

2. Do some research on wicca. What do adherents believe? What practices do they engage in? How are they perceived? Have there been cases that you can find in which adherents were involved in criminal or civil procedures because of their faith or practices?

Notes

[1] See also Spivack (1992) and Sklar (1992) on twentieth-century depictions of Morgan Le Fay. Sklar (1992: 28) finds that, "Like her Malorean prototype, the Morgan of contemporary popular texts is a thoroughly bad egg, a composite of all the patriarchal nightmare-women of literary tradition: Eve, Circe, Medea and Lady Macbeth compressed into a single, infinitely menacing package." Spivack (1992:19) finds that, "Morgan le Fay as depicted in recent popular fiction reveals the ambivalence of her heritage. In a few works she is a total villain." In several novels, the portrayal of Morgan "is much more complex in its ambivalence" (Spivack, 20).

[2] There is also the story of the seduction and betrayal of Merlin, the magician, by Vivien (also called Nineve, Nimue, or Niniane), who leaves him trapped inside a cave or a tree. Merlin foresees his fate, but is too captivated by her to resist. Like Morgan Le Fay, Vivien varies in her characterization in various stories. It is Arthur, Lord Tennyson in "Merlin and Vivien," in his *The Idylls of the King,* who "turns Vivien into the epitome of evil" (The Camelot Project, online).

[3] There were also pagan superstitions about women's hair. One superstition was that if a snippet of hair from a menstruating witch were buried, it would turn into a snake. But, at the same time, lovers exchanged locks of hair, and knights carried a lock of their ladies' hair into combat (Ackerman, 1995: 193).

[4] See Bitel (1996) and Clover (1993) on tales and sagas of warrior goddesses and maiden warriors in other societies.

[5] Edwards (1999: 144) observes that through the inquisitorial and trial records for Joan of Arc, historians and others can gain perhaps more insight into her life and death than that of other less documented medieval women of her class. The records reveal that:

>throughout the Trial of Condemnation Joan of Arc fashioned herself with characteristics common to a knight, associating herself with the potent imagery of medieval warrior and male ideal. . .But her androgynous identity shocked and outraged the judges of the trial. For these men of God, Joan's transvestism was dangerously transgressive and unorthodox, 'an abomination before God.'

[6] The authors note here a comment from Sanders (1995) about the claim made by some historians that midwives in Europe were especially vulnerable to charges of witchcraft. Sanders finds that some recent historical research claims to refute this belief that midwives were vulnerable because of their professions (Sander, 114).

Chapter 4

A Punishment to Fit Her Crime
From Settlement to Antebellum Era

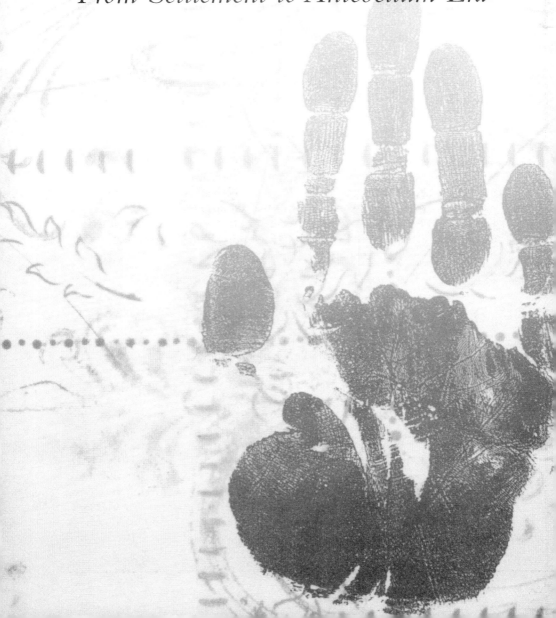

The Murderer and the Heroine

Regarding the perception of gender and deviance in Puritan Massachusetts,[1] Hull (1987: 12) writes:

> Men were obstinate and disorderly by nature; when women behaved in the same fashion, they violated the roles magistrates and ministers assigned to "good wives." The process of labeling transformed the female suspect into a symbol of deviance far more striking than her male counterpart...

In 1693, a jury convicted **Elizabeth Emerson,** an unwed mother of one child, of killing her twin babies at birth.[2] She denied the charge, but was hanged after receiving a gallows sermon from minister Cotton Mather on the subject of sin. Dismayed and irritated by Emerson's refusal to confess and repent, Mather told her, "I Question whether ever any Prisoner in this World, enjoy's such means of Grace as you have done since your Imprisonment, and may be there never was a Prisoner more Hard-Hearted, and more Untruthful" (quoted in Ulrich, 1991: 200).

Four years later, in 1697, Mather had occasion to speak about the conduct of Emerson's older sister, **Hannah Duston.** Unlike her sister, Duston earned Mather's unqualified praise. Five days after giving birth, Duston and her companion, Mary Neff, were taken captive by Indians who also held a young boy named Samuel Lennardson. Duston not only managed to orchestrate their escape, but in the process she and her two companions killed ten sleeping Indians and brought home their scalps. She was hailed as a heroine. Mather said that Duston had imitated "the action of Jael upon Siseria." Of this comparison, historian Laurel Thatcher Ulrich (1991: 168) writes:

> The Biblical image was apt. In Jael, Mather found a model which both justified and elevated Hannah Duston's deed. As recounted in Judges, chapter 4, the tale is a simple one. Jael, the wife of Heber the Kenite, welcomed the enemy Sisera into her tent, fed him, lulled him to sleep, and then murdered him driving a tent peg through his head. Retold in the Song of Deborah in Judges, chapter 5, it became a narrative and poetic masterpiece, carefully exploiting the contrasting images of the woman as nurturer and killer.

Although she was the sister of a woman who had been hanged for murdering her newborn twins, this had no impact on the acclaim Duston received for her actions. It was said that after witnessing the murder of her own newborn by "savages," Duston had, even in her weakened condition, shown courage and resolve. Like Jael, she had struck a blow against an enemy that threatened the social order. The blood on her hands was righteous blood, even though six of the ten Indians she had killed and scalped were children. As Ulrich notes, the Puritans were able to view the action of Elizabeth Emerson and her sister Hannah Duston as separate and apart. They did not

question the fact that two women from the same family had committed homicides. They saw Emerson, as an unwed and murderous mother[3] and her sister Hannah as a modern-day Jael, as an "archetypal heroine of the New World frontier" (Ulrich, 168, 167-201).

Later, New Englanders such as 19th century novelist Nathaniel Hawthorne would see Duston's actions differently. In his novel, *The Marble Faun,* Hawthorne's heroine Miriam contemplates murder to solve a problem from her past but turns away from the idea, instead venting her hatred of her oppressor in her drawings. For Hawthorne, a product of 19th century Jacksonian sensibilities, the idea of the kind of female aggression that Duston had displayed (and been rewarded for not only with acclaim but with a bounty for the scalps) was repulsive. He called Hannah Duston a "bloody old hag" (Ulrich, 1991, 170-172).

But Duston was not unique among frontier women in her violent response to a perceived enemy. In 1677, in Marblehead, Massachusetts, fishermen brought two Native American captives back with them to the village. Women of the village stoned, clubbed, and mutilated the Indian men, and then severed their heads from their corpses. In the eyes of the colonists, the Indians were savages who captured, killed, and destroyed. The colonists saw themselves as defenders against enemies who threatened not only their lives but everything they hoped to build. Like their men, colonial women could respond to their enemies with rage and violence (see Axtell, 1974). Ulrich (1991) writes in a final observation about Hannah Duston (and by extension the women of Marblehead), "Her violence was possible because she had been raised in a world where women slaughtered pigs and fought their neighbors; it was permissible because it was directed in wartime at a hated enemy. . . ." (Ulrich, 235). Or, as Henwood (1997: 170) observes, "anger was not forbidden to Puritan women, so long as they turned their rage to heroic, communal uses."

Of course, there were women on the other side of this war, Native American women. The people that the colonists called Indians or "savages" were not a homogenous group. Tribal conflicts had existed before the colonists arrived and would continue even as Native Americans faced this new and more pervasive threat to their ways of life. Concerning the role of Native American women in tribal conflicts, Haefeli (1991: 21) writes:

> The politics of Amerindian wars were inseparable from Amerindian domestic politics. Behind the killing by men lay the pleas of grieving women. When someone died, Native Americans expected the mourners, especially the female relatives, to fall into a deep depression. Something had to replace their loss. . .

As a part of this mourning ritual, in this system of warfare known as "mourning wars," women would urge their male relatives to avenge their losses by attacking their enemies. Although the men might bring back scalps or some other body part as "visible sign of justice done," to return with captives was even more of a triumph. Captive women and children were often

adopted into the tribe and assimilated. But in the case of warriors, it was more likely that the captured warrior would be killed.

> The women who had urged their men to go to war decided the fate of the captives....Captured warriors...were rarer and offered a chance for the entire village, and especially the family of mourners, personally to avenge themselves and soothe their grief by torturing the men to death...Warriors knew that such a fate awaited them if captured. They were expected to die heroically, singing, dancing, and defying their tormentors (Haefeli, 21).

In colonial warfare between European settlers and Native American tribes, each group viewed the other from its own perspective regarding violence and its appropriate use.[4] In this context, the Reverend Cotton Mather could praise Hannah Duston's actions in killing and scalping sleeping Indians, including children, because that was the way one fought and survived when dealing with "savages." In this context, Native American women could send their men out to avenge their tribes' losses and then join in the torture of captives because that was the way to respond when an enemy made war against one's people.

But warfare with Native Americans was only one aspect of the unease that permeated the Massachusetts Bay colony in the late 17th century. There were day-to-day problems such as illnesses, bad weather, cows that refused to give milk, and neighbors who were disagreeable. Then there were the larger problems such as uncertainty about the colony's charter and village-town conflicts about religious and economic affairs (Davidson and Lytle, 1992: 22-46). Of course, religious conflicts had always been present in the colony in the form of heretics and non-conformists.

Heresy and Monstrous Births

In 1634, **Anne Hutchinson** arrived in the colony with her husband. Hutchinson began to convene weekly religious meetings that soon attracted sixty to eighty people. At these meetings, Hutchinson—a woman not given to keeping the silence instructed by St. Paul—made her views on religious doctrine known. These Antinomian views were not in keeping with those of the Puritan church elders (see Dunn, 1978 for discussion). They brought charges against Hutchinson, accusing her of "traducing the ministers and their ministry" and of heresy. In two trials, one civil and one religious, Hutchinson was found guilty. Her sentence was banishment from the colony and excommunication from the Church of Boston. Hutchinson's husband, William, joined her in her banishment, saying that he was "more nearly tied to his wife than to the church." The couple moved to the frontier in what would later become New York state, and Anne Hutchinson was killed in 1643 in an Indian attack (Frost-Knappman and Cullen DuPont, 1997: 3-6).

During her civil trial in November 1637, Governor Winthrop told Hutchinson that she had been called before the tribunal because

> ... you ... are one of those that have troubled the peace...you have spoken of divers[e] things ... very prejudicial to the honour of the churches and ministers thereof, and you have maintained a meeting...that hath...been condemned...as a thing not tolerable nor comely in the sight of God nor fitting for your sex (Frost-Knappman and Cullen-DuPont: 4).

Hutchinson questioned Winthrop about his view of her behavior in the exchange that followed. When John Cotton, a leading Puritan minister, stepped forward to testify in her behalf, it seemed she might be acquitted. But then Hutchinson announced that she had received divine revelation that her accusers would be destroyed. She was convicted of heresy. In the religious trial that followed, Cotton, who now testified against her, warned Hutchinson's female supporters that Hutchinson should not be listened to because, "You see she is but a Woman and many unsound and dayngerous [sic] principles are held to her" (quoted in Frost-Knappman and Cullen-DuPont, 5).

This was more than a simple squabble about religious orthodoxy. With the expression of her views and her insistence on teaching, Hutchinson challenged the gender role assigned to women in the Puritan church. From the perspective of the church fathers, she also placed her fellow colonists who listened to and believed her teachings in danger of disobedience not only to church leaders but to God. During the months that followed, other women challenged church doctrine and received punishment ranging from being forced to make a public promise to obey their husbands to whipping or excommunication. But these punishments were mild compared to that of **Mary Dyer** who would eventually be hanged for her faith.

In 1638, Dyer had supported Hutchinson and been among those who followed her when she left for Rhode Island (Schutte, 1985). However, in 1652, Dyer, accompanied her husband and Roger Williams, founder of the colony, back to England. Although William Dyer returned to Rhode Island the following year, she lingered in England for five years. During this time, Dyer experienced a religious conversion. When she returned to Massachusetts, she began practicing her new faith. By 1660, Dyer was facing charges of Quakerism (i.e., being a practicing Quaker). The Puritan fathers of the colony had identified the Quakers as dangerous dissenters and by 1658 had passed a law banishing them from the colony on threat of death. When Dyer went to visit two male Quaker friends who were being held in the Boston jail, she herself was arrested and charged. When her husband petitioned Governor Endicott, Dyer was released under her husband's supervision and warned not to return to the colony. But she did return in October 1659, following her companions who had gone back to Massachusetts. She too was arrested. According to the authorities, Dyer and her fellow Quakers were imprisoned for "their rebellion, sedition, & presumptuous obtruding themselves upon us."

They were also charged with being "underminers of this government." Governor John Endecott, the judge at the trial, sentenced all three to death.

Dyer's husband, William, attempted to protest the sentence as an infringement of his wife's religious liberty. Others, including the governors of Connecticut and Nova Scotia, joined him in his protest. Dyer's son, William, petitioned the Court. On the day of the appointed hangings, Dyer's companions were executed. She was led to the gallows and the rope placed around her neck. Then she was released with the warning to depart from the colony within forty-eight hours or be executed. She left—only to return seven months later. In May 1660, she again appeared before the governor, saying she had come to "bear witness" against the law. In spite of her husband's appeal for mercy, the court met in whole and decided to carry out the commuted sentence. In June 1660, Dyer was hanged. In 1958, the Massachusetts General Court erected a statute in her honor, inscribed "Witness for Religious Freedom" (Frost-Knappman and Cullen-DuPont, 1997: 7-9; Warnes, forthcoming).

Neither Hutchinson nor Dyer committed acts that would now be defined as criminal. But these women were accused of acts that in the society in which they lived were considered serious enough to threaten the peace and tranquility of the colony and to endanger the mortal souls of the people with whom they came in contact. Long before Dyer was hanged as a Quaker, Puritan leaders such as John Winthrop were sure they had received a sign from God about these two Antinomian women. That sign had come in the form of their two "monstrous births."

Both Dyer and Hutchinson gave birth to severely deformed fetuses. Dyer was the first, in October 1637. Hutchinson and a midwife named Jane Hawkins were in attendance. The Reverend John Cotton was also present. It was he who advised secrecy. Later he would say that he had believed the birth was a private matter that concerned only the parents. In any case, the baby was buried, and the matter might not have come to the attention of the Puritan elders if Dyer had not stood up after Hutchinson's trial to follow her from the church. A bystander identified Dyer to someone as the woman who had given birth to a monster. Learning of this, Winthrop eventually ordered the exhumation of the infant's body (Schutte, 1985, also see Myles, 2001).

Although the infant had been buried several months earlier, the indications of deformity were still profound enough to convince Winthrop that the birth had been a warning from God to the Antinomian parents. He reasoned that this was a matter that should be made public as an example to others. He himself recorded the event (as would several other prominent Puritans). In his *A Short Story of the Rise, Reigne, and Ruine of the Antinomians, Familists, and Libertines,* Winthrop wrote that Dyer "brought forth her birth of a woman child, a fish a beast, and a fowle, all woven together in one, and without an head" (quoted in Myles, 2001: 3). When Anne Hutchinson experienced her own monstrous birth in 1638, Winthrop wrote:

she brought forth not one (as Mistris Dier did) but (which was more strange to amazement) 30. monstrous births or thereabouts, at once. . .some of one shape, some of another; few of any perfect shape, none at all of them. . .of humane shape" (quoted in Myles, 2001: 3-4).

Based on descriptions of the two births, it seems probable that Dyer's infant was "an anencephalic with spina bifida and other abnormalities." As for Hutchinson, her "misbirth has been identified as a hydatidiform mole" (Schutte, 1985: 90). But in the 17th century in Puritan Massachusetts, the births were matters for interpretation and the meaning assigned was "fueled by the theological conflicts" in which these Antinomian women were prominently involved (Schutte, 86).

Winthrop's account of the two births were published anonymously in London in 1644, attracting interest on both sides of the Atlantic. Other accounts would follow. Nord (1990) describes Mary Dyer's (and by extension Hutchinson's) monstrous birth as news in the journalistic sense.

> Mrs. Dyer's story was typical of popular English street literature of the era. Ballads and broadsides describing "monsters"—both animal and human—and other "strange occurrences" were standard fare in Britain and Europe. Such sensational printed news derived from oral folklore. . . .(Nord, 11).

In this sense, the theological use made of the births was only one aspect of their employment. Because the births were considered events worthy of note, they also became fodder for the incipient practice of journalism in the colonies. Nord (1990) argues that this focus on events-based reporting was one aspect of American journalism that was retained as it evolved from its religious roots. But for Dyer and Hutchinson, the reporting of their unfortunate births linked their "heresy"—their delusional and wrong-headed thinking—to monstrous motherhood.

As for **Jane Hawkins,** the midwife who attended both Dyer and Hutchinson, she was said by Winthrop to be "notorious for her familiarity with the devil." He charged that she "used to give young women oil of mandrakes and other stuff to cause conception; and she grew into great suspicion to be a witch" (quoted in Westerkamp, 1993: 590). In describing the assertions made about these three women and other transgressors, Westerkamp finds that there was a tendency on the part of the church leaders to describe such female deviance in terms of seduction. That is, to characterize what was "essentially sexual. . .essentially female" about their mysticism as "flagrant, adulterous, dangerous, evil" (1993: 594).

These early gender-based conflicts occurred long before the witchcraft trials of 1692. However, the episodes involving the Antinomian and Quaker women and their male co-religionists reflected the underlying tensions in the colony that would be on full display during that episode.

The Witchcraft Trials

In *Wayward Puritan,* Kai Erikson (1966) argues that challenges from religious heretics and non-conformists, the Indian wars, the uncertainty about the charter, and other tensions in the colony created "boundary crises" to which the Massachusetts Bay officials responded with "repressive justice." Convicted religious heretics such as Hutchinson, Dyer, and their associates were among the first to feel the force of this repressive justice. However, Erikson argues that this sense of crisis in the form of perceived "crime waves" culminated in the Salem witch trials (see also, Norton, 2002, on the Indian Wars).

Two hundred people were accused in the trials that began on June 2, 1692 and continued until September of that year. Twenty-nine of the accused were found guilty of witchcraft. Of those twenty-nine, 10 were imprisoned. Nineteen were executed (Frost-Knappman and Cullen-DuPont, 1997: 11). The first colonists to be accused were women. The majority of the colonists placed on trial and executed were women. Karlsen (1987) finds that of the 178 accused who can be identified by name, more than three out of four were women. Of the accused men, nearly half were husbands or male relatives of the accused women (cited in Davidson and Lytle, 1992: 41). With regard to this gender inequity in the witchcraft trials, Davidson and Lytle write:

> Given that women in Puritan society were placed in decidedly subordinate roles [legally and economically], how does that help explain the preponderance of female witches? As it turns out, a significant number of accused witches were women who were not subordinate in some way. They did not fit accepted stereotypes of the way women were expected to behave. In refusing to conform, they threatened the traditional order of society... (Davidson and Lytle, 43).

The women who were accused included those who stood out because of their "contentious, argumentative nature" (Davidson and Lytle, 43). Others stood out because they were widows or *feme sole* ("woman alone") and did not fall under the law of *feme covert* (and therefore male control). Some of these women owned property and therefore had some economic power. Other women, like **Tituba,** the West Indian slave who was the first to be accused, stood out because they were marginal in Salem society.

The trouble began in the house of Reverend Samuel Parris. Parris, himself, had been the subject of some contention after a village church was estabablished and he became its minister. But it was with the females in his house that the trouble began. A group of adolescent girls, including his daughter and his niece, had gathered to play a game—crystal-ball reading. Having no ball, they used a raw egg suspended in water instead. They wanted to see their future husbands. What one of them claimed to see instead was "a specter in the likeness of a coffin." The girls had been encouraged in their play by Tituba, the slave. When the girls began to behave oddly, Tituba baked a "witch cake" made of rye and urine from the afflicted girls to determine if they were bewitched.

Before she had an opportunity to complete her experiment by feeding the cake to the dog, the Reverend Parris learned of what was going on and reacted by questioning Tituba about her activities. Under questioning by Parris and later the magistrates, Tituba confessed and begin to name other witches in Salem. The girls, now displaying convulsions, "fits," and other signs of bewitchment also began to name witches. Among the first accused, other than Tituba herself, were **Sarah Good** and **Sarah Osbourne**, neither of whom was particularly popular with her neighbors.

In the trials that followed, the magistrates relied on "spectral evidence," the bizarre visions reported by those who said they had been victims of witchcraft. As each defendant was brought into court, the adolescent girls and others who later came forward to claim bewitchment were asked if the accused was a witch (or wizard, if male). Ideally—and from the standpoint of the magistrates more desirable—these witches and wizards would confess, repent, and name others. This was what Tituba did, and she survived. Those who did not confess had to try to disprove the spectral evidence of their accusers or to prove that the material objects (such as dolls or pins) found in their possession or the physical marks (such as a "witch's tit") found on their bodies was not proof of guilt (Davidson and Lytle, 1992, also see Hill, 1995).

I, Tituba

In the first paragraph of her novel about Tituba, the servant who was the first person to be accused during the witch craze that swept Salem, Massachusetts in 1692, Maryse Condé has her heroine, Tituba, recall:

> Abena, my mother, was raped by an English sailor on the deck of *Christ the King* one day in the year 16★★ while the ship was sailing for Barbados. I was born from this act of aggression. From this act of hatred and contempt (Condé, 1992:3).

In the novels of both Condé and Ann Petry (1964), as well as Arthur Miller's play, *The Crucible* (1954), Tituba is portrayed as at least part black. However, recent scholarship suggest that Tituba was instead a Native American from the West Indies (see Breslaw, 1996; also Hansen, 1969).

Whatever her origin, for some feminist novelists and scholars, Tituba symbolizes oppression based on gender, race, and servitude. These novelists and scholars highlight the resistance offered by Tituba and the other accused "witches" to the narratives of their accusers.

Historians have offered a number of possible explanations for what happened in Salem Village in 1692. These explanations range from the social and political (animosity between two important families; townspeople versus farmers; misogyny) to environmental (mold on the grain used for baking bread) to psychological (hysteria convulsion attacks). These explanations are not neces-

sarily mutually exclusive; various factors might have converged to bring about and sustain the events of 1692. What is of interest here is that when a witch craze occurred in colonial America, it followed much the same pattern as such crazes elsewhere in that women were the principle targets of the accusations. As in Europe, the people of Salem had no trouble believing that if the Devil was in Salem, he was there in the form of the deviant women who had invited him in and become his instruments.

However, in the decades following this episode, criminal justice in New England began an evolution that was reflected both in its legal proceedings and in its literature.

From Gallows Sermons to Legal Narratives

In his study of New England crime literature, Daniel Cohen (1993) finds that there was a gradual evolution from the control of the literature by ministers to control by lawyers, novelists and others. That is, the movement in crime literature was from the religious to the secular. The earliest published crime narratives in the New England colonies were the gallows sermons prepared by ministers such as Cotton Mather. The sermons were prepared on the occasion of an execution and sometimes included a confession by the condemned person.[5] But gradually, the legal storytelling which occurred in courtrooms and the works produced by fiction writers superseded the works of ministers. By the 19th century, novelists such as Nathaniel Hawthorne were not only creating fictional narratives dealing with crime but were commenting on real life crime and justice. Of interest here is how this evolution in crime narratives affected how women as criminals were portrayed in New England and elsewhere in America.

In 1697, **Esther Rodgers** of Newbury, Massachusetts "committed her first murder." Rodgers was seventeen at the time. She had been apprenticed to a family as their servant when she was thirteen. The family was religious, and Rodgers was pregnant with a child that had been fathered by another servant in the household who was African. Rodgers managed to conceal her pregnancy and when the child was born she stopped its breath and buried the body. This first crime was not detected, but when Rodgers became pregnant a second time a few years later and again killed and buried the infant after a secret delivery, she was discovered. Charged with murder "under a seventeenth-century English law that held any women guilty of infanticide who buried a newborn child in the absence of witnesses to its natural death," Rodgers confessed her earlier homicide. Convicted and sentenced, she spent eight months in prison before being executed (Halttunen, 1998: 7).[6]

However, as Halttunen (1998) points out, this straightforward recitation of events, was not the way the three execution sermons that the Reverend John Rogers preached on Rodgers behalf were presented. These sermons, later printed as *Death the Certain Wages of Sin* (1701), followed the formula for such narratives. In presenting his sermons, Reverend Rogers focused not on the details of the crime but instead on "the spiritual pilgrimage of Esther Rodgers

as she moved from a state of religious indifference to overwhelming conviction of sin to a strong hope . . .in her salvation" (Halttunen, 8).

The purpose of execution sermons was to demonstrate to the listeners (or readers) how even the most sinful could be redeemed and find God's grace. In these narratives, the ministers who visited and counseled the condemned man or woman played starring roles in guiding the sinner in his or her pilgrimage. The condemned person's confession and repentance prior to execution was the proof that this process had been successful.[7] As Halttunen (1998: 8) describes it, "In offering up condemned murderers as models for more ordinary sinners to empathize with and emulate, the execution sermon was a distinctive response to dramatic acts of criminal transgression in early New England culture."

But by the late 18th century, much had changed in New England and elsewhere in the colonies. In 1786, when **Hannah Ocuish,** age twelve, killed Eunice Bolles, age six, the crime narrative was on the brink of moving from religious to secular. The tellers of such tales were beginning to explore the dramatic possibilities of constructing a murder as a mystery to be solved. This case was in many ways ideal for this evolving approach to murder. When the body of the murdered child was discovered it was beside a wall and covered with stones. When Hannah Ocuish was questioned, she claimed that she had seen four boys near the scene of the crime. But when Ocuish was taken to the child's home, confronted with the body, and again questioned, she made a tearful confession.[8] She had killed the child because Eunice Bolles had reported that she saw Ocuish stealing fruit a few weeks earlier during "strawberry time." Plotting revenge, Ocuish waylaid the child as she was on her way to school, lured her off the path, and then beat and choked her. The stones left on her head were intended to suggest the child had been killed by the falling wall (Halttunen, 1998: 91-92).

As in the case of Esther Rodgers almost a hundred years before, a minister, the Reverend Henry Channing, delivered an execution sermon for Hannah Ocuish. In this sermon, using Ocuish as an example, he warned "parents and masters not to neglect the religious and moral instruction of children" (Halttunen, 91). When the sermon was printed, the editors added a brief account of the crime. In during so, they moved the narrative toward the "murder as mystery" (Halttunen, 91-93).

This evolution would culminate in the birth of the mystery or detective story in the mid-nineteenth century and would also be reflected in the legal storytelling that would evolve in the courtroom. But this movement also introduced less certainty into the process. Now the investigation would move center stage. Now the physical evidence would become the subject of debate and interpretation. In the case of women, the uncertainty in the storytelling about murder would also reflect the strains that continued to exist in gender relations.

Wives, Husbands, and Marital Discord

In March 1776, Abigail Adams wrote a letter to her husband John. At the time he was in Philadelphia, representing Massachusetts in the Second Continental

Congress. In her letter, which blended news of home and family with inquiries about American defenses and other political matters, Abigail Adams told her husband:

> In the new Code of Laws which I suppose it will be necessary for you to make I desire you would Remember the Ladies, and be more generous and favourable to them than your ancestors. Do not put such unlimited power into the hands of the Husbands. Remember all Men would be tyrants if they could. If perticular [sic] care and attention is not paid to the Laidies [sic] we are determined to foment a Rebelion [sic], and will not hold ourselves bound by any Laws in which we have no voice, or Representation (Adams, 1776).

American women would not receive that voice—in the form of the suffrage—until 1920. In spite of threatened rebellion by outspoken women such as Adams, men would continue to hold the balance of power in gender relationships.[9] Many men would continue to perceive women as a necessary but unpredictable, occasionally unruly, and sometimes dangerous element in their lives. As in past eras, this is particularly evident in those discourses concerning marriage.

Male Duty and Marital Harmony

Little (1999) describes one marriage in which an unruly woman challenged her husband's authority. The couple, **Anne Eaton** and her husband, Theophilus, lived in the New Haven colony in the 17th century:

> There is little doubt that Anne Eaton was a troubled woman. Those who lived in her house—her stepdaughter, her mother-in-law, and various servants—testified that they had been subjected to her damaging lies, verbal abuse, and even physical assault. Her husband, Theophilus, was forced to intervene one evening at supper when Anne reached across the table to strike her mother-in-law "twice on the face with the back of her hand"...Theophilus leaped up to restrain his wife...His attempts to correct his wife, either by physical restraint or moral suasion, were ineffective, and moreover thoroughly resented by her (Little, 43).

This situation was particularly humiliating for Theophilus Eaton because in public life, he was a man who exercised some power. He was the governor of the colony of New Haven. Anne Easton's troubling (and troubled) behavior occurred during a time when men were expected to be able to control their wives. The "harried husband" was the subject of jokes, and little sympathy. Husbands had a legal mandate and a perceived social obligation to exercise their authority. Both law and religious doctrine placed men at the head of their

households, therefore, "any challenge to their authority not only was perceived as a threat to household order but was understood as an attack on the general social order" (Little, 45). When relationships between husbands and wives broke down to the point that they found themselves in New Haven courtrooms, judges had the opportunity to intervene and to help in restoring the status quo.

Based on the court records, there seem to have been relatively few cases of husband abuse prosecuted in the New Haven colony. However, Little (1999: 46) asserts that the number is more impressive when we note that not a single case of wife abuse was ever prosecuted in the colony, and only two cases appear in the records after the colony became a part of Connecticut in 1665. Little suggests abused wives were rendered invisible in the court records because in "the traditional hierarchy of marriage, it [wife beating] was not seen as problematic, nor were women seen as creatures with rights to protest their husbands' exercise of domestic statecraft" (Little, 46).

When husbands and wives did appear in the courtroom, it was often because others had complained about the conduct of the wife, particularly about verbal abuse ("scolding") or slander. In these cases, the husband was in the position of a man who had lost control of his domicile, who was "not fulfilling his gender duty" (Faith, 1993, 30). The courts sought to intervene with a range of punishments directed toward the offending wife, from fines, to whipping, to in extreme cases, threat of banishment.[10]

What these early colonial cases illustrate are the expectations held by others about how a man should behave in regard to his wife. It was his responsibility—at least in the eyes of other males—to keep her from becoming an annoyance to himself and others. However, the fact that disorderly marriages were a common theme in English drama and popular verse in the sixteenth and seventeenth centuries makes clear that the relationship between husband and wife was not always as law and religion would have it. In popular culture, "the shrew, the fishwife, and the cuckold" symbolized the possible forms of subversion in which women might engage (Little, 52-53; also see Smith, 1991: 128-129 on stereotypes of the "scolding wife" and the "virtuous wife").

However, Miller's research (1999) on 18th century Philadelphia offers a notable exception to these images of disharmony in marriage. Miller finds that by the 1750s, middle-class Philadelphians had come to accept the idea of "marriage as a partnership that stressed mutual affection, companionship, a single standard of sexual behavior, and complementary gender roles"(46). In this city where the Quaker influence was still strong, both men and woman (and their children) were expected and thought capable of rational behavior and emotional restraint. Although violence between married couples sometimes occurred, such outbursts were deemed unacceptable. In their emphasis on working to create domestic harmony, middle-class couples saw themselves in contrast to the lower class, who they "rarely assumed... possessed rationality" (Miller, 46). For these Philadelphians, "learning to govern one's passions lay at the heart of bourgeois domestic life..." (58). In their marriages, these couples strove for "balance."

This concern on the part of the middle-class with balance was related to their beliefs about disease. In Philadelphia, as in other urban areas, physicians not only provided medical care for their patients, they also offered medical explanations of illnesses. Physicians such as Dr. Benjamin Rush tutored their patients on the connection between unruly emotion (fear, unrestrained grief, anger) and ill health. During the yellow fever epidemic of 1793, this seemed a particularly important lesson, as the middle class observed that the poor—who they believed more unrestrained in all their habits—were more prone to fall ill (Miller, 50-51).

The dual motivations for emotional balance—good marriages and good health—that seemed to be at work in 18th century middle-class homes in Philadelphia worked to suppress domestic violence. Roth (1999) finds that in Northern New England other forces worked to "dampen and restrain deadly passions." Those restraining forces were "a unique social order, grounded in universal literacy and the household economy which encouraged economic interdependence and mutual regard among spouses" (Roth, 89). But the unique social orders that Miller and Roth discuss were, respectively, class and region specific. For other Americans, the balance of middle-class Philadelphians and the mutual regard of Northern New Englanders had not been achieved in their marriages.

The Murder of Husbands

In British common law, the murder of a husband by his wife was a form of subversion. One of the more famous of such cases of "petty treason" occurred in 1778, during the upheaval of the Revolutionary War which pitted the colonial patriots against their Britain king. **Bathsheba Spooner** was the daughter of the most prominent and, therefore, despised Loyalist in Massachusetts. This became relevant when she was put on trial for conspiring with three other people to murder her husband, Joshua Spooner, a wealthy farmer. The marriage had been unhappy. Although the couple had three children, they were painfully mismatched. Bathsheba was lively and intelligent. Her husband was a drinker and abusive. She felt an aversion for him. She became even more dissatisfied after she met the man who became her lover. She was thirty-two when she took in a young soldier she saw passing on the road. He was making his way home after a year's enlistment in the Continental Army. When Bathsheba saw him he was ill. She invited him into her home and nursed him. Her husband was apparently not concerned about the possibility of a romance developing and agreed to the arrangement. In fact, he and the sixteen year old soldier became friends (Navas, 1999).

Different stories were told during the trial about how and why two British soldiers became visitors to the Spooner house. What is certain is that one dark evening Joshua Spooner was attacked and killed by the soldiers as he returned home and his body was placed in the family's well, where it was later discovered by a servant. Bathsheba Spooner's behavior after the event was fluttered and confused. During the trial, as the other witnesses told their stories,

she emerged as a calculating woman who had tried to persuade her young lover to kill her husband and, when he faltered, enlisted the aid of the two British soldiers. Certainly, her lover's family painted her as an evil, seductive woman.

When the four were convicted of the charge against them, Bathsheba Spooner pled her belly. She said that she was pregnant. She was given a physical examination by a midwives' jury chosen by the sheriff. Of this examination, Navas (1999) asserts that the findings of the midwives' jury illustrated "poignantly the virulent hatred directed toward Bathsheba."

> The first soft stirrings of fetal life are so delicate and interior that they weren't likely to be felt by a hand laid on the pregnant belly. Nor could they have been discovered by a more intrusive manual examination of the vagina, which very likely also took place (Navas, 87)

Navas argues that even if the female midwives, and the two male midwives who were there as witnesses, had not felt the quickening of the fetus (critical in British common law), they would surely have seen the swelling of Spooner's breasts and belly that would have been evident late in the fourth month of pregnancy. But the midwives' jury certified that she was not pregnant. She swore that she was and pleaded to be allowed to live until her child was born. In a letter to the Massachusetts' Council, she thanked the Council for the reprieve she had so far been given and stated:

> I am absolutely certain of being in a pregnant state, and above four months advanced in it, and the infant I bear was lawfully begotten. I am earnestly desirous of being spared till I shall be delivered of it. . .What I bear and clearly perceive to be animated, is innocent of the faults of her who bears it, and has, I beg leave to say, a right to the existence which God has begun to give it. Your honors' humane *christian* principles, I am very certain, must lead you to preserve life, even in this its miniature state, rather than to destroy it. . . (quoted in Navas, 88).

The Council denied Spooner's petition, but arranged for a second examination which included two of the female midwives from the first jury, the two male midwives who had observed, a new female midwife—and Bathsheba Spooner's brother-in-law, John Green, a prominent physician. A majority of the second committee, with the exception of the two matrons from the first jury, supported Spooner's claim that she was pregnant. But the Council failed to act on the report from the second examination. Plans for the execution proceeded. Spooner was too ill to attend her execution sermon. In the post-execution autopsy, it was discovered that she was indeed pregnant with a five-month male fetus.[11]

The Reverend Thaddeus Maccarty, who had been Bathsheba Spooner's confessor and visited her regularly in jail, included this information in his published account of the prisoner. Although the Council did not publicly acknowledge the truth of what Maccarty had written, the news did spread. The

suggestion that this execution of a pregnant woman had an impact on the capital punishment of women in Massachusetts dates back to an 1899 article that Elizabeth Cady Stanton wrote for the *New York World,* "The Fatal Mistake that Stopped the Hanging of Women in Massachusetts". . . . (Navas, 106). Stanton wrote her article hoping to sway public opinion and Governor Theodore Roosevelt in the case of a woman who was facing execution in the state of New York. But, as Navas notes, the assertion by Stanton was inaccurate. At least two other women were hanged in Massachusetts, one for infanticide and the other for highway robbery, following the execution of Bathsheba Spooner (Navas, 106).

With regard to the narratives generated about the Spooner case, Halttunen (1998) finds, "The Spooner case prompted much language of Gothic horror: it was a 'bloody tragedy,' 'a most shocking, cruel murder,' 'scarcely to be paralleled in all history.'" Among the factors contributing to the horror with which the murder was viewed were the use of hired assassins, the attack upon the victim's doorstep, and the role of the victim's wife in his demise (Halttunen, 151). But, in spite of the outrage expressed about the crime, the Spooner case did not generate a narrative about the "peculiar heinousness of female crime." This early case stands in contrast to the nineteenth-century cases of husband murder which would generate narrative treatments that were "heavily gendered explorations of guilt." This change in the portrayal of such crimes seems to have been influenced by the new ideas that appeared in the nineteenth century about "true womanhood" (Halttunen, 152).

As early as 1816, in a published sermon, Parson Mason Locke Weems (author of a popular biography of George Washington) described the murder of **Rebecca ("Becky") Cotton** by her brother. Weem's title was *God's Revenge Against Husband Killing.* As an itinerant bookseller, Weems worked for one of the first publishing house in the United States. In this role, Weems advised Mathew Carey, the publisher, about the reading taste of the public. Weems himself was the author of such works as *The Drunkard's Looking Glass, God's Revenge Against Adultery,* and *The Bad Wife's Looking Glass.* He saw no contradiction between moral instruction and sensational literature (Moore, 1989: 219-220). In one of his reports to Carey, he requested that the publisher find an artist to supply one of his tracts with the "likeness of a very beautiful woman distorted or convulsed with Diabolical passion, in the act of murdering with up-lifted ax, her husband in sleep" (Moore, 221). In this sense, the Becky Cotton story was perfectly suited for Weems' approach to providing both entertainment and tales with a moral.

The vivacious and beautiful Becky Cotton, a resident of Edgefield District, South Carolina,[12] was alleged to have done away with three husbands — killing the first with a mattress needle, the second with deadly nightshade, the third with an ax. According to Weems, Becky made the mistake of marrying the daughter of her fourth husband off to her brother. Apparently now allied with his wife and outraged by Becky's public flirtation with a young man, Becky's brother approached her in the village square and struck

her a fatal blow to the temple with a stone. He rode away without interference. According to the legend reported by Parson Weems, Becky Cotton's brother and his wife prospered in the West, producing a family with several branches of respectable and influential people. Becky Cotton, on the other hand, rested in an unmarked grave. Small boys dared each other to go to "Becky's Pool," haunted by John Cotton who was disposed of there by his murderous wife, "the Devil in petticoats" (Mims, 1963).

Although not as notorious as Becky Cotton, **Lucretia Chapman** too was painted by some observers as wicked. In 1831, when Lucretia Chapman stood trial in Andalusia, Pennsylvania for the murder of her husband, the prosecution and the defense offered competing narratives. The prosecution portrayed Chapman as abandoned and depraved and "lost to moral principle." The defense portrayed Chapman as a devout Christian woman, the mother of five, who had fallen victim to a "smooth tongued villain" (the man who the prosecution claimed Chapman had conspired with to kill her husband). After her husband's death, she had married this villain, not knowing his true nature. The defense said that any female evil to be found in Chapman's house was in the form of the female servants who had testified against her. The jury accepted the defense argument. Chapman was acquitted. Her new husband, who was foreign born and "certainly provided a handy scapegoat" was convicted and executed (Halttunen, 152-153).

However, in the nineteenth century, the ability to make effective use of the ideology of "true womanhood," as Lucretia Chapman had, was limited by class and race. Yalom (2001) in her history of the wife points out the necessity of recognizing the diversity of experience of women in Victorian American. Only white middle and upper class women were in positions to claim the benefits of an ideology that located them in the "domestic sphere" as the guardians of family virtue while their husbands pursued the commercial goals that were deemed appropriate for 19th century business and professional men (see e.g. Fessenden, 2002).

A defendant such as **Frances ("Frankie") Silver** who was white, but who was also a lower-class woman from the Appalachian Mountains, was not able to claim the male "chivalry" that was a part of middle-class ideology. In 1833, Silver was hanged for the murder of her husband, Charlie. She was nineteen; he had been twenty. They had one child, an infant, who had probably witnessed her father's slaying in their mountain cabin. The homicide occurred a few days before Christmas. The next day, Frankie Silver went across the hollow to her in-laws house and told them Charlie had gone out hunting and not come home. They initiated a search that eventually—and there are various legends about how this happened ranging from Charlie's old hound dog to a black slave seer—but eventually the search came back to the cabin. The ashes in the fireplace revealed fat from Charlie's body. When the floor boards were lifted, body parts were found. There is a legend that Charlie was buried in three different graves because he had been dismembered by the person or persons who killed him and parts of him kept turning up (*The Ballad of Frankie Silver*, n.d.)

At any rate, Frankie Silver and her mother and brother were brought down from the mountain to Morganton, North Carolina, the county seat. The mother and brother were eventually released, but Frankie Silver was charged. She stood trial with two lawyers to assist her, but under English common law, as the accused, she could not testify in her own behalf. She was convicted and sentenced to death. It was only later that concerned townspeople began to hear that if she had killed her husband it was quite possible that she had done so in self-defense, during one of the beatings he had sometimes given her. But a petition signed by a group of townswomen and by several members of the all male jury, did not sway the governor. The sentence was carried out—and the story of what really happened that night in that mountain cabin remains a mystery. When Frankie Silver was asked if she had any last words, according to legend her father yelled out to her to, "Die with it in you, Frankie!" (*The Ballad of Frankie Silver,* n.d.). It has been suggested that other members of the family were involved in the killing and that this was the secret Silver's father urged her to keep (see also Young, 1998).

The story of the Silver case has become a part of the folklore of the Appalachian mountains (where descendants of both families still live). The case was reinvestigated by a North Carolina assistant district attorney after a group of school children made an appeal for the pardon of Frankie Silver (*The Ballad of Frankie Silver,* n.d.). The story went national when best-selling writer, Sharyn McCrumb, adapted it for one of her "ballad" novels set in the Appalachian Mountains (McCrumb, 1998). A non-fiction book has been written by a journalist (Young, 1998) and a documentary has been produced by a Silver family descendant in conjunction with a North Carolina university. That descendant and his singing partner have written and recorded a ballad about the case. But, in the end, the truth still remains a mystery—and a fertile source for narratives about class, gender, domestic violence, Appalachian mountain culture, and the quality of justice. In this respect, McCrumb uses the case in her novel to illustrate class inequities in the administration of capital punishment (Bailey, 2000).

The Killing of White Masters

There are other cases that illustrate the difficulty marginal women had in making a claim of feminine virtue. This was especially true for African American slave women. Not only were they not included in the discourse of genteel womanhood, they were under the law property, not persons. The resistance by black slave women to their status in the antebellum South has been the subject of numerous narratives about slavery. It is a part of the embedded text in those 19th century cases in which black women were accused of murder. One particularly poignant case will illustrate black female resistance and criminal justice system response.

In 1850, a prosperous white Missouri farmer named Robert Newsom, purchased a fourteen year old slave named **Celia.** Over the course of the next

several years, Newsom made regular visits to Celia's cabin to rape her. She bore him two children. One evening, in 1855, she tried to refuse him. He persisted. She struck and killed him and then burned his body in her cabin's fireplace. The crime was discovered, and at the age of eighteen, Celia stood trial for murder. She was convicted and sentenced to death. Because she was pregnant at the time—and because the child she was carrying was valuable as slave property—she was given a stay until after she had given birth. The child was still-born. Celia, the slave, was then executed.

Regarding public response to this case, McLaurin (1991: 52) writes:

> The fact that papers in Missouri towns as far apart as Boonville, roughly forty miles upriver from Fulton, and St. Louis, approximately a hundred miles east of Fulton, carried reports about the murder indicates the level of the white's population's concern with slave violence, and especially with the murder of a slaveholder by one of his slaves...

Because Celia had been ill and because Newsom's family knew Celia had taken a slave lover named George, there was some suspicion that she had not acted alone. As in the case of Frankie Silver, there was discussion about whether a woman would have been able to alone carry out the gruesome task of dismembering a body and burning it. When George, Celia's slave lover, fled the farm, this fueled suspicion that he—and perhaps other blacks -- had been involved (McLaurin, 53-54).

As Bynum (1992: 85) observes, in the Old South "[f]ew women publicly assaulted white males, and even fewer committed murder." However, when white women did kill white males, African American slaves were sometimes implicated in the crime, and it was the slaves who often suffered more severe punishments than their white mistresses. For example, in 1846, when **Mary Meadows,** a white farm wife, was accused of hiring a slave named George to kill her abusive husband, it was George the slave who was convicted and hanged.

> Mary Meadows was acquitted despite the fact that several neighbors, including a relative, supplied evidence that she had arranged the murder of her husband. John B. Duncan testified that Meadows had offered to indenture herself to him almost a year before the murder if he would kill her husband (Bynum, 85).

Neighbors had witnessed Meadows' abuse of his wife. They had also heard her public statement that she intended to stop him from "scandalizing" her further. Bynum suggests:

> The Granville Court perhaps used George's involvement to avoid the question of how to punish a wife who had retaliated against her husband after years of abuse and humiliation. Convicting a slave instead of a wife enabled the court and the community to focus on the outrage of a black man's killing a white man rather than confront the thorny issue of violence within a marriage (Bynum, 85-86).

During this period what occurred between husband and wife within a marriage was still considered a private matter. As this case suggests, in the antebellum South when a homicide did occur, the community might prefer to focus on the behavior of black slaves rather than that of white wives. The community was also less likely to send white women to prison.

The Control of Slaves

With regard to black women, Fisher-Giorlando (1995: 25) finds in her study of commitments to Baton Rouge Penitentiary in Louisiana, 1835-1862, that:

> Louisiana's Black Code, which allowed for the substitution of life imprisonment for execution, did spare slave women's lives, but it also resulted in a unique Southern incarceration pattern: in Louisiana's antebellum penitentiary, white women came and went, while black women came to stay.

One hundred percent of the slave women in this penitentiary had been confined for violent offenses, in contrast to the white women, who appear to have generally been poor, and who were mainly serving short sentences for property offenses (Fisher-Giorlando, 23). The incarceration of these slave women suggest the fear that violent behavior by slaves engendered in whites.[13]

A constant fear among slaveholders was that black slaves would rise up in rebellion and slaughter white men, women, and children. They had been given an example of what could happen with Nat Turner's 1831 rebellion in Virginia. Yet, in spite of white fears, for a number of reasons, slave revolts were relatively rare in the United States. Instead, slaves engaged in day-to-day resistance to the system by actions that ranged from work slowdowns and escapes to individual acts of violence. In the case of slave women, it was suspected, although difficult to prove, that they sometimes poisoned or contaminated the food that their owners consumed (see Bailey and Green, 1999: 7-11).

It was also asserted that some slave women killed their own children, preferring to see them dead rather than enslaved. This could be proven if a slave woman acted with disregard for discovery—for example, if she threw a child into the river as they fled. But, in other cases, such as those that involved "overlaying," suspicions were difficult to prove. As discussed earlier with regard to allegations about careless wet nurses, overlaying occurred when a woman took a baby into her bed to sleep with her and during the night rolled over and suffocated it. Regarding slave women, there was the suspicion that such deaths were sometimes not accidents. But a female slave was valuable property, and she could produce more babies. As in cases of infant deaths involving white mothers (and wet nurses), modern medical knowledge would suggest that some of the deaths attributed to overlaying might in fact have been Sudden Infant Death Syndrome (SIDS). At any rate, it seems that most slave mothers did not choose to kill their children as a form of resistance to the

system. Black female slaves in the United States gave birth to and reared enough infants to make the system self-sustaining after foreign slave trade was banned in 1808 (see Bailey and Green, 1999; also Roberts, 1997).

A 19th Century Medea?

In 1856, Margaret Garner, an African American slave woman fled from Kentucky to Ohio with her husband and children. Tracked down by her master, Garner seized a knife and slashed her two-year-old daughter's throat. In 1867, Kentucky artist Thomas Satterwhite Noble rendered the scene of Margaret Garner confronting the slave catchers. In his painting she stood over the outstretched bodies of two male children. He called it "The Modern Medea." As Weisenburger (1998: 8) observes it is:

> a title with deeply troubling inferences. In Euripides' drama, a Medea already suspected of practicing the 'black arts' of witchcraft kills her two children to spite their father, Jason.

Jason betrayed Medea by rejecting her in favor of a "racially 'purer' wife." Thus, if Noble's title were taken literally by those who viewed the painting, they might have assumed that the slave Margaret Garner had destroyed the sons fathered by her white master and done so "out of jealous rage" (Weinsenburger, 8). Aside from its explicit commentary on the lethal defiance of slave mothers, the painting by implication dealt with themes of "miscegenation, sexual bondage, and the black woman as alluring and dangerous Other, themes nineteenth-century Americans typically spoke about in code" (Weisenburger, 8).

When Noble drew on Greek myth for the title of his painting—which later appeared as a lithograph in *Harper's Weekly Magazine* and other publications—he must have been confident that viewers would understand the classical reference. In the nineteenth-century, touring companies performed operatic versions of the Medea myth. The myth had also appeared on canvas. In 1838, the French artist Eugene Delacroix, who was a part of Romantic movement, had painted Medea as a "beautiful and fatal woman ... *la belle dame sans merci.*" In Delacroix's painting, she was "not only the *femme fatale* ... but also the royal virago (such as Lady Macbeth), the woman scorned, the desperate mother torn between love and hate" (de la Croix and Tansey, 1975: 674). In the nineteenth-century, Medea as the mythical murderous mother was still a part of cultural discourse.

Slave Women as Wet Nurses

An intriguing aspect of the slave system in the American South in the 19th century was that white families sometimes used black slave women as wet nurses for white infants. Recall that as early as ancient Greece and Rome, there were physicians and philosophers who asserted that the characteristics of the wet nurse could be transmitted to the infant who suckled at her breasts.

Yet, in some aristocratic white families in the South, black slave women were routinely used for this function, even though these women were considered racially inferior to their white owners.[14]

Golden (1996) finds that historians "remain divided" about how important the African American wet nurse was to the white nursery. In the beginning, Southerners seem to have been as "pragmatic" in the use of slave "mammies" as early settlers had been in the use of Native American wet nurses when needed.

> As the use of slave wet nurses developed into a common cultural practice, however, Southerners began to articulate arguments about its propriety. Like other aspects of racial thinking, the Southern attitude toward cross-racial nursing matured over time along with plantation economy. Also stimulating the defense of the practice in the South were the observations and queries of visitors to the region (Golden, 25-26).

These visitors seemed to view cross-racial wet nursing "with a mixture of fascination and disgust" (Golden, 26). As with other matters concerning its lifestyle, the plantation South found itself increasingly on the defensive.

In general, when it came to wet nursing, American opinion was mixed about its appropriateness. But, as in Europe, there was the recognition that wet nurses were important to an infant's survival if the mother could not herself nurse the baby. A wet nurse was seen as preferable if the mother was ill. Landon Carter, an eighteenth century Virginia plantation owner, complained in his diary that his ailing daughter-in-law (who was also having sexual relations with her husband while she nursed) was forcing his grandchild "to suck the poizon" from her breasts. He called her a "vile, obstinate woman." When she insisted on nursing a second child while ill, he described her as a "bilious mother" (Golden, 1996: 25). On the other hand, some observers during Carter's time and later were more concerned about what they perceived as the neglect of maternal duties when a middle-class mother hired a wet nurse because she herself did not wish to undertake the task of nursing her child. As in earlier times, there was also the concern that contact with a wet nurse might endanger the child.

Child Care and Child Abandonment

Increasingly in the nineteenth century, in the urban cities of the North, when a wet nurse was used there was more effort than in the past to have the child nursed in the home, under the watchful eyes of the parents. As medicine evolved as a profession, there was also more involvement by physicians in providing guidance to families and in attempting to exercise more control over wet nurses. Golden (1996) finds:

> In the books written in the 1840s and 1850s, a new theme emerged in the discussion of wet nursing: the threat of the dan-

gerous stranger. The subject inspired both the popular and the medical imagination, combining the growing alienation of the middle and upper classes from the urban poor with more specific fears about disease (Golden, 51).

For example, in a 1848 home medical guide, the author, Wooster Beach, a "botanic practitioner, used the term 'stranger' in reference to wet nurses who communicated 'loathsome and fatal diseases'" (Golden, 51). The wet nurse entered the home of the family who hired her as an outsider who might bring into the household diseases such as tuberculous, "the deadliest killer of the nineteenth century" (Golden, 143), or syphilis. She had to be hired with care and watched for signs of depravity and/or illness.[15]

At the same time, in the nineteenth-century as the ideology of true womanhood and the home as "the seedbed of spiritual wealth" became more pervasive, middle class women found themselves under increasing pressure to assume the responsibilities of "modern motherhood," including nursing. Popular literature "lauded women who breast-fed, reprimanded those who chose not to, and detailed the exceptional circumstances that required a wet nurse." These works also vilified the "fashionable lady" while ennobling motherhood (Golden, 48). Undoubtedly, women who chose to use wet nurses felt some obligation to justify their actions.

A related development was also occurring in the nineteenth century, as the pace of urbanization and foreign immigration quickened. More single and unwed mothers, or women who were married but poor, were abandoning their infants. These babies were "left on the steps of police stations, in church doorways, and at the gates of almshouse; they were tossed out of carriages and shoved into alleyways, and their corpses filled public burial grounds" (Golden, 113). Some fell into the hands of "baby farmers" (who accepted babies for a fee, promising to place them with a family). These babies often died in their care. The babies who survived became increasingly a public responsibility, with cities establishing foundling hospitals and baby asylums (see Zelizer, 1985). Wet nurses were hired to suckle these babies as well. Often women who had given birth in a public hospital or almshouse would be employed (or compelled as a condition of their stay) to act as wet nurses. However, as in Europe, the infants in these public facilities had high rates of mortality from disease, neglect, and inadequate nutrition (see Golden, 97-127).

One alternative for a woman who found herself pregnant was to seek an abortion. The next chapter looks more closely at nineteenth century responses to the practice of abortion, using the case of one famous (or infamous) New York City practitioner, "Madame Restell," who rose to middle class status and provided services to middle class women.

Summary

This chapter has examined the religious conflicts involving women that occurred in 17th century Puritan New England. The cases of Anne

Hutchinson and Mary Dyer were used to illustrate the intersection of religion and gender politics. Both Hutchinson and Dyer were perceived as dangerous and disruptive. Their deviance seem confirmed by God in the form of "monstrous births." However, the prosecution of these women should be considered within the context of the societal tensions in Massachusetts that culminated in the witch trials of 1692.

The evolving crime narratives of this era in American history reflect both a focus on events as news and on sensational crimes. The cultural storytelling about women as killers appears in these various narrative forms, from gallows sermons and tracts to novels and newspapers.

This chapter concluded with an examination of cases that illustrate the impact of a 19th century ideology that favored white middle class females, while denying "male chivalry" to African American and poor white women. This discussion was extended to address the roles of race and class in the wet nurse debate and in the matter of child abandonment and infanticide.

The next chapter continues exploration of the ideology of true womanhood and its impact on those cases in which women were accused of murder. As discussed in this chapter, certain women—non-white and/or lower class—did not often benefit from the same doubts that were raised in those cases in which middle-class women were accused of crimes. However, gender expectations placed behavioral restrictions on "respectable" middle-class white women and shaped the defenses that they needed to make in order to avoid punishment when they did stand accused.

Discussion Questions

1. What was the status of women in colonial New England as reflected in the cases discussed in this chapter?

2. How did gender interact with race and class in the cases discussed in this chapter?

Notes

[1] Regarding perceptions of gender differences and deviance in England during this period, see Nadelhaft (1982), who discusses the responses of a small group of feminists to male perceptions.

[2] Regarding rates of infanticide in colonial Massachusetts, see Hoffer and Hull (1981) who report: "The incidence of infanticide in seventeenth-century Massachusetts was 1.58 per hundred thousand people per year, while that for Maryland was 5.65 per hundred thousand." These authors note that the Maryland statistic "is, if anything too low" based on changing estimates of the population. But the conviction rate for infanticide was significantly lower in Maryland than in Massachusetts (Hoffer and Hull, 45). The authors note the importance of the "Elizabeth Emmison" case involving the infanticide of twins in 1691, in bringing English infanticide law to Massachusetts (Hoffer and Hull, 59).

[3] Between 1630 and 1692, eleven people, including Elizabeth Emerson, were executed for murder in Massachusetts. Of these eleven, four were women, three of the four had been convicted of killing their own children (Ulrich, 1991: 195). By comparison, Symonds (1998: 63) finds that in rural Scotland between 1690 and 1730, the crime of infanticide was particularly dangerous for women because of a harsh statute enacted in 1690. However, after 1730, convicted women was more likely to be banished than executed.

[4] For an account of a homicide involving a Native America woman in Spanish Florida see Hann (1992).

[5] The first book published in Boston was an execution sermon. Between 1674 and 1825, more than 75 such volumes were published (see Cohen, 1993: 8-10).

[6] For an early case involving allegations made against Alice Tilly, a Massachusetts Bay midwife, see Norton (1998) in which she attempts to reconstruct the circumstances based on fragmentary evidence, including six petitions signed by women who supported Mistress Tilly. However, Tilly's chief accuser was female, and it is not clear what was the exact nature of the alleged offense. Moreover, Tilly had offended some, including the authorities, with what was perceived as her arrogance and pride. Her supporters championed her because of her skill as a midwife.

[7] In 17th century France, priests played a similar role. For example, in the case of Mme De Brinvilliers, a woman sentenced to death for the murders of her father and two brothers, and the attempted murder of one of her sisters, a priest named Edme Pirot was appointed by the premier president to prepare her for death. Pirot recorded a narrative account of the process through which he led Mme De Brinvilliers from defiance to submission to her fate. Of this process, Perkins (1995: 103) observes: "In the narrative she is brought under the control of the dominant system, offering by the end no resistance whatsoever. As we might expect, this process is presented from the start as being for her own good."

[8] This procedure reflected the popular belief that "Murder will out," as in the biblical story of Cain and his brother Abel. A killer confronted with the corpse would betray his or her guilt (Halttunen, 1998: 93).

[9] See Lewis (1987) on the matter of the "Republican wife" and the "Republican mother," roles assigned to women in the evolutionary democracy of the Revolutionary era. In this political and social ideology women was assigned the role of "raising sons and disciplining husbands" (Kerber, 1976) to be good citizens. As Lewis (1987: 720) notes, "even as an image, she was limited. Indeed, she led to a dead end, for her capability always depended upon masculine susceptibility. She had no more power than men allowed. . . ."

[10] However, as Faith (1993) points out the scolded husband "could be publicly humiliated, through straightforward ostracism or the satire of a charivari. . . . Just as women were being trained to be passive, so were men being trained to be authoritarian" (Faith, 30).

[11] Brown (1998) examines cases in which women prisoners sentenced to death during the French Revolution pled their belly. One such case was that of Therese-Francoise de Stainville, wife of the Prince of Monaco. Like Bathsheba Spooner, the princess was examined to substantiate her claim. The tribunal infirmary surgeons and the midwife who examined her found no indication of pregnancy. The princess wrote to the public prosecutor confessing that she had lied, but making another appeal:

> I did not soil my mouth with this lie out of fear of death, nor to avoid it, but to give me one day more, so that I might cut my own hair, and not have it done by the executioner. It is the only legacy that I can leave to my children at least it must be pure (quoted in Brown, 136).

Brown examines the evolving response to these women prisoners who were treated by the Revolutionary Tribunal as "viable, and dangerous, political actors" (Brown, 138), but who at the same time made certain claims to mercy in the name of motherhood.

[12] This is the county in the South discussed by journalist Fox Butterfield (1997) in his book, *All God's Children,* about Willie Bosket, a violent young African American offender in the New York State correctional system. Butterfield traces Bosket's family tree back to Edgefield County, described by contemporary observers as one of the more violent in the antebellum South.

[13] For discussion of criminal justice and community response to the homicide of a white male (her husband) by a Native American woman see Thrush and Keller (1995).

[14] Regarding the origins of colonial American images of Africans and of black slave women see Sweet (1997) and Morgan (1997).

[15] However, in the case of venereal disease, the wet nurse might be at risk from an infected infant. There were reports of women who had been infected with syphilis by the infants they nursed. As Golden notes, these reports tended to focus on wet nurses working with foundlings, with no reports of such occurrences among wet nurses to the well-to-do. This "class and morals" map of the "social geography of venereal disease" was in keeping with the medical popular discourse linking venereal infection to the "vice problem." However, there is indication that the "better classes" also suffered from venereal infections (Golden, 1996: 144-145).

Chapter 5

A Proper Lady
Victorian Women

The Queen had only one way of settling all difficulties, great or small. "Off with his head!" she said, without even looking round.

"I'll fetch the executioner myself," said the King eagerly, and he hurried off.

Alice in Wonderland
(Lewis Carroll, 1865: 87)[1]

Introduction

In 1865, when Lewis Carroll's tale of Alice's adventures in the topsy-turvy world of Wonderland appeared, England's decidedly less lethal Queen Victoria had been a widow for four years. She would live for another thirty-six years after the death of her royal consort, Albert. As the mother of nine children, she would become the "grandmother of Europe," as her children made marriages that connected England to the royal families of other European countries. Queen Victoria gave her name to an age[2] that has been often stereotyped as "prudish," but in recent decades historians have argued that the era was not as strait-laced as it was reputed to have been. However, there were some aspects of Victorian society that did dismay contemporary 19th century social observers and reformers. For example:

> In 1837, the year of Queen Victoria's accession, Calcraft [the public executioner] hanged James Greenacre at Newgate for the murder of Hannah Brown, whom he had cut up and distributed in various parts of London south of the river. Greenacre had been a prominent tradesmen and politician at Southwark, and in the condemned cell he was visited by Members of Parliament and even, it is said noblemen. Calcraft wore a black suit for the occasion with a gold watch chain hanging from his pocket (Bailey, 1989: 62).

By 1837, the number of executions was "rapidly diminishing" (Bailey, 62). Although some abolitionists favored the end of capital punishment, opinion was stronger in favor of the end of *public* executions. The Victorian middle class was concerned about the rowdy, lower class spectators who gathered to watch public hangings. After an distressing episode in 1807, when almost one hundred people were trampled to death during a double execution, there had been increasing concern about maintaining order during these events. Also,

> Apart from concerns about morality and disorder, there was evidence that public hanging did not achieve its aim, since the very people who needed to be deterred—habitual criminals—were the most regular attenders (Ballinger, 2000: 32).

The people who should have been frightened away from a life of crime by public hangings, came instead to witness the spectacle of someone else

being hanged—and to ply their illegal trades among the other spectators. Among these spectators were women, who seemed to middle class observers to be a particularly unruly element.

>there was concern over the vast numbers of women in the audience who would 'shriek' with excitement and hiss and boo if they felt particular animosity toward a prisoner as in 1829, when Esther Hibner was executed for starving a workhouse child to death (Ballinger, 33).

As the example above suggest, there was another aspect of female participation in the spectacle of public executions—the female felons who were put to death in front of these unruly crowds. The reformed-minded among the "refined and respectable Victorian middle class" were concerned that the sight appealed to the prurient interests of some spectators, who experienced "sexual titillation within the spectacle of female executions" (Ballinger, 34). There is some support for this suspicion in the observations of novelists such as the young Thomas Hardy and Charles Dickens, who recorded their personal reactions to the executions they observed. Regarding the 1849 hanging of the beautiful **Mrs. Manning** (with her husband), Charles Dickens described:

> . . . the woman's [body], a fine shape, so elaborately corseted and artfully dressed, that it was quite unchanged in its trim appearance as it slowly swung from side to side (quoted in Ballinger, 34).

Even if members of the lower class were not able to articulate any "erotic fascination" (Ballinger, 33) that they felt at the sight of a woman hanging from the gallows, there was the suspicion that some among them also experienced such feelings. If indeed spectators made this inappropriate connection between death by hanging and female sexuality, then this was one more argument for abolishing public executions. Following the execution of Mrs. Manning, in November 13, 1849, Charles Dickens himself wrote the London newspaper, the *Times,* to deplore "the atrocious bearing, looks and language, of the assembled spectators" and to urge that henceforth executions be carried out in private (quoted in Knelman, 1998: 104). In 1868, with the Capital Punishment Amendment Act, public executions were abolished in England. However, executions behind prison walls continued.

During the remainder of the century, a number of women would be accused of high profile crimes for which they faced the possibility of capital punishment.

Baby Farmers

Among the last female offenders to be executed in England in the nineteenth century was **Amelia Dyer,** who was hanged in June 1896 for child murder.

Dyer was one of the notorious "baby-farmers" who had been quite common during earlier eras. By the end of the Victorian era, they were both fewer in number and more likely to be pursued and prosecuted when they disposed of their small charges. Dyer was arrested when she threw a baby placed in her care into the Thames River. Ballinger (2000: 65) writes:

> Baby-farming as a profession was both despised and stigmatised, since its existence emphasised the contradictions between dominant images of idealised motherhood and its reality for those women whose circumstances did not fit this image.

The concept of baby-farming was that the baby-farmer, as entrepreneur, would receive the unwanted infant for a fee and agree to find it an adoptive home. However, baby-farmers were not ideally situated to play such a role. Most were as poor and uneducated as their clients and unlikely to have access to potential adoptive parents (Ballinger, 65). As a result, baby-farmers sometimes (often, it was alleged) received the baby from the mother (or parents) and then disposed of it by killing it or allowing it to die. The degree of culpability of the mother and/or father in this transaction was often raised. It was alleged that parents who gave their child to a baby farmer knew that this could amount to a death sentence for the infant.

By the last decade of the Victorian Age when Dyer was tried, convicted, and ultimately hanged, this form of child homicide produced stronger public reaction against offenders than it had in the past. Such entrepreneurs were now called "monsters." But considering baby farming in the context of feminist criminological theory, Laster (1995) argues that such characterizations fail to consider the life circumstances of some of the women who became baby farmers: "Portrayed by contemporary society as 'evil women' killing for profit, the reality was that baby farmers were trying to earn viable, but marginal, livelihoods." Laster offers the example of **Frances Knorr,** who had taken up baby farming after her "shiftless" husband was sent to gaol and she herself had recently given birth to a daughter. Knorr was executed in 1894 for killing at least three infants in her care. Laster suggests that the choice of Knorr and other women, such as the elderly and notorious **Mrs. Parry,** "was 'rational' given the limited employment options available to women in the 19th century" (Laster, 157). But their late 19th century contemporaries saw baby farmers as women motivated by greed who treated infants as disposable commodities.

In the United States, reformers were also expressing concern about the disposition of unwanted infants. In an 1873 editorial, the *New York Times* asserted that it was time "that some active means were taken to put a stop to the practice of baby farming which in the vast majority of instances, is only another term for baby-killing" (quoted in Zelizer, 1985: 176). In her research on the transformation of cultural perspectives on the value of children, Zelizer (1985) finds that the late 19th century revulsion against baby farming and baby farmers reflected the evolution in outlook on children. In this "chang-

ing market," children acquired less value as laborers, but more value from a sentimental perspective. Now, unwanted infants that would once have been considered of little value were among the "priceless" children that reformers and others sought to place in good homes where they would receive affection and care. With this transformation in societal attitudes, baby farming "was. . .denounced largely as a symbol of an antiquated and mercenary approach to adoption" (177). Baby farmers, who placed a price on the "priceless child" and who were engaged in a business in which children died, were seem in the United States as profoundly offensive if not monstrous (171-177).

There was, however, another type of female criminal whose offenses stirred even more outrage—and fear—on both sides of the Atlantic.

Women as Poisoners

Men in particular were shocked and dismayed by female poisoners. Knelman (1998) writes:

> Poison was (not unreasonably) feared by groups that oppressed women, such as the masters and mistresses of servants, and husbands. When a woman was implicated in such a crime, these endangered groups fought back by blackening her name even before guilt was proved (Knelman, 53).

However, even when developments in forensic chemistry allowed the presence of arsenic in the victim to be detected, it was not always clear by whose hand it had been administered. "But such terror attached to the female poisoner that she was often branded a monster before being convicted of the crime" (Knelman, 53).

Robb (1997) finds that during the Victorian era in England about forty cases (out of the about 1,000 men and women who killed spouses from 1830-1900) involved women who were alleged to have poisoned their husbands. Sensational media coverage of these cases, led to heightened public awareness and concern. Fear of malice domestic, in the form of poisonings, led Parliament in 1851 to enact a law restricting the sale of poisons (Robb, 176). Although the majority, (more than 90%), of spousal homicides were committed by men who beat or stabbed their wives, it was the women who poisoned who generated greater alarm. In fact, more women than men did poison their spouses. However, mere numbers were deceiving.

> Unlike the average wife murder, which was an act of physical brutality, the most common means by which women killed their husbands was poisoning. More than half (55%) of wives who killed their husbands . . . used poison as compared to only 5% of husbands who killed wives. In absolute numbers, however, the difference was not so dramatic—40 wives and 20 husbands were tried for poisoning their mates (Robb, 1997).

Many more husbands were killing wives than the other way around. Husbands were using not only physical violence but also resorting to poison. In fact, as Curtis (2001) notes in the decade between 1855 and 1865, "newspapers were filled with the shocking details of murder by poison carried out by three respected members of the medical profession. Their known victims were family members, friends, and former lovers, but suspicion persisted that the actual body count were much higher." The physicians in question were all male (Curtis, 99). But, as Robb observes, "the popular image of the poisoner remained overwhelmingly female, drawing on archetypal images of the sorceress from Circe to Morgan La Fay to Lucrezia Borgia" (Robb, 176).

Concerning the reasons for suspecting a Victorian woman of having committed murder by poison, Morris (1990) finds that in the case of poor women, the "repeated attempt to collect insurance money" often roused suspicion. This usually occurred after the insurance company or the police noted "several unexpected deaths." However, in the case of middle or upper-class women, "suspicion was generally aroused by sexual misconduct, specifically adultery" (Morris, 34-35). Morris points out that all five of the affluent British women who were accused of poison murders during this period were involved in "premarital or extramarital sexual relationships that became the focus of scandalous attention" when they became murder suspects (Morris, 35). The five—often named in discussions of Victorian women poisoners—were:

***Madeline Smith** in 1857
***Florence Bravo** in 1876
***Adelaide Bartlett** in 1886
***Florence Maybrick** in 1889
***Edith Carew** in 1895

Of these five women, Morris (1990: 35) writes:

The popular—and judicial—assumption in each case was that the accused had poisoned the inconvenient lover or husband in order to pursue her profligate sexual desires. The court and the press expressed the appropriate outrage, as the trial records, newspapers, and magazines of the period clearly indicate. Yet Bravo was not indicted; Smith's case was "Not Proven"; Bartlett was acquitted; and although Maybrick and Carew were convicted, neither was executed.

Examining poison murder trials during the Victorian era, Robb (1997) finds that science played an important role in the ability of the prosecution to make its case. In 1836 and 1841, reliable and specific tests for the presence of arsenic had been developed. Since popular discourse still held to the belief in a "sisterhood of poisoners" (Robb, 180), in the courtroom, the man of science emerged as the "heroic, masculine response to the dark, irrational ways of criminal women" (Robb, 181).

However, in Florence Maybrick's trial in 1889, in which she was charged

with poisoning her husband with chloroform, the judge and jury were confronted with battling experts who presented conflicting scientific evidence. As Robb notes, this was only possible for those women like Maybrick who possessed the financial resources to hire their own expert witnesses (Robb, 181). Even for wealthy defendants, as Morris (1990) and Robb both point out, "nothing was more damning" (Robb, 183) than being an accused poisoner who was also alleged to have committed adultery or to be less than virtuous. But more affluent defendants seem to have survived even this, and there was the fear that other poison cases were going undetected.

This tantalizing fear fed into Victorian newspaper coverage of "domestic murder news." Whether or not it could be proven that the accused woman had committed the crime, the inquest and trial made good copy. In the case of Florence Bravo ("The Balham Murder") in 1876, the chief subeditor of the *Daily Telegraph,* Drew Gay, launched his own investigation into the death of Bravo's wealthy husband Charles. After the first inquiry had resulted in a verdict of suicide, questions remained and rumors continued to circulate concerning Florence Bravo's illicit affairs. Pressured by the *Telegraph,* the authorities convened another inquiry. Bravo's body was exhumed and a second autopsy performed. Although the twenty-three day inquest was inconclusive in implicating Florence Bravo as a murderer, the *Telegraph* and other newspapers were able to cover the "sensational revelations" about Bravo's "criminal intimacy" with her physician while traveling on the Continent. The official verdict of the second inquiry was "death by misadventure," poisoning by persons unknown. Bravo went free, but the *Telegraph,* "praised the jury for its hard work and then congratulated itself for having brought about the second inquest." Curtis (2001) concludes, "Once again the combination of death by poison, an elite household, sexual misconduct, and serious disagreements among the medical experts enabled the press to create a media event. . . ." (100-101).

Regarding the interest that many Victorian women displayed in Bravo's trial and "domestic murders" in general, Ruddick (2002) asserts:

> . . .the interest amongst women. . .could not be dismissed merely in terms of bloodthirsty prurience. It was more complex than that. Their curiosity stemmed from the evidence that the proceedings exposed about domestic conditions which they recognized within their own lives. . .They were fascinated by the spectacle of the accused women taking extreme measures to resolve domestic conflicts similar to their own (176-177).

Cases involving male poisoners in similar situations provided the same opportunity for sensational trials. But the focus on women and poison symbolized the underlying concern about "domestic disharmony" acted out by an unhappy wife (Robb, 186). The threat to use poison on an offending spouse became a part of the slang of the era. Wives were heard to threaten to "white powder" their husbands or to "season their pie" (Robb, 187). The imagery of woman as poisoner was reinforced by and expanded to include real

life examples. But, in these cases the method of murder was generally not the only issue. In the case of Florence Maybrick, her supporters raised the following concerns: her husband's abuse of Maybrick; the divorce laws which made it difficult for her to end the marriage; the obvious bias of the presiding justice against her; and the controversial medical evidence (Morris, 1990: 47-49). Maybrick's case also played into societal anxieties about the "New Woman."[3] Robb (1996) notes that the Maybrick trial opened in summer of 1889. Newspaper coverage of the Liverpool trial appeared alongside coverage of the Whitechapel murders in London.

> If Jack the Ripper came to represent some monstrous example of male violence against women, Florence Maybrick's alleged poisoning of her sick husband seemed to embody the dark possibilities of female rage against men (Robb, 32).

However, in the case of **Madeline Smith,** charged with the murder of her lover, Pierre Emile L'Angelier, Altick (1970) suggests other societal fears worked in Smith's favor:

> The jury's verdict, perhaps the only justifiable one considering the prosecution's inability to correlate Emile's visits to Madeline with his illnesses, was Not Proven. It may well be that the jurors were affected to some extent by the defense's strategy of depicting L'Angelier's character in such ways as to touch off their xenophobic prejudices. The 1850s were a time when anti-Gallic sentiment, which had been present in Britain ever since the French Revolution, had become especially virulent. . . (Altick, 179).

Moreover, Emile L'Angelier fit the "stereotype of the lubricious Frenchmen on the loose in law-abiding, God-fearing society." He had reputedly been vain and prone to "dramatic suicidal gestures" whenever Smith seemed inclined to end the affair. And, he smoked cigarettes, which in the 1850s "were still notoriously the preference of affected persons from Latin nations," in contrast to true-born British men who smoked cigars and pipes. So, even though the jury might have had its doubts about Madeline, perhaps it had even more about Emile (Altick, 179).

But in France, too, although prosecutions of women for murder by poison were few in number, there was concern about this type of offender. Shapiro (1999) finds that

> in spite of the relative insignificance of the crime, the symbolic importance of poisoning persisted and anxieties about the possibility of being poisoned remained high (207).

Shapiro asserts that the anxieties expressed by husbands and other males reflected male anxieties about the status of women. She writes:

> The cultural credibility of the notion of domestic treason [in the form of poisonings]. . .derived from its implicit reference to the

new areas of cultural tension prompted by a new kind of female disorder: the growth of an organized movement for women's rights, seeking to overturn the customary practices and legal privileges that had guaranteed male authority in the home and in the state. In effect, it was the figure of the feminist that made the crime of domestic treason so culturally resonant (Shapiro, 212).

But if Altick's (1970) assessment of the jury's response to the Madeline Smith case is accurate, even in cases of poisoning—in which images of the "venomous woman" (see Hallissy, 1987) were center-stage -- other factors such as ethnicity and the character of the victim could work in the woman's favor. Even with the cultural tension created by women's demands for their rights, it was still possible for an attorney to mount a successful defense in a case in which there was no doubt that the woman had killed. If the circumstances were favorable, he might present to the jury a narrative that

Hysteria: The Female Malady

In the late 1800s, after a century of neurasthenia, fainting spells, and "the vapours," a new female malady was "discovered." Hysteria (from the Greek *hystero*, meaning womb) erupted in epidemic proportions across the body of women in England and the United States. It signaled, in ways often not heeded, a sickness ravaging not only woman's body but the social body (Schutzman, 1999:2).

Among those diagnosed with hysteria was Charlotte Perkins Gilman, who would later write a story titled *The Yellow Wallpaper*. The story depicts a woman's descent into madness under the restrictive rest cure imposed by her physician-husband following the birth of her child. Both her husband and her brother, also a physician, diagnose her nervous ailment as "temporary nervous depression—a slight hysterical tendency" and prescribe tonics, raw meat, and above all no excitement (Gilman, 1899). Shut away in the upstairs bedroom (formerly a nursery) in the country house they are renting and forbidden to work, the woman begins to hallucinate about the odd pattern of the wallpaper. She begins to believe that there is a woman trying to escape from behind the wallpaper. In the final scene, her husband enters the room and finds her creeping around on all fours. She is now the woman behind the wallpaper, and she has escaped. He faints, forcing her to creep over him.

The symptoms of hysteria were "myriad," ranging from "definite physical ailments (rashes, vision abnormalities, muscular pain, sexual dysfunction, speech impediments, nausea, and palpitation) to more dissociative forms (multiple personality, fugue states, amnesia, and hallucination)" (Schutzman, 1999:7).

encouraged jurors to focus on the physical and mental weaknesses of his client and her vulnerability.

Honor and Irresistible Impulse

As has been suggested above, sexual chastity—or at least profound discretion—was required of the respectable woman during the Victorian era. Paradoxically, in certain settings, the loss of a woman's virtue—her "honor"—might be used as a defense for homicide. On January 31, 1865, nineteen year old **Mary Harris** of Burlington, Iowa, the daughter of Irish immigrants, walked into the Treasury Department building in Washington, D.C. She had come to kill her former lover, a thirty-three year old clerk, named Adoniram Judson Burroughs. She laid in wait for him in the hallway outside his office. When Burroughs and another man came out of his office, Harris fired. Narrowly missing his companion, the bullet struck Burroughs in the back. He turned, recognized Harris, and tried to flee. She fired again. He fell dead as he reached the stairwell. Harris turned and walked away. She was described by witnesses as "cool" and "self-possessed" (Chambers-Schiller, 1999: 185-186).

Harris was arrested. She came to trial in July 1865, less than two months after the trial of the alleged conspirators in the assassination of Abraham Lincoln. On July 7, four of the alleged conspirators, including **Mary Surratt,** a widowed mother and innkeeper, had been hanged. Chambers-Schiller (1999) asserts that in this moment of national social and political anxiety, the Harris trial assumed a meaning greater than that of the killing of a former lover by a scorned woman: "The trial expressed critical concerns roiling the northern public at the end of the Civil War, concerns having to do with what was perceived to be a dramatic and dangerous upturn in both sexual and gender disorder during the war." During the trial, the arguments made by the attorneys and by newspaper reporters and editors who attempted "to interpret the trial's meaning crafted vivid images foreboding dire consequences for the well-being of the republic" (Chambers-Schiller, 187).

During her murder trial, Harris presented herself as a woman wronged by a lover who had seduced her with the promise of marriage. She had come to Washington after seeing the announcement in a newspaper of Burroughs' marriage to a socialite. She had made an earlier trip to Washington to try to institute a breach of promise suit against him. Burroughs was away at the time, in Chicago. The second time Harris returned to Washington, she sought Burroughs out and killed him. She was described as highly agitated after learning of Burroughs' marriage, as being obsessed with his betrayal. After shooting him, she made no effort at all to escape. Her defense attorney argued that she had been acting "under an impulse she could not resist" (Chambers-Schiller, 188-189). This argument of temporary insanity was a new one. This was only the second time that a lawyer had attempted to argue not insanity (long recognized as a defense), but instead that a temporary lapse in reason, an "irresistible impulse"[4] was the cause of a homicide.

In addition to any temporary derangement Harris might have experienced, the defense also cited her difficult and painful menstrual cycle. Her attorney argued that her heartbreak over her unfaithful lover who had betrayed her and the "paroxysmal insanity" caused by her menstrual problems had resulted in her violent actions. The defense portrayed Burroughs not only as a betrayer of an innocent young girl, but as having lured her away from home with the intent of involving her in prostitution (Chambers-Schiller, 191). In his competing narrative, the prosecutor presented Harris as a traitor to both her country and her sex. The prosecutor argued that while Burroughs had given honorable service in the Union army, Mary Harris was engaged in more questionable activities, including "practicing the use of a deadly weapon" and "going in company. . .to a house of assignation without an escort" (Chambers-Schiller, 196).

But the jury found more persuasive the image of a young woman seduced and abandoned. Chambers-Schiller (1999) describes the verdict as the jury's sense that more was at stake than the violent end to the relationship between one man and one woman. She suggests that the case resonated with the jury as a reflection of two competing regional cultures, North and South.

> The South, like Adoniram J. Burroughs, was disorderly. It had abandoned the manly virtues of discipline, industriousness, and self-control, and in so doing, betrayed itself and the Union. Its evil ways could not be permitted to spread, further undercutting the social values of the North, already weakened by five years of war (Chambers-Schiller, 201).

The South was decadent, and so was Burroughs. Both region and man needed to be defended against. Mary Harris had struck a blow against sexual license and decadence. She had avenged her lost honor (Chambers-Schiller, 201).[5] In contrast, Mary Surratt had been hanged because she had supported the wrong cause and because she had provided aid and comfort to the men, including her son, who had struck down Lincoln, a heroic leader. In the aftermath of the Civil War, the South, even more than the North struggled to restore balance, including that in gender relations. Between white Southern men and women there was the chasm of five years of pain and suffering, when women had taken on roles that they had not performed during peacetime. There was also the matter of the freed African American slaves and the fear in the minds of white men that white women would now become the prey of the black males who were reputed to lust after them. There is a great deal of literature dealing with the violence produced by race/class/gender conflicts in the postwar South, including the lynching of black males for the alleged rape of white women (see e.g., Kennedy, 1997; Huber, 1998; Bailey and Green, 1999; Tolnay and Beck, 1995). Suffice it to say here that in the aftermath of war, both North and South went through a period of readjustment. In the process, debates about the status of women and their rights were a subtext to the national discourse about economics, politics, and race relations.

Urban Women

In his examination of the history of "bachelor culture" in America, Chudacoff (1999) finds that in the last decades of the nineteenth century, the growing numbers of single men in American cities "were stirring up comment."

> Reports from state bureaus of labor statistics in the 1880s noted the impermanence of working force participation among unmarried men, and employers bemoaned the inconstancy and irresponsibility that they believed these "wanderers" exhibited. Moral reform groups voiced fears that unrestrained single males were forming the vanguard of social breakdown. . . .(Chudacoff, 75).

Although bachelors had always been a part of urban culture, it was the visibly increasing numbers of single men that social reformers found disturbing. Bachelors made up an urban subculture that was reflected in the proliferation of boarding houses, saloons, dance halls, and theaters. They shared these places of residence and recreation with other residents of the city, including single, working class women. The problem reformers had with bachelors was that they symbolized a trend in American life that they saw as threatening the stability of home and community. Jane Addams, the settlement house founder, wrote:

> Freed from the benevolent restraints of the small town, thousands of young men and women in every city have received none of the lessons in self-control which even savage tribes imparted to their appetites as well as their emotions (quoted in Chudacoff, 75).

This problem of unregulated young people in the city was one that reformers had been discussing since before the Civil War. In the antebellum era, two New York City murder cases were seen by many as illustrative of the dangers and temptations of city life.[6] In neither case was the woman the killer, but in both cases the woman as victim symbolized death and corruption. In the narratives about their deaths, their victimizations were portrayed as the outcome of their violation of the prescribed moral code. Thus, their stories became a part of the discourse about female deviance and criminality. They became symbolic of the dangers of the city not only for young women who might become victims, but for men who might be lured by their beauty into inappropriate sexual behavior.

The first case involved the alleged murder of a beautiful brothel prostitute named **Helen Jewett** by a young man who was one of her clients. In 1836, a nineteen year old clerk named Richard Robinson, a participant in the male "sporting culture" of the city was charged with murdering Jewett in the brothel where she was employed. She had been bludgeoned to death and her body set on fire. Robinson's acquittal came amidst rumors that his friends had bribed jurors and procured false testimony from the witnesses in the trial (Chudacoff, 38-39). During the investigation of the murder and the trial, the

emerging penny press and established newspapers competed to provide readers with accounts of Helen Jewett's upbringing, her life as a prostitute, and the circumstances of her demise. What the often conflicting details of these news articles suggested was that Jewett was an ambitious, clever, and imaginative woman who had found in the city an opportunity for self-creation. She was both fallen woman and seductress, charming enough to attract a number of suitors (Cohen, 1999). The depiction of Jewett's murder "prompted a multi-layered Gothic tale of female sexuality as the true perpetrator of the crime" (Halttunen, 1998: 203). There was some limited focus on Richard Robinson as a selfish and spoiled young rake, but this was a part of the general discourse about the corrupting influence of the city on unsupervised young people (Chudacoff, 39). Portrayed as beautiful, seductive, and according to some commentators, depraved, Helen Jewett was implicated in her own demise. In the version of the crime put forth by the defense, Jewett had either committed suicide, or she had been killed by Rosina Townsend, the thirty-nine year old madam who ran the brothel (Halttunen, 202-203).

In a second high-profile murder case in New York City, during the summer of 1841 the body of **Mary Rogers,** "the beautiful cigar girl" was found floating in the Hudson River. The exact circumstances of her death were so much a mystery that Edgar Allen Poe used the case as the basis for his short story, "The Mystery of Marie Roget." As the investigation into the murder evolved, Mary Roger's mutilated body became an object of horror and fascination because it held the key to her life and death. In her capacity as a clerk in a cigar store, Mary Rogers had been known by many of the journalists who worked in the area where the shop was located. Now, the press turned with fascination to describing her transformation from beautiful woman to horrible corpse. The *New York Post* described how she had looked in the city morgue, "There lay, what was but a few days back, the image of its Creator, the loveliest of his work...now a blackened and decomposed mass of putrefaction, painfully disgusting to sight and smell" (quoted in Halttunen, 1998: 197-198).

The question of how Mary Rogers came to this end prompted extensive speculation, with suspicion falling on her fiancé who lived in her mother's boarding house and was to have met Rogers to accompany her home on the day that she disappeared. There was also the revived rumor that when she had disappeared briefly a few years earlier, she had eloped with a man. It was suggested that her murder might be related to that episode. Eventually, suspicion turned to the female owner of a tavern on the New Jersey side of the Hudson. Had Mary Rogers gone to the tavern with a male companion to procure an abortion? Had the woman and her sons then disposed of the body, attempting to make Rogers's death look like gang rape and murder rather than a botched abortion?

In this discussion about the possibility that Mary Rogers had been seeking an abortion when she died, the name of the infamous New York City abortionist **Madame Restell** came up. Restell's name was synonymous with

that of unlicensed practitioners who specialized in "female problems" involving the menstrual cycle. Madame Restell, whose real name was Ann Lohman, ran a profitable practice with her husband, providing "French pills" and other remedies for menstrual problems and, allegedly, abortions for those clients for whom other methods— including her own—had failed.[7] With regard to the Mary Rogers's case, Srebnick (1995: 31-32) writes:

> The history of Madame Restell, the most infamous abortionist of the period, played a significant role in many of these narratives [in popular guidebooks and cheap fiction]. Whether Mary had in fact undergone an abortion performed by Madame Restell herself (or even by any of her alleged New Jersey associates) will probably never be resolved. But in a short time Mary Rogers and the abortion issue were inextricably linked. . . . Mary would emerge ultimately not as a seductive femme fatale, but as the victim of this widely condemned but extensive practice.

Criminalizing Abortion

In the aftermath of the Rogers's case, there was an outcry for police reform and for a crackdown on abortionists. In 1845, the New York legislature responded with an act that modernized New York City's police system and with an abortion law that criminalized the practice. Madame Restell was arrested and charged with criminal abortion. In the past, she and other practitioners—her competitors—had enjoyed a certain amount of invulnerability. Madame Restell had counted among her clients the wives and daughters of respectable and wealthy men. She had been able to live well. Now that had come to an end. Assessing Madame Restell's career and the services she provided, Browder (1988: 189) writes:

> Ann Lohman did not deserve to be known as the "wickedest woman in New York." Snob, opportunist, lawbreaker, and part sham she certainly was—roles that she shared with many a politician and capitalist of the time—yet in all her forty years of practice, there is not one confirmed instance of her ever having lost a patient—a record matched by few of her competitors, and for that matter by few M.D.'s.

Madame Restell provided a service that her clients sought and needed. As did other abortionists, she fell victim to public opinion and the criminalization of a widespread practice. One factor shaping public opinion was the increasing control the medical profession—i.e., licensed physicians and their organizations—sought to exercise over unlicensed providers of services for women. Regarding this effort by physicians, Reagan notes, "In 1857, the newly organized American Medical Association (AMA) initiated the ultimately successful crusade to make abortion illegal" (Reagan, 1991: 1241).

Smith-Rosenberg (1985) asserts that the anti-abortion movement focused with particular venom on the white middle-class woman. With the appearance of a "new male metaphoric language," abortion was associated "exclusively with women, and, most significantly, with the bourgeois matron, portraying her not as an oppressed and abandoned victim…but as an unnatural and monstrous woman, lethal to men and babies alike" (226-227).

Although women continued to seek and to receive abortions after laws had been passed criminalizing the procedure, the crusade had an impact—particularly on working-class women. In her study of abortion in Chicago, Reagan (1991) finds:

> The penalties imposed on women for having illegal abortions were not fines or jail sentences, but humiliating interrogations about sexual matters by male officials—often conducted at women's deathbeds (1244).

Women were coerced into making "dying declarations" about the persons who had performed their abortions. Even those physicians who were sympathetic to the plight of these women felt under pressure to try to obtain dying declarations to avoid being suspected themselves (Reagan, 1251-1257). If the abortionist was brought to trial, the intimate details of the dead woman's life was likely to be revealed by witnesses called to testify or in newspaper accounts of the woman's death. Reagan (1991) finds:

> Sometimes newspapers covered abortion stories on the front page and included photos; often abortion-related death and arrests of abortionists appeared in small announcements. The story of an unwed woman's seduction and abortion-related deaths made exciting copy and could dominate local newspapers for days" (1257).

This anti-abortion movement was linked to the effort to control vice, in the form of prostitution. It was also linked to white fear of "race suicide" if white American-born women turned to birth control and abortion as a means of controlling their fertility while immigrant women and non-white women continued to reproduce in large numbers (see Reagan, 1997). With regard to the rhetoric surrounding abortion, Stormer (2001: 8) notes that among the dangers abortion was said to constitute for the mother was "moral shock" that could even cause physical death.

Aside from fertility concerns, in the United States and in England and France, there was concern about female sexuality and the balance of power between men and women in both the private sphere of the home and the larger public arenas of the saloon, the brothel, the theater, and city streets. In discussing the birth control movement in France, 1890-1920, Accampo (1996) comments on the difficult position in which feminists found themselves:

> Because of Victorian attitudes toward sexuality, feminists at this time found it exceedingly difficult to place issues concerning the

female body on the public agenda...To combat prostitution and the spread of venereal disease, advocates of women's rights encouraged social purity and sexual continence. To separate production from sexuality, let alone suggest that sexuality formed part of the female identity, violated conceptions of womanhood even among feminists (Accampo, 355).

Because of these issues, feminists tended to focus on changing the civil laws, on gaining the right to vote and education and divorce rights, rather than on reproductive rights. In general, feminist movements, particularly in France, tended to express "family-centered, nonindividualist values" (Accampo, 355). Of British society during this era, Kent (1999) observes:

> Victorian ideology finally offered only two possible images for women. They might be either idealized wife and mother, the angel of the house, or the debased, depraved, corrupt prostitute. The image of the respectable, passionless middle-class lady, in fact, depended upon a contrast with the other image of the 'fallen' woman (190).

But at the same time there was the plight of poor, working women, those women who were often the object of reform activities by middle-class women in the United States and elsewhere. These working class women, particularly those who were non-white or immigrants, found themselves with limited options when faced with an unwanted pregnancy.

Infanticide As An Alternative

In his examination of homicide in 19th century American, historian Roger Lane (1997) concludes that it is impossible to know the exact extent of infanticide cases, but it is clear that more infanticides occurred than cases of adult homicide.

> Through the 1850s no record was kept of "dead infants found" in vacant lots, privies, and gutters, but at times during the following decade the reported annual total for Philadelphia reached about one every other day. In addition to these, thousands were reported each year as stillborn, or having died either of suffocation or of a number of causes impossible for the medical science of the day to distinguish from strangulation, at a time when only a small minority of births were attended by a doctor....(Lane, 119).

Throughout the latter half of the nineteenth and early twentieth century, women continued to turn to infanticide and infant abandonment as one solution to the problem of unwanted motherhood. In a study of Richmond, Virginia during this period, Green (1999) finds growing concern on the part of city fathers about the problem of infanticide. Green suggests, "infanticide and abandonment can serve as a barometer of sorts, with indexes of stress, economic dislocation, and a limited range of options for poor and working women" (Green, 188, also see Wright, 1987).[8] In Richmond, because of racial

segregation, African American women had even fewer public institutions to which to turn than did white women.

In general, working women, both black women and white, "tended to cluster in poorly paid domestic work," such as servant, seamstress, or farmhand, rather than in higher paid factory and mill jobs (Green, 190-191). Some women were able to leave their infants at the city almshouse, but those mothers who could not found it difficult to find employment with a child.[9] Some abandoned their babies. Some turned to infanticide. Given the state of forensic medicine at the time, it was often difficult for the coroner to determine how an infant had died or if it had been born alive. In some cases, the infant's death came to the coroner's attention after a woman—often a domestic servant—who had concealed her pregnancy, gave birth and was discovered by employers or fellow servants with the dead baby. But, often, the coroner and the police were able to obtain little information about an infant's death because family and neighbors claimed to know nothing (Green, 1999). Green writes regarding cases involving African American women in Richmond:

> Given that the large percentage of these cases involved black women. . .and that the cases were being pursued by white police and city officials, the reluctance of neighbors to cooperate fully suggests the possibility that these communities were trying to protect their own against the harassment and intervention of whites (Green, 204).[10]

Donovan (1991) in his study of infanticide in France during this same era finds, as in Richmond, that poor and unwed mothers were the most frequent offenders. French juries tended to show some leniency toward these women at the beginning of the era because they were often young women from rural areas who were seduced and left to cope with the consequences. This leniency increased toward the end of the nineteenth century even though the government was attempting to fight child abuse and increase birth rates. Donovan hypothesizes that this trend reflected both growing leniency toward female criminals in general and the impact of the feminist campaign to hold men responsible for male sexual misconduct.

These studies by Green and Donovan make clear that the problem of infanticide and child abandonment was one that Western nations were attempting to come to terms with during this era. It was an issue that produced a number of responses from government agencies and reformers and that presented juries with the dilemma of what to do about women who had been driven by desperation to kill an infant or to allow it to die.

At the same time, if the matter of errant motherhood presented dilemmas for juries, so did cases involving women who were alleged to have killed the adults with whom they shared their lives.

Plots and Axes

In March 1860, **Ann Bilansky** became "the first white person and the only woman ever to be legally executed in Minnesota." The crime of which

Bilanksy had been convicted was the arsenic murder of her husband. Cecil (1997-98) suggests that both the power of the press (in influencing public opinion) and the "intertwining of politics and justice" (in influencing the governor's decision not to commute her sentence) were issues in this case (351). Three other cases are offered below to illustrate the impact of extra-legal factors—including perception of the female defendant—on decision making in 19th century cases involving women accused of the murder of intimates.

In spring 1876, in Osborne, Kansas, a farm woman named **Henrietta Cook** was arrested and placed on trial for the strychnine murder of her husband. Concerning her arrest and trial, Cook said, "It was a plot got up to convict me." In reviewing the record of the case, McNall (1986) concludes that the jury might have as easily found Cook innocent as guilty of the crime. However, in this frontier settlement, Cook challenged "not only the fragile definition of community that had been constructed, but also the order, rationality, and progress that gave people hope" (McNall, 26). How did Cook do all this? McNall points to the sense of disruption of gender relations that the alleged murder of C. Hiram Cook created in the community. The prosecutor argued that Cook had slowly poisoned her husband with small doses of strychnine. She admitted in court that she had given him one dose of strychnine. Her defense attorneys argued that she had given Cook the strychnine at his request, that Hiram Cook had used it to medicate himself for a heart condition. (At the time, the use of strychnine was recognized as a stimulant for those with heart problems). But in the end, although Henrietta Cook insisted she had tried to follow the instructions given her by her husband's doctor, she was not believed by the jury.

McNall (1986) concludes that what was most damaging to Cook's case was "the fact that she was portrayed as devious and cold by the witnesses marshalled against her" (McNall, 30). Cook served thirteen years in prison for first degree murder before being pardoned by the governor. The pardon came after the governor responded to a petition from citizens of Osborne County requesting Cook's release. A report from the Board of Pardons to the governor led him to conclude among other things that the witnesses against Cook had been less than trustworthy (McNall, 31-32). In assessing this trial and its outcome, McNall describes it as "an order-affirming ritual":

> The jury of husbands and fathers was faced with a difficult reality: Hiriam Cook had died of strychnine poisoning. In front of them sat—and smiled—Henrietta Cook, who, whether by her husband's orders, the doctor's, or her own design, had administered the drug. The jury had to mold an explanation that made sense to them and the community. At the end of the trial only one truth could stand. The truth that the jury finally arrived at was crafted out of the ideological and cultural materials at hand and was an active process (McNall, 44).

In Fall River, Massachusetts, a number of years later, another trial in

which a woman was accused of murder would require a jury to craft an verdict out of "the ideological and cultural materials at hand." This double murder case has continued to fascinate historians and crime buffs since it occurred because it remains officially unsolved. The facts of the case are that on an August morning in 1892, Andrew Borden, one of the wealthiest men in the city of Fall River, came home from his office and went into the sitting room to take a nap. He was murdered with multiple blows from an axe as he slept there on the sofa. Upstairs, in the spare bedroom, his second wife Abby Borden had been murdered in a similar fashion, with multiple blows to her head, neck, and face. Suspicion fell on Andrew's daughter, **Lizzie Borden,** because she and the maid Bridget were the only two people (other than the victims) who were known to have been in the house that morning. It was difficult to imagine how anyone—stranger or acquaintance—could have gained entry to the house without being seen by Lizzie, Bridget, or a neighbor. Moreover, at least an hour was believed to have elapsed between the murder of Abby, who had died first, and of Andrew, who had been killed when he came home for lunch. Where would the killer, if an intruder, have hidden all that time?

There were other suspects suggested, including a visiting relative. But the relative had an alibi. Emma, Lizzie's older sister, might have been a suspect, but she was away from home visiting friends. As the prosecution argued, Lizzie Borden had possessed both motive (hatred of her step-mother coupled with the desire to be free of her father's control and to inherit his wealth) and opportunity. The story she had told about what she had done that morning had been confused and contradictory. There was also the suggestion that she had planned to poison her father and step-mother, had perhaps even tried to do so with a breakfast that she had not eaten. There was also the matter of the dress that a neighbor had seen Lizzie burn. Lizzie had told her that it was old and smeared with paint.

On the other hand, the defense team argued, Lizzie Borden was a respectable, middle-class spinster who had loved her father, if not her step-mother. When she was seen immediately after the crimes were discovered, there was no blood on her clothing. The timing was such that it would have been difficult for her to kill her father and then have time to change her clothing. The jury found the argument made by Lizzie Borden's lawyers convincing—or perhaps they refused to believe that a lady like Lizzie could hack two people to death with an axe. Nickerson (1999) writes:

> A story of parricide within a wealthy household was, apparently, not a story that the justices and jurors, themselves middle-class fathers and heads of households, wished to hear. They would rather, it seems, see Lizzie as the angel hovering solicitously over the parlor sofa where her father prepared for a nap than as the madwoman descending the staircase with an axe to bash his head in and claim her inheritance. The defense allowed them to feel comfortably masculine and comfortable with their sense of what women are capable of doing (Nickerson, 276).

In her self-presentation in the courtroom, Borden presented herself as well-bred, feminine, and in need of masculine comfort and support. She garnered the support of women's groups and at least some members of the press. A female reporter recounted "a sentimental vignette about Lizzie kissing her father's corpse after it was carefully prepared by the undertaker." This same reporter gave Borden an opportunity to respond to allegations in the press that she was cool and detached. She said in explanation of her demeanor, "I have tried very hard to be brave and womanly through all" (Nickerson, 268). Some people saw this as the courage of a victim of unjust prosecution. Others saw it as the smooth performance of an accomplished actor. But in the end, it was the jury who decided Lizzie Borden's fate, acquitting her of the charges against her.

As in the case of twentieth-century defendant O. J. Simpson, acquittal in Lizzie Borden's case did not mean that she was accepted back into the bosom of her community or even her family. After a quarrel in 1905, she and Emma lived apart. During the remaining years of her life, there were stories of improper relationships (e.g., with an actress) and inappropriate behaviors, including shop-lifting episodes and violent rages. But there were other stories of Lizzie Borden's generosity to the elderly and shut-ins (Nickerson, 276). Until her death, Borden bore the stigma of the accusations that had been made against her.

Lizzie Borden: Tourist Attraction

For those who prefer to explore the Borden case from their armchair, there are numerous sites, including the "virtual museum and library" maintained by Pear Tree-Press.com (www.lizzieandrewborden.com), offering a complete overview of the case with maps, photos, evidence lists, and key documents. Visitors who travel to the city of Fall River can visit the Fall River Historical Society and examine the Borden artifacts that have been donated to the Society. These artifacts include pillow shams spotted with blood, locks of the victims' hair, and crime scene photos. Books and collectibles related to the case are available in the gift shop. Visitors who plan an overnight stay can reserve a room at the Lizzie Borden Bed and Breakfast, located in Lizzie's former home at 92 Second Street. Here the bedrooms are named in honor of the Borden family members, the maid, and the relative who was visiting the family when the murders occurred. Guests can enjoy a breakfast similar to that eaten by the Borden family on the morning of the murders.

Hobson (1993: 170-171) observes regarding the historical context in which the Borden case occurred:

> According to a widespread understanding in nineteenth-century America, women fell into one of two categories, respectable or unrespectable. . . A woman was bad either because she came from a bad family or because she had allowed herself to develop a bad character, or both. . .

In 1892, in Memphis, Tennessee, a middle-class white woman named **Alice Mitchell** slashed her lover's throat. As a woman who had killed her "girl lover," Freda Ward, Mitchell fell into the category of "unrespectable." Duggan (2000: 2) finds that the popular press's depiction of the murder was an "influential cultural narrative" that portrayed "romance between women as dangerous, insane, and violent" and that also "worked to depoliticize, trivialize, and marginalize the aspirations of women" for political and economic equality and "alternative domesticities."

As Duggan notes, this crime occurred in the same city and in the same year that African American journalist Ida B. Wells had the presses of her newspaper *Free Speech* destroyed and was threatened with death because she dared write an editorial about the lynching of black men for alleged assaults on white women. Although Mitchell and Wells occupied different social worlds, they each engaged in acts that challenged cultural norms and assumptions (Duggan, 11-14). For her crime, Mitchell was committed to the Western State Insane Asylum at Bolivar, Tennessee (Duggan, 193). Wells left Memphis and continued to write and lecture on "the myth of the black rapist" that was a part of the distorted narrative of race, gender, and sexuality in the South and elsewhere in the United States.

Summary

This chapter has examined Victorian perceptions of women and how those perceptions affected the social construction of women as killers. The chapter focused on those crimes by women that aroused public anxieties and received extensive media coverage, such as the "moral panic" concerning female poisoners in England and France. The role of female sexuality and alleged illicit sexual behavior in these cases was discussed.

This chapter also explored the concerns voiced by social reformers as the pace of urbanization increased and young men and women became part of an urban culture. Of concern to the newly founded American Medical Association was the availability of abortions. The organization's anti-abortion crusade resulted in laws criminalizing the procedure. The process of obtaining an abortion became more dangerous as a result. The related issue regarding the lack of alternatives to pregnancy and the commission of infanticides by young working class women in the U.S. and France during this era was discussed.

Finally, the chapter ended with a look at three cases that illustrate the factors that juries might have considered as they deliberated on cases involving women accused of crimes that challenged their perceptions of what respectable women might be capable (e.g., the accusation that Lizzie Borden had hacked her father and step-mother to death with an axe).

In the next chapter, the impact of Social Darwinian and eugenics in shaping the images of "bad women" in the early twentieth century will be examined.

Discussion Questions

1. What factors contributed to the criminalizing of abortion? How did abortion fit into the larger social context of gender relationships during this era?

2. What special problems were faced by nineteenth-century women with unwanted pregnancies? How does this seem to have been related to infanticide?

3. What characteristics distinguished "good women" from "bad women" during this era?

Notes

[1] Aside from the Queen, with her fondness for executions, Auerbach (1982: 167) observes that

>Wonderland is ruled by potentially murderous women. The Queen of Hearts, the Duchess, the Cook, and the Cheshire Cat insofar as it functions as a dream version....

[2] In this chapter, we will discuss both England and the United States during this era known as the Victorian age. Although the two countries were each unique, as Stevenson (1991: xx) observes, "British and American Victorians shared many ideas, and the institutional development of the two countries was similar."

[3] See Dowling (1979) for discussion of the reactions of critics to literary decadence and New Woman fiction in the 1890s.

[4] The first case was that of New York congressman Daniel Sickles, who had shot his wife's lover the day after she confessed her adultery. Sickles was acquitted by the jury that heard his case.

[5] See Bakken (1998) for discussion of three cases in the western United States (California) in which "courts supported women's intrinsic right to defend their personal honor against men who violated the social contract" (Bakken, 1998).

[6] See Kasson (1990) on the advice offered by etiquette writers to respectable middle class women on how to avoid the dangers inherent in venturing forth into city streets. Kasson finds that these advisers were strict in their assessment of female behavior in public:

> When middle-class women left the confines of their home to venture out in public, they entered a realm in which they felt—or were expected to feel—particularly vulnerable. Possibilities for intrusion and symbolic violation abounded. From an impertinent glance, an unwelcome compliment, the scale of improprieties rose through a series of gradations to the ultimate violation in rape. According to many etiquette writers, a properly behaved woman could escape all rudeness. But this superficial assurance concealed a less pleasant implication. Any disrespect a woman did encounter she must have deserved (Kasson, 129).

Stevenson (1991) finds that "public antebellum city life was unsafe for women" because men of all classes "suspected women on the streets of selling their sexual favors." This had changed by mid-century, however, respectable women still had to be careful of their dress and behavior. They "never attended dance halls and saloons" which were associated with the lower classes, and businesses such as department stores, banks, and art galleries often provided separate entrances in order to attract respectable women as customers (Stevenson, 51).

[7] In Halifax, Nova Scotia (Canada), patent medicines were also available. Wright (1987: 14-15) finds regarding aids to abortion:

> Much more common [than seeking a medical abortion] were self-induced abortions produced by the ingestion of some abortifacient substance, such as the traditional tansy, pennyroyal, cotton root and ergot of rye. The last-named was the most reliable but also the most dangerous, capable of producing convulsions or a form of gangrene. The most readily available abortifacients, however, were a wide variety of patent medicines. These wonder-drugs, capable of curing everything from asthma to venereal disease, were advertised at length in every Halifax newspaper.

Although the ads did not mention the word "pregnancy," it was understood that relieving a "blocked" menstrual cycle might mean aborting a fetus. Thus, in Halifax, as in the United States, these often ineffective or dangerous methods represented one alternative for a women with an unwanted pregnancy.

[8] See Schulte (1994) on infanticide in a village in Upper Bavaria during this same time period. Schulte describes these infanticides as "predominantly the work of farm maids, and their stories as they unfold in the courtroom are mainly concerned with women's work, their love affairs, and their illegitimate children" (Schulte, 193). Note Schulte's discussion of the "pathological homesickness" that some women experienced.

[9] Concerning the dilemma of women during this era, Lane (1997) observes that "in the wage economy of the midcentury city children were only hungry mouths until they could earn cash." An unmarried man could usually find enough work to support himself, but for an unmarried, unskilled woman, it was hard to make it on her own, and "utterly impossible while caring for a baby." But, at the same time, there was "no way for a poor woman to safely give up a live infant" because "wet nursing was expensive," pasteurization of cow's milk had not yet been invented, and it was likely a sentence to "slow death" for a child who was left as a foundling (Lane, 1997). The other alternative was abortion, which was not outlawed as a practice until the 1860s and after. However, "while contemporaries estimated that perhaps a quarter of all American pregnancies were aborted by the 1850s, only the middle and upper classes could afford safe and reliable procedures" (Lane, 119-120).

[10] Williams (1955) finds that on those occasions when high status women in antebellum South Carolina were suspected of infanticide, they often received special treatment from criminal justice officials:

> Infanticide cases, in common with other sex-connected transgressions, were handed gingerly if they involved ladies of high social rank. The defendant was not always forced to attend the public hearing, her lawyer giving word-of-mouth assurance of her whereabouts; and newspapers did not often print her name (Williams, 365).

Williams quotes an article from an Edgefield, South Carolina newspaper in which the female suspect was said "to have previously sustained an excellent character." The newspaper reported that her name was being withheld "to avoid adding a pang to the already lacerated feelings of her unhappy relatives, many of whom are very respectable" (Williams, 366).

Chapter 6

Modern Life and Primitive Woman
Women in the Early 20th Century

Introduction

In an 1890 issue of *Life* magzine, illustrator Charles Dana Gibson introduced his "Gibson Girl" to the American public. Over the next four decades, Gibson, along with other popular and well-paid illustrators such as Coles Phillips (the "Fadeaway Girls"), Howard Chandler Christy (the "Christy Girl"), and Harrison Fisher (the "Fisher Girl") would engage in the visual construction of the "New Woman." These illustrators created covers for magazines such as *The Saturday Evening Post, The Ladies' Home Journal, Good Housekeeping, Collier's, Cosmopolitan,* and *Life*. They also illustrated the advertisements for the consumer products (from soap and silverware to clothing and sporting goods) that appeared in these magazines (Kitch, 2001).

The visual images of women created by these illustrators were important because:

> Magazines were the first truly mass medium in the United States. ...in 1905, there were some 6,000 magazines with a total audience of sixty-four million, averaging four magazines per household. By the same year, ten American magazines had readerships in excess of half a million, and the *Ladies' Home Journal* and the *Saturday Evening Post* each had passed the million mark...(Kitch, 4).

In an era when illustrations not photographs were used on magazine covers and for ads, these illustrations formed what visual theorists call an "iconology"—a symbolic system. This visual text conveyed to American men and women information about the status of women, gender relations, and social and economic mobility (Kitch, 8). In the four decades from 1890 to 1930, magazine illustrators transformed the visual stereotypes of the "American woman." The mature wife and mother in her domestic sphere, symbolic of the Victorian "cult of true womanhood," was superseded by the "Gibson Girl"and her contemporaries. These images of "college girls" and athletic young women overlapped in the 1910s with images of the "vamp," who (in her lighter incarnations) was flirtatious and a gold-digger. Then came the flapper, short-skirted, careless and carefree, drinking, smoking, and dancing until the wee hours. These images of the American woman as cultural constructs reflect the seething tensions that characterized an era doing which American men experienced a "crisis in masculinity." For American men who were experiencing doubts about their manhood, these independent "New Women" were both alluring and threatening (Kitch, 2001, also see Kimmel, 1996).

This iconology of American women is relevant here because during the early 20th century, these images were an aspect of the discourse about the nature of women. Along with criminal anthropology, eugenics, and the theories of Sigmund Freud, this iconology would provide cultural resources for narratives about deviant women.

A Gibson Girl and A Vamp

The Gibson Girl reflected a moment of transition when both the image of the ideal American woman and many aspects of the lives of real women were in flux. This was an era when young women, actively engaged in work and play, began to reject the restrictions of the corset and "the Victorian moral sensibilities" that it represented (Fields, 1999: 355).

In this challenge to Victorian moral sensibilities, a young woman named **Evelyn Nesbit**—who had posed for illustrator Charles Dana Gibson—inadvertently led the way. In 1904, Evelyn's husband, multimillionaire Harry Thaw, shot Evelyn's former lover, famed New York City architect Stanford White. The murder happened one evening in the rooftop café of Madison Square Garden, a building that White had designed—and in which he kept an apartment to which Evelyn had often gone before her marriage to Thaw. When Thaw shot White, he said that he had done it to avenge his wife's honor. Under pressure and repeated questioning from Thaw about her relationship with White, Evelyn had confessed to her husband that White had taken her virginity after drugging her. She had awaken in White's bed, and then they had become lovers. Among the more scandalous aspects of their relationship was a red velvet swing in his apartment that White liked to have Evelyn sit in naked, swinging up toward the ceiling.

When she and White met, Evelyn had been a teenager. Her ambitious mother had brought Evelyn to New York from Pittsburgh (the hometown they shared with Thaw). Evelyn had found success first as an artist's model, then on Broadway. White had spotted her when she was performing in a Broadway theatrical revue as one of the much sought after Floradora Girls. White was married, in his forties, and with a reputation as a sophisticated man about town. He was also a brilliant architect with a zest for life. Years after his death, Evelyn would say that he was the only man that she had ever loved. But she married Harry Thaw, perhaps because he, unlike White, was free to marry her, and he was wealthy and doggedly persistent in his determination to have her.

Even before he began to pursue her, Thaw had been obsessed with Stanford White and what he perceived as White's immorality. When Evelyn told Thaw the details of her relationship with White, Thaw was enraged. When he saw White at Madison Square Garden that evening, he acted on his rage, shooting him in front of a room full of witnesses. But with a skilled defense team and a lovely wife who could be persuaded to testify about White's rape of her, Thaw managed to avoid prison. Instead, he was committed to an insane asylum. When he was declared sane and released (after an escape to Canada), he initiated divorce proceedings to free himself of his wife (*Murder of the Century;* also see Mooney, 1976).

The Thaw-Nesbit-White triangle provided the media and a fascinated public with the first "trial of the century." Many observers saw the murder as a New York City crime, a crime that reflected the unique combination of wealth and decadence to be found in the city. The revelations of the events leading up to the murder itself both shocked and titillated readers and spectators who were

allowed to glimpse the sexual practices of the rich and famous (*Murder of the Century;* also see Abramson, 1990). If before the murder Evelyn Nesbit had represented to Harry Thaw a damsel in distress and in need of rescue from a dastardly villain, after the murder she was quite publicly a woman over whom blood had been shed. She had inspired both passion and obsession.

Regarding how Victorian men perceived passion, Erenberg (1981) writes that because of its power to "distract men from success, weaken their resolve, and ultimately destroy their will," passion was

> considered bad for business, and business men's wives and daughters were expected to conform to 'the kind of sexual relationship that made the least trouble.' Women had to be what men were not—refined, controlled, nurturing, self-effacing, and stable—so as to provide the one non-competitive and nurturing environment in the anarchic and hostile world of nineteenth-century economic competition (Erenberg, 7).

By the early 20th century, some things had changed, but this was not one of them. Respectable women still were expected to inspire devotion rather than passion. Sexual passion was still considered dangerous for civilized (i.e., respectable, educated, business-oriented) Western men. A lovely young woman like Evelyn Nesbit might by her existence become the excuse for bloodshed between two men who despised each other, but there was another kind of woman who deliberately set out to destroy.

In *Dracula* (1897), Bram Stoker's late 19th century novel about vampires, Count Dracula is of an old race of immortals who live on human blood.[1] He comes to civilized England from mysterious Transylvania, bringing with him, his taint, his disease of the Undead. Although he attacks both males and females, it is the gently bred young women who are most susceptible to his influence. Auerbach (1982) observes of this novel:

> Neither Renfield nor the Russian sailors Dracula attacked at sea are transformed after death; only his three thirsty brides, Lucy, and Mina rise into the Undead. Had Dracula survived the end of the novel, this army of women might indeed have devoured the human race under his generalship....his greatest power lies in his ability to catalyze the awesome changes dormant in womanhood.... (24).

In the early 20th century, in a film titled *A Fool There Was* (1915), silent screen legend **Theda Bara** made her debut as "The Vampire." The film opens with an excerpt from Rudyard Kipling's 1897 poem with the same title. In Kipling's memorable line the beautiful and merciless woman to whom the fool prays (even as other men do) is "a rag and a bone and a hank of hair."

Bara plays the Vampire as an exotic, primitive (non-Anglo Saxon) woman who delights in bringing men to their knees. As Bennett (2002) describes the film, in retaliation for a snub from his wife, the Vampire targets a wealthy lawyer/diplomat for seduction. When his wife is forced to stay behind because

of a family emergency, the Vampire seduces him aboard ship during a voyage to England. When rumors of his affair spread, the diplomat loses his position. Returning to the United States, he deserts his wife and daughter for the Vampire. In spite of appeals from his family and a male friend, he is unable to leave the woman who has brought him to financial ruin and alcoholism. Finally, he falls dead. The smiling Vampire showers rose petals over his body (Bennett, Silent Era).

In one pivotal scene, the Vampire proves her control over her victim by kissing him in front of his wife. It was a kiss unlike any that early twentieth century audiences had witnessed on the screen. Dijkstra (1998) asserts that the "massive crowds" who saw the movie

> decided that they had discovered a true devil's disciple in the female lead. . . .the ferocious energy she brought to the role was destined to bring a new word in the English language. For "the Vampire" of *A Fool There Was* became a popular model for the characterization of all women who used their bodies as lures to attract able-bodied and financially secure males (Dijkstra, 1998: 12).

In the jargon of the day, "vampire" was shorten to "vamp" and the behavior of the woman in question was known as "vamping" (Dijkstra, 12). The movie itself (based on a play) had captured a range of economic, gender, and class concerns in Western European and American culture. As Dijkstra (1998: 12) notes, the film offered a "shrewd distillation of many of the period's most popular theses about the inherent nature of gender conflict."

On one hand, sociologists, evolutionary biologists, economists, and physicians praised the "civilized, highly acculturated white woman" who was a mainstay of the civilized man's "dreams of domestic glory." On the other hand, they looked with wary eyes at the "the depredation of the sexual woman, the stalking temptress, the destroyer of family fortunes, the pre-Bolshevik economic vampire of early-twentieth-century capitalist society" (Dijkstra, 12). Their concern was that because she was so highly evolved, so civilized, the "good woman" was no match for the "bad woman" who might draw a civilized man to his own destruction (Dijkstra, 12).

Theda Bara, who "assumed the vamp identity as her professional persona, called herself a 'feministe'." This was during a period when the term "feminist" was associated with women's rights activists who used it as a political statement. But Bara was making a different kind of statement. She said that she wanted revenge on men. She said, men

> take everything from women—love, devotion, beauty, youth—and give nothing in return! V stands for Vampire and it stands for Vengeance, too. The vampire that I play is the vengeance of my sex upon its exploiters" (quoted in Kitch, 2001: 60).

This statement by Bara is a rather curious echo of what criminologists Cesare Lomboro and William Ferrero had written in their 1893 volume, *The Female Offender*.

The Female Born Criminal

Published first in Italy, the book was translated into English, with editions released in both London and New York in 1895. The book was reissued twice more in the 1890s, making Lombrosian theories about female criminality available to an American audience (Gibson, 2002: 61). In *The Female Offender,* in a chapter about "the born criminal," Lombroso and Ferrero observed that one trademark of this rare but dangerous woman was that her innate female tendency toward vengeance was not "neutralised by piety, maternity, want of passion, sexual coldness, by weakness and an undeveloped intelligence." Unlike "normal" women who did have their "defects" neutralized by these characteristics, the born criminal was free to act on her "bad qualities" (Lombroso and Ferrero, 1958: 12). Therefore, they wrote:

> The inclination to acts of revenge which we noted even in the normal woman is carried in the criminal to an extreme. The psychic centres being in an excited condition, the smallest stimulus provokes a reaction out of all proportion to its cause (154-155).

However, they also noted that unlike the male born criminal, the female was inclined to be "far less rapid in her vengeance."

> Revenge in her case follows after days, months, or even years, the explanation being her weakness and the relative timidity of nature which restrains where reason alone is powerless (155).

The description that criminal anthropologists Lombroso and Ferrero offered of the female born criminal was rooted in their interpretation of Darwin's theory of evolution. In the case of women, the inferiority of the cerebral cortex—which was less active in women than in men—placed most normal women in what can be described as the dull middle. They asserted that the typical form of female criminality was prostitution. There were few female geniuses and few female born criminals (Gibson, 2002: 68). However, Lombroso described female intellectuals as showing signs of degeneracy that was most often displayed in their physical appearance. He described several well-known female novelists as having faces like men, or the low voices of men, or preferring to dress like men (Gibson, 64-65). By the same token, female born criminals might also display physical and behavioral characteristics that was more masculine than feminine. But the "atavistic diminution of secondary sexual characters" also showed itself

> by the psychology of the female criminal, who is excessively erotic, weak in maternal feeling, inclined to dissipation, astute and audacious, and dominates weaker beings sometimes by suggestion, at others by muscular force; while her love of violent exercise, her vices, and even her dress, increase her resemblance to the sterner sex...(Lombroso and Ferrero, 187).

As described by Lombroso and Ferrero, the female born criminal was a predator who was out of place in the world that 20th century Social Darwinians envisioned. Social Darwinism had been formulated by Herbert Spencer and popularized in the United States by William Graham Sumner, John Fiske, and others. These writers argued that evolution (i.e. natural selection) had acted as "an intuitive form of genetic engineering" creating "fundamental inequalities" between different races and social classes and between men and women (Dijkstra, 1998: 14). In this hierarchal system, men were more evolved than woman; the Caucasian race more evolved than non-white races. However, the civilized white woman was weak and in need of protection by men. The more primitive non-white woman was more like a man and more likely to exhibit similar strength and independence. She was unrestrained by the feminine virtues that governed the behavior of the civilized woman, who was uninterested in sex but instead concerned with her reproductive duty to her husband (Dijkstra, 33).

Images of the Primitive Woman

By the turn of the century, both Western European and American men had been exposed to non-white people ("natives") through their nations' colonialism and empire-building. Early explorers to the North American continent used the term "Amazons" to describe the Native American women they saw along the "Amazon River." This term was also used in the 18th and 19th centuries by British explorers to Africa who recorded their impressions of the half-naked "savage" women that they encountered. Loth (1987: 62) notes that as early as the European Middle Ages, "there was a rumour that the sources of the Nile were guarded by a fierce tribe of Amazons. . .Again and again, women are mentioned who served as bodyguards for African rulers." In fact, such women warriors did exist, and included the royal guard of the king of Dahomey (Benin, West Africa) (Loth, 63).

Like other aspects of African life and culture, the existence of these female warriors was incorporated into the European mythology about the continent. Loth (1987) comments on the four pastels representing the four known continents (Europe, Asia, America, and Africa) created by one 18th century artist, the Italian Rosalba Carriera (1675-1757):

> These allegories show the typical features of the various races—the African female is enveloped in mystery: 'The dusky beauty is seductive; but dangers await whoever fails to resist the seduction and tries to penetrate the mysteries of the Dark Continent. The deadly vipers in the hands of the daughter of Africa serve as a warning'—thus the picture is described in a calendar...(Loth, 181).

In 1902, Charles Carroll, author of a popular book on race, *The Negro A Beast* or *"In the Image of God"* (1900), offered his theory about what had gone wrong in the Garden of Eden. In *The Tempter of Eve* (1902), he argued

that the "serpent" in the garden who had led Eve astray had been a black woman. According to Carroll, the tempter was "a *negress* who, served Eve in the capacity of maid servant." Eve had "accepted the negress as her counselor, and allowed the negress to control her." This was Eve's first offense. The eating of the forbidden fruit was the "second offense." Thus, it was "man's social's equality with the negro that brought sin into the world" (quoted in Stokes, 1998: 728). The tempter in Carroll's narrative, the cause of white humanity's fall from grace was the primitive black woman who with her words seduced Eve into sin. As Stokes notes, this was a twist on the myth of the sexually potent black male rapist.

Generally speaking, non-white women, whether found in Africa or in the United States, were considered not only exotic, but sexually promiscuous. By the early 20th century, this perception had been expanded to include to some extent Eastern European immigrants to the United States. In the film *A Fool There Was,* Theda Bara as the Vampire portrayed exotic sexuality at its most sophisticated, and, therefore, at its most dangerous.

The real life young white women who took up "vamping" were said to range from slightly naughty to brazenly destructive in their behavior. But more closely linked to the original idea of the "vampire" as a threat to civilized man (and hence "civilization") were those predatory women who seemed to represent the less evolved, defective in both moral and biological design.

"A mere child not yet seventeen . . .:" The Execution of Virginia Christian

In 1912, the state of Virginia put to death in the electric chair a seventeen year old girl named Virginia Christian. Christian had been convicted of first-degree murder in the death of her white employer, Mrs. Ida Virginia Belote on the evening of March 18, 1912. In the midst of great agitation in the city of Hampton, Virginia, the case went to trial less than two weeks after the offense.

Christian was represented by two African American attorneys, Joseph Newsome and George Fields, who discouraged her from taking the stand to testify in her own defense. As Newsome and Fields explained in a post-conviction letter to Virginia governor, William Hodges Mann, they had believed that if Christian, who was "ignorant, uncouth, and not by any means prepossessing in appearance," testified, it would only harm her case. The two attorneys noted the racially-charged atmosphere at the time of the trial, which had occurred "while the excitement caused by the news of the tragedy was yet unabated." In this appeal to the governor for commutation of Christian's sentence from death to life in prison, they explained that they had been sensitive to the damage that a crime such as Christian's could do to the harmonious race relations existing between blacks and whites in Hampton. However, they had felt it their duty to represent Christian, and they now appealed to the governor to show mercy. Christian's attorneys argued that

"A mere child not yet seventeen . . .:" The Execution of Virginia Christian *Continued*

their client was "a mere child" who had suffered from a poor upbringing. They argued that she was the daughter of "ignorant negro [sic] parents," and although her crime was horrendous, she had acted in the heat of passion. There had been no premeditation in her killing of Mrs. Belote, therefore, her act should be considered second degree murder or even manslaughter.

There were several narrative versions of how Christian came to kill her employer. As her attorneys said in their letter, because Christian did not testify, she had "sat silent while the blood stained garments, broken crockery ware, and the tell-tale strans [sic] of hair said to have been torn from the head of the deceased spoke eloquently against her." The prosecutor's narrative was that Christian had stolen from Mrs. Belote before and had come to the house with the intention of doing so again. The defense attorneys had argued that although Mrs. Belote had accused Christian of the theft of a skirt and demanded she pay for it, Belote had come to the Christian house and asked Virginia's parents to have her come back to work for her. At the insistence of her parents, Virginia went to Belote's house. It was then that they became embroiled in an argument that culminated in physical combat. It was during this struggle that Christian had shoved a towel into Belote's throat with a broomstick and beaten her over the head. Although silent during her trial, Christian later made a statement to a minister in the presence of a newspaper reporter who took down her confession. The reporter was among those who appealed to the governor on Christian's behalf, arguing that he was convinced that the homicide had not been premeditated.

As Moton (1997) points out in a dissertation about the Christian case, this episode presented a special quandary for middle-class African Americans. During the early 20th century, the African American middle-class in Virginia and elsewhere was focused on upward mobility. Members of the middle-class felt the need as "race leaders" to engage in "uplift" of the lower class. At the same time, middle class blacks wanted to distance themselves from the criminality whites often associated with blacks. Thus, Christian's two attorneys took on her case as a matter of duty, but at the same time they strove to maintain the uneasy equilibrium of race relations in Hampton. However, some African American groups did write on Christian's behalf in appeals to the governor.

Outside of Virginia, the Christian case attracted the attention of Chicago social activists and businessmen who wrote to the governor, appealing for mercy. One of the aspects of the case – one which placed the state of Virginia on the defensive – was the suggestion by some observers from outside the state that Virginia was in part responsible for Christian's situation because the state had failed to provide her with the education that would have lifted her from her poverty and ignorance. Another issue in the case was Christian's age. Was

> **"A mere child not yet seventeen . . .:" The Execution of Virginia Christian** *Continued*
>
> she seventeen, as her parents and attorneys, asserted? Or was she the more mature age that she appeared to some to be. If she were a juvenile, then by executing her, the state was ignoring its own legislation with regard to those under the age of majority.
>
> However, Moten (1997) argues that in the final analysis, what was most important to the state of Virginia was making an example of Virginia Christian. She was a black servant who had killed her white employer. If she was not punished and punished harshly, then no white person would be safe. Virginia Christian must serve as "a gruesome warning to black girls."
>
> Sources: *Executive Papers, Governor William Hodges Mann, 1912; Derryn Eroll Moten (1997).*

Was She Man or Woman?

One form of this more primitive woman, not beautiful or glamorous, but deadly to unsuspecting males was represented by the Midwestern serial killer, **Belle Gunness.** On April 28, 1908, there was a fire at the Gunness farm in LaPorte, Indiana. When the flames were out, neighbors found a headless female corpse and the bodies of two children in the ashes. A handyman who had worked for Gunness and quarreled with her was suspected of the arson fire that had apparently killed his employer and two of her children. As the sheriff and Gunness's neighbors poked about in the debris looking for evidence, they began to make unexpected discoveries. First they found watches. Then they found bodies.

> In the end, they unearthed eleven bodies on the Gunness farm. Two of the victims were female, one of these Gunness's long-awaited adopted daughter, Jennie, who had not been seen for two years [and was supposed to be away visiting]; the identity of the other female victim was never ascertained. Authorities would later assert that Gunness was responsible for these deaths in addition to the deaths of two husbands, and possibly the deaths of all her children (Hinton, 1999:330).

The authorities suspected the headless woman's body that they had found in the house was not that of Belle Gunness. It was becoming clear that Gunness had made a business of luring well-to-do suitors to their deaths. It was recalled that she had often placed ads in Norwegian newspapers seeking a compatible husband for a widow with a farm. Now, it was obvious what had become of those men who had come courting the Widow Gunness. One man who came looking for his missing brother arrived as the search through the fire debris was in progress. He identified his brother's remains.

As Gunness's crimes were revealed, tourists began to drive from neighboring towns and cities to see the "murder farm." In LaPorte, the residents began to reassess what they thought they had known about Belle Gunness. Outsiders joined in the speculation about the widow and her fate. A *New York Times* editorial expressed the hope that there had been some mistake, that Gunness might prove to have been "no murderess, but a coarse, thrifty woman who picked up occasionally an honest, if unclean, penny by disposing of cadavers for medical students of her neighborhood" (quoted in Hinton, 1999: 341). It was a bizarre theory. Hinton (341) suggests that it spoke to "the irrationality of those who could not bring themselves to believe that a woman could have killed anyone."

On the other hand, there were others, including some of Gunness's neighbors, who were willing to accept the opinion offered by criminologist Cesare Lombroso. He asserted that a woman would not have had the strength to commit the murders alone, so Belle must have had "one or more man accomplices" (Hinton, 341). However, some people in LaPorte pointed out that Belle Gunness had been a strong woman, capable of hefting a bag of grain or butchering a pig. She had possessed strength, and she had been skillful in doing the tasks about her farm.

Some people began to speculate in still another direction. What if Belle Gunness had really been a man disguised as a woman? Langlois (1985) finds that even prior to the discovery of the bodies at the farm, some of the local women were said to have been suspicious of Gunness's claims of maternity. In 1903, when her youngest child was born, Gunness had behaved oddly. She had turned away a neighboring farm woman from her door, and she had waited too late to send for the midwife who was supposed to assist with the delivery. Later, she produced for inspection an infant boy. However, her earlier actions had deviated from the normal practice of farm women, and "set up a sexual uncertainty in the woman's world of midwives and children" (Langlois, 56). The women suspected that all of her children might be adopted, and suggested that Gunness was too masculine to have produced children—even that she might really be a man (56-57).

But if she had not been a man, she had certainly been "unwomanly." She had dressed like a man. She had worked like one too. Again Lombroso offered an explanation. If she had not been a true man, she had been man-like, particularly in her criminality. Gunness had displayed a ferocity and a brutality, as well as an ability to dissimulate that was quite the opposite of the passive, pious, and maternal behavior of the true woman. Gunness had been one of those female creatures who not only resembled men in their physical characteristics (e.g., skull measurements), but who also had suppressed or perverted what was feminine in themselves (Hinton, 345).

There were some people who preferred to think of Gunness as not even human. They likened her to a demon—using words such as "hyena," "ape," "she devil," "ogress," and "female vampire" (Hinton, 346). Belle Gunness was not glamorous or seductive like Theda Bara's Vampire, but like that movie

character, she was seen as a predator and a destroyer of men. Offering a modern assessment of Gunness, Jones (1996) asserts that Belle's attraction for her suitors was not her "sensuality" but her property:

> [I]t was good acreage, a big chicken yard, and a thirteen-room brick house. Like any good confidence man, Belle appealed to the greediness of others. She matched her suitors' desire to exploit her with plans of her own, and most often, she won.... Belle Gunness merely applied to the domestic sphere the "cutthroat" tactics of the business world ... (138)

Because Gunness was so "precisely what men imagined a vicious female criminal would be" and "that model was so outrageous," she was perceived as "an absolute *freak* of nature" (Jones, 138).

But Gunness did for LaPorte, her adopted hometown, what Lizzie Borden had done for Fall River, Massachusetts. Gunness, like Borden, became a bizarre and macabre tourist attraction and a source of some pride (with ballads, plays, and other productions still performed about the murders). Langlois (1985) describes one production by a local women's group. Titled "The Day Before Yesterday," the women offered seven skits, each representing a season in the history of the organization. For the 1907-1908 season the women chose Belle Gunness, and respectable women dressed in authentic Gibson Girl costumes sung "The Ballad of Blood-Thirsty Belle." In the song, they advised Belle to "Lay that hatchet down/Hatchet-hackin' Mama." Langlois (1985) observes:

> That Belle Gunness could enter the inner sanctum of this elite women's group and be laughable indicates that their play world was transmuting the murderess and using her in symbolic ways. Society [Women's Literary Society] members' laughter fixed Belle Gunness, the code breaker, next to the Gibson girl, the code maker.... They laughed at the anomalous yoking together of an image that subverted and an image that idealized their class's expectations. Their irony domesticated the murderess. (Langlois, 30-31)

In fact, Langlois (1985) finds that in spite of the emphasis on Gunness's physical unattractiveness, in earlier visual representations Gunness was sometimes "shaped into the current fashion." On the cover of *The Mrs. Gunness Mystery* (1908), she is presented as a Gibson girl offering poison to a bedridden man. A British crime pamphlet from the 1920s, titled "The Crimes of Belle Gunness: Murderess, Adultress, and Baby Farmer," shows her as a flapper (65).

Because of her ambiguity and her presumed criminality, Belle Gunness became a subject for cultural interpretation and a canvas on which to work through issues such as the meaning of and breakdown of community (Langlois, 1985). She was a larger than life example of the Lombrosian deviant woman, but hardly the only flawed female who was a matter of concern during this era.

Other "Defective" Women

By the early 20th century, eugenicists' theories of heredity were in circulation in mass market magazines read by the middle class (Happe, 2000). These theories were also having an impact on social policy. In her study of the history of eugenics in the United States, Rafter (1997) identifies the establishment of the Newark Custodial Asylum for Feeble-minded Women in 1878 as the beginning of "eugenic criminology," which had

> the notion that criminality is caused by an inherited biological defect and can be curbed by reproductive controls. The Newark Custodial Asylum singled out one segment of the mentally retarded population, feebleminded women of childbearing age, and redefined them as a eugenic problem (Rafter, 35).

The founders of this Asylum believed these women were "inherently promiscuous" and that they gave birth to "crime-prone offspring. On Newark's opening, eugenics doctrine became the basis for public policy" (Rafter, 35).

In New York, one of the leaders of the philanthropy movement was Josephine Shaw Lowell. In 1876, the governor appointed Lowell to the State Board of Charities (SBC), "the agency responsible for coping with the state's welfare problems." She became "the charity board's first female commissioner" (Rafter, 35). As a member of the Board, Lowell's approach was shaped by her perception of the problem. Influenced by the concept of degeneracy, she concluded that feebleminded women was "depraved in body and mind." This was a view that had tremendous influence at the turn of the century. As Rafter (1997) explains, degeneracy was "[r]oughly synonymous with *bad heredity*" and "conceived as an invisible attribute of the 'germ plasm' or 'blood.'"

A case study of this alleged hereditary degeneracy was presented by Richard Dugdale in his 1877 work, *"The Jukes": A Study in Crime, Pauperism, Disease and Heredity.* The initial version of Dugdale's study was released just before Lowell joined the charity board. In his study, Dugdale traced a rural clan over seven generations, finding in the family tree over 1,200 "bastards, beggars, murderers, prostitutes, thieves, and syphilitics" (Rafter, 38). Because the work was a best-seller, it helped to popularize the idea of degenerative families who constituted not only a public burden but a criminal threat.

As social policy, applied eugenics resulted in the creation of institutions for male and female defectives and the use of classification systems within criminal justice aimed at identifying defective persons. In many states, persons identified as "degenerate" were institutionalized in asylums or prisons. Many degenerates, particularly women, were sterilized to prevent reproduction. However, the other aspect of the eugenics movement aimed to improve "human stock." This involved securing the cooperation of healthy white parents who could produce and rear healthy children. One exercise in making eugenics a family affair took the form of "fitter families" contests sponsored at state fairs and exhibitions by the American Eugenics Society during the 1920s and early 1930s (Selden, 1999).

Kline (2001) asserts that in their discourse, eugenicists addressed two areas of paramount societal concern—gender and race. With regard to gender, both the "woman adrift" and the "new woman" (10-11) seemed to constitute threats to the status quo.

> Because they challenged the conventional standards of womanhood, these women were attacked as "unsexed" or "mannish." Their demand for equal rights called into question the sanctity of gender roles. Many men believed that economic equality threatened to merge the two sexes into "dangerous confusion." Women were becoming masculine just as [white middle class] men were becoming increasingly weak and effeminate. Home and the family were the cornerstones of society, and if women abdicated their domestic duties, what was to become of moral order? (11)

Thus, if the alleged "virility" of African American males was seen as a threat to "middle class male authority," so was the assertiveness of the "new woman," who demanded rights and privileges that had formerly been reserved to white men. The assertion by the eugenicists that white middle class women should devote themselves to procreation to prevent "race suicide," had the additional benefit of redirecting the attention of these women to the domestic sphere. In this campaign, Kline (2001) finds some women were encouraged to become "the mother of tomorrow" (16-19). Other women—the carriers of "negative eugenics" were labeled as "unfit." The "depraved woman," "the fallen woman" might now also be labeled a mentally deficient woman who was genetically flawed. Kline argues that this appealed to the Progressive belief in science, and it offered a "simple solution" to both the problem of curbing "sex immorality" and of advancing "race progress" (19-20).

With the coming of World War II and the war-time atrocities committed by the Nazis, the discourse about racial superiority diminished. However, Selden (1999) finds that during the years when eugenics was acceptable social science discourse, these ideas entered the mainstream through high school textbooks and college courses. Because of this, ideas about degeneracy did not disappear once they fell out of favor. Kline (2001) argues that eugenics continued to influence marriage and family counseling through the 1950s.

These ideas about the primitive woman and about the degenerate woman of inferior stock, both of whom threatened civilization, remained as a part of the discourse about women and crime. At the same time, male chivalry toward females deemed deserving continued to be a part of the response to accused women.

Death and the Prostitute

In 1922, the high court in the state of California ruled on an appeal from Betty Carey, a San Francisco prostitute. Carey was appealing her sentence

Death and the Prostitute *Continued*

under a 1919 law that allowed convicted prostitutes to be sent to the California Industrial Farm for Women for "custody, care, protection, industrial and other training. . . ." In ruling against Carey, the judges held that "fallen women" (i.e., prostitutes) were a prime source of "economic, social, moral, and hygienic loss" to society. According to the judges, prostitutes were also "pestilential,. . .a common pathological danger" (quoted in Friedman, 1993, 425). Depictions of prostitutes in literature and art and in real life tended toward either the sentimental or the demonical. The sentimental depictions were of innocents betrayed by men or struggling to survive poverty. The demonical depictions were of women who because of their own bad character gleefully embraced immorality.

With regard to their connection to disease and death, prostitutes were associated with "the pox" (syphilis) and other sexually-transmitted diseases. Reformers during the 19th and early 20th century argued that a prostitute might infect not only her male client, but, through him, "innocent" women and children. Because there was no certain cure for syphilis in the 19th century, the disease—which in worst case could lead to "paralysis, deafness, blindness, or dementia"—was particularly feared. The usual treatment, compound of mercy, was itself poisonous and "in many patients produced such nightmarish self-effects as ulcerated jaws, tongues, and palates, swollen purple gums, loosened teeth, fetid breath, and excess salivation" (Anderson, 1995: 126).

The dread of venereal disease led to such legislation as England's Contagious Diseases Acts, enforced from 1864-1883. The Acts focused on prostitutes, rather than their customers, compelling suspected women to submit to medical examination and confinement to special hospitals for treatment if found to be infected. As Anderson (1995: 126) notes, feminists opposed the Acts, arguing that the laws

> . . . officially reinforced a double standard of morality—one for men, another, harsher one for women. They condemned the predominantly male medical profession for its part in executing the laws, and from that point the speculum examination became for them a symbol of the subjection of all women by all men.

Today, in the age of AIDS, prostitutes, particularly those who are drug-addicted, continue to be seen as a source of lethal disease and pestilence.

> *Query: Do you think a double standard of morality continues to exist with regard to prostitutes and their customers? Who should be considered most "blameworthy" in a sexual transaction in which a female prostitute infects a male customer who later passes that infection on to a wife or girlfriend?*

Chivalry and the Deserving Defendant

In discussing the responses of male prosecutors, judges, and juries to female

offenders, the "chivalry theory" has sometimes been posited. According to this theory, men involved in the criminal justice process are more likely to show leniency to female offenders than to male offenders. The theory asserts that men will respond in a protective manner toward women, doing their best to shield them from the harsher and more distressing aspects of the criminal justice process, such as imprisonment or capital punishment. One of the questions often posed is who benefits from this supposed chivalry. Is it only offered to white, middle-class women who can lay claim to respectability? Two high profile cases from Toronto, Canada offer interesting examples of the circumstances and the legal narratives that evoked male chivalry for working class defendants. Although one case occurs in the 1890s, slightly outside the time period discussed in this chapter, it is relevant here. In each case, the accused woman confessed to killing a man of higher class and was acquitted by a jury.

The first case, in 1894, involved **Clara Ford,** a mulatto seamstress charged with the murder of a wealthy young white man, Frank Westwood. She was alleged to have gone to his parents' home disguised as a man and shot him when he answered the door. The prosecution's evidence included a ballistics match with Ford's gun; a witness who claimed to have heard Ford threaten to shoot Westwood if she caught him with another woman; Ford's police court plea of guilty and her confession to the police (Strange, 1992: 164-165). In the confession, Ford stated that Westwood "insulted" her, a euphemism for sexual assault. However, this was a non-issue in the trial. The prosecution offered a different motive for the crime.

In the newspaper stories, Ford was presented as a woman of eccentric habits who carried a gun, fought with her fists, hopped onto fast moving streetcars, and dressed like a man when she worked in livery stables (Strange, 158-159). Vying dailies such as the *World* and the *Empire* portrayed her as a "man-woman" with a "violent temper" (Strange, 158). Another newspaper, the *Globe* contributed to the rumors, but offered a sympathetic account of Ford's background, as the child of a black female servant and the son of a old and respected white Toronto family. Ford herself was said to be the mother of an illegitimate child (Strange, 160). Even while condemning her habit of dressing and behaving like a man, the *World,* expressed sympathy for Ford as a mulatto who "had come to regard herself as a sort of social Pariah" (160).

As Strange (159) notes, racial stereotyping affected the standards by which Ford was judged. Even though her behavior was eccentric, it was not bizarre to the citizens of Toronto who had attended the minstrel shows of the 1880s and 1890s. They were accustomed to images of blacks as both "childish and outlandish." (159).

The legal narrative presented by Ford and her attorney at trial used her background to best advantage. When called to the stand by her attorney, Ford presented herself "not as a murderer but an unschooled mulatto woman who had been outwitted by big city detectives eager to advance their careers" (168). She said she had not even known Westwood. In his summation, her defense attorney warned the jurors that they would be responsible for sending Ford to the gallows

if they accepted the word of the detectives who had built a case against her based on information they had received from drunkards and thieves (168).

In their narratives, the two crown prosecutors focused on the circumstantial evidence and Ford's questionable character. The first prosecutor argued that the confession Ford had given to the police had not been coerced. She had indeed committed a murder while dressed like a man. She had shot Westwood because he discarded her. In his summation to the jury, the second prosecutor continued the portrayal of Ford as a self-possessed, half-savage, woman scorned. The prosecutor suggested that Ford's "African blood" made her superior at deceit (Strange, 169).

Regarding the murder scenario presented by the prosecution, Strange (1992) finds that this plot of a woman carrying out a crime in male clothing would have been one that was familiar to the jury. Toronto theater-goers of all classes attended popular "romantic melodramas." In these melodramas, when the heroine "wronged by a rich villain, found herself without a champion, she turned to self defense." Often the heroine disguised herself in boy's clothes to shoot the villain (Strange, 157). But at the same time, the prosecution had the problem of presenting in best light a story in which a wealthy and "apparently respectable" (169) young white man had been involved in a relationship with an older mulatto woman of eccentric habits.

Given a choice between competing legal narratives, the jury answered the appeal by Ford's attorney that as honorable men they protect his client, a woman who had been badgered into a confession and now stood falsely accused (169). It took the jury less than one half hour to vote to acquit Ford (Strange, 170).

In the second high profile case, spectators cheered and the judge was said to be teary-eyed as he announced the verdict when **Carrie Davies,** an eighteen year old immigrant from Great Britain was acquitted of her murder charge. In February 1915, Davies, who worked as a housemaid, shot her employer Charles ("Bert") Massey as he came up the walk to his home. She explained that he had made improper advances to her the day before. She had fought him off and then gone to visit her sister and brother-in-law. She had returned to the house only because it was her duty. Mrs. Massey was away visiting friends, and Davies had promised that she would be there to mind the house and the couple's young son. But she had been so frightened when she saw Massey returning home and began to think of what he might do that she had shot him.

There was a great deal of support for Davies during her trial. Her claim of besieged chastity was believable because Davies seemed to be genuinely chaste and well-behaved. Her defense attorney (one of the men who had prosecuted the Ford case years earlier) presented her as a heroine whose young man was away fighting for his country in the war. Left alone, at the mercy of her employer, she had no one to depend on but herself. She had done what she had to do in order to avoid being raped. Other British immigrants of the working class rallied around Davies. Speaking out in Davies's defense became a "patriotic exercise" (Strange, 171).

Her attorney told the jury:

The attack gave the girl only one alternative. . . If she did not defend herself against this man she would have been a fallen woman, an outcast, one more sacrifice. Let that sink into your mind. **It was not manslaughter. It was brute-slaughter** (Strange, 174).

Her attorney argued that by freeing Davies, the men on the jury would be enacting the role of fathers who understood her desperation as they would that of their own daughters.

The prosecution found this appeal to the chivalric code difficult to overcome. Davies had shot an unarmed man, but Massey was not there to defend his own honor against her charges. Because of Massey's absence, it was difficult to overcome the strong wave of sympathy for the defendant. The prosecutor argued for the letter of the law, for law and order. He told the jury members, they must do their duty even if it was hard (Strange, 175-176). The jury rejected his argument and freed Davies.

These two women, Ford and Davies, were studies in contrast. Davies was the picture of virtuous distress. Ford was bold and eccentric and of an "inferior" race. Each case attracted a high profile, skilled defense attorney who welcomed the challenge posed by the case and saw it as an opportunity to "enhance [his] reputation with the legal fraternity" (Strange, 178). In each case, the jury responded to the melodramatic narrative of heroine and villain(s) by confirming "men's prerogative to defend weaker beings" (Strange, 178).[2]

In his research on homicide in Chicago, Adler (2003a) also finds evidence of exercise of this male prerogative. However, it occurred as Chicago women who killed asserted a new right.

The Right to Self-Defense

In studying homicide in Chicago, 1875-1920, Adler finds that by the early 20th century women "committed a growing proportion of a skyrocketing total" of lethal violence. The nature of female violence was changing in two important ways that "reflected a shift in gender relations" but did not signal "the demise of gender inequality" (2003a, 869). Women were killing their husbands at a higher rate than in the past. At the same time, they were using a new courtroom defense strategy. Historically, men had claimed the right under the "unwritten law" to kill another man who was discovered in an illicit sexual relationship with the defendant's wife, sister, or daughter. Now, giving a twist to this concept, women in Chicago in the early 20th century were claiming the right to kill husbands who physically abused them under a "new unwritten law."

Adler suggests that "such a carefully scripted argument was unnecessary" in a city where killers were rarely sent to prison (2003a, 886). However, this new defense strategy "played on male jurors' sense of chivalry and their inclination to protect weak, fragile women" (2003a, 885-886). What these women who killed their husbands were claiming was the right to self-defense

against an abusive male. Adler notes this perceived right seemed to grow out of the middle-class ideal of a "companionate marriage." Both the relatively older and wealthier women who numbered among the husband killers and those who heard their defense narratives, had a sense of the "proper use of a wife" by a husband. That use did not include physical abuse (2003a, 888). Thus

> Murdering wives 'constructed' a specific image to present to local policemen, judges, and especially jurors. To be sure, defense attorneys played an important role in this process and helped to shape their clients' images. But many husband killers. . .revealed their strategy to the Chicago policemen who arrived at the scene, explaining their behavior well before defense attorneys were involved (2003a, 882).

These women argued that they had the right to use lethal violence—even pre-emptive violence—against husbands who had demonstrated a pattern of physical abuse and might well have killed them if they had not acted. Even though prosecutors were enraged by this defense strategy, jurors "embraced the new unwritten law" (Adler, 2003a, 883). Between 1875-1920, only 16 of the 102 women who were prosecuted for killing their husbands were convicted. Of these women, 9 were African American— "for whom this defense clearly appeared subversive and dangerous" (2003a, 883-884). Of the seven white women who were convicted, the sentence of one was remitted by the judge. Two were judged criminally insane. Two received prison terms of one year. One of the women convicted of murder was younger than most of the acquitted wives. Only nineteen years old, she had killed her husband during an argument about other men. The other convicted murderer was a Swedish immigrant who had a reputation for battering her smaller and weaker husband during quarrels. Even though, she killed him after he stabbed her with a knife, she would probably have seen less worthy of protection than the women who were able to offer proof that they had been the long-suffering victims of stronger and more violent men (Adler, 2003a, 884-885; also see Adler, 2003b for discussion of racial/ethnic differences in domestic homicides).

In this respect, the defense used by the women who killed their husbands was in keeping with a movement that was under way in Chicago. Adler (2001, 2003a) finds that there was a general movement to prosecute crimes that affected innocent and/or vulnerable victims. Thus, vehicular homicides and other deaths that in the past had been labeled "accidents" were now being prosecuted. What this meant for women was that on one hand, abused women could now evoke the right to defend themselves against their abusers even if it required lethal violence. On the other hand, some other women were now more subject to prosecution.

Adler finds that in the past, police officers had not recorded infant deaths that might have been infanticides. In the last quarter of the 19th century Chicago police recorded only five infanticide cases, even though babies were routinely found by sewer and street cleaners. But in the decade of the 1910s,

the police and coroner's officer identified 49 infanticide cases (2001a) and police became more vigorous in their investigations.

This increased attention to infanticide occurred as the criminal justice system in Chicago began to pursue offenders in abortion-related homicides. During this era, reformers and sensational literature offered accounts of young women who arrived in the city and were twice victimized. The first victimization came at the hands of male seducers. The second victimization by incompetent abortionists. With the help of coroner's physicians, police and prosecutors began to pursue midwives and doctors who were responsible for these homicides (Adler, 2001: 39-41). Although abortion had been a crime in Illinois since 1867 and abortion-related homicides subject to prosecution as murder, it was not until the early 20th century with the changing "sensibilities of law enforcers" that real effort was made to link such deaths to abortion rather than other causes (Adler, 2001: 39).

Something else was occurring in Chicago. Mothers who killed their children were speaking out about their crimes in the same way as the women who killed abusive husbands. However, Adler (2003a) notes that the rate of child murder in Chicago had not gone up. For "most of the women who killed their children" (not including infanticide), it seems that "illness triggered the violence." Some mothers committed "mercy killings" of children who were ill or disabled. Other mothers who were themselves ill or dying and feared there would be no one to care for a child, decided to kill both the child (or children) and themselves. The mothers who survived their children told their stories to the police and/or prosecutors. Those who died with their children often left suicide notes. Adler (2003a) finds:

> Both in the violence itself and in the preparations for the violence, Chicago's murdering mothers insisted that they were fulfilling their roles as loving mothers trying to protect their children from painful or ominous futures (875).

An ocean away, in Paris in 1914, another woman—a member of the elite—would claim that her act of homicide was intended to protect her child from pain. As a wife and mother, she claimed the right to defend her family against the threat represented by the victim.

Madame Caillaux's Defense

As the world teetered on the brink of war, a murder trial claimed the attention of the French press and the French people. The defendant was **Henriette Caillaux,** the wife of French cabinet minister, Joseph Caillaux. She was accused of shooting the editor of *Le Figaro*. On the evening of March 16, 1914, she had walked into the editor's office, asked to speak with him, and when received by him, pulled a Browning automatic from her fur muff and shot him. She made no effort to avoid arrest, but asked—and was permitted—to go to the police station in her own carriage.

The shooting had grown out the untidy personal histories of Henriette

and Joseph Caillaux. The marriage was the second for both of them. They had met when Joseph was married to his first wife, Berthe Gueydan, who he had met when she too was married. Berthe had become his mistress and then his wife. Henriette had followed the same pattern. Joseph had divorced Berthe to marry Henriette. This state of affairs, adultery, mistresses, and divorce, was not unknown in Paris in 1914. However, it was not a matter that the parties involved were supposed to flaunt. Much could be overlooked if matters were handled with discretion (Berenson, 1992).

Unfortunately, as Henriette and Joseph Caillaux would argue during Henriette's trial, it became impossible to handle the details of their private life with discretion when Gaston Calmette, the editor of *Le Figaro,* printed the letter that became known as the "Ton Jo" letter. This was a love letter that Joseph had written years earlier to Berthe, when he was pursuing her. Not only was the publication of such as letter (signed by Joseph as "Ton Jo") embarrassing, it was also potentially damaging to his political career because of a boast Joseph had made in the letter concerning the clever and hypocritical fashion in which he had handled a piece of legislation in his role as a junior member of the Senate. The revelation of this letter came at a time when Caillaux already faced criticism for the sub rosa manner in which he had handled an incident involving the German government. Caillaux was known to favor peaceful negotiation while many of his fellow Frenchmen favored a more aggressive approach in dealing with the country that they considered an enemy (Berenson, 1992).

But aside from the damage, Calmette, the editor of *Le Figaro,* might do to Joseph Caillaux, Madame Caillaux claimed that she feared further revelations. She feared Calmette would print other letters that would destroy her own reputation—and shame her in front of her innocent teenage daughter—by showing that during her first marriage she had been Caillaux's mistress. She feared that her indiscretions would be made public. Although her husband had sworn he would kill Calmette if he printed anything else, Madame Caillaux said—in fact left a note to her husband saying as much— that she believed it would destroy her husband if he killed his enemy. She would do it for him to save them both (Berenson, 1992).

So in court, during the seven days of a trial that occurred as France moved toward war with Germany, Madame Caillaux and her defenders tried to present her as a woman who had acted in defense of her honor and to protect her family. As Berenson (1992) describes the trial, Joseph Caillaux and his ex-wife Berthe both played significant roles as they debated the facts of their marriage. On the one hand, Berthe sought to present herself as a wronged wife, led into adultery by the philanderer that she had eventually married. On the other hand, Joseph Caillaux portrayed his ex-wife as a woman of intelligence and boldness, who had vied with him for dominance in their marriage, while being cold and rejecting in her behavior toward him. In contrast to his second wife, Henriette, Berthe was hard and unwomanly. Moreover, Berthe had betrayed him by keeping and releasing copies of the letters that she had found in his desk drawer and pretended to return to him.

In these proceedings, Henriette Caillaux also spoke. She presented herself as a good wife and mother. She had become involved with Joseph Caillaux because she had fallen in love with him. As his wife, she had been supportive and loyal. As a mother, she wanted to protect her innocent daughter from scandal and shame, and the lost of faith in her mother if she discovered her indiscretions.

But, as Berenson (1992) finds, the Caillaux trial attracted so much attention because it provided a courtroom drama through which the larger issues troubling French society could be debated. In particular, the trial focused attention on the meaning of masculinity. Madame Caillaux said she had acted to protect her husband. But in a culture in which duels among elite men were not only accepted but expected when insult had been given, why had Joseph Caillaux not called the editor of *Le Figaro* out? Calmette himself was said to have wondered this, in fact been expecting to receive a challenge from the politician. At the same time, if her husband had failed to act, had Madame Caillaux played the part of man when she herself went to Calmette's office and shot him? Madame Caillaux's successful defense depended on convincing the jury that she had acted as a woman—a "true woman"—when she killed her husband's enemy. Her acquittal depended on convincing her audience that although she had bought a gun and even tried it out on a firing range in the shop where she had purchased it, her actions were not cold and calculated, but committed in a moment of passion, i.e., that her act had been a "crime of passion."

In this, her gender served her well. Berenson (1992) finds that the French were more inclined to believe that a woman could kill while caught up in the emotions of the moment than with premeditation. Women, as a gender, were more emotional, more sensitive than men, and therefore more prone to lose control. Moreover, Madame Caillaux's defense attorney also pointed out delicately that the lady had been in the midst of her menstrual period when she committed the homicide. The jury accepted Madame Caillaux's defense and acquitted her.

But the reputation of her husband had been destroyed by the revelations of the trial. During the war, he was arrested and imprisoned for treason. Later, in the postwar years, he again gained political prominence, but the luster that had surrounded him prior to the trial was gone. Madame Caillaux withdrew from society—and spent the rest of her life locked in a marriage that she had killed to preserve with a man that she might well have believed had planned to cast her off for a third wife before she killed Calmette. Apart from the unhappy fates of the participants, the Caillaux case came to symbolize the debate about femininity and masculinity, honor and corruption, courage and cowardice that was a part of the larger sociological/political picture in France on the brink of war (Berenson, 1992).

A Jazz Age Murderess

In the aftermath of World War I, those in Europe and the United States who had survived the conflict found that much had changed. In the United States,

the 1920s was the decade of Prohibition, gangsters, flappers, and jazz. Women had finally gotten the vote. As in the 19th century, some middle class women were political and social activists. Now some had careers as professional women. As always poor women continued to work outside their homes. Americans still talked about gender relations, but now they referred to the theories of Sigmund Freud. Those theories would be relevant in a murder case that would rivet the attention of New Yorkers in this post-war era. The defendants, **Ruth Snyder** and (Henry) Judd Gray, would eventually be put to death.

On the cover of Leslie Margolin's true crime book, *Murderess!* (1999) is a black and white photograph of Snyder with a leather mask over her face and leather straps around her legs. She is seated in a chair and her hands are also strapped down. If she were not fully clothed, one might wonder if the book were about sadomasochistic sexual practices. But the subtitle to the left of the photograph provides the information that this is "The Chilling True Story of the Most Infamous Woman Ever Electrocuted." The subtitle is, of course, hyperbole. The photograph in its stark, blurred black and white with the title in red letters above is intended to grab the potential reader's attention. Yet, the photograph does say something significant about the case. It was taken by a photographer who attended the execution as a witness using journalist credentials and snapped the photo with a camera strapped to his leg as the switch was thrown on the electric chair. He had managed to get a strictly forbidden execution photograph of Ruth Snyder, and the public was eager to see it.

This was the era of "jazz journalism," when the tabloids vied with each other and with more staid newspapers for readers. Some competent women journalists and editors had made places for themselves in city newspaper rooms. But it was still a man's world, and the men were still engaged in newspapers wars in which sex and violence made good copy (see Douglas, 1999; Emery and Emery, 1984). The "yellow journalism" of the late 19th century was now the "jazz journalism" of the 1920s (Emery and Emery, 387-389). Both were characterized by sensationalism. In the 1920s, two New York City daily tabloids, the *Daily News* and the *Mirror*,

> were in fierce competition with each other to cover the most sensational and lurid happenings of the day. If there was some nasty society divorce, some gruesome murder or high-profile criminal trial (and the 1920s seem to have been richly endowed with these), the tabloids devoted pages upon pages to them. The celebrated Hall-Mills murder case in New Jersey became the special preserve of the *Mirror*, which took literally thousands of photographs during the trial and ran many of them on a daily basis (Douglas, 1999, 230).

In 1922, a New Brunswick, New Jersey minister, Edward Hall, and his choir-singer lover, Eleanor Mills, had been found dead, apparently suicides. But, through the efforts of the *Mirror*, Mrs. Hall, the minister's wife, was put on trial for their murders. Although she was acquitted, the case was a media sensation with 200 reporters present to hear the testimony of a witness they

dubbed "the pig woman." After her acquittal, Mrs. Hall sued the *Mirror* for libel (Emery and Emery, 1984: 391, 392). But its competitor's misfortune did not deter the *Daily News* from going after an execution photo of Ruth Snyder. When the photographer was successful in getting the photo, the *News* ran 250,000 extra copies of the paper featuring the touched-up picture on the front page. Sales were so brisk, that an additional 750,000 copies of the front page were run off later (Emery and Emery, 392).

There was such interest in the execution because by the time of her death, Ruth Snyder had become notorious. The murder trial of two adulterous lovers had played well in the tabloids and been covered extensively by more conservative papers such as the *New York Times*. Like the other high profile cases discussed in this book, the Snyder-Gray case provided melodrama. The two defendants had been human in their actions and fallible in their attempts to cover up what they had done. Their motives were not as straight-forward as they seemed at first glance. During the course of the trial—even before that, in their confessions—they turned on each other. In the end, it became a spectacle in which the prosecutor, the defense attorneys, and the defendants themselves struggled for dominance. They presented competing narratives of the murder and the adulterous affair that had led up to it and the jury, the spectators in the courtroom, and the audiences who read newspapers or listened to radio were left to debate about the "truth."

This phenomenon of two "average" people (a housewife and a traveling corset salesman) in a high profile trial was one that Brazil (1981) argues was common during the 1920s. He asserts, "the newspaper public wanted not 'real' murder but a particular kind of murder, one that involved situations and central figures with whom it could identify" (167-168). In this respect, the Snyder-Gray trial provided that.

During the trial, one of Ruth Snyder's attorneys, Dana Wallace, described his client to the jury as more sinned against than sinning. He said that she had been courted by Albert Snyder, a man who had showered her with gifts and attention before they were married, but then become cold, stingy, and even abusive. Ruth Snyder had met Judd Gray through mutual friends during an innocent afternoon out. She had been drawn to him, but tried to resist that attraction. But Gray had been a smooth, fast-talking Lothario, someone who made his living closing sales, and he had seduced Ruth Snyder. She had found him sympathetic. She had told him about the state of her marriage and that she was beginning to fear what her husband might do. It was Gray who suggested killing Ruth's husband. It was Gray who insisted on going ahead with the plans even when Ruth tried on the night of the murder to dissuade him. Her defense attorneys argued that Ruth Snyder had signed her supposed confession under duress after being held and questioned by the police for forty-eight hours. The confession was not true; it was worthless.

When Ruth Snyder herself took the stand, she presented herself as a woman who had tried to be a good wife to a difficult husband. She presented herself as a good and loving mother. During her testimony, her other defense

attorney, Edgar Hazelton, led her through a series of questions concerning her daughter Lorraine. Snyder testified that she had undergone an operation so that she could conceive, but then her husband had been disappointed when the child was born because he had wanted a boy. As Lorraine's mother she had done her best to made sure that her child was not only well-clothed and fed but that she also received religious training. But her emotionally distant husband had ignored their child and often thrown his own dead fiancee, Jessie Guishard, in Ruth's face when they quarreled. In his eyes—even though she cooked, cleaned, canned preserves, and made their daughter's clothing and the drapes and curtains—Ruth had been inadequate as a wife because she could never replace his beloved Jessie. In her loneliness and desperation, she had turned to Judd Gray (see Margolin, 142-144).

In his competing narrative about the crime, Judd Gray's defense attorney presented Ruth Snyder as a treacherous, domineering woman who had seduced his client and drawn him deeper and deeper into her web of deceit until the final act of murder. In this narrative, it was Ruth who struck some of the blows that killed Albert Snyder as he fought for his life in his own bed. It was Ruth who had put the wire around Albert Snyder's neck. It was Ruth who had tried ineffectively to kill her husband several times before that night, with poison and with gas left on in the living room. But Albert Snyder had survived these attempts, and Ruth had turned to Judd Gray, demanding that he help her. He had been unable to resist. In his closing statement, William J. Millard, Gray's attorney described Ruth Snyder in this way:

> That woman, that peculiar creature, like a poisonous snake, like a poisonous serpent, drew Judd Gray into her glistening coils, and there was no escape. That woman. Why gentlemen, it was a peculiar, alluring seduction. I want to say here that this woman was abnormal. . . . I must speak plainly, gentleman. This woman, this peculiar venomous species of humanity was abnormal; possessed of an all-consuming, all-absorbing sexual passion, animal lust, which seemingly was never satisfied (quoted in Margolin, 1999: 221).

Prior to the beginning of the trial, his defense attorneys had arranged for Judd Gray to be examined by two alienists (psychiatrists). The prosecution arranged for its own experts to take part in the procedure. Covering the event, the *New York Times* reported that the examination had lasted over five hours, from noon to 5:10 p.m. According to the newspaper, the lengthy interview with Gray focused on questions about his "life and habits." In the physical examination scheduled to follow, it was anticipated that Gray's skull would be X-rayed, blood and spinal fluid analyzed, and his reflexes tested (*NY Times*, Gray is Examined, 04/15/1927).

Two days later, the newspaper reported "Mrs. Snyder Breaks As Trial Day Nears" (*NY Times*, 04/17/1927). According to the story, Ruth Snyder had experienced a "hysteria attack" in her cell. This was worthy of note because

prior to this episode, during the three weeks of her imprisonment, she had been "self-possessed and clear-headed." Both she and Judd Gray now seemed to be showing signs of stress. Gray had "stumbled on the staircase from exhaustion as he was led back to his cell" after his examination by the alienists. In this same articles, the *Times* reported that the alienists took time to talk briefly with reporters. The alienists were in agreement that Gray was "bright and alert" in spite of his exhaustion and his worry about his family. During the examination, he had told them that he blamed Ruth Snyder for the murder. *The Times,* apparently quoting the alienists, reported that Gray said that Snyder had dominated him and driven him to murder. He claimed that he had been "under her spell" and victimized by her charms (*NY Times,* Mrs. Snyder Breaks, 8).

During the trial, his two defense attorneys did not deny that Judd Gray had helped to kill Albert Snyder. Instead the attorneys sought to tap into the current fascination with psychoanalytic theory. Using the Freudian language of the day they described their client as the victim of an "inferiority complex" who suffered from a "mania for martyrdom." As they explained it, Gray had found himself involved in a situation that could best be characterized as "Oedipal." He fell under the spell of a woman who he had nicknamed "Momsie." Driven by his compulsion, he sought to kill Albert Snyder, who was a decade older than he, and marry Ruth. According to Gray's lawyers:

> He had been "hypnotized" by a "mastermind." Needless to say, Snyder's lawyers . . . saw things differently. They painted their client as a victim of sexual thralldom right out of Freud's "Taboo of Virginity"(1918), a "hysteric" who was subject to difficult menstrual periods and fainting spells, trapped in a loveless marriage and sexually frigid until awakened for the first time by her "demon lover," and soon a helpless pawn in his hands (Douglas, 1995: 126).

Prior to the trial, Ruth Snyder had tried to bring her case before the court of public opinion. After a meeting with her lawyers, she sent a statement to the press in which she appealed for understanding from the public. *The New York Times* reported her statement in an article titled "Mrs. Snyder Asks Women's Sympathy" (04/16/1927, 17). Addressing the people who had read newspaper stories about her, Snyder asked the public not to rush to judgment, but instead to wait until after the trial and the jury's verdict. She asked other women, other mothers, to imagine how they would feel if they were in her circumstances. She challenged the claims made by Gray, who she described as "unscrupulous" and "vicious." Snyder said that she had known Gray, but only as well as a woman could know a man. She had been mistaken in his character, and he had now shown himself to be a "jackal," who was trying "to hide behind [her] skirts." Snyder assured readers that she loved her child and had loved her child's father. Finally, Snyder asked for the sympathy of the wives and mothers who read her statement. She asked them not to judge her harshly (*NY*

Times, Mrs. Snyder Asks). Unfortunately for Ruth Snyder in the battle of images, Judd Gray came off as more believable. In the courtroom, he was bespectacled, slumped, often in tears, repentant. He did not have the appearance of a ladies' man, or even a very strong man. She, on the other hand, came across as stylish, theatrical, even vulgar. The spectators in the courtroom and the jury found it hard to believe that she was the victim of his seduction. It was easier to believe that she had seduced him and led him down the path to murder—especially when his loyal and weeping mother sat in the courtroom listening and offering comfort to her son (Margolin, 1999).

In the end, it did not matter. They had both confessed and the confessions were difficult to take back. And there was a motive. Aside from any aversion Ruth Snyder had felt for her husband, aside from any love she had felt for Judd Gray, there was, the prosecutor argued, the matter of the life insurance policies that paid off in double indemnity. Dead, Albert Snyder had been worth $96,000 to his wife. This was the story the jurors believed. Both Snyder and Gray were sentenced to the electric chair. Jones (1980) observes of the execution of Snyder:

> Like Sacco and Vanzetti, Ruth Snyder died in the electric chair while the whole country watched the clock. The limits of acceptable American behavior in the twenties were drawn by these highly publicized punishments: the electrocution of two "bolsheviks" and a "flapper"—two immigrant workingmen and a suburban Long Island housewife (Jones, 20).

Jones asserts that although there were "outraged demonstrations" when Sacco and Vanzetti were put to death, "[a]lmost everyone agreed that Ruth Snyder had to die (Jones, 20).[3]

In the last chapter of her book, Margolin (1999) makes a strong argument for the "resurrection" of the Snyder-Gray case in film noir classics such as *Double Indemnity* (1944), *The Postman Always Rings Twice* (1946), and such neo-noir classics as *Body Heat* (1981). But if the story of an adulterous love affair and murder inspired Hollywood films, there were two other murder cases involving women killers that inspired horror. They seemed to be tales of madness.

"The Most Beautiful Murderess"

In December 1926, *Chicago,* a play written by *Chicago Tribune* reporter, Maurine Watkins premiered in New York City. The play was drawn from Watkins' coverage of two sensational murder trials with female defendants. The play focuses on how press coverage of the case of fictional murderess, Roxie Hart, transforms her from a drab woman who killed the lover who tried to leave her into a sympathetic, even glamorous, media celebrity. In the play,

"The Most Beautiful Murderess" *Continued*

reporter Jake Callahan is elated by the possibilities offered by the story which has all "the makin's: wine, woman, jazz, a lover" (Watkins, 1927: 16). He decides to bill Roxie in his story as " the most beautiful murderess" (Watkins, 14). Other characters in the play include Mary Sunshine, a reporter for a competing newspaper who writes about the hardships of the women in jail. By the time Roxie goes to trial, she has acquired "a new identity that exonerates her actions and makes her socially acceptable" (Pauly, 1997; Introduction, x).

The play offers a satirical examination of both the motives of the reporters who pounce on the killings, and of the eagerness of Roxie and the other inmates on "murderess row" to vie for media attention. As a real-life reporter, Watkins later wondered if she had contributed to the acquittal of several women accused of murder with her witty coverage of their cases (Pauly, Introduction, xiii). For example, when accused murderer Beulah Annan announced she was pregnant, Watkins in a May 1924 article asked what counted with a jury when a woman was on trial. Was it youth and beauty? What if the woman could add motherhood?

> For pretty Mrs. Beulah Annan, who shot her lover, Harry Kohlstedt, to the tune of her husband's phonograph, is expecting a visit from the stork early this fall. . . .(Watkins 133).

When Annan was acquitted, Watkins wrote:

> Beulah Annan, whose pursuit of wine, men, and jazz music was interrupted by her glibness with the trigger finger, was given freedom last night by her "beauty proof" jury (Watkins, 143).

In *Chicago,* fictional murderer Roxie Hart is also found not guilty. When the play was filmed as the movie, *Roxie Hart* (1942), film star Ginger Roger portrayed a Roxie who readily won sympathy from the all male jury during her courtroom testimony.

After Watkins' death, her play was transformed into a musical by choreographer Bob Fosse. That musical premiered in 1975. In 1996, the musical version of *Chicago* was revived to rave reviews. *Chicago* (2002), the movie has been equally successful, garnering not only glowing reviews, but the Oscar for Best Picture. This movie about "media hype" has led some reporters to ponder the impact of the "hype machine" on American culture (e.g., Danton, 03/09/2003).

A Trunk Murderess and Raging Sheep

In retrospect, the **Winnie Ruth Judd** case may be about corruption within the criminal justice system. But in 1931, it seemed to be about an insane woman who had killed her two best friends, dismembered them, and traveled to California with their dismembered bodies in trunks and a suitcase. On November 10, 1931, the

New York Times reported that Judd, the "reputed 'trunk murderess," was being held for trial on the charges that she had murdered Mrs. Anne Le Roi and Miss Hevig Samuelson. The article noted that the hearing had drawn a crowd of a thousand people who had fought in vain to get into the courtroom. The *Times* went on to note that during the hearing, Judd had often whispered to her attorneys. She had been amused enough by the response to a question that she had told them to ask to laugh aloud (*NY Times*, 11/10/1931, Mrs. Judd Held).

In February 1932, Judd was found guilty of first-degree murder. An Associated Press article reported that Judd had heard the verdict read with no show of emotion. She continued to bandage and unbandage her left hand with her handkerchief – a habit that she had displayed during the trail. According to the reporter, she was able to walk out of the courtroom without assistance, and she stared down anyone who looked at her as she made her way back to her cell (*NY Times*, 02/19/1932).

When she appeared before the judge for sentencing, an article that was "Special to The New York Times," reported that Judd had tried to speak. However, her "rambling story" and claim that the State had not proven its case, had tried the judge's patience. However, before he could pass sentence, Judd asserted that the two women she had been convicted of killing had not been murdered. The judge then sentenced her to death as she "stood defiantly" at the defense table (*NY Times*, Mrs. Judd to Die, 02/25/1932; see also Fox 1985).

But Judd was not put to death.

Her sentence was commuted, and she was sent to an insane asylum. Exactly how her two friends died, remains something of a mystery. Jana Bommersbach, an investigative reporter who published a book about the case in 1992, reviewed the police reports and court transcripts and interviewed people who lived in Phoenix, Arizona when the murders occurred in 1931. She also did extended interviews with Judd herself and had a police detective, a judge, and a forensic expert review the evidence. She concludes that Judd was convicted of first degree murder for a homicide (or homicides) that she committed in self-defense. According to Bommersbach, because the man who Judd recruited to help her was a well-known and well-connected businessman who could not afford to be involved in scandal, he was protected from prosecution even when the police became aware of his involvement. Judd, on the other hand, was villified as the "trunk murderess." Whether or not, Bommersbach's conclusions are correct, what can be said with certainty is that in the aftermath of the killings, Judd emerged in popular thought as monstrous. The story of her nightmarish journey with two dismembered bodies in trunks and a suitcase was perfect for narration as a horror story.

After being sentenced to an asylum, Judd escaped repeatedly. Once she was free for six and half years during which time she lived with a wealthy family in Oakland, California as their valued servant. She was exposed when her nephew, for whom she had purchased a car, left it near a crime scene. But, with the aid of attorney Melvin Belli, Judd was paroled by the state of Arizona.

She returned to Oakland, California and moved into an apartment as Marian Lane, the name she had used during her escape.

But when she was Winnie Ruth Judd did she kill two people? She admitted killing one of her friends (perhaps the other as well) in self-defense during an argument. The reason for that argument offers a fascinating insight into American life in the 1930s. The two friends, one of them an X-Ray technician at the clinic where Judd worked, the other a school teacher suffering from tuberculosis and too ill to hold a job, had been Judd's roommates at one point. Judd's husband, a drug-addicted physician, was always away in search of another job, and the three had become close. They often entertained friends, many of them men, at the apartment. On the day, that Ruth Judd and her friends, Anne LeRoi and Hevig "Sammy" Samuelson quarreled, Sammy was angry at Ruth because she had introduced one of their wealthy gentlemen friends to a new nurse from the clinic. The gentleman friend, Jack Halloran, was married, but he had been generous with all of the women. Sammy was upset because the nurse Ruth had introduced him to as a companion on a hunting trip to the desert had syphilis. As Bommersbach (1992: 155) writes, "The threat of syphilis has no modern equivalent; not even AIDS carries all the weight syphilis did in those days."

Even though—as Ruth Judd recounted the story to Bommersbach—Sammy had been outraged, Ruth had not been particularly concerned about the introduction because she did not expect the nurse and Halloran to become involved. But the argument with Sammy led to threat and counter threat. Sammy threatened to tell Halloran what Ruth had done. Bommersbach (1992) theorizes:

> If Jack Halloran knew Ruth had exposed him to a woman with syphilis, he would surely have broken off their affair? And what about Ruth's husband? Implicit in Anne's threats was the revelation to Dr. Judd that his nice young wife was sleeping with another man. If there was any social taboo that headed the list in 1931, it was an illicit affair . . . (156).

But there was another taboo, that of lesbianism. During the argument, Ruth Judd threatened to confirm the suspicions that some people at the clinic had that Sammy and Anne, who were devoted to each other, were also lovers. This would have placed Anne's job in jeopardy, and she was the only breadwinner (although she too had contracted tuberculosis).

This is the scenario, the story that Bommersbach pieces together. During a struggle with Sammy who had attacked her, Ruth shot her. Then Anne attacked Ruth. Ruth shot and saw Anne fall back. Ruth passed out. When she came to on the floor, she thought that Anne was dead too. In a panic, she called Halloran, who came to help her clean up. After sending Ruth away, he found someone to dismember Sammy's body. It was he who put the

bodies in the trunk. And, according to the story that Ruth Judd finally told, it was he who had instructed her to take the still bleeding bodies with her on the train to California. But Halloran, who was later tried as an accomplice, was acquitted (Bommersbach, 1992). Winnie Ruth Judd who had killed her friends (or at least one of them), but who probably did not commit cold-blooded murder became notorious as the "Tiger Woman!" and the "Wolf Woman." It was she who in stories told to children was the infamous "trunk murderess" who would come and get them if they misbehaved.

In February 1933, two sisters also became raging women to haunt children's nightmares. In the French town of Le Mans, they were charged with a double murder. **Lea and Christine Papin** had worked as housemaids in the home of the Lancelin family. They killed the mother and daughter of the household. In committing the murders, the sisters, age 21 and 27, attacked their victims viciously, killing them with a knife and a hammer, and gouging out the women's eyes with their fingers. After the attack, they did not run away.

When Monsieur Lancelin, a retired solicitor, became annoyed because his wife and daughter were late joining him for dinner at a relative's home, he tried calling them. When there was no answer, he became worried and went home. The doors were locked from the inside, but no one answered. Lancelin went to fetch a police officer. The officer climbed in through a window and found the dead women. When he went looking for the maids who he feared might also be dead, he found them in their attic bedroom. They were wearing only their pink dressing-gowns and laying together in each others' arms. The bloody hammer was on the floor beside the bed (Jouve, 1994: 7).

This sensational story of savage murder and possible homosexual incest, received wide-spread media coverage. The two sisters were described by such names as "The Monsters of Le Mans" and "The Raging Sheep." The last name was a reference to the fact that they had worked for their victims for years and had seem quiet and well-behaved. The task faced by investigators, legal, psychiatric, and media, was to discover what it was in the Papin sisters' histories that could account for their crime, for the rage that had led to such a savage attack on two other women (Paton, 2000).

In the second volume of her autobiography, Simone de Beauvoir described the reaction of the young French intelligentsia, of which she was a member, to the case:

> The tragedy of the Papin sisters was immediately intelligible to us. In Rouen [where Simone de Beauvoir was teaching at the time] as in Le Mans, perhaps even among the mothers of my own pupils, there certainly were some women who subtract the price of a broken plate from their maids' wages, who put on white gloves to track down motes of dust that have been left on furniture: in our eyes, they deserved death, a hundred times over. With their waved hair and white collars, how good Christine and Lea seemed . . .

> What was responsible was the orphanage in which they had been put as children, the way they had been weaned, the whole hideous system devised by so-called good people and which produces madmen, murderers and monsters . . . (quoted in Jouve, 1994: 8).

As de Beauvoir recalled, the young intellectuals in her circle had imagined the Papin sisters taking "dark justice" against an oppressive system. The spark that had ignited the sisters' rage might have been their fear of Madame Lancelin's reaction when she discovered that an iron, recently repaired, had been damaged again when a fuse blew (Jouve, 10). But the psychiatrists and others who studied the case and observed the sisters suspected that the rage had been long simmering.

While in prison, Christine Papin showed signs of mental instability. The elder of the two, Christine cried out for her sister and begged to see her. She experienced "fits" and convulsions (apparently of a sexual nature), hallucinated, and attempted at one point to gouge out her own eyes (requiring restraint in a strait jacket). At trial, the two sisters did not deny that they had killed, but they did deny that they had been involved in an incestuous relationship. Christine was convicted and sentenced to death for her part in the murders. Lea, who apparently took part in only one of the murders, that of the mother, was sentenced to ten years' hard labor. Later, Christine's sentence was commuted to imprisonment, but she fell into a deep depression and "wasted away" ("cachexie"). Receiving time off for good behavior, Lea was released after eight years. Under an assumed name she found a job as a hotel chambermaid and remained anonymous until years later when a journalist sought her out for an interview. She died in 1982 at the age of seventy (Paton, 2000).

The case of the Papin sisters jarred observers into discussions about the social structure and about servant-employer relationships. Later, it was also interpreted as a classic example of a condition known as *folie a deux,* "a shared paranoid disorder" in which two people do what neither would have done alone. That is, they "go mad" together (Paton, 2000). But whatever the reason for their acts, for contemporaries there was something in the brutality of the murders that also suggested that something "monstrous" might lurk in the hearts of the most meek appearing women.

Summary

This chapter has looked at the cultural forces that were at work in early 20th century America and in Europe. These forces included the mass media which in magazines, films, and books helped to construct the varied and evolving images of the "New Woman." In social science, the work of Lombrosian criminologists with their focus on criminal anthropology in conjunction with Social Darwinism and the eugenics movement had an impact on both perceptions of women criminals and the responses to them.

Yet, throughout this era, older concepts such as male chivalry toward women and honor and reputation continued to play roles in both the behavior of female offenders and the responses of jurors to them.

By the 1920s, Freudian psychoanalytic theories and the work of the alienists was being evoked in high profile trial such as the Snyder-Gray case. The Snyder-Gray case occurred during the era of jazz journalism, and media coverage framed the case to appeal to the audience for whom the tabloids competed.

Finally, the chapter ended with a look at two cases in which images of women and madness took center stage. But as in the other cases discussed in this chapter, the Judd case and the case of the Papin sisters were interpreted at the time, and have been since, to reflect existing social issues.

The next chapter looks at women and murder in the post-World War II era, forcing on the social forces related to domestic life that were at work.

Discussion Questions

1. Discuss the image of the vampire and its link in popular culture to female sexuality and deviance.

2. Discuss the theories put forth about Belle Gunness with regard to gender and crime.

3. Discuss the cases presented here in which women killed and were acquitted by juries. Is the idea of a woman's defense of honor in conflict with cultural constructs of the "New Woman"?

Exercises

1. Watch *Double Indemnity* and compare the film portrayal of adultery and murder to the Ruth Snyder-Judd Gray case.

2. Watch *The Maids,* based on Jean Paul Sartre's play, and discuss the depiction of the two female servants in the film and their relationship with the employer that they plot to kill.

Notes

[1] Stoker was inspired by the legend of Erzsebet (Elizabeth) Bathory (1560/61-1614), a 16th century Transylvania countess who is supposed to have killed six hundred young women in her mountain principality because she believed that if she bathed in—or drank—the blood of young virgins it would keep her young. Bathory went too far when she established an academy for young ladies from well-to-do families and also began to kill them as she had been doing with peasant girls. When she and her accomplice, Doretta Szentes, began throwing bodies over the castle wall, the villagers had evidence concerning the disappearances that had been occurring. The Hungarian Emperor, Matthias II, ordered Bathory's arrest and public trial. Her aristocratic status did not allow arrest, but under an act of Parliament this privilege was removed and she was brought before a formal hearing in 1610. Doretta and several "witches" were burned alive. The countess could not be executed, but was sentenced to house arrest, sealed in a closet in her castle. She died four years later (Krause, online).

[2] Also see the case of Angelina Napolitano, the Italian immigrant to Ontario. Napolitano, a young mother of four, killed her husband with an axe as he slept. She was seven months pregnant at the time. She claimed that she had killed her husband in retaliation for physical abuse and his insistence that she become a prostitute. Dubinsky and Iacovetta (1991:505) find, "Napolitano's guilty verdict and the death sentence she received sparked one of the most impressive clemency campaigns ever launched on behalf of a Canadian murderer." As in other such cases, an important issue in the debate about Napolitano's guilt was the question of who was the "victim" and who was the "villian." As Dubinsky and Iacovetta (1991) note, although the criminal justice system had branded Angelina Napolitano as the victim, "[w]ithin the public arena was an entire theatre of contested assumptions and meanings" (506).

Shadron (1983) examines state and local records from the case of Edna Perkins Godbee, a Georgia woman in her forties, who at about the same time, shot her abusive ex-husband and his new wife in the local post office. Unlike the Napolitano case about which much is known, the Godbee case presents the challenge of historical reconstruction. Shadron offers the case as example of how state and local records can be used as women's history sources.

[3] Also see Jones (1980) for discussion of media coverage of the Synder case.

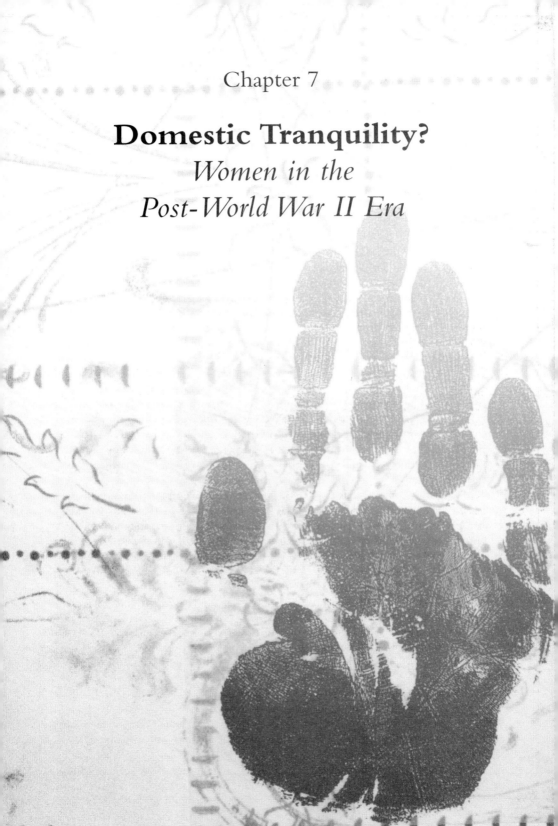

Chapter 7

Domestic Tranquility?
Women in the Post-World War II Era

> Life in Loyalton is like sitting in a funeral parlor waiting for the funeral to begin. No. Not sitting. Lying in the coffin and waiting for them to carry you out.

The woman speaking is Rosa Moline, the protagonist in *Beyond the Forest,* a 1949 movie starring Bette Davis. The audience is told in the prologue that Rosa Moline is not a "good woman." The narrator states: "This is the story of evil. Evil is headstrong. It is puffed up." Rosa Moline is the wife of a small town (Wisconsin) doctor, but she longs to escape to a life of glamour and excitement. In the final scene, sick and feverish, she dies in the street as she tries to get to the station to catch the 10 o'clock train to Chicago. But the audience is not supposed to feel sympathy (or empathy) for Rosa Moline. She had an affair with a wealthy businessman under her trusting husband's nose, and killed the elderly lodge keeper who discovered her adultery. She died from injuries she sustained when she flung herself out of a moving car to destroy her husband's child. She might not have been "evil," but Rosa Moline certainly wasn't the loyal wife and joyful mother-to-be that a women were supposed to be in the 1940s.

This Hollywood melodrama aims to depict the restlessness and desperation felt by at least one kind of woman—Rosa Moline's kind—when confined to domesticity and small town life. But this was not supposed to be how most middle-class women living in small towns and in suburbia felt about their lives. In the aftermath of World War II, many families had been able to achieve the "American dream." With the G.I. Bill, they had moved to the suburbs and purchased single-family homes. Birthrates were up and so was purchasing power. If the dominant images presented in popular culture were to be believed, life was good for these middle-class families. By the 1950s, television situation comedies such as *Ozzie and Harriet, Leave to Beaver, Father Knows Best,* and *The Donna Reed Show,* brought fictional depictions of this good life into American homes. In the ideal nuclear family of the mid-twentieth century, there were no unwanted pregnancies that ended in abortion and certainly no woman was ever desperate, depraved, or misguided enough to kill.

The Good Wife's Guide

Although the authors find no evidence that the magazine existed, an article credited to the May 13, 1955 issue of *Housekeeping Monthly* has circulated widely on the Internet (see www.snopes.com/language/document/goodwife.htm). The article instructs wives on how to greet their work-weary husbands, including:

> Be a little gay and a little more interesting for him. His boring day may need a lift and one of your duties is to provide it.

Exercise: Examine several popular magazines from the 1950s and discuss the possible impact of advice given to women (and men) about how to have a happy marriage.

However, even in the world of mass market magazines, there was some indication that real life did not always follow this cultural script. In her study of women's magazines published between 1945-1965, Moskowitz (1996) finds that in counterpose to images of domestic contentment, there was a "discourse of discontent." She asserts that the *Ladies' Home Journal, McCall's* and *Cosmopolitan*

> did not merely promote "the happy housewife" image. Indeed, far from imagining the home as a haven, the women's magazines often rendered it as a deadly battlefield on which women lost their happiness, if not their minds. Images of unhappy, angry, and depressed women figure prominently in these magazines, and this is found to be particularly evident in marital relations" (Moskowitz, 67).

At the same time that these popular magazines acknowledged the discontent of some women who were homemakers, they "promoted a variety of therapeutic techniques" for resolving the problems that women presented as causing their unhappiness (77). This is why Moskowitz argues that Betty Friedan's *The Feminine Mystique* (1963) was not as ground-breaking as she and many feminists believed.

> Ironically, while Friedan saw herself in opposition to the experts who promoted the "feminine mystique," many housewives perceived her as yet another expert analyzing and complaining about the state of women's lives ... Readers did not appear to make a distinction between Friedan's critique of domesticity and that of the magazines; instead, they found continuity (Moskowitz, 89).

However, Friedan's book appeared at a psychological moment for which the groundwork had been laid in the 1950s. As Molloy (1993) notes in the 1950s, there were underlying "cultural anxieties" present in the United States and other English-speaking countries. The factors contributing to these anxieties included the Depression of the 1930s, the recent World War, and the threat of nuclear war in the midst of affluence. Social historians have described the "exaggerated domesticity" of the 1950s, with its emphasis on gender divisions and female focus on marriage and motherhood as a reaction to this societal unease. Among the social scientists who contributed to the 1950s discourse about family life were the British psychologist John Bowlby, who wrote about the impact on children of "maternal deprivation," and Alfred Kinsey, who published the two best-selling Kinsey reports about the sex lives of married couples in America (Molloy, 2-3).

One aspect of gender politics in the 1950s and 1960s was that the demand for abortion increased as the procedure became less available.

Pregnancy Alternatives and Abortion Restrictions

Reagan (1997: 194) finds: "Structural changes in women's lives magnified the demand for abortion at the precise moment that the availability of abortion

was being severely limited." These structural changes were related to the growing number of women who were entering college and the workplace. As Reagan asserts, "both of these male-defined territories required that women postpone and control childbearing." Day-care services were not provided by schools and businesses, nor were flexible work schedules. Moreover, "[o]nce a woman was visibly pregnant, her school would expel her and her boss fire her." This left women in a "double bind—required to control their reproduction and forbidden the means of doing so." Some women who found themselves pregnant, believed abortion was their "only option" (Reagan, 1997: 194; see also Solinger, 2000).

Theoretically, there was the option of having the child and giving it up for adoption. But this meant that the mother, often unwed, would have to risk scandal if her pregnancy was discovered. Some middle-class women went or were sent away to homes for unwed mothers.[1] However, this was often not a viable solution for poor and working class women. So pregnancy or the risk of pregnancy remained a problem for single women. Obtaining birth control was a "near impossibility" because physicians and clinics would not provide contraceptives to unmarried women (Reagan, 196).

Some women turned to abortion as the solution to an unwanted pregnancy. However, as Reagan points out the logistics of getting an abortion had become more complicated than in the past. She cites the example of New York City where by 1955 not only were there fewer practicing abortionists than in 1940, but a "sharp crackdown" had pushed the prices charged by those still in business up to more than triple the pre-war era. "One magazine investigated abortion in nine cities in 1955 and found that prices charged by physician abortionists ranged from $200 to $500" (Reagan, 197).

Abortion practitioners also were taking more precautions. Contacts were used more often. Women were sometimes blindfolded before being taken to secret locations. And because of the shortage of practitioners, the women were sometime forced to turn to abortionists that they found less than respectful, who sometimes were dirty and ill trained, and even demanded sexual favors (Reagan, 197-200). By the 1960s, some women had learned that one route for obtaining an abortion was by finding a psychiatrist and claiming to be suicidal. However, this route to a "therapeutic abortion" was only successful "if she found the right psychiatrists and said the right words. Women learned to speak of their emotional distress and suicidal intentions" (Reagan, 201). Among those women who either lacked the means or the access to an abortionist, as in the past, self-induced abortions continued to be another option. As in the past, this was a dangerous option, sometimes resulting in the death of the woman. One of the more common "and frequently fatal" methods of self-induced abortion was douching with soap or bleach (208-209).

> The racial differences in abortion-related deaths and access to safe therapeutic abortions mirrored the racial inequities in health services in general and in overall health. Maternal mortality rates of

black women were three to four times higher than those of white women (Reagan, 213).

But on the surface, the majority of middle-class American women seemed to be leading lives that were untroubled by problems such as unwanted pregnancies. Feminists such as Betty Friedan would later challenge this image of domestic bliss. They would argue that not only were reproductive rights (access to contraception and abortion) an issue, but that these issues reflected what was wrong with gender relations in America. Middle-class American women were neither Rosa Moline, nor June Cleaver. They were oppressed by their lifestyles, and by the 1960s many of them were ready to rebel.

On the Status of Women

It is my thesis that the core of the problem for women today is not sexual but a problem of identity—a stunting or evasion of growth that is perpetuated by the feminine mystique. It is my thesis that as the Victorian culture did not permit women to accept or gratify their basic sexual needs, our culture does not permit women to accept or gratify their basic need to grow and fulfill their potentialities as human beings, a need which is not solely defined by their sexual role.

Betty Friedan, *The Feminine Mystique* (1963), p. 77

Good Time Girls

Two women, who are of interest here, did rebel. These two "party girls"—**Barbara Graham** and **Ruth Ellis**—made headlines in the United States and in England, respectively, during their murder trials. Each received the death sentence. Each is still a controversial figure and a *cause celebre*.

In 1955, actress Susan Hayward portrayed Barbara Graham in the Hollywood film, *I Want to Live*. Although there was criticism from those who had been involved in the case about the accuracy of the film's portrayal of Graham, the movie won an Academy Award. It remains one of a few films dealing with women and the death penalty. It is probably the sum total of what most Americans know about the Graham case. In the film, Graham is presented as a woman with a ready wit. When one of the guards at her execution advises her to take a deep breath when the lethal gas is released because that will make it easier, Graham retorts, "How the hell would you know?" The prison staff is shown suffering with Graham when she is given two stays on the day of execution, each coming moments before she starts into the death chamber. A belatedly sympathetic reporter who attends her execution has the final word as he leaves the prison.

In real life—as seen in the film—Barbara Graham was portrayed as "Babs, the party girl" and dubbed "Bloody Babs." She was described as a prostitute and a liar (she had once served time for perjury). She was also described as the female decoy who persuaded an elderly woman to open the door of her house so that Graham and her male partners in crime could rob

her. According to one of these men, it was Graham who pistol whipped the victim when she refused to reveal the location of the money her ex-son-in-law, a gambler, supposedly kept in her house.

Also damaging to Graham's case was the close (lesbian) relationship she was reported to have had with another inmate while she was awaiting trial. Approached by an undercover policewoman who had become aware of the relationship, the inmate agreed to set Graham up in exchange for favorable treatment in her own case. The inmate suggested that Graham allow her to help provide her with an alibi. A male friend would come to see Graham and the two of them could concoct a story about having been together when the robbery and murder were occurring. Graham agreed. The man who came to see her, and who she was sure would provide her with an alibi, was a police detective who testified for the prosecution—complete with tape recording of their conversation. This effort on Graham's part to clear herself and to thereby shift the blame to the two male friends that were standing trial with her, alienated them. But this was a secondary issue because one of their group had turned state's evidence, and Graham had been caught in a lie. All three defendants were convicted of murder.

Did Barbara Graham do it? She said, no. She said, she had done a lot of bad things but not murder. She claimed that she had fallen in with bad company, including her drug-addicted husband, who she had kicked out. But before he left, he had introduced her to the men with whom she was arrested and charged with murder. Even before Barbara met Harry Graham, her life had been difficult. She had been the illegitimate child of a teenage mother, who was sent to a reformatory when Graham was two years old. After that Graham was raised by neighbors. When her mother returned, their relationship was not good. Her mother often reminded her that she was illegitimate and that she had no use for her. However, her mother refused when a social worker wanted to adopt her daughter. Eventually, Barbara Graham ended up in the same reformatory that her mother had been in as a teenager. When she was released, she tried various legitimate jobs. She got married and had two children. But the marriage failed and Graham began to drift into prostitution, getting her start with other young woman who provided companionship to sailors on shore leave (" sea gulls"). After several more attempts to go straight, and two more marriages and divorces, Graham met her fourth husband Harry Graham. She had her third child, Tommy. He was two years old when she was executed (Howard, 1999).

Those who defend her argue that because Graham's lifestyle was unorthodox—the antithesis of 1950s domesticity—she was vilified during her trial. She was not a suburban wife and mother. She was flashy and outspoken. As O'Hare (forthcoming) observes, "Graham was an ideal subject for media coverage." As they vied for readers, the five Los Angeles daily newspapers seized on the case of a young, attractive woman accused of a "man's crime"—robbery and murder. In their coverage, they focused on Graham's physical appearance, describing her hair as alternatively blonde, red, or brunette, but generally as a

signifier for her bad character. Reporters described her "lacquered fingernails," shapely thighs, and stylish clothes. Such commentary followed Graham until the moment of her death, with newspaper accounts of what she wore as she walked to the gas chamber (O'Hare, forthcoming). In his study of newspaper coverage of the case, Nichols (1990) finds that aside from the emphasis on her appearance, reporters also tended to assume Graham's guilt and to focus on tangential and lurid aspects of her personal life. Receiving more coverage than her two male co-defendants, much of it stigmatizing, Graham was unable to convince a jury that she was innocent of the crimes of which she was accused (Nichols, cited in O'Hare, forthcoming).

In the case of Ruth Ellis, who was British and the other notorious 1950s party girl, there was no question that she had killed. She followed her upper-class, "playboy" lover, David Blakely, and waited for him to come out of a tavern. Then she yelled out his name and emptied her gun into him as he tried to run from her. In the process, she injured a banker's wife, who was headed to the tavern with her husband and who was struck by a ricocheting bullet. There was no question that Ellis had committed homicide, the question was did she deserve to die.

Ballinger (2000) finds that immediately after the shooting and before the trial began, public and media discourses "placing Ruth firmly within the 'bad' rather than the 'mad' category was activated." Descriptions of Ellis as "a model" and a "club-hostess" carried implication that she "was a lower class woman employed in non-respectable professions" (Ballinger, 293). In an era when increasing attention was being paid to the nuclear family and threats to its existence, Ellis as a "bad woman" symbolized "moral decay." When she killed her lover, "she provided the ultimate reinforcement of her dangerousness." She fit the stereotype of the femme fatale, and she had carried out what seemed to be the cold-blooded revenge execution of the man she claimed to love (Ballinger, 297).

Ellis had been persuaded to plead not guilty on the grounds of provocation. However, during the trial, she did not try to portray her act as a crime of passion. When she took the stand (as only one of two witnesses called by the defense), she admitted that David Blakely had moved in with her when she was still married. She also admitted that she had taken another lover, Desmond Cullen, while she was involved with Blakely. She admitted that at one point she had been pregnant with Blakely's child and that he had offered marriage, but she had told him she could "get out of the mess quite easily" (an abortion) (Ballinger, 303). In fact, Ruth Ellis on the stand, did nothing to help her own case. She was not sweetly feminine and fluttering, but stylish and cool (see Chapter 11). An editorial that appeared in one newspaper, the *Daily Telegraph*, reflected the perception among the media and the general public that Ruth Ellis, by her behavior, had placed herself beyond the pall. As this editorial illustrates, she was seen as not deserving of the chivalrous treatment – "the leniency" – that was traditionally shown to women (quoted in Ballinger, 299).

During her trial, Ellis's attorney argued that Ellis's lover had treated her badly. He had dangled the prospect of marriage before her while he pursued other women. He had abused her, physically and psychologically. In the end, Ellis, had felt that the only way she could be free of Blakely was to kill him. But Ellis's attorney failed to pick up on and develop the matter of Ellis's condition prior to the killing. Ellis testified that she had gone for three days with little sleep, drank a great deal, and smoked constantly, as she became more obsessed with finding Blakely and confronting him. The attorney did not call the psychiatrist who she had been seeing for several months and who was treating her with tranquilizers for emotional distress at the time of the shooting (Ballinger, 316-317). Neither the police nor the lawyers involved looked closely at Desmond Cullen's role in the crime. It was he who drove Ellis in his car to find Blakely. He might have supplied her with the gun that she used (Ballinger, 319).

Because of the failure of the defense to develop a strong counter-narrative, the account told by the prosecution stood. Even Ellis's own testimony seem to reinforce the image of her as the greedy, sexually promiscuous manager of a night club who had been the mistress of a upper class man. Not content with that role in his life, she had demanded more. When he had tried to break it off, jealous and vengeful, she had stalked him and killed him. This was a "party girl" who had not known her place.

Like Barbara Graham, Ellis paid for her unacceptable image with her life. In the prosecution and media narratives, not only their alleged crimes, but their immorality—their rejection of respectable lifestyles—was used in constructing them as women who deserved to die. But what of the women killers who appeared to be living quiet, middle class lives?

Still A Woman's Weapon

In his 1950 book, *The Criminality of Women,* Otto Pollak wrote about what he described as the "largely masked criminality" of women (5). He asserted that women possess a unique ability when compared to men not only to conceal emotions and bodily functions, but to conceal criminal behavior. Pollak wrote, "There seems to be almost unanimous agreement among criminologists that the woman who kills uses poison more than any other means"(Pollak, 16). In this section on homicide, Pollak reported, "The poisons which women employ in their homicidal attacks on human life are rather few in number. Outstanding and most frequently used of them all are derivatives of arsenic." Having identified arsenic as a woman's poison, Pollak explained:

> The reasons for the frequency with which arsenic is used are the following: It is easily obtained as an insecticide or rat poison for apparently legitimate uses in the household. It is easily disguised in food or drink, and the signs and symptoms which it produces are often deceptively similar to those caused by all diseases which lead to gastroenteritis, such as cholera, typhoid, intestinal flu and others.

The detectability of the poison is particularly low when the victim has already been suffering from a chronic disease which suggests a natural cause of death... (Pollak, 17).

Pollak went on to discuss the social roles that women played as food preparers and nurses for the sick that gave them easy and ready access to their victims. He pointed out that for a woman to buy a gun would be suspicious. If she tried to engage in an overt physical attack her victim would defend his or herself. Therefore, poison made a much more practical and sensible weapon. Although Pollak admitted men with access to poisons (i.e., doctors and druggists) did sometimes use these poisons in homicides, he dismissed such men as only a "very small fraction of the male population." Women on the other hand were the majority of the people who played the social roles he had identified (Pollak, 18), and one aspect of the use of poison as a weapon was that it made it easier for women than for men to successfully mask a homicide (Pollak, 18).

Writing in the mid-twentieth century, Pollak repeated the arguments that 19th century Victorians had made about women and the use of poison. According to Pollak women still had opportunities, and at least some of them seemed to believe that they had motives for murder. As wives, mothers, and caregivers, these women were in perfect positions to engage in this secretive, underhanded form of murder and get away with it.

When well-known and well-liked, restaurant owner **Anjette Lyles,** a resident of Macon, Georgia, was arrested for murder her friends and neighbors were shocked. She had been a wife, working in the family restaurant with her husband, until he died. She was a mother, although her nine year old daughter had also died. She was charged with the murders over a seven year period of two husbands, her mother-in-law, and her daughter. If the charges were true, Anjette Lyles was a serial killer.

As the case unfolded, there were stories told by the staff who worked in the restaurant about Lyles' sometimes eccentric behavior, including her use of voodoo rituals in an attempt to obtain what she desired. Her employees told of her habit of burning candles, red or black or white, as a part of these rituals. They also told about the meals she had taken to her ailing daughter in the hospital. Was it possible that Lyles, the loving mother, had poisoned her child in the same way she had the adults she was accused of killing? Carrie Jackson, the African American woman who worked as a cook in the restaurant, had believed Lyles was poisoning her child. She had sent an anonymous letter to the child's great-aunt that said, "Please come at once. She is getting the same dose as the others" (quoted in Jordon, 2000: 1). But it was not until after the child was dead that Jackson's suspicions were confirmed with an autopsy.

In the courtroom, Lyles presented herself as a stylish, almost glamorous figure. Spectators lined up to listen to the proceedings. Witnesses in her defense described her as a sweet, loving woman who would go out of her way to be kind. But the prosecution presented a more sinister story. Charles Adams, the prosecutor, told the jury (and the spectators):

> Anjette Lyles is one of the most scheming women that anyone could imagine. She killed four people who loved her out of hate and greed. As the case is presented to you in this courtroom, you are going to hear a chilling tale of malice and greed (quoted in White, 1999: 84).

According to the prosecutor, Lyles had killed her first husband, Joe, because he was not ambitious enough. Feeding him arsenic, she had driven him "practically insane." Formerly, a strapping six-footer, he had been reduced to a "cold corpse" (White, 1999). Lyles had received $20,000 in insurance money when her husband died. She was broke three months later and in search of another victim.

In presenting the case against Anjette Lyles, the prosecution called doctors and nurses who testified about Lyles' behavior at the hospital when her daughter was dying. They told of Lyles' coldness and her certainty that the child would die even when she seemed to show signs of improvement. Lyles' defense attorneys attempted to discredit these prosecution witnesses and to present alternative theories. When it was the defense's turn, they called on Lyles herself to testify. How she would present herself, the hope that she could make a favorable impression on the jury, was crucial to her defense.

> Looking solemn and sincere, several pages of notes in one hand, Anjette made her way to the witness stand. She wore a long-sleeved black jersey dress with a big gold buckle. The famous platinum hair was demurely pinned up close to her head. She settled in the chair, turned slightly to her right so that she could face the jury and began to speak in a clear, calm voice (White, 1999: 143).

In its October 14, 1958 edition, the *Atlanta Journal* commented on Lyles' demeanor during the trial. The newspaper noted that Lyles portrayed herself as a woman, who even as she faced a string of personal tragedies, continued her valiant struggle to provide for her children (Jordan, 2000: 4). Lyles told the jury that she had not killed anyone. Then she attempted to explain the evidence that had been presented against her. The jury, however, did not believe her. They found her guilty of murder. Her sentence was death in the electric chair.

This sentence was controversial because it was unheard of for a white woman to be sentenced to death. In fact, both the media and Lyles's attorney emphasized that if her sentence were carried out, she would be the first white woman that the state of Georgia had ever executed. As White (1999: 154) observes, "That statement made a lot of people uneasy in the pre-civil rights South of 1959." However, her attorney said he was seeking justice, not sympathy. He argued that the state "had presented an inflammatory case to the jury" (White, 154).

Lyles was sent to Reidsville, the state's largest prison to await her execution. Special accommodations had to be made for her as a prisoner awaiting death. If she did die, she would be only the second woman to be

executed at Reidsville. The first had been an African American woman named Lena Baker, who had been executed in 1945 after being convicted of killing her white male employer. But Lyles was luckier. The governor granted a 90-day stay so that her attorneys could prepare a motion to the Board of Pardons and Paroles to have Lyles' sentence commuted. They argued that although she appeared to know the difference between right and wrong, she was actually suffering from "psychosis" (White, 162-163). To the outrage of the prosecutors who had tried her, the three medical professionals, two psychiatrists and a doctor, assigned to Lyles' Sanity Commission reported that she was a "chronic paranoid schizophrenic" (White, 170-171). Prosecutor Charles Adams remarked that Lyles deserved to receive "the Academy Award as the best actress of 1959" (White, 171).

Whether Lyles was insane or only giving an award-winning performance, her sentence was commuted. She would not become the first white woman to die in Georgia's electric chair. Instead, she lived out her remaining days in an asylum, where she became increasingly withdrawn. She died in 1977, at the age of fifty-two (White, 174). With other women, such as Joyce Turner (who with her two best female friends planned and carried out her husband's murder), Anjette Lyles represented the underside of domesticity in small towns and suburbs. These were the women who were not supposed to kill, but who did, and narratives had to be constructed to explain why.

Narratives were also required to explain the lethal violence of teenage girls. Although the subject of this book is women who kill, the discourse during this period about dysfunctional families and mothers who were ineffective in their socialization tasks suggest it would be profitable to look at two high profile cases involving adolescent girls.

Adolescent Aberrations

As historians and scholars of popular culture now document, another aspect of life in the 1950s was the perceived "teenage rebellion" that ran parallel to images of well-scrubbed, well-mannered adolescents. This rebellion was said to have its roots in the disruption of family life caused by World War II when men left home to serve in the military and women took jobs in war industries. It also reflected the rise of the teenager as "consumer," with an allowance or money earned in part-time jobs. Increasingly, entrepreneurs, from Hollywood film makers to manufacturers of acne cream, rushed to provide the goods and services that would appeal to these adolescent consumers. At the same time, according to critics, some aspects of popular culture, such as rock and roll and horror comics, offered role models and images that teenagers should not emulate. This was the era when Elvis Presley's gyrating hips could not be shown on network television. It was also the era of the Senate hearings to investigate sex and violence in comic books.

Two cases will serve to illustrate the worst nightmare of those who feared adolescents in rebellion. One occurred not in the United States, but in Christ-

church, New Zealand. However, it was linked to the United States by motive—the two young killers had hoped to come to America to publish their novels and to become actresses in Hollywood. An observer writing about the case in 1955, recalled the Leopold and Loeb murder case in Chicago in the 1930s, when two brilliant and wealthy young men had committed a "thrill-killing." As had the Leopold-Loeb case, the Parker-Hulme case sent shock waves through the society in which it occurred (Furneaux, 1955, p. 1).

The New Zealand case involved two teenage girls, **Pauline Parker and Juliet Hulme.** The girls, schoolmates, became strongly attached to each other. Both sets of parents were concerned that the relationship was "unhealthy." When Juliet's father, a scientist, decided to resign his post as Rector of Canterbury College and return to England, it was decided that Juliet would go with him as far as South Africa. Pauline wanted to go with her. They decided that the only way that would be possible was if they killed Pauline's mother.

According to *The Star Sun* (1954), the Crown Prosecutor offered a motive for the crime in his opening statement. He said that the girls had resented Mrs. Parker's efforts to break up a relationship that she considered "unhealthy." The Prosecutor asserted that this resentment became hatred and they formed the plan to kill her (*Star-Sun*, 1).

They carried out their plan, which they hoped to make look like an accident, by bludgeoning Pauline's mother to death during a walk with a half brick wrapped in a stocking. When they were found out and convicted of murder, the girls were sentenced to an adult prison. On release, Juliet returned to England. Many years later, as a movie was being made about the case, Juliet was discovered living quietly in a village near her mother. As an adult, she had become Anne Perry, a best-selling writer of historical murder mysteries. Still in New Zealand, Pauline had disappeared into obscurity.

In the film about the crime, *Heavenly Creatures* (1994), the murder is presented as a *folie a deux* in which two adolescent girls, ages fifteen and sixteen, come together to commit a horrible act that neither of them would have committed alone. Both girls are portrayed as on the fringes of their peer group because of medical conditions. Both are emotional and sensitive. The film portrays them as not just close friends but lovers caught in the throes of a fantasy romance. When asked about this aspect of the case, Juliet Hulme, denied that she and Pauline Parker had been lovers. She said she remembered little about the actual crime.[2] However, during the trial, spectators noted Juliet's cool self-possession as compared to the sullen, "dumpy" Pauline. The defense attorneys for the two teenagers attempted an insanity plea. Both defense and prosecution presented psychiatrists to testify about the girls' ability to distinguish between right and wrong and as to whether or not they had "knowingly" committed the homicide. After reading the novels that the girls had written and Pauline's diary (which was entered into evidence) and interviewing the two girls, the experts agreed that the two were more intelligent than average—and like Leopold and Loeb believed themselves to be above the law. The defense experts said they had been involved in a fatal *folie a deux,* feed-

ing on each other's emotional dysfunctions. On the other side, the prosecution experts said that the girls were not insane, that they had known what they were doing when they committed the crime. The jury, who voted for conviction, apparently accepted the assessment of the Crown Prosecutor who described Parker and Hulme as "two highly intelligent and perfectly sane but precocious and dirty minded girls" (Furneaux, 1955: 1; see also Gurr, 1994; The Press, Oct. 5, 1991; and *The Press,* Aug. 6, 1994).

The phrase "dirty minded girls" referred to the strong suspicion on the part of the Crown Prosecutor and some of the experts that the girls had been involved in a lesbian relationship (directly tied to the fantasy world they had created in their novels and stories). Molloy (1993) finds that the Parker-Hulme trial was the first of two "sexual scandals" involving young people that rocked New Zealand in 1954. The other involved the discovery of improper sexual behavior among sixty male and female school children in Lower Hutt, New Zealand. The response by the government to this was to appoint a special committee to investigate "moral delinquency" in the young. In its report, the Mazengarb Committee ignored the fact that the delinquency rate in New Zealand "had been more or less stable since the end of the war" and was actually lower than it had been between 1938 and 1946. In its report, the committee cited the media, broken homes, materialism, working mothers, and sexually aggressive girls as among the causes of sexual delinquency in New Zealand. During the trial of Parker and Hulme, testimony had revealed that both the Parker and Hulme families had irregular domestic situations. The Hulmes were about to divorce because of Mrs. Hulme's affair with a man who lived on the family estate. The Parkers had been together for years and had four children but had never actually legalized their relationship. The Parker-Hulme trial was repeatedly referred to during the Mazengarb hearings, which went on at the same time. Both Parker and Hulme were seen as having suffered the effects of "maternal deprivation." In fact, "[t]he focus on motherhood, and the complementary absence of fathers as significant actors in the constitution of the family and sexuality, was evident in the publicity surrounding the Parker-Hulme case" (Molloy, 1993: 14-15).

In a 1950's crime spree involving American teenagers, there were also elements of illicit romance and fantasy and apparent problems within the family. The relationship was between Charles Starkweather and his underage girl friend, Caril Fugate. Starkweather idolized actor James Dean, star of *Rebel Without A Cause,* a movie about alienated teenagers. In one photograph, Starkweather emulating Dean poses with cigarette dangling from his mouth, jacket open over white tee shirt. When he was introduced to Caril, the younger sister of the woman his best friend was dating, Starkweather began to court her. She had just turned thirteen. He was nineteen. But Starkweather began to tell people that he and Caril were planning to get married. He also said that she was pregnant with his child—a rumor that Fugate's parents heard.

Dissatisfied with his job as a garbage man, Starkweather decided to turn to crime. He robbed a service station and killed the attendant. Then when he

was fired from his job and locked out of his apartment for not paying his rent, he became desperate. On January 21, 1958, he drove to the house Fugate shared with her family. Although it isn't clear how involved she was in the murders, that day her step-father, mother, and their two and a half year old daughter were all killed. After cleaning up the mess, Fugate and Starkweather apparently spent the evening drinking Pepsi and eating potato chips. They stayed at the house for almost a week. During that time, several people became suspicious. But when Fugate's brother-in-law persuaded the police to go to the house and investigate, she and Starkweather had already gone. During the crime spree that followed, they committed several more murders. When they were finally taken into custody, the two were extradited back to Nebraska to face charges. They were both charged with first degree murder and murder while committing a robbery (Bardsley, 1999).

During her trial, Fugate claimed that she had been held hostage by Starkweather. However, he argued that he had often left her alone in the car, with the guns, and she could have left at any time. The jury did not see Caril Fugate as an innocent victim. With Starkweather, she was found guilty of murder. Because she was only fourteen years old, she was not given the death penalty that Starkweather received. Instead, she was sent to the Nebraska Center for Women, where she remained until she was paroled in June, 1976.

This case has significance not only in the annals of crime but in popular culture as well. Fugate and Starkweather's crime spree has inspired a number of movies, including *Badlands* (1974), *Wild at Heart* (1990), *True Romance* (1993), *Kalifornia* (1993), and *Natural Born Killers* (1994) (Bardsley, 1999). In *Natural Born Killers,* the slaughter of the teenage heroine's family comes as the climax of an interlude titled, "I Love Mallory." In this vicious satire of 1950s' situation comedies (with a nod to modern sitcoms about dysfunctional families), comedian Rodney Dangerfield is Mallory's vulgar, verbally and sexually abusive father who pursues his daughter under the nose of her ineffectual mother. Set to music and a laugh track, this disturbing interlude ends with the murders that free Mallory to join her boyfriend on his killing spree.

Other Killer Pairs

But if murders committed by pairs of young people were troubling, even more so were the crimes carried out by adult "killer pairs." Among the murderers who became notorious in the 1950s were Beck and Fernandez in the United States and Hindley and Brady in England. In each case, the pair were serial killers. When finally apprehended, they were described by some observers as monsters in human form. The women were seen as worse, more depraved, than the men.

Known as "The Lonely Hearts Killers," **Martha Beck** and Raymond Fernandez met through an ad in a newspaper for a lonely hearts club. Martha Beck had already been married three times. She was overweight, and she had been raped by her brother when she was thirteen. She had trained as a nurse and worked as undertaker's assistant before being appointed superintendent at

a home for the handicapped. Fernandez had spent some time in British Intelligence before receiving a head injury, but when he met Beck, he was making his living as a con man. He charmed women and cleaned out their bank accounts. He and Beck joined forces, with Beck pretending to be his sister. However, she was jealous of him and concerned that he not consummate any of his relationships with the women he was meeting through the ads. In December 1948, they killed a 66-year old widow named Janet Fay in New York. Fernandez had invited her to the apartment he shared with Beck. There they strangled and bludgeoned her to death. Later they buried the body. They did the same with the bodies of Delphine Downing, a young widow, and her two year old daughter. They had moved into Downing's house, and killed her by forcing sleeping pills down her throat. When her daughter cried, Beck drowned the child in the bathtub. Reports from suspicious neighbors led to the discovery of the two bodies buried in the cellar. Beck and Fernandez were arrested and extradited back to New York because New York had the death penalty. They confessed to the three murders, but they refused to claim the seventeen others of which they were suspected. While in prison, Martha Beck sent messages to the press describing her exploits with Fernandez. Both were judged sane, and in March 1951 they were executed (Lane and Gregg, 1992: 41-43).

In England, **Myra Hindley** and Ian Brady were the perpetrators of what came to be called "the Moors Murders." Lane and Gregg (1992: 66) find that Hindley was remembered by neighbors as a happy if "not particularly bright" child, who grew into a "not very sociable" teenager.

> A convert to Roman Catholicism, Myra Hindley held a number of low-grade jobs before joining Millwards Chemical suppliers . . . and meeting Ian Brady. She was twenty-four, Brady was twenty-eight. Before long she was under the spell of Ian and his Nazi heroes, and began to dress and behave as she imagined a concentration-camp commandant might—she was Brady's ideal woman (Lane and Gregg, 66).

Together Brady and Hindley kidnaped, tortured, and murdered children and teenagers. Their activities included taking pornographic photographs of their captives and making tape recordings of their torture. They were arrested when Myra Hindley's brother-in-law, David Smith, who they had invited to take part in one of their sessions, called the police the next day to report what he had seen. At trial, they pleaded not guilty to the three murders with which they were charged. But the police had found incriminating evidence, including the photos, and were later able to find the remains of two of the victims buried on the moors. Myra Hindley were convicted of two of the murders; Brady of all three. They were sentenced to life in prison. In 1986, Hindley confessed to the murders of two more children (Lane and Gregg, 66-68).

An intense public aversion to Hindley still persists in England. Ballinger (1996) finds that apart from the heinous nature of the crimes she committed with Ian Brady, Hindley's self-presentation contributed to an even more negative

perception of her. Writing prior to Hindley's recent death, Ballinger observed:

> Forty years after the Ellis trial, and despite the very different nature of her crime, Myra Hindley finds herself in a similar space to that which Ellis occupied—that is her account cannot be heard outside the 'evil woman' category. As had been the case with Ellis, Hindley's appearance, composure and attitude during her trial became sources of fascination. Her newly bleached hair, heavy make-up and smart suits were commented upon as were her antagonistic attitudes toward marriage, motherhood and religion. . .(Ballinger, 23).

Ballinger asserts that because of this lingering image of Hindley, whatever she later had to say "appear[ed] almost irrelevant" (Ballinger, 23). But, as did Ruth Ellis, Hindley refused to claim that she was "mad" when she committed her crimes. Paradoxically, the fact that Hindley had accepted personal responsibility created the problem of how her acts should be interpreted. If she were not mad, then she must be "evil" (Ballinger, 24). If she was evil, then perhaps she should be hated (see Chapter 11 for further discussion).

These two killer couples (Beck/Fernandez and Hindley/Brady) have been portrayed in narratives as somewhat unappealing people joined together in a kind of obscene love. However, as will be discussed in the next chapter, couples who kill are sometimes clean-cut and attractive. When presented with this contradiction between crimes and criminals, those narrating such stories must struggle to provide an interpretation that can explain why handsome and beautiful is not always also "good."

But there were other aspects of life in the 1950s that created tension between expectations and reality. One of the fears promoted by government was that those who seemed on the surface to be good American citizens might be engaged in activities that could bring death not just to individual victims but to millions.

Cold War Casualties

During this era, there was a great deal of concern in the United States about espionage and treason. This concern was a by-product of the "Cold War" in which the United States was engaged with the Soviet Union. This was an era in which middle-class families living in the suburbs found blue prints for bomb shelters in their favorite magazines. School children went through drills in which they learned to fall to the floor and cover their heads ("duck and cover") in the event of a nuclear attack. In this atmosphere of distrust and suspicion, Julius and **Ethel Rosenberg** were charged with treason, with collaborating with the enemy. In pronouncing their sentences on April 5, 1951, Judge Kaufman said:

> [Your crime is worse than murder, having put] into the hands of the Russians the A-bomb years before our best scientists predicted Russia would perfect the bomb has already caused, in my opinion,

the Communist aggression in Korea, with the resultant casualties exceeding 50,000 and who knows but what that millions more innocent people may pay the price of your treason. Indeed, by your betrayal, you undoubtedly have altered the course of history to the disadvantage of our country (quoted in Aiuto).

The judge sentenced them to death. At the time of their trial, the Rosenbergs were the parents of two young sons and from all accounts devoted to each other. J. Edgar Hoover used his promise to recommend Ethel not receive the death penalty as a lever to persuade Julius to confess. Hoover was concerned about public reaction to the execution of the mother of young children. During the trial, the defense had tried to focus attention on Ethel Rosenberg's life as wife and mother with a series of questions. A. Bloch, her attorney, asked where her children were now. She responded that they were in a temporary shelter in the Bronx. He asked if she had seen them since her arrest. She said no. He then turned to her role as a housewife, asking about the kinds of chores she did and whether or not she had hired help. She responded:

> On occasions for brief periods. I know that when I came from the hospital after the birth of the first child I had some help for the first month, and then upon the time that the second child arrived, I had help for about two months, and there was a period when I was ill and that started about November 1944, I had to have help, right up to about the spring of 1945 (Testimony, online).

But, the defense attorney asked, aside from these three periods, had she done her own housework ("Your laundry and everything")? Rosenberg replied: "That is correct" (Testimony, online). So the accused spy was not living in pampered luxury on the profits from her crimes. She was a hardworking housewife who did her own chores and only hired help when she had to because of weakness from childbirth or illness. But this attempt to portray the normality of Ethel Rosenberg's life did not help her case. She and her husband were convicted, and the appeals made on their behalf were unsuccessful. Their politics worked against them even though there was a groundswell of public support from Communists and non-Communists, who staged rallies in the United States and Europe. Before their executions, the Rosenbergs said farewell to their children who had been brought to Sing-Sing by their attorney.

Concerning Ethel Rosenberg as mother, Scheffler (1990) observes:

> With expressions of genuine pain, Rosenberg's letters to her sons and husband often express this sort of "acceptable" response to her problems. Her critics, however, saw her coldness at the trial and her refusal to confess, even if it meant orphaning her children, as atypical and unacceptable actions for a woman and especially for a mother (Scheffler, 29).[3]

Scheffler examines Rosenberg's letters in the context of contemporary

prison literature in which women express their anger as well as other emotions. She notes that Rosenberg "believed she was dying for a principle too important to betray" (Scheffler, 29).

In 1975, the Rosenbergs' sons sued the federal government to have the files on their parents' case opened to the public. According to the *New York Times*, the two brothers charged that their parents had been victimized by the federal government's political agenda. They alleged that the trial occurred when America was engaged in an "anti-Communist frenzy" (07/15/75). These assertions by the Rosenbergs' sons came in the aftermath of the social and political revolutions of the 1960s.

Women and Revolution

The 1960s were a time of turmoil with challenges to the status quo and to mainstream culture coming from a variety of sources, including women, racial/ethnic minorities, and students. At the same time, there was the sense that profound change to the social structure was possible and could be achieved. It was a time of "love-ins," "flower children," and "peace movements." It was also a decade of riots in cities, civil rights demonstrations in the South, sit-ins, stand-offs, and clashes between police and citizens. A president and his brother were both assassinated, so were several civil rights leaders.

In August 1969, in a mansion in Beverly Hills, a housekeeper came to her job and found five bodies in and around the house. It was the home of director Roman Polanski and his wife actress Sharon Tate. Tate, who was eight months pregnant, had been murdered. The other victims included friends of the couple and a local teenager whose body was find in his car in the driveway. The word "Pig" had been written in blood on the living room door. The next day, the bodies of Rosemary La Bianca and her husband Leno, a supermarket executive, were found in their mansion. Rosemary La Bianca had been stabbed forty-one times, her husband twelve. Again words had been written by the killers: "War" on the woman's stomach. "Death to Pigs," "Rise," and "Healter Skelter" [sic] on the walls (Lane, 1997: 281-282).

When the killers were found, they were a "cult leader" named Charles Manson and his "family" of followers. This family included women, and they had participated in the murders. These young women became known as "**The Manson Girls.**" One of them, **Susan Atkins,** had been arrested on a prostitution charge and while in custody confessed her involvement in the murders to a cellmate. The Manson family was rounded up. Two other women, **Mary Brunner** and **Linda Kasabian,** turned state's evidence. No charges were brought against them. Atkins pleaded guilty to one murder, that of Gary Hinman, a musician friend of Manson's. The family had believed he had money from an inheritance in his home. Atkins went on trial with Charles Manson. The two other defendants were **Leslie von Houten** and **Katie Krenwinkel,** who had taken part in the La Bianca murders. They were all convicted and sentenced to death in the Tate-La Bianca murders, but when

capital punishment was suspended in California, their sentences were commuted to life imprisonment (Lane and Gregg, 1992: 254-255).

These murders, which seemed to be the work of a messianic madman and his disciples with wealthy people as their targets, happened in the context of a society in which capitalism was perceived as being under attack. This was the era when groups who called themselves "revolutionaries," but who the government called "terrorists" were active. These groups included the Weathermen, "a tiny splinter off the student New Left" (Lane, 1997: 283-284) and the Black Panthers, a militant organization of black nationalists. Both groups counted women among their numbers. The alleged crimes of these revolutionaries would be played out in the trials of women such as **Angela Davis,** the black political activist associated with the Student Nonviolent Coordinating Committee (SNCC) and the Black Panther Party, and later with the Communist Party.

The Trial of Angela Davis

In 1972, African American political activist Angela Davis was brought to trial in San Jose, California. She was charged with murder, kidnaping, and conspiracy. Aptheker (1999: xi) writes:

> Davis, placed on the FBI's "Ten Most Wanted" list and designated "armed and dangerous," had been arrested in New York City on October 13, 1970. President Richard M. Nixon congratulated the FBI on its "capture of the dangerous terrorist, Angela Davis,"a sentiment echoed by Ronald Reagan, then governor of California, and by an editorial in the New York Times (October 16, 1970). Images of a handcuffed Davis appeared on the covers of Newsweek and other leading journals. . .

Davis was a member of the U. S. Communist Party. The Los Angeles Che Lumumba Club, the all-black collective to which she belonged, was named after two revolutionaries. Davis was also associated with the L.A. chapter of the Black Panther Party. She was a founding member of the Soledad Brothers Defense Committee, formed in support of three Soledad Prison inmates accused of killing a prison guard.

The events that lead to Davis's arrest and trial involved a Marin County courtroom takeover by a seventeen year old high school student during the trial of a San Quentin prisoner for an attempted assault on a guard. The student, Jonathan Jackson, (younger brother of George Jackson, one of the Soledad Brothers), armed the accused man and two other prisoners who were there as witnesses. The four took five hostages (the judge, prosecutor, and three female jurors). During a roadblock shootout, three of the hostage takers and the judge were killed. The prosecutor and a juror were wounded. Angela Davis was implicated in what had occurred because several of the guns used in the takeover were legally registered to her.

The Trial of Angela Davis *Continued*

Davis's trial for the charges against her lasted three months and included over 104 prosecution witnesses, twelve witnesses for the defense, and 203 pieces of evidence. After three days of deliberation, the jury found Davis not guilty of on all counts (Aptheker, xiv).

Exercise: Angela Davis was only one of a number of women involved in "radical" political groups during the 1960s and 1970s. Examine media coverage of these women at that time and since.

In another case that attracted both media coverage and controversy, **Patricia Hearst,** a wealthy young white woman, the granddaughter of newspaper magnate, William Randolph Hearst, was placed on trial for a robbery that she had participated in after being taken hostage by the Symbionese Liberation Army (SLA). The prosecution alleged that she had become a member of the group and been a willing participant in the robbery and gone willingly into hiding with the group after six members were killed in a shoot-out with the Los Angeles police. When she was captured by the FBI in 1975, Hearst was tried and convicted and sentenced to seven year in prison. During her trial she had claimed that she had been "brainwashed" by the SLA. However, she remained in prison until her sentence was commuted by President Jimmy Carter in 1979, after she had served almost three years of her sentence.

Women, Male Violence, and Self Defense

If the cases of Angela Davis and Patricia Hearst focused on revolutionary politics and class issues, that of **Joan** (pronounced and sometimes spelled "Joanne") **Little** focused on race, gender, and the justice system. In August 1974, Joan Little was a prisoner in a North Carolina (Beaufort County) jail when she was accused of having murdered the jailer, Clarence Alligood. Alligood's body had been discovered by police officers who were bringing a prisoner to the jail. Alligood was naked from the waist down and slumped across a bunk in a cell. There was sperm on his leg and an ice pick in his hand. There were ice pick wounds to his temple and heart. Joan Little, the female prisoner who should have been in the cell, was gone (Reston, 1977: xi-xii; *NY Times,* Joan Little Jury, 07/29/1975).

Eight days later, Little turned herself in. She claimed that she had killed Alligood, who was white, in self-defense during a sexual assault. She was charged with first degree murder and faced the gas chamber. During the months of her incarceration and trial, she drew support from a wide-range of groups across the nation. As Reston (1977) states, Little "became a symbol of women's groups, civil-rights groups, prisoners' rights groups, and the opponents of capital punishment."[4]

A reporter who covered the trial for the *New York Times* observed that the defense attorneys had opened the trial with a challenge to the Southern

justice system which they declared as much on trial as Little, who was accused of murder (King, 07/15/1975).

Outside the courtroom, Little's supporters chanted and sung protest songs. Inside the courtroom, the lawyers, who were being paid with money raised mainly by the Southern Poverty Law Center, asked that the special prosecutor be required to step down. Little's attorneys questioned the special prosecutor's impartiality given the fact that he had once represented the Ku Klux Klan before the House Committee on Un-American Activities. They also objected to what they asserted was the use of peremptory challenges to exclude African American jurors (King, 07/15/1975).

The woman who was at the center of this high profile trial was twenty-one, and had been in jail awaiting action on the appeal of a breaking and entering charge. The deputies who testified about their discovery of the dead jailer and their subsequent investigation, acknowledged that Little had been a good prisoner. One of them described her as "a perfectly nice person" (King, 08/02/1975).

But the same deputy also testified that Little had been out of her cell twice on the night that Alligood died to receive telephone calls. He said that Little had been acting oddly. The prosecutor asserted that Little had been acting oddly because she was planning her escape. He said that she had lured Alligood into her cell with the promise of sex and then killed him to make her getaway (King, 08/01/1975).

However, the deputies who had found the body had badly mishandled the crime scene. Among other irregularities, the deputy who had testified about Little's odd behavior had stuck the ice pick found in Alligood's hand into his own back pocket. Other evidence, including the bloody sheet on Little's cot, stained tissues, and a pack of cigarettes were not photographed or preserved (King, 08/02/1975). These factors contributed to Little's acquittal.

While the trial was underway, Little put in an appearance at a press luncheon for female reporters. She seemed to be coping with the stress of the trial. However, she told the reporters that she believed the prosecution wanted to get a conviction so that they could see her executed (*NY Times*, Joan Little Jury, 07/29/1975).

Commenting on the fact that many feminists supported Little, Jones (1996) observes:

> Society is afraid of both the feminist and the murderer, for each in her own way, tests society's established boundaries. Not surprisingly, the interests of feminist and murderer sometimes coincide: Gloria Steinem argues for Joan Little's right to self-defense just as Lucy Stone argued in another century for Lizzie Borden's right to trial by a jury of her peers (13).

Over $350,000 was raised for Little's defense. She was acquitted of the charges against her in August 1975. Little's trial occurred during what Ballinger (1996: 26) describes as "the height of Second Wave feminism." During this period of activism by feminists, several cases involving women

who had killed became a part of the debate about gender politics. It was during this period that **Inez Garcia**, shot and killed the man who raped her, and **Yvonne Wanrow,** a Colville Indian woman shot two men, wounding one and killing the one that she believed was a child molester. In her first trial, Wanrow, a California resident, had been sentenced to two twenty-year prison terms and one five-year term. In her second trial, she plea bargained. She was sentenced to five years probation for manslaughter and second-degree assault (Jones, 1996: 285-286).

In deciding to grant, Wanrow a second trial, the Washington Supreme Court had looked at the fact that in her case, the "reasonable man standard" had been applied. This historically was the standard used in self-defense cases. However, the Court ruled that the standard was not appropriate when one considered the fact that this had not been an altercation between two men, but between a 6'2" intoxicated man and a 5'4" woman with her leg in a cast and using a crutch. Regarding jury instructions, the Court stated, "The respondent was entitled to have the jury consider her actions in the light of her own perceptions of the situation. . . ." (see Jones, 286).

This matter of what standard should be applied to self-defense claims by women who killed would continue to be debated. Although it was not raised as a significant issue, it was an underlying question in the 1977 case of **Francine Hughes,** who set her abusive ex-husband's bed on fire as he slept. In that case, her lawyers made a successful temporary insanity plea rather than arguing self-defense. However, still in contention over a quarter century later is what standard should be applied when judging the act of a woman who kills a man who she claims has been physically violent toward her. The next chapter includes consideration of the use of "battered woman syndrome" in the cases of women who kill spouses or lovers that they claim were abusive.

Summary

In the post-World War II era, the factors that would lead to feminist challenges of the status quo in the 1960s and 1970s were already in place. The 1950s was the last decade when television and movie portrayals of middle-class women as contented housewives could flourish relatively unchallenged in popular culture. Yet even in the 1950s, the cracks in the illusion of the "domestic sphere" were becoming apparent. However, in the murder trials discussed in this chapter, traditional ideas about women and their place played a role in the portrayal of the defendants and perhaps in the outcome of the cases.

By the 1960s, the women's movement had began to make gains in challenging both the images and the status quo. At the same time, women as revolutionaries and cult members offered new constructions of the violent woman. In the 1970s, courtroom advocates presented arguments for a woman's right to respond with lethal resistance to attacks by violent males.

The next chapter brings this discussion of the social construction of images of women into the modern period.

Discussion Questions

1. What factors seem to have contributed to the convictions and executions of Barbara Graham and Ruth Ellis?

2. What aspects of Annette Lyle's sentence to death created controversy?

3. Discuss the Parker-Hulme case as a *folie a deux*.

Exercise

Watch the film, *Heavenly Creatures* (1994) and discuss the fantasy world that the two young women are portrayed as creating for themselves.

Additional Exercises

1. Watch several episodes of the 1950s television shows *I Love Lucy* and *Leave It To Beaver* on a cable television channel (broadcast each day on the cable television network, TV Land). Discuss the depictions of the roles of women and of gender relationships in these shows.

2. Watch the film *Beyond the Forest* (1949) starring Bette Davis. Discuss the depiction of Rosa Moline as the antithesis of the popular image of the contented 1950s wife and mother.

Notes

[1] See Cahill (1992) for the saga of the Ideal Maternity Home in East Chester (near Halifax), Nova Scotia. The maternity home was operated in this rural community by Lila and William Young from 1928 to the 1940s. Many women, both married and unwed, came to the home to give birth. The unwed mothers often worked off their fees by helping out in the home and then left their babies to be put up for adoption. Some of these babies were adopted by couples from the United States. Some of the babies died at the maternity home and were buried in butter boxes. Because of the Youngs' social and political connections with wealthy families to whom they had provided services and because of loopholes in Canadian law, public health officials were ineffective in regulating the sanitary conditions, medical practices, and unethical adoption practices at the home. After Cahill, a journalist, broke the story, adult "survivors" of the maternity home living in the United States begin to actively search for their Canadian birth parents. Although brought to trial on several occasions, the Youngs' managed to survive the efforts to close down the home until the 1940s, then they faded quietly into obscurity.

[2] One of the historical mystery series that Anne Perry writes features a Scotland Yard detective who has amnesia about his past.

[3] In comparison, see Kennedy (1998) on the World War I era prosecution of Kate Richards O'Hare who alleged that "the war corrupted motherhood" (Kennedy, 106).

[4] Flowers (1995) writes that the Joan Little case focused greater attention on the sexual and physical abuse of women in jails, "a common practice in some parts of the country" (Flowers, 214). In popular culture, this matter of abuse of women in Southern jails was played out in films such as *Jackson County Jail* (1976) with Yvette Mimieux, as a middle-class young white woman, who ends up in jail and at the mercy of the lecherous sheriff. She kills him during a sexual assault and flees—aided by Tommy Lee Jones, another wanted inmate.

Chapter 8
Contemporary Images of Women

Women with Guns

In the November–December 1998 issue of the magazine, *Women & Guns* (p. 63), there is an ad sponsored by the Citizens Committee for the Right to Keep and Bear Arms. Bumper stickers are displayed in this ad. One of these bumper stickers states: *A Lady With A Gun Has More Fun.*

The reference is to the fun women (ladies) can have while engaged in activities that involve a gun, such as hunting. However, the existence of a popular magazine called *Women & Guns* aimed at female consumers raises some interesting questions about current attitudes concerning women and violence. Elsewhere in the magazine, there are other ads by manufacturers who showcase not only the weapons that they have for sale but the paraphernalia every well-equipped gun owner should have. Among the items offered are a stylish leather handbag with a separate concealed pocket for a firearm. Another item is a hidden holster that anchors between the mattress and the box spring of a bed. The advertiser advises the potential buyer that this will allow her to have her firearm readily at hand and to get to it "with no alerting moves" (*Women & Guns,* ad, March/April 1998, p. 5).

This last ad in particular creates a rather compelling picture of a sleeping woman who suddenly awakens to the sounds of an intruder. But unlike less well-prepared females, she is ready. She slips her gun from its holster and takes the intruder by surprise. Of course, those who oppose handguns in the home would argue that at this point, the intruder might take the gun from the woman and use it in victimizing her. However, a woman who reads *Women & Guns* would also have learned about the necessity of training with her weapon and presumably would not be as easily disarmed as the woman who buys a gun and then tucks it into a bureau drawer without ever once venturing onto a target range.

The debate about women arming themselves is one that brings together unexpected bedfellows. For example, some feminists have joined with Second Amendment advocates in speaking out for the right to own a handgun. Those feminists who advocate gun ownership on the part of women argue that women cannot depend on the police to protect them against violent men (abusive spouses, stalkers, and rapists). Women must be prepared to defend themselves (see e.g., Quigley, 1989).

This argument is heard not only from self-defense advocates but from some women who live in urban areas. For example, in focus groups about women and fear of crime conducted with Latina and African American teenagers in New York City, when the discussion turned to carrying protection, the young women mentioned a variety of weapons that they carried. These included keys, nail files, and knives. A number also admitted carrying a gun. One teenager said:

> I feel more protected with a gun; that is when I feel protected . . . No man protects me . . . They pretend to protect you and then they end up beating you up (Madriz, 1997: 141, ellipses in original)

Another teenager expressed doubts about carrying a gun because "you have an attitude." However, gun ownership was also reported by a few of the white women in other focus groups. A couple of these women said that they did not own a gun themselves, but their husbands did and the gun was kept in the home (Madriz, 141).

Concerning efforts to persuade women that they should become gun owners, Madriz reports:

> According to an article published in *Harper's Bazaar,* the gun industry and the National Rifle Association began to target potential women buyers when handgun production dropped from 2.6 million in 1982 to 1.4 million in 1985. Two appeals were used in the sales campaign: feminism and motherhood. Some images even depicted a mother with a gun tucking her children in to bed! (Madriz, 142).

With regard to feminism and guns, Martha McCaughey, a women's studies professor, advocates what she calls "physical feminism." After 140 hours as a participant-observer in a variety of self-defense courses ranging from karate to handgun instruction, she argues that feminists should encourage women to become more physical in their defense of self (McCaughey, 1997). McCaughey does not endorse any one form of self-defense. However, in an interview with a university magazine, she observes that women and girls are not generally taught how to fight or to shoot. She adds that many people mistakenly believe that women require male protection from dangerous strangers when in fact women are "more likely to be assailed by the men they know." McCaughey argues that when it comes to self-defense, "women are capable of spoiling most attacks" (Harris, 1998).

Other advocates of female self-defense argue forthrightly that a gun is the best means of defense for women. One argument made by pro-gun ownership advocates is that although martial arts such as karate or judo have been presented as "a woman's best defense against assault," from a practical perspective, many years of training and continuous practice and conditioning are required in order to be proficient (Curtin and Kates, 1978: 4). Moreover, even then, it's doubtful that they would protect a woman against a determined and physically stronger attacker, much less two or three of them (Curtin and Kates, 4).[1]

But there are sometimes legal consequences when a woman uses a gun in what she perceives as self-defense. Advocates of gun ownership sometimes argue that the legal consequences of self-defense are something one can deal with after the fact. The important thing during an attack is to stay alive and to avoid serious injury, and that could well involve using a gun. However, in an assessment of the risks and benefits of gun ownership and use, the legal consequences can not be ignored. The potential legal consequences of gun use for women are linked directly to the situations in which guns are used. But the

consequences also appear to be linked to how the female gun user is perceived by those who evaluate her actions.

One question that might be posed here—given Madriz's assertion that gun ads have targeted women by emphasizing not only feminism but motherhood—is how the image of female gun ownership is reconciled with the traditional roles of women as wives and mothers. In the ad Madriz cites, the message is that a good mother protects her children from danger. This same message is present when we look back at the captivity episode in Puritan Massachusetts when the Reverend Cotton Mather praised Hannah Duston as a heroine who not only escaped from the savages who had taken her and her companions hostage, but returned with their blood (in the form of their scalps) on her hands. She was unable to save her own infant, but Duston, the grieving mother, became a frontier heroine when she slew the enemy, thereby doing her part to protect other (white) children from danger.

In an examination of women and violence in American frontier literature, McCall (1999) analyzes 104 best-selling novels and finds a "relatively low incidence of violence" for all characters given the frontier setting (179). As for the women, McCall finds that they were "strong and resourceful" (180).

> ... fictional women were capable of committing violent acts and, with the exception of violence born of sexual dishonor, the authors discussed this issue casually and rarely felt the need to defend their female characters. On rare occasions, writers pointed out that a woman's familiarity with firearms was exceptional, but, for the most part, women protecting themselves or their families were described matter-of-factly. In addition, authors freely accepted the propriety of women's hunting (McCall, 179).

McCall's findings about fictional depictions of women and frontier violence tally with historians' findings about the lives of women on the American frontier. Women needed to be self-sufficient enough to defend themselves and their families when necessary. They needed to be at least familiar with the use of weapons. But this familiarity was seen as a practicality and not a threat to the gender status quo. Aside from Belle Starr[2] and Calamity Jane, few women achieved the legendary status of frontier men with guns.

In the late twentieth century, women with guns appeared in films and books in increasing numbers. As film scholars have observed, in the 1990s there was a wave of films in which female protagonists beat up, shot, and generally demolished adversaries ranging from male rapists to monstrous aliens (see Chapter 10). However, in real life, although the use of guns by women as recreation may be encouraged by gun advocates, the use of guns by women in self-defense is still controversial.[3] At the root of the controversy is that when women use guns in self-defense, often the attackers they are taking aim at are not strangers, but men they know. It is these men that they know who present the greatest threat to female victims. It is these men that women in fear of their safety sometimes shoot when a gun is at hand. Of course, guns are not

the only weapons that women use. However, armed with a gun a woman is capable of more lethal force than with most other weapons she might use.

As stated above, this question of gun use by women needs to be considered in the larger context of attitudes toward women and violence. We might ask under what circumstances is it considered appropriate for a woman to use violence? Have the rules changed so that now female violence is viewed in the same way as male violence? Perhaps the best way to address these questions is to look at modern women who are accused of criminal homicide. These accused killers range from female poisoners of family members to women who kill strangers.

As discussed throughout this book, historically women—like men—have killed for a variety of reasons. Some of these women managed to offer narratives of their homicides that jurors and others saw as either mitigating or completely negating their culpability. But other women were not able to achieve this in their narratives about their acts of violence. The question that might be asked is whether the stories told and the self-presentation by those women who kill and go free have changed since the 16th century manumission narratives mentioned in the introduction (Davis, 1987). Does a woman still have to be perceived as a "true" woman, in order to make a successful defense of her lethal actions? In answering these question, it would be useful to look at some of the cases in which women have killed during the past twenty years.

Battered Women Who Kill

In examining the homicide rates for married couples from 1976 through 1987, Browne and Williams (1993) find that homicide rates between married couples declined during this period. However, the rate of wives killing husbands decreased more than the rate of husbands killing wives. In 2000, the Bureau of Justice Statistics (BJS) reported that women "experienced intimate partner [current or former spouses, boyfriends, girlfriends] violence at lower rates in 1998 than in 1993." But at the same time, while the number of male victims of intimate partner violence had gone down an average of 4% per year between 1976 and 1998, the average decrease for female victims had been 1% per year. According to the BJS statisticians:

> In 1998 women were nearly 3 out of 4 victims of the 1,830 murders attributed to intimate partners. In 1976, women were just over half of the approximate 3,000 victims (Rennison and Welchans, 2000: 1).

Browne and Williams (1993) find that attempts at social control through domestic violence legislation and extra-legal resources for battered women (e.g., shelters, crisis lines, and legal aid) are associated with the decline in female-perpetrated partner homicides—but have less impact on male violence, particularly among unmarried partners. Male partner violence that ends in homicide is often preceded by incidents of non-lethal violence. Female homicide victims are often stalked by the men who eventually kill them.

However, Dunn (2002) finds that for women, stalking "like sexual assault, is a highly gendered crime" (13). Although since 1990, 48 states and the District of Columbia have enacted anti-stalking legislation (Dunn, 4), the crime remains one in which "social construction of 'victims'"occurs (9). Claiming victim status is complicated by the fact that the stalker often is a man with whom the woman was formerly intimate. The stalking itself may include acts that resemble "courtship" behavior. Thus, the woman must establish her claim as a "credible victim" (Dunn, 2002).

In their analysis of the 141 femicides (murders of women) and 60 attempted femicides that occurred during a twelve month period, McFarlane et al., found that 76% of the femicide victims and 85% of the attempted femicide victims had been stalked by the their attacker. The researchers conclude that stalking when "coupled with physical assault is significantly associated with murder and attempted murder" (McFarlane et al., 1999: 300)

Yet, even though men remain the perpetrators of the majority of homicides among intimate partners, women who kill the men who have abused them and who they perceive as threatening their lives often find it difficult to construct a socially acceptable and legally effective narrative of self-defense. With the popularization of the "battered woman syndrome" as an explanation of the cycle of violence in which battered women find themselves (see Walker, 1979 and 1984), there has been increasing discussion during the past two decades about the use of this syndrome by the defense in explaining the behavior of battered women who kill to the jury. Concerning this matter, Busch (1999) writes:

> Why a battered woman did not leave is usually the first question from the jury, but more important in self-defense cases is the reasonableness of the woman's perception of danger at the moment of the homicide. The purpose of expert testimony on the battered woman syndrome, within both trial and commutation proceeding, is primarily to dispel common misconceptions about domestic violence that may bias society against battered woman in general (Busch, 34).

As Busch points out, the battered woman syndrome is not a defense in itself. It is "a theory used to expand the traditional doctrine of self-defense to accommodate the situations of battered women who have killed their abusers" (Busch, 34). Hearing testimony about the battered woman syndrome does not mean that a jury will accept the syndrome as sufficient explanation of a given female defendant's actions. The jurors might not believe she was really battered. If jurors believe she was battered, they might not believe that being battered justified the manner in which she killed her abuser. The use of expert testimony about the battered woman syndrome in presenting the defense has not been a "get out jail free" card for battered women who kill (see Busch, 80–81).

Belknap (2001: 299) finds, "Women who are released from charges of killing their batterers have typically had to plead insanity or temporary insanity; however, the insanity plea is problematic." Such a plea is problematic

because although the woman has avoided being labeled a criminal, she has now been labeled insane. As Belknap, notes that stigma could be "almost as harsh." The other problem with an insanity plea is that it might not reflect the reality of the woman's actions because

> most evidence shows that these women were acting sanely, using the only means they had left to get themselves, and possibly their children, out of a lethal situation. The insanity plea negates the fact that women frequently have no other alternative but to kill their batterers (Belknap, 299).

In general, the pleas available to battered women who kill their abusers are sometimes inadequate to allow such women both to truthfully tell their stories and at the same time to successfully argue that they acted in self-defense. For example, Ewing (1997) describes the case of **Judy Norman,** a North Carolina woman who had been married to her husband for twenty-five of her thirty-nine years. According to Norman, her husband was frequently brutally abusive, slapping, punching, and kicking her. He sometimes used weapons that included shoes, bats, bottles, and ashtrays. He had forced her into prostitution, demanding that she earn $100 a day. He sometimes made her eat dog or cat food and sleep on the floor. Two days before she killed him, he had dropped her off at a highway rest stop to look for customers to whom she could offer sexual services. When he returned to pick her up, he was drunk. He punched her in the face and shut the car door on her. On the way home, he was arrested for drunk driving. The next morning, he was released. As soon as he arrived home, he began beating her. He continued to beat her throughout the day. The police came twice that evening, the second time because Judy Norman had taken an overdose of pills. Her husband told the paramedics who responded to let her die. She spoke to a therapist at the hospital, and then went to spend the night at her grandmother's house. When she returned the next day, her husband began to beat her again. He poured beer over her head and threatened to cut off her breast. Later, he lay down to take a nap. One of Norman's daughters brought her child by and asked Norman to babysit. When the baby began to cry, Norman took it to her mother's house. While she was there, she took a .25 caliber automatic pistol. She went home and shot her sleeping husband three times in the back of the head.

She was charged with first-degree murder. Evidence was presented that she was a battered woman, but she was convicted of manslaughter and sentenced to six years in prison. On appeal, the conviction was reversed, and she was remanded for a new trial. But the North Caroline Supreme Court reinstated the original sentence. The Court concluded that there was no evidence that when Norman shot her husband she could have "reasonably believed" that it was necessary to kill her husband "to save herself from imminent death or great bodily harm" (Ewing, 28-29).

This case occurred in 1985. In the intervening years, there has been movement in the criminal justice system and by governors to recognize the unique situations of battered women. However, as feminists and others have

observed there is still a lack of connection between the battered women's perception of imminent threat and that of the law. It is still difficult for a battered woman to convince the jury that a lethal act that she commits is justifiable homicide when it occurs after (or in between) abuse by the man she kills.[4]

The People v. Juanita Thomas

Across the country, law school students participate in legal clinics which give them "the opportunity to incorporate theory and practice" (Lyon et al., 2001: 28) by taking on the case of a real client. Juanita Thomas, an African American woman convicted of killing her boyfriend, became one such case for a team of students supervised by law professor Andrea Lyon. In a unique writing collaboration published as an article in the journal *Women & Criminal Justice,* Professor Lyon, one of her former students, and Juanita Thomas each wrote about the experience. In her narrative of the events leading up to her boyfriend's death, Thomas wrote, "No one seemed to help me or care what was going on with me. I went to work many times with black eyes..." (Lyon et al., 39). After she killed her boyfriend, Thomas recalled:

> I was in a daze for weeks. I could not believe my lover was dead.
> I went and looked at him in the casket. Still it was hard to believe.
> I never meant to kill him...(Lyon et al., 40).

However, she was convicted of premeditated first-degree murder. The prosecution argued that Thomas had stabbed her boyfriend to death while he slept. It was only when Professor Lyon's law students began to reinvestigate the case that they uncovered problems that included police and prosecutorial mishandling of evidence and ineffective defense counsel during trial. The legal team petitioned the case. After 18 1/2 years in prison, Thomas was released.

There are other situations in which women kill husbands and lovers and must offer an explanation of their violence.

Triangles and Love Affairs Gone Wrong

One of the more controversial cases of the late 20th century was that of **Betty Broderick,** a California socialite who went to the home of her ex-husband, a prominent attorney, and shot him and his new wife in their bed. In her second trial (following a hung jury in the first), Broderick was unable to convince the jury that what she had done should be understood as the desperate act of a woman who had been pushed beyond her endurance by her ex-husband and the younger woman with whom he first had an affair, then married. She was convicted of two counts of second-degree murder. Although some narratives about the case have attempted to explain and to some extent mitigate her actions, others narratives -- such as two Lifetime Network made-for-television movies—have presented her as a raging "woman scorned."

Based on her analysis of the press coverage of the case, Halkias (1999) concludes:

> As it was presented by the media, Elizabeth Broderick's story is a cautionary tale. Through it, she becomes a monster of sorts, patrolling the boundaries of what is acceptable gender behavior and what is not (295).

In this respect, Halkias argues that Betty Broderick is presented not only as a vengeful woman, who kills the husband who has put her aside for another woman, but that she also emerges in the press narratives as an "endangering mother" (291), who puts her children at risk by her behavior. Although Broderick does not physically harm her children, Halkias argues that she is portrayed as a "modern-day Medea" with the latent potential for child-murder.

By the same token, **Amy Fisher,** the teenager who was sent to prison for shooting and seriously wounding the wife of the older man with whom she was having an affair, has found it difficult to combat the image machine that continues to portray her as the "Long Island Lolita." Granted parole after serving seven years of her fifteen year sentence, Fisher was forgiven by Mary Jo Buttafuoco, the woman she shot in the head. Although the couple would later divorce, Buttafuoco moved to Los Angeles with her husband Joey after he served six months in jail for the statutory rape of Fisher. Buttafuoco said she was able to forgive Fisher because of her faith in God. In return, during a court appearance, Fisher assured her victim that neither Mary Jo, nor Joey, nor Fisher's own father were to blame for the attack. She said it was her fault and she was sorry (Humbert, 05/06/99, B13).

Fisher was seventeen when she shot Buttafuoco, twenty-four when she was granted parole. In her court appearance, she took responsibility for her actions, suggesting increased maturity. However, two years earlier, a district judge who denied her a transfer to another prison when she claimed she was being raped and abused by several corrections officers at Albion Correctional Facility, had expressed doubts about her veracity. The judge dismissed her narrative as not rising to the standard expected of a federal lawsuit, but instead reading like cheap fiction (Humbert, 05/06/99, B13). It is quite possible that Amy Fisher will always be plagued by a credibility gap and that any story that she tells of victimization will be viewed as another installment in her melodrama.

This also applies to **Pamela Smart,** who is now serving time in prison for conspiracy in the murder of her husband. Smart has become synonymous with the real life *femme fatale* who uses sex to persuade men to kill. Like Bathsheba Spooner in 18th century Massachusetts, Smart was convicted of using her wiles on a younger man, a teenage boy. She was twenty-two when she began an affair with a fifteen year old sophomore at the high school where she was employed as media director. The fifteen year old and two accomplices killed Smart's twenty-four year old husband, Gregory, a week before the Smarts' first wedding anniversary. During her trial, Smart denied that she had ever asked them to kill her husband. She denied telling her teenage lover that

her husband was abusive and that if she were free of Greg, they could be together. But the jury did not believe her. And the media dubbed her "The Ice Princess" because of her calm demeanor in the courtroom. In an interview given the year after her conviction, Smart expressed her outrage at how she had been portrayed in the media. She asserted that because her case had received extensive coverage, many people had believed she was guilty even before she went to trial. She expressed her astonishment at the fact that the jurors were not sequestered during the trial (*The New York Times*, 04/01/1991).

Whether she was the victim of adverse publicity, or whether the jury based its decision on the evidence presented against her, Smart too have not been successful in overcoming the narratives in which she is depicted as a scheming and lethal woman.

But for those women who are not only convicted of murder but who face death sentences, how they are portrayed in narratives about their crimes is even more crucial. For them it is not a matter of when or if they will be paroled and whether they will be able to successfully resume their lives. For women on death row, how they are portrayed can literally be a matter of life or death.

Women on Death Row

Historically, it has been assumed that only the worst of women deserve to die. In the United States, this assumption has been more often made in the case of white women than women of color. However, as scholars of the death penalty have argued, there seems to be another double standard at work with regard to how willing listeners are to believe the stories told by female inmates about how they came to find themselves on death row. As in other situations, women who are perceived as feminine and attractive seem to have an advantage when it comes to getting their stories out when compared to women who are perceived as more masculine or less attractive. For example, Farr (2000) contrasts the differing public responses to two death row inmates, **Karla Faye Tucker** in Texas and **Judy Buenoano** in Florida. She argues that although both inmates were women who had become "born-again" Christians while in prison, Tucker received much more sympathy and much more media coverage than did Buenoano.

> The extensive media coverage surrounding Tucker's execution was feminized, with reports describing her as pretty, young and demure. One newspaper account ... for example, notes "Tucker's soft, brown eyes, bashful smile, and long dark curls"... Indeed, she had married the prison chaplain while on death row; restricted by the "no-conjugal-contact" policy, the marriage was literally virginal (Farr, 50).

In contrast, Buenoano, who was sentenced to death for the poisoning murder of her husband, "did not strike a chivalrous chord."

Pictures of her show a grim and masculine visage with pursed lips and short, slicked-back black hair. . . . All along, Buenoano was portrayed as a man-hater, the "black widow" who fed upon the men in her life (Farr, 50).

Based on this portrayal, Buenoano was not seen to be as worthy of commutation of sentence as Tucker. Even though Tucker had been convicted of taking part in the pick axe murder and robbery of a man against whom she had a grudge and the woman who happened to be with him at the time, she argued she was now a different person. She had killed while she was under the influence of drugs.[5] The murders were something that she regretted and repented. In the state of Texas, with its high rate of executions, this plea was not sufficient to enable her to avoid the death sentence. However, the story she told did draw a number of supporters from the Christian right to her side. This was not something that Buenoano was able to do.

In 1984, **(Margie) Velma Barfield** also had attracted supporters who believed she had been rehabilitated while on North Carolina's death row. Barfield had been convicted of being the serial poisoner of family members and elderly people in her care. However, Barfield claimed to have been addicted to drugs when she committed her crimes. On death row, she had become a born-again Christian—or perhaps a revived again Christian. Barfield had at one time been active in her church. But, according to Barfield and her defense attorneys, stresses in her family life and in her marriage as well as physical illnesses had taken their toll. Her addiction was attributed to the fact that Barfield had used and abused prescription drugs obtained from several different doctors.

Barfield was suspected of having burned her first husband in his bed. She was known to have poisoned other people over the years. According to the prosecution, she had pretended to offer care and nurture as her victims suffered and died. But in prison, according to her defense attorneys, as she waited for the appeals process to play itself out, Barfield became the woman she had once been. She was a maternal figure to the younger female inmates. She was someone with whom they could share their problems and concerns. She was a model prisoner, winning the respect and affection of the prison staff. If Karla Faye Tucker was sweet and virginal on death row, Velma Barfield was grandmotherly and lovable.

The fact that both women were executed had less to do with the images that they projected and their ability to convey their stories effectively to their audiences, then with the politics of commuting the sentences of death row inmates. Barfield's final appeal for clemency came in the midst of a political campaign being waged by the governor of the state. At first, Barfield's supporters hoped politics might work in her favor:

> North Carolina's death row had been growing steadily in the five years since the new death penalty had been enacted. Twenty-three

people now faced execution, but Velma was the only woman among them, and her case was farthest along. Still, many people could not believe that Hunt would want the distinction of allowing the first woman to be executed in the nation in more than twenty years. He, after all, was a progressive Democratic with higher ambitions (Bledsoe, 1998: 238).

When all of Barfield's appeals had been exhausted and the decision was finally in Governor Hunt's hands, he spent a day with his legal counsel reviewing her record, including the reports from psychiatrists and letters of support. Then he called a press conference. As he explained, he was denying her request for clemency because:

> I cannot in good conscience justify making an exception to the law as enacted by our legislature, or overruling those twelve jurors who after hearing the evidence, concluded that Mrs. Barfield should pay the maximum penalty for her brutal actions (Bledsoe, 281).

The governor added that Velma Barfield had been convicted of killing one person, admitted to three more (one of them her mother), and it was likely she had killed a fifth person. She had killed them in a manner that was "literally torture to death." She had given them arsenic, a "slow and agonizing" way to die. For these reasons, he denied her request. When asked by the press what impact this decision might have on his Senate campaign, the governor responded, "I have no idea." He added that the campaign had "no place in the consideration of a matter of this kind" (Bledsoe, 281). It was quite possible that it did not, but the fact that the campaign was underway added to the uncertainty of the outcome in Barfield's case. As for Tucker, she made her appeal in a state notoriously reluctant to grant clemency and in which the board appears to have been concerned about the message that its decision would send about gender "equity" (see Chapter 11 for further discussion).

However, another point that should be kept in mind is the long lapse of time that is now common between the trial and sentencing and the execution of the condemned person. Because of the appeals process, it is not unusual for an inmate to be on death row for over a decade. In that time, it is quite possible that a woman (or a man) may change in ways that would allow the condemned person and others to argue that he or she is "no longer the person" who committed the crime. This often figures into narratives offered in support of commutation.

With regard to media portrayals of condemned women as a group, Shipman (2002) finds that it is possible to identify both continuities and changes in how women's executions have been portrayed since the first woman was executed in the colonies in 1632. He finds that media coverage has reflected the beliefs and stereotypes of the larger society. Women were expected to be "more virtuous than men." Women were expected to fulfill their roles as good wives and mothers.

As other scholars have noted, these stereotypes had an impact on the response of both the media and the criminal justice system. In the case of the media, when a woman violated role expectations by having a lethal love affair or killing her husband or children, this "increased the news value" of her story. At the same time, when a woman had been convicted and faced execution, stereotypes of women as "gentle, caring, and motherly made executions of women more difficult" than executions of men (Shipman, 2).

Moreover, Shipman's analysis of media coverage reveals a consistency that repeatedly surfaces in sensational cases that receive wide coverage. That consistency is the complaint by the defendants about "unfair, prejudicial stories prior to trial" (10). Evaluating the evolving nature of media coverage, Shipman finds:

> The nineteenth-century press also routinely injected religion into stories, and, until the mid-twentieth century, expressed displeasure or concern about women's unseemly interest in executions and trials. Many press reports extending into the mid-twentieth century resembled dramas, and in the nineteenth century, the press often published lengthy reviews of the cases. . . .Until the mid-twentieth century, the press consistently engaged in hyperbole when describing cases, and routinely reported defendant's confessions, a practice that still continues . . . (10).

A practice that also continues is that some death row women fare better in press coverage of their trials, appeals, and executions than others. Shipman (2002) points to "the shameful treatment of black women." Prior to emancipation, slaves who were executed, usually received no mention in the white press. The case of Celia, the slave, was one of a few exceptions. During the last two decades of the nineteenth century, black women received more coverage, but the white press still tended to use negative physical descriptors and negative stereotypes (such as references to blacks as superstitious). Nor did the press raise concerns about the execution of juvenile black women. Shipman finds that in the twentieth century, most of the executions of black women has received "only cursory notice in the press" (Shipman, 20-21).

However, the execution of **Wanda Jean Allen,** an African American woman who killed her lesbian lover, did receive "substantial coverage." Allen was the first woman to be executed in Oklahoma since 1903. She was the first black woman to be executed in the 21st century, as Betty Butler had been the last to be executed in the 20th century. In 1954, Butler had also been put to death for the murder of her lesbian lover. But the "cultural difference" between 1954 and 2001 made it easier for the press to report about Allen's sexual preference and the motivation for her crime (Shipman, 183-185). The exact nature of Allen's relationship with her victim was a prominent aspect of the prosecution narrative. Later, when the press that had given the trial "little coverage," began to focus on the execution, the question of how the fact she was a lesbian had influenced her sentence became a part of the media discourse (Shipman, 185-189).

For another woman on death row, the matter of her sexual preference was also a prominent—and stigmatizing—aspect of the narratives about her.

The Lesbian Serial Killer

In January 1991, when **Aileen Carol Wuornos** was arrested on an outstanding weapons-violation charge, she was a suspect with another woman in the deaths of men whose bodies had been found along the highway in north central Florida and southern Georgia. Wuornos confessed to the killing of Richard Mallory. She said she was confessing to clear the name of her lesbian lover, Tyria Moore (who later testified against her). Wuornos said she had killed Mallory after he raped, tortured, and threatened to kill her.

> Wuornos explained that after the first shot, she realized she had a decision to make: to continue shooting or to stop and help her assailant. But who would believe a prostitute claiming that she had been raped and feared that she had either to kill or be killed? She continued to shoot. By her account, Aileen Wuornos killed a total of seven men, under similar circumstances in self-defense. (Skrapec, 1994: 242).

As a bisexual prostitute who shot men, Wuornos was at a decided disadvantage in the construction of the narratives about her acts. She was labeled a "lesbian serial killer" and a "man-hater." Like male serial killers, she had preyed on strangers. Both the FBI and most media characterized her as the first female serial killer, ignoring the fact that historically other women had killed several people over a period of time. According to the narratives about her, Belle Gunness was a serial killer. But Gunness invited her victims to her farm in LaPorte rather than roaming the highways.

However, in a contest of images, even the "masculinized" Mrs. Gunness fares better than Aileen Wuornos. In the narratives about her Belle Gunness is gruesome, but she is also the subject of almost affectionate ballads, plays, and jokes. Wuornos also does not fare as well as male serial killers. Her crimes seem to be perceived as even more of an aberration than those of male serial killers because she laid claim to the role of "deadly stranger" usually reserved for men. Hart (1994) observes, "Wuornos embodies two incontrovertible reversals in the profile [of serial killers]: she is a woman; and her victims were heterosexual, white, middle-class males, not members of powerless groups" (136).

Even when in custody in the courtroom, Wuornos seemed full of rage. After the jury reached its verdict finding her guilty, she screamed at them, "Scumbags of America!" Two days later, when the judge sentenced her to death based on the jury's recommendation, Wuornos yelled, "Thank you. I'll go to heaven now, and you will rot in hell" (Lane and Gregg, 366). However, Chesler (1993) challenges the treatment of Wuornos in the media and by the criminal justice system. She asserts that Wuornos became a media commodity, even to the extent that witnesses who might have been called in her defense were involved in negotiating with a Hollywood film maker and, therefore, did not cooperate with Wuornos' public defenders (Chesler, 12). Although the media were later instrumental in exposing the violent past of Richard

Mallory, one of the men Wuornos claimed she had killed in self-defense, this came too late to help Wuornos during her trial. At the same time, Wuornos' attorney failed to call expert witnesses that might have testified about Wuornos' fear of male violence as the "long-term consequences of extreme trauma" (Chesler, 12). Chesler also questions the behavior of the police investigators who obtained a confession from Wuornos and the judge's decision to allow the videotaped confession to be used in court. Chesler finds it disturbing that the lead prosecutor, John Tanner, a born-again Christian, had served as the death row "minister" for Ted Bundy. She notes that although Tanner had "tried to have Bundy's execution delayed," his attitude toward Wuornos reflected a "legal theory. . .replete with misogynist stereotypes." This was reflected, she argues, in Tanner's trial narrative. In his opening and closing arguments during the trial, he "portrayed Wuornos as a 'predatory prostitute'." Tanner said that Wuornos had "killed for power, for full and ultimate control" over men (Chesler, 13).

Wuornos as an unrepentant, lesbian serial killer with a foul mouth did not play well with the prosecution or the jury.[6] Wuornos was portrayed as a woman who committed crimes that should have been alien to a woman's nature.

But what of women who kill within a role that is supposed to be natural to them? What about modern mothers who kill?

Murder and Mothers

Since Medea was accused of destroying her children in revenge against the husband who deserted her for another woman, her name and image has been conjured up to describe women who kill their children. In modern times, **Susan Smith** has become another woman whose name is synonymous with "murdering mother." Smith was not seeking revenge on her former husband, but she was seeking to rid herself of her two children. She sent them into the river in her car, still strapped in their car seats. Then, as did Charles Stuart in Boston, she created an African American stranger as the culprit (for discussion of racial hoaxes, see Russell, 1999).

Smith claimed that this stranger had taken her children during a carjacking. But even though her tearful pleas during press conferences (held with her former husband) convinced much of the public that she was a grieving mother who only wanted the safe return of her kidnaped children, the police investigating the case began to find her story suspicious. When confronted with what she had done, Smith was repentant and distraught. But during the trial, the prosecution argued that she had disposed of her children because they stood in the way of her relationship with her well-to-do lover. The photos of the two handsome, smiling little boys that were shown repeatedly helped to make her crime seem even more "evil." She had killed her children, sending them to drowning deaths. Even when the defense attempted to counter with details of Smith's own childhood and the stresses

that had led to her crime, the images of the two boys and of Smith's duplicity in concocting her story of an African American carjacker remained.

If a woman is driven to kill her children because she is mentally ill, she can be given a psychiatric label. She is "mad," not "bad." This has been an issue in the cases of both Susan Smith and **Andrea Yates,** who drowned her five children in the bathtub. Although Yates was eventually sentenced to prison, the role of postpartum depression loomed large in the public discourse about why she had killed her children (see Chapter 11 for further discussion). With Smith, claiming the status of "mad" rather than "bad" was much more problematic. Psychiatrist Seymour Halleck, who examined Smith and testified on her behalf said that she suffered from suicidal depression. But her "survival instincts overcame her maternal instincts" when she jumped from the car at the last moment. He suggested that if she had received treatment for her depression, she would not have killed her boys. This explanation of her behavior might have been more readily accepted by the public if not for the man, Thomas Findlay, that Smith was supposed have wanted enough to kill her children to get him. Based on his interviews with her, Halleck said that Smith had told him of sexual encounters with other men. The psychiatrist expressed his doubts that Findlay was the only man in whom Smith had been interested and noted that she tended to be dependent in her relationships with men (Baxley, 07/22/1995). Even if an accurate assessment of Smith's mental/emotion state, one wonders how the jury interpreted Smith's vulnerability and neediness when it translated into the pursuit of sexual liaisons with men.

Diane Downs (1983)

In *Small Sacrifices* (1988) Ann Rule presents the story of Diane Downs who shot her three children on May 19, 1983 in Springfield, Oregon. Downs reported that she had stopped her car to help a "bushy-haired stranger," a man, who waved her off the highway and shot her children, Cheryl, Danny, and Christie at close range. Downs only suffered minor injuries (see, Geringer, online).

When investigators searched Downs' home, with her permission, they found a .22 caliber rifle and a box of standard .22 caliber shells. (The same caliber shells as taken from the children's bodies.) Downs stated that it was not her weapon. The police also located her diary and letters that described her relationship with a man she had an affair with at work. Downs' belief that he broke up with her because of the children may have contributed to her shooting them (Geringer, online).

At trial, Downs' surviving daughter, Christie, was the District Attorney's star witness. She testified that her mother first shot Cheryl and then shot Danny. She also stated that her mother shot her (Geringer, online).

Diane Downs (1983) *continued*

Diane Downs was sentenced to life plus fifty years in prison.

Diane Down's Victims

NAME	AGE AT TIME OF SHOOTING	OUTCOME
Christie	9 years	Survived shooting
Cheryl	7 years	Died from gunshot wound
Danny	4 years	Survived shooting

As did Susan Smith, **Marybeth Tinning** initially received a great deal of sympathy as a mother in distress. In Tinning's case her children were dying one after another. This pattern began in 1972 and continued until 1981, when she had no more children left. Then in August 1985, she gave birth to a daughter. By December, 1985, that infant too was dead. Tinning, a former pediatric nurse's aide, later admitted that she had killed three of her nine children. It is probable that she actually killed eight children, seven of her natural children and one adopted child.

The deaths of the Tinning children went on for so long because the physicians who saw the children were unable to explain the acute illnesses that would send Tinning rushing to hospital emergency rooms with each child in turn. During the investigation by the police that led to her murder conviction, the police found that many people had suspected Tinning was killing her children. But because of lack of communication or centralized records keeping, none of these people—friends, police, social workers, doctors—had pursued his or her suspicions. One child who had a fever immediately before her death was diagnosed as having Reyes' syndrome. With another child, the doctor certified cause of death as Sudden Infant Death Syndrome (SIDS). When one infant son died, the doctors ordered genetic tests, thinking a genetic abnormality might be the reason Marybeth Tinning's children were dying. Then the adopted son died too. But it was only in 1985, when her daughter died and Tinning told her husband, family, and the doctors that she had found her tangled up in the blankets in her crib and not breathing that an investigation was initiated. Dr. Michael Baden, director of the New York State Forensics Science Unit, concluded the child had actually been suffocated. After reviewing medical records, he concluded that eight of her nine children had been suffocated.

Tinning was charged only in the death of her last daughter. Her defense attorney said that the child, Tami Lynne, had died of a rare hereditary disorder, and that was the cause of death for the other children as well. Although Tinning had said prior to trial that she had put a pillow over the child's head to stop her from crying, in court, she recanted her confession. The jury concluded that there was reasonable doubt about whether she had deliberately

killed her daughter, but believed she had acted recklessly and with depraved indifference. Convicted of second degree murder, she received a sentence of 20 years in prison. The prosecutor decided not to pursue charges in the other deaths (Ewing, 1997: 41-45).

In explaining Tinning's behavior, experts have suggested that she was suffering from Munchausen Syndrome by Proxy. People with Munchausen syndrome present themselves for medical treatment with an array of feigned or self-induced illnesses. They do this because of the attention that they receive when they are ill. In Munchausen by Proxy (MBP), which is even rarer, mentally disturbed parents, usually mothers, induce the symptoms in their children. They themselves receive attention in the role of caring and distressed mother (Ewing, 46-47). These cases, Tinning and Smith, were only two of those during the 1990s (see Boxes for overview of some others) that left the public and a jury trying to unravel the true story behind a woman's behavior toward her child or children (see McCormick et al., 1994).

Defenses Used in Alleged Infanticide Cases

Postpartum depression (PPD): There are three types of PPD. Many women experience **"baby blues"** that may last from a few hours to a couple of weeks. Mothers experience symptoms such as sudden mood swings, unexplained crying, irritability, and restlessness. **"Postpartum depression" (PPD)** may occur in 10 to 20 percent of new mothers (Watkins, 2000). It differs from **"baby blues"** in its onset and duration. It may happen a few days or months after delivery, and the mother may experience the symptoms more strongly than with **"baby blues."** The symptoms are similar to those of **"baby blues,"** but the mother may also be indifferent to the child and in completing daily routines (Oglesby, 2001). A very serious and rare condition, **"Postpartum psychosis,"** may occur in 1 or 2 of 1,000 new mothers (Ibid) within the first 3 months after childbirth. Symptoms include auditory hallucinations, delusions, and less commonly, visual hallucinations. These women may also appear agitated, angry, and experience insomnia. The treatment for PPD includes antidepressants and psychotherapy.

Schizophrenia: Schizophrenia is a severe mental disorder. It is a particular form of psychosis. Symptoms include delusions, hallucinations, thoughts disorders and paranoia (www.schizophrenia.com). The peak period of onset for women is the 20s to early-30s (Ibid.). Miller (1997) reports that "a significant proportion of women with schizophrenia experience increased symptoms during pregnancy and postpartum" (see National Institute of Mental Health, "Women Hold Up Half the Sky: Women and Mental Health Research," 2001).

Sudden Infant Death Syndrome (SIDS): is the sudden death of an infant younger than one year that remains unexplained after review of the clinical history, examination

Defenses Used in Alleged Infanticide Cases *Continued*

of the scene of death and postmortem (Creery and Mikrogianakis, 2003:1376).

Munchausen Syndrome by Proxy (MSP): occurs when a caretaker intentionally creates symptoms of illness in another person in order to receive attention from others for themselves. The mother is the perpetrator in about 95% of the cases (D'Agostino, 2002).

Waneta Hoyt 1965-1972

Waneta Hoyt was arrested in 1994 after questioning by state troopers about the deaths of her five children whose deaths were attributed to Sudden Infant Death Syndrome (SIDS). At the time of their deaths during the mid-1960s through the early 1970s, it was believed that genetics was the cause of SIDS (MacKeen, 1997). In 1972, Dr. Alfred Steinschneider, published his research based on his study of Hoyt's two children, Molly and Noah. In the article he discussed how sleep apnea was directly linked to SIDS, which may be genetic (Toufexis, 1994:63). His article was Waneta Hoyt's main defense (BBC Horizon, 1999).

In 1995, Waneta Hoyt was convicted of one count of first-degree murder and four counts of second-degree murder for killing her children. Hoyt's defense argued that she suffered from Munchausen Syndrome by Proxy. She was sentenced to 75 years to life in New York's Bedford Hills Correctional Facility where she died in 1998.

Waneta Hoyt's Victims

NAME & YEAR OF DEATH	AGE AT TIME OF DEATH	SYMPTOMS	DEATH OFFICIALLY RULED AS
Eric (1965)	3 months	Breathing Problems	SIDS
James (1968)	2 years	No Symptoms	SIDS
Julie (1968)	48 days	Breathing Problems	SIDS
Molly (1970)	2 months	Breathing Problems	Apnea/SIDS
Noah (1972)	2 months	Apnea	Apnea/SIDS

Marie Noe 1949-1968

Over the course of two decades, Philadelphia resident Marie Noe smothered her eight children. Their deaths were attributed to Sudden Infant Death Syndrome (SIDS). Although police investigators suspected she killed the children, they did not have sufficient proof (www.courttv.com).

In 1999 Marie Noe pled guilty to eight counts of second-degree murder. She received a sentence of twenty years probation. Specifically, the first five years were to be served under house arrest. As a condition of her probation, she was ordered to receive intensive psychotherapy. Through her treatment, researchers anticipate a clearer understanding of what causes mothers kill their children (Ibid).

Marie Noe's Victims*

NAME & YEAR OF DEATH	AGE AT TIME OF DEATH	DEATH INITIALLY RULED AS
Richard (1949)	1 month	Congestive Heart Failure
Elizabeth (1950)	5 months	Bronchopneumonia
Jacqueline (1952)	21 days	Choked on vomit
Arthur Jr. (1955)	12 days	Bronchopneumonia
Constance (1958)	1 month	Undetermined
Mary Lee (1962)	7 months	Undetermined
Cathrine (1964)	2 years	Undetermined
Arthur Joseph (1967)	1 year	Undetermined

*Information from Stephen Fried (1998) "Cradle to Grave." Phillymag.com

Gloria Greenfield 1967-1971

In 2002, after more than thirty years, Gloria Greenfield was charged with three counts of first-degree murder for the deaths of her three children Melissa, Theodore and Regina (*The Herald*, April 2, 2002). At the time of their deaths, it was believed that the babies had died as a result of Sudden Infant Death Syndrome (Ibid.)

The current investigation resulted from the request of Greenfield's surviving daughter to review the death records of her three siblings. She was curious about their deaths because, according to family members, she also had

Gloria Greenfield 1967–1971 *Continued*

stopped breathing as an infant. Greenfield is also charged with two counts of assault with intent to kill her surviving daughter on two separate occasions in 1972 when the daughter was an infant (Bobby, 2002).

Greenfield pleaded innocent to all charges.

Gloria Greenfield's Alleged Victims

NAME & YEAR OF DEATH	AGE AT TIME OF DEATH	ORIGINAL REPORTED CAUSE OF DEATH
Melissa (1969)	Under 1 month	SIDS
Theodore (1970)	Under 1 month	SIDS
Regina (1971)	Under 1 month	SIDS

Several cases that attracted a great deal of media attention brought a new word into the headlines, "neonaticide." As discussed in earlier chapters, the killing of newborns is an old crime. Historically, explanations offered for the crime often focused on the woman's economic plight, as in the case of 18th century servant girls who smothered their new-borns and then concealed the bodies. Observers said such acts were born of poverty and desperation. But what explanation should be offered for modern acts of neonaticide in which a white teenager from a "good" family manages to conceal her pregnancy and then, either alone or with the aid of her boyfriend, give birth and dispose of the newborn?

Neonaticide and Teenage Mothers

In the photographs published in magazines and newspapers, **Amy Grossberg** and Brian Peterson, looked well-scrubbed and clean-cut. However, they were accused of killing their infant, after Grossberg had given birth in a hotel room, and then disposing of it in a Dumpster. In England, Amy Grossberg, the teenager mother, probably would have been assumed to be suffering from a mental disturbance and treated rather than being sent to prison.[7] In the United States, she was convicted of a crime and punished. One difficulty Grossberg had in presenting herself as a frightened and traumatized young woman was that she and Peterson had acted together. The July 13, 1998 cover of *New York* magazine carried one of the photos of Grossberg and Peterson mentioned above. They were smiling. The caption read:

> This week, when sentencing the high school sweethearts who killed their child, a judge must decide: are they mixed-up kids or monsters?

The defense attorneys for Grossberg and Peterson claimed that the baby had died of "schizencephaly, perhaps aggravated by eclampsia." One defense attorney argued that if the baby had been alive, the teenage parents would have

"dropped it off on a doorstep." But Grossberg and Peterson thought that the baby was dead because it was still and blue. That was why they put it into the Dumpster (Thernstrom, 1998: 23). However, the deputy chief medical examiner of Delaware who had performed the autopsy offered another narrative about what must have happened. Quoted in the *New York* article, she said that the baby had not been dead when it was put into the Dumpster. She asserted that it had died from trauma, oxygen deprivation, and exposure. She was confident that the fractures she found had not been accidental (Thernstrom, 22-23).

When faced with this evidence, Grossberg and Peterson began blaming each other. He insisted that she urged him to dispose of the baby. She claimed that he acted alone in putting the baby in the Dumpster. Peterson accepted the opportunity to plead guilty to manslaughter in exchange for his testimony against Grossberg at her trial. As a part of the agreement, he also admitted disposing of the baby. He continued to claim that he thought the baby was dead, and that Grossberg begged him to dispose of it. When Grossberg learned of his plea agreement, she decide to plead too. She acknowledged that she had unintentionally killed her baby. They both received an eight-year prison sentence, but Grossberg had five and half years suspended from her sentence and Peterson, six.

The question that remained for many people was how these middle-class teenagers had come to not only have a baby in secret but also dispose of it. In her *New York* article, Thernstrom (1998:84) pondered the dilemma in which Grossberg and Peterson had found themselves. She suggested that they were prototypical "good kids," who feared disappointing their parents, so instead they killed their child. A psychiatrist she interviewed for the article, Dr. Paul McHugh of John Hopkins Medical School, noted that the choice made by the couple suggested a kind of "moral retardation" that made it difficult for them to understand that what they were doing was wrong (Thernstrom, 84).

The judge in the case expressed outrage over Grossberg's behavior, describing her "egocentrism" that led her to devalue her child's life (Jonas, 1998). Do Grossberg and Peterson emerge from the narratives about them as "mixed up kids" or "good kids gone bad" or are they seen as "baby killers"? The newspaper headlines when Grossberg was released from prison in May 2000 reflected the varied emotions that the case had produced.

What has emerged in the media with these cases of middle-class young women who kill their new-borns, alone or in concert with their boyfriends, is a tendency to report these cases as events that require the interpretation of experts. As the students in the mass media class taught by one of the authors observed after watching a television news program about neonaticide, it was difficult for the young women interviewed—and their parents—to present a convincing narrative of the young woman as suffering from a mental disturbance at the time when the offense was committed. The claim that it all happened in "a kind of dream" rang false even when the journalist then turned to an expert on neonaticide who said that this sense of detachment and

unreality was common in the cases that she had studied and a symptom of the disturbance. The majority of the students watching felt that the young women did not make convincing witnesses in their own defense. Even those students who were willing to accept the explanation that the young women had been suffering from a mental disturbance at the time when they killed their infants, felt that on television the young women seem "unbelievably naive," "spoiled," and/or "immature." The parents of these young women did not fare much better in the students' estimation. The authors would suggest based on this non-random sample of undergraduate students and on their own observations, that the success of the message does depend on the medium. In the case of young women accused of neonaticide, television might well not be the best medium for presenting their narratives about their acts.[8]

Two other groups of women who have been characterized as "bad mothers" should be considered in this chapter.

Substance-Abusing Mothers

Two categories of substance-abusing mothers, women who are alcoholics and women who are drug addicts, have been the subject of both negative criticism and attempts to control their behavior. When fetal alcohol syndrome (FAS) was discovered in the 1970s, women who drank while they were pregnant were portrayed as putting their fetuses at risk of birth defects. Golden (1999) writes:

> Popular magazines aimed at female readers began publishing uplifting stories of women who overcame their dependency on the bottle, while movies depicted "fallen women" who, through psychiatric treatment or attendance at Alcoholics Anonymous (AA) meetings, regained their self-respect and their families . . . (272-273).

But although, therapeutic abortion was recognized as one possible solution when a woman discovered that her fetus had been damaged by her drinking, this use of abortion was soon seen as undesirable (Golden, 273-274). Instead women were expected to be good mothers to the fetuses in their wombs and avoid drinking to prevent injury to their unborn children.

As Native American women became identified as a "problem group," who had high levels of alcohol abuse and alcoholism, FAS became identified with this racial minority. Golden (1999) argues that this made it easier to re-frame a medical condition as "the moral failings of mothers and marked their children as politically marginal and potentially dangerous" (Golden, 270). Gradually, between 1973 and 1990, "when it began to be cited in appeals from death-row inmates, FAS was demedicalized . . . physicians . . . lost the cultural authority to frame its public meaning." Instead, FAS, now associated with deviance, became a matter for government and legal professionals who set out to first warn women and then to penalize those who continued to drink while pregnant (Golden, 278).

At the same time, some women whose babies had been born with FAS

attempted to bring law suits against liquor companies. But here again, the mother's failure to show restraint in her consumption of alcohol for the sake of her unborn child made the mother's attempt to blame the manufacturers difficult. For example, in 1989, when a woman named Candance Thorp sued James A. Beam Distilling Company because of damage that her son Michael had suffered, she was not a particularly effective witness. The defense got her to reveal under cross examination that she had drank a fifth of Jim Beam a day when she was pregnant (Golden, 280). The Chief Executive Officer of Jim Beam quipped that Thorp would not have stopped drinking even if the bottle was labeled with a "skull and crossbones" (Golden, 280). Golden observes of the jury's failure to find in Thorp's favor, "To medical professionals, the stigmata of prenatal alcohol exposure may have been visible: to the general public, Michael Throp [sic] bore the signs of bad mothering. The line between congenital and social deficiencies proved hard to draw" (Golden, 281).

Regarding the emergence of criminal prosecution of pregnant women who use substances harmful to their fetuses, Baer (1999) finds that in the mid-1980s, the use of criminal law to control the behavior of these women became a part of the public agenda. Women who smoked, drank, and used drugs were the targets. She notes that the prosecution of drug-using mothers "was a logical extension of both the prevailing anti-drug sentiment and greater public awareness of the fetal dangers of the mid-1980s" (Baer, 158). Between 1987-1991, "about sixty criminal proceedings [were brought] against mothers for substance abuse in nineteen states and the District of Columbia. Accounts exist of women on Indian reservations being locked up during their pregnancies" (Baer, 158).

In the case of "crack mothers" much of the public seemed willing to accept the argument that any damage done to their fetuses was completely the fault of the mothers. As the "war on drugs" in the inner city escalated, African American women who used the new drug of choice, "crack cocaine," were seen as mothers who were creating defective children that would in all likelihood be both unhealthy and mentally deficient. These defective infants, coming as they did from a "bad environment," might be expected to be the next generation of violent criminals.

In this regard, Humphries (1999) finds that the use of drugs by lower-class women has tended to amplify drug scares because

> issues of lower-class sexuality and reproduction have historically bothered elites . . . So when the media interviewed women who used crack during pregnancy, the emerging stereotype that stressed the mothers' indifference to their suffering newborns reinforced the drive to reduce services and benefits to the undeserving poor and tended to justify punitive responses . . . (12)[9]

Golden (1999) writes, "A tidal wave of fear washed over the public as the media reported on the wild, damaged, and dangerous children emerging from the

wombs of their cocaine-addicted, lower-class African-American mothers" (283).

Bringing the criminal justice system to bear on the problem, prosecutors began to develop legal theory based on the concept of maternal liability for damage to fetuses. This argument was based on the idea that the fetus at the time of viability had a right to legal protection and that a mother who "delivered" drugs to her unborn child could be prosecuted for the damage done to it (Golden, 283). Baer (1999) relates the issue of fetal protection to "gender thinking":

> Fetal protection policies include several kinds of regulations. Employment restrictions limiting women's exposure to substances harmful to fetuses thrived from the late 1970s to the early 1990s. Civil courts have heard lawsuits to force pregnant women to undergo procedures such as cesarean sections or fetal surgery, and lawsuits by children against mothers for prenatal damage. Lifestyle restrictions—the use of criminal law or civil judgments to prohibit pregnant women from using drugs or alcohol—comprise a fourth type of fetal protection (151).

Kasinsky (1994) finds parallels between fetal protection policies aimed at substance-abusing mothers today and the policies advocated by Progressive Era "child savers." She asserts that in both the modern era and during the Progressive Era (1890-1920s), the state has implemented policies based on an ideology that privileges certain perceptions of motherhood and parenting, while penalizing others (Kasinsky, 98). In the modern era, as in the past, this approach creates a category of "unfit mothers" and some women are more vulnerable to such classification because of their use of public facilities and bureaucracies:

> In public hospitals drug testing seems to be a regular procedure, whereas in private hospitals testing is done only when a mother is suspected of using drugs. Class correlates are relevant, since a higher percentage of low-income women use public hospitals and clinics. Testing can be triggered by a history of drug or alcohol abuse, preterm labor, or little or no prenatal care. Low-income women who are not covered by health insurance are more likely to deliver with little or no prenatal care or with other pregnancy complication from poor or lack of care...(Kasinsky, 116-117).

One response to this attempt at what critics have called "pregnancy policing" is the recent class action lawsuit brought by women against a South Carolina hospital in which staff voluntarily worked in cooperation with the police, informing the police when a woman who gave birth at the hospital tested positive for drugs. In what Roberts (1997) calls "The South Carolina Experiment," the Medical University of South Carolina (MUSC) "a state hospital serving an indigent minority population" (164) initiated a program under which pregnant women were tested for drugs. Pregnant women who tested positive were arrested

by the police. These women were held in jail until they were ready to give birth. Other women who arrived at the hospital in labor were arrested after they had delivered their babies (Roberts, 165-166, also see Sealey, 10/4/2000).

However, Robert finds that most pregnant women charged with prenatal crimes has been pressured into accepting pleas (167). When women have appealed the application of child abuse, homicide, or drug abuse laws to their status as pregnant women, their appeals have generally been successful in higher courts in states including Florida, Missouri, and New York (167-168). The state of South Carolina was forced to dismantle the MUSC experiment when the class action lawsuit brought the program to the attention of the federal government. The National Institutes of Health determined that the hospital had in effect been conducting experiments on human subjects (testing the relationship between incarceration and reduction of drug use by pregnant women) without federal review and approval. Threatened with the loss of federal funding, the hospital shut down the program (Roberts, 168-169).

However, the state seems committed to its hard line approach. In January 2003, South Carolina's Supreme Court upheld the conviction of a woman who delivered a still born 5 lb. baby girl at MUSC. By a vote of 3-2, the court let stand the 12 year prison sentence that Regina McKnight had been given. McKnight was convicted under South Carolina's "homicide by child abuse" law because her baby was still born after she had used cocaine (Collins, 01/27/2003; also see Stevens, 02/23/2003). In May 2003, McKnight's attorneys asked the United States Supreme Court to review the decision by the South Carolina Supreme Court. In July 2003, twenty-six medical and health care groups registered their support of McKnight by entering a plea with the U.S. Supreme Court. Their decision to do so was prompted by concern that if McKnight's conviction were not overturned the case might set a precedent for the prosecution of mothers of stillborn children. However, in October 2003, the Court declined to accept McKnight's case for review (*The Post and Courier*, 10/7/2003).

As noted above, such prosecutions have been rare and generally unsuccessful. However, such punitive actions by the state are based on the perception that a woman has obligations to her unborn fetus. This controversial perception relates directly to the question of a woman's autonomy over her own body. It is the question that is also inherent in the debate about abortion. Moreover, the discourse about drug-addicted mothers has served to stigmatize these women and their children. It has continued the debate—related to welfare policy—about the obligations of a "good mother." In her examination of this issue, Roberts (1997) argues that racial bias has been an underlying factor in the actions of prosecutors. She writes:

> . . . choosing these particular mothers [Black women] makes the prosecution of pregnant women more palatable to the public. Prosecutors have selected women whom society views as

undeserving to be mothers in the first place. If prosecutors had brought charges instead against wealthy white women addicted to alcohol or pills, the policy of criminalizing prenatal conduct would have suffered a hasty demise (Roberts, 178).

Although given a late 20th century twist, these policies represent a continuation of the monitoring of maternal behavior that runs like a bright thread through history. Both fathers and the state have interests in the oversight of maternity. Here women are charged with failing to be good mothers even before their babies are born

Finally, other women are sometimes perceived as failing to care for their children because they choose to pursue careers outside the home rather than devote themselves to full-time childcare.

The Career Woman Mother

Although it was **Louise Woodward,** the young British au pair, who was put on trial in 1997, when Matthew Eappen, the eight month old infant in her care, died, a part of the discourse in the media, by the public, and in the courtroom focused on the culpability of Matthew's mother, Deborah Eappen. Eappen was a professional woman who had returned to work after her son was born, leaving him in Woodward's care. The discussion about Eappen focused on whether in doing so, she had been a "bad mother." Purkiss (1999: 1) quotes a joke about Louise Woodward that appeared on the Internet: "They say Louise Woodward is going to open her own branch of McDonald's, where with every burger children will get a free shake." Purkiss asserts that this joke was open to dual readings. On one hand, it referred to the allegation that Woodward was the person who had killed Matthew by shaking him (Shaken Baby Syndrome).[10] On the other hand, the joke made allusion to Deborah Eappen who had left frozen breastmilk that Woodward was supposed to thaw and give to baby Matthew. If Woodward had given way to frustration and anger and killed baby Matthew by shaking him, Eappen had been an "unnatural" mother because instead of providing her infant with warmth and nurturing (in the form of her breasts rather than frozen milk), she had chosen to pursue her career. Eappen had left her baby in the care of an au pair (a nanny) who was hardly more than a child herself. Therefore, Eappen was at least partially to blame for her infant's death.

As Purkiss notes, among the facts this narrative of Eappen, as a professional woman who placed her career before her child, fails to take into account is that in leaving frozen breastmilk for her child, Eappen was attempting to provide her infant with milk she considered healthier than formula and following the standard recommendations about how to do so (Purkiss, 2-3). The motif of the "foreign milk" (i.e., frozen breastmilk fed to the baby by Woodward) that appears in this case can be traced to the Medea

story and, later, to the witch trials. In the Greek tale, Medea is a foreigner, the "other," an outsider. In addition:

> Medea is among other things a witch, using her breast for the perverse motherhood of witchcraft, and the breast also played an important role in the witchtrials of the sixteenth century. Early modern witchcraft is all about who counts as a good mother; this is evident from the fact that in both England and Germany, women accused of witchcraft were often not only servants in the households of their accusers, but particularly suspect if they were the woman who looked after mother and baby after child-birth ... suspicion often fell on women who fed other women's children ... (Purkiss, 4-5).

In the Woodward case, the public (and the jury) "agonized over which of these women was the witch, which the unnatural and which the real mother" (Purkiss, 5). Although Woodward was convicted of murder, the presiding judge reduced her conviction to manslaughter and gave her a sentence of time served (279 days). This sentence itself became the subject for more debate on both sides of the Atlantic (particularly because Woodward's British supporters thought she had been badly treated).

This discourse about Matthew Eappen's death reflected societal anxieties about working mothers and inadequate childcare. Eappen, a upper middle-class woman who was married to another professional and who did not "have to work," became a symbol of the conflict between motherhood and career. Law (2000) notes that in the politics of breastfeeding, advocates "generally pit the well-being of babies against women's participation in the wage economy" (428). As this case would suggest, the debate itself is most relevant for white middle class women who have access to a male breadwinner and to childcare (Law, 410) and who are perceived as having options. Thus, it is difficult for even middle-class women to avoid dealing with the gender politics of motherhood. As the Woodward ("nanny") case illustrates, on occasion, the courtroom can become a forum for this debate.

Summary

This chapter has focused on perceptions of and responses to women who kill in the modern era. The chapter began with a discussion of the gun ownership by women in the context of the discourse regarding armed self-defense and a woman's obligation to protect her family. The chapter then turned to the issues raised in narratives about battered women who kill and the "battered woman syndrome." The chapter continued with discussion of several high profile cases in which women killed husbands or children. Discussion of media coverage of women on death row was followed by a look at the stigmatizing and prosecution of drug-abusing mother in the interest of fetal protection. The chapter ends with a look at the Louise Woodward case as an example of contemporary concerns regarding child-care providers and working mothers.

Having brought the discussion of the social construction of women as killers from antiquity to the present, the book turns in Part II to a more thorough examination of the role of popular culture/mass media. The roles of the news media and magazines in the social construction process has been discussed in the preceding chapters. The next chapter presents an analysis of true crime books about women and murder. This is followed by a chapter that focuses on women and homicide in literature, music, and popular films.

Discussion Questions

1. Discuss the use of guns by women as defensive weapons. Do you think arming themselves is an effective way for women to deal with male violence?

2. Discuss the battered woman syndrome and its use in the defense of women who kill their abusers. Do you think it is fair, as some critics have done, to characterize the use of this syndrome in explaining the behavior of abused women who kill as an attempt to use a "Get out of jail free" card or to claim a "license to kill"?

3. Do you think a woman should be liable for harm done to her fetus during the course of her pregnancy? If so, under what circumstances?

Notes

[1] Kates continues to advocate gun ownership by women and others who historically have not been able to depend on protection by the police. He is involved in offering conferences on the Second Amendment which a cross-section of men and women are invited to attend. These conferences include an opportunity to participate in a handgun training session.

[2] Lombroso and Ferrero (1895 [1958]) attribute Belle Starr's skills to the education she received as the daughter of a "guerilla chief" who fought for the South during the Civil War. They devote almost a page to discussing Starr's aptitude with revolver, carbine, and bowie knife and her strength and boldness (188-189). Of course, Annie Oakley also achieved legendary status as a sharpshooter in Wild West shows.

[3] Actually, some animal rights advocates also look with disapproval on the participation by women (and men) in hunting. Britain's Queen Elizabeth came under fire (no pun intended) from activists when she not only went hunting while at her estate in Norfolk, but also wrung the neck of a wounded pheasant. Hunting experts said the Queen had been following common practice, that wringing the neck of a wounded bird is the most humane way to put it out of its misery. Advocates said the Queen and the other members of her party had put the bird in its misery in the first place. Queen Elizabeth's silent response was to wear pheasant feathers in her hat when she attended church the next day (Queen Ruffles Feathers, on-line).

[4] There is also the matter of the responsibility of the battered woman who is a mother to protect her children from battering. See Miccio (1995) for a discussion of this topic in the context of passive battered mothers and child neglect.

[5] See Mann (1990) for her study of 96 women who killed while under the influence of alcohol or drugs.

[6] See Brown (2000) for the controversy about the case of two lesbians who were convicted of killing a Toronto (Canada) police officer and then, to the outrage of many, including the police officer's widow, housed together in the same minimum-to-medium security institution where they could continue to see each other.

[7] See Adler and Baker (1997: 19) who state:

> This understanding of the situation of women who kill young children has in fact been enshrined in British and Commonwealth law in the offence of infanticide....while the balance of her mind is believed to be disturbed due to the effects of lactation or giving birth...However, the medical assumption and its legal affirmation that some mothers may be pathologically predisposed to filicide faces increasing scepticism....

> Also see Treneman (1998); Jourdan, (1998); and French (1998).

[8] For more on neonaticide cases and examples of media discussion see McCullough (1997) and Pinker (1997). For medical discussion see Herman-Giddens et al. (2003). For discussion in law journals see Barton (1998) and Macfarlane (1998).

[9] The authors note here that the legal system does not make crack-addicted males subject to punishment when they conceive a child. However, Wonders and Rector (2003, forthcoming) find babies may be born crack-addicted because they were exposed to the drug by their father rather than by their non-substance abusing mothers.

[10] Regarding Shaken Baby Syndrome, see Starling et al (1995), Wehrwein, 1998; and American Academy of Pediatrics, 2001.

Part II
Constructing the Women Who Kill in Popular Culture

In October 2002, "Mugshots: A Mother's Madness," a prime-time documentary about the Andrea Yates' case debuted on Court TV. *Houston Chronicle* TV reviewer Mike McDaniel observed that although the documentary might not cover new ground, it did offer a balanced narrative about the case (McDaniel, 10/28/2002, p. 6). The documentary included an interview with Suzy Spencer, the author of *Breaking Point,* a book about the case of the Texas mother who had drowned her five children.

The role played by the true crime writer in not only offering a written narrative to readers, but through involvement with the visual media means that such writers often acquire the status of "expert" about a given case. As will be discussed in Chapter 9, true crime writers come to the genre from a variety of fields—defense attorneys and prosecutors, law enforcement officers and journalists, psychiatrists and historians. In some cases, a personal relationship with an offender becomes the springboard for a narrative, as in the case of Beverly Lowry, a Texas novelist who lost her son in a hit-and-run accident, befriended convicted murderer Karla Faye Tucker, and wrote a book about it all, *Crossed Over: A Murder, A Memoir.* The memoir eventually became a movie. The movie succeeded in bringing Lowry's narrative about Karla Faye Tucker to an audience who might never have read her book. Although at least one critic was disdainful of the quality of the made-for-TV movie that was shown on CBS (see Hodges, 3/31/2002), the book-made-into-movie revived the debate about Tucker's execution.

However, in the case of Lorna Anderson, her attorney argues that having been the subject of a made-for-TV movie, *Murder Ordained,* has helped to make Anderson notorious in the state of Kansas. He asserts that because of extensive media coverage Anderson has been repeatedly denied parole. Thus far Anderson has served over 15 years in prison for second degree murder of her husband as a consequence of her affair with a married minister. The minister, Tom Bird, was convicted of the first degree murder of his wife (Fry, 3/27/2001). Anderson's lawyer argues that because of her notoriety, she has served double the average time for women convicted of second-degree murder in the state of Kansas (Fry, 3/27/2001).

Clearly, the impact of the media in a given case may not be limited to the news coverage of that case. True crime writers, movie makers, novelists, playwrights, and others outside the newsroom all may play a role in framing a particular case and the social construction of the debate about controversial issues such as domestic violence, infanticide, and the death penalty. In the next two chapters, the role of non-news media in the social construction of narratives about women who kill will be discussed. Chapter 9 focuses on the true crime genre. Chapter 10 examines literature, music, and films.

Chapter 9
Women and Murder in True Crime

Writing about Murder

In his nonfiction book, *Writing Bestselling True Crime and Suspense* (1997), journalist and author Tom Byrnes offers his readers (would-be authors of true crime books) guidance in selecting a case to write about. Byrnes asserts, "a great true crime case is always instructive." Going beyond any surface sensationalism, the case should allow the readers to "gain an understanding of the world that is foreign to them." In true crime books this world is revealed to readers as "a clash between layers of society," "a conflict between generations," or "a set of fundamental drives—greed, sex, or violence—that have gone out of control." According to Byrnes, a good writer "takes a reader beyond the violence" to delve into "the underlying motives that have created it; certain truths are revealed that are bigger than the story. . ." (21).

These comments from Byrnes locate such works as the literary descendants of the broadsides, gallows sermons, novels, sensational news and magazine stories in which the genre has its roots. However, a few pages earlier, in a section titled "The Classic Case," Byrnes cautions the would-be true crime writer that nowadays "a run-of-the-mill murder case won't capture attention in a way that would lead people to spend money to learn more about it." Byrnes explains that as a "result of tabloidization of the general news media," it takes "something spectacular to get the public's attention"(17).

Byrnes goes on to offer his readers practical instructions about finding a crime and doing research as well as the process of writing and finding a publisher. A later chapter features first-person essays from true crime writers about their craft. Best-selling author, Ann Rule—who was briefly a Seattle policewoman and then author of magazine articles before writing her first book, *This Stranger Beside Me,* about serial killer Ted Bundy—explains that she will go through "over three hundred cases before I pick one to work on. I'm not looking for the high-profile case. . ." (244). Rule goes on share the criteria she employs when selecting a protagonist for her next true crime book. The subject, whether male or female, should "have a certain set of qualities." These qualities include: "physical attractiveness, education, money, charisma, charm, success, all the things that people want in their own lives. . .The beautiful people make the best subjects for true crime and I like women protagonists because when they're bad, they're *really* bad! . . ." [italics in the original] (245)

Among the female protagonists that Rule has written about is Diane Downs, the Oregon mother who killed her three children. The book, *Small Sacrifices,* was made into a television movie starring Farrah Fawcett.

The success of Rule and other true crime writers such as Jerry Bledsoe and Aphrodite Jones illustrates that there is an audience for mass-market true crime books. The formula of compelling narrative combined with psychological analysis has attracted readers to books such as Jerry Bledsoe's *Death Sentence,* about Velma Barfield. Barfield was the first woman executed in the United States in the post-*Furman* era. During an interview about his book, Bledsoe explained that one of the questions that had intrigued him

about the case was whether or not someone like Barfield, "a sociopath, could achieve redemption. He noted that Barfield and her attorneys had claimed that she experienced a death row transformation. From his own perspective, he had been impressed by the degree to which those who interacted with her were touched and comforted by her. But it was the fact that her story involved a family drama that had moved him to write about her (Wheelan, 12/12/1998).

Given the criteria offered by these writers for selecting a case—a protagonist—to write about, it seems obvious that most murders committed in the United States are not worthy subjects for true crime books. Since so few women commit murders and many of the ones who do don't do so in sensational fashion, it would seem that the pool of possible female true crime subjects would be limited. But conversely the women who do become the subjects of true crimes are more likely to be the women who are involved in sensational crimes and who are—to quote Ann Rule—"*really* bad!" This would suggest that true crime books like other forms of mass media are prone to offer consumers a distorted view of women who kill. Because of the popularity of this genre and its role in the social construction of women killers, this chapter examines the field.

Historical Narratives and Modern True Crime

As an editor at *Yankee* magazine, Deborah Navas first wrote an article about the Bathsheba Spooner case in 1978. Over two decades later her book, *Murdered By His Wife,* was published by the University of Massachusetts Press (Sacks, 1/04/2000). With its publication the book joined a growing number of works focusing on murder cases from the more distant past. Other such titles include *The Trial of Madame Caillaux* (Berenson, 1992), *Death at the Priory* (Ruddick, 2001), and *A Murder in Virginia* (Lebsock, 2003).. The existence of such studies of historical murder, especially when written by academics, raise questions about what distinctions should be made between these books and the popular, mass-market genre known as "true crime" books.

As a genre, true crime books evolved from earlier narrative forms that depicted the exploits of notorious murderers and the sad fates of their victims. Like these earlier narratives, modern true crime books—distinguished here from scholarly historical works about murder cases/trials—are sometimes viewed with disdain. In an interview about the book market, Patricia Springer, a Texas writer, observed that writers of true crime are also sometimes viewed as being outside the mainstream (Stowers, 01/09/2003). However, true crime books are an important component of the publishing industry. They are especially popular with female readers (Stowers, 01/09/2003). As an example of how well some true crime books sell, during the week of January 19, 2003, Ann Rule was both Number 1 and Number 3 on the *New York Times* non-fiction bestseller lists for paperbacks with respectively a collection of true crime sto-

ries (*Last Dance, Last Chance*) and a book about a millionaire who hired a killer to murder his wife (*Every Breath You Take*). According to the *Puget Sound Business Journal,* the Seattle-based writer has 20 million books in print worldwide (Amundson, 12/03/2001).

The true crime genre came into its own in 1965 with a book that was also a best-seller.

The Evolution of the Genre

At the beginning of the twenty-first century, Barnes and Noble.com lists true crime as nonfiction published as biography, espionage, general, and murder. True crime as a genre began with the publication of Truman Capote's *In Cold Blood* (1965), a non-fiction book about the murders of the Clutter family in Kansas. Although the modern true crime narrative had been popularized over twenty years earlier in *True Detective,* a magazine first published in 1941, Capote's book is said to have established true crime as a genre (Dickson, 1999: 1; Miles, 1991:59). This was so in spite of the books that had preceded Capote's. For example, in the 1930s three books were written about the kidnaping of Charles and Anne Morrow Lindbergh's baby and the subsequent trial of Richard Hauptmann. But Capote's book was groundbreaking because in his style he combined the factual account of the investigative journalist with the creative storytelling of the fiction writer. After Capote, perhaps the next true crime book was Gerald Frank's *The Boston Strangler* (1966). Two early entries into this genre—Vincent Bugliosi's (*Helter Skelter,* 1974) and Ann Rule's *The Stranger Beside Me* (1980)—remain popular today.[1]

As the genre has evolved, a significant proportion of the writers of true crime books have been journalists. In a *Writer's Digest* article, Pulitzer (2000), a true crime editor explained that most of the books his company published are written by journalists because of the "legal responsibilities," particularly the need to document each fact, and "to have two reliable sources saying the same thing" (p. 3 of e-text). In the content analysis of 120 true crime books about women criminals, the authors found that 30.8% of the books were written by journalists or other media personnel. As one might expect, the background or profession of the author will have an impact on the narrative of the true crime as a story. For example, Vincent Bugliosi brings his legal expertise as the prosecutor of the Manson murders to his book about the cult killings (*Helter Skelter* 1974). He is also the author of *The Sea will Tell* (1991), a true crime narrative about his defense of Jennifer Jenkins who was accused along with her lover of killing Mac and Muff Graham. Bugliosi was successful in Jenkins's acquittal. As noted above, Ann Rule who according to her web site, has published over "17 books and 1400 articles, mostly on criminal cases" (www.annrules.com/bio.htm) is a former police officer.

But aside from the background of the writers, modern true crime books also have some unique narrative qualities.

True Crime as Narrative

In 1965, Truman Capote's use of narrative techniques in *Cold Blood* changed the true crime genre from the "true detective" magazine variation of the 1930s, and the "lurid pictures" and "just the facts journalism" of the 1940s and 1950s (Byrnes, 1997:7-8) to a thorough description and analysis of the crime itself and the criminal justice response to crime. Perhaps the first modern true crime book about a woman criminal is Emlyn Williams's *Beyond Belief: A Chronicle of Murder* (1967). This is the account of Myra Hindley who along with her lover, Ian Brady, "killed five young people between the ages of 10 and 17" (Phillips, 2000:106). After audiovisual evidence recording Brady and Hindley's sexual torture of a 10-year-old girl was presented during their trial, "Hindley became Britain's most notorious and reviled woman" (Phillips, 2000:106).

Regarding true crime books in general, Byrnes (1997) believes that the genre is popular because it provides "quick-packed narrative" of the crimes, and people are interested in these stories because the crime stories are "outside their normal experience" and allows readers to explore the "dark side of human nature" (1997:14). Durham, Elrod, and Kinkade, 1995:146) conclude, after their exhaustive search of true crime books for their own study, that "it appears that the true crime genre has become an important source of information about crime for substantial numbers of American readers."

The public's interest in true crime may explain the development of "insta-books." Byrnes (1997: 11) reports that by the early 1990s, sales of true crime books (1997: 11) "[were] at a fever pitch and several trends had clearly emerged" (1997, 11). One of these trends was "insta-books" that often were published before actual acquittals or convictions occurred. The demand for insta-books resulted from the public's interest in true crimes they heard about in the media (television news, tabloid shows, and newspapers). The insta-books satisfied the public's immediate curiosity about these cases. But because the insta-books came out so quickly, Byrnes (1997, 11) suggests they "siphoned off interest from more serious works that took several years to produce." The media coverage of cases such as Susan Smith's trial for the deaths of her two young sons in 1994, the O. J. Simpson's murder trial and his eventual acquittal in 1995, the Jon Benet Ramsey murder investigation in 1996 provide examples of sensational crimes that captured the public's attention in the last decade. Such cases may have contributed not only to the growth of true crime as a genre, but also to the market for quickly produced true crime books.

Table 1, "True Crime Publication by Decade," and Table 2 "True Crime Publication by Year" on the following page illustrate the growth of the true crime genre from the 1970s to 2000. Growth was highest during the 1990s with the publication of over 80 books about women. This finding lends support to Byrnes (1997) discussion of the brisk publication of insta-books.

However, Byrnes points out that true crime insta-books "often focus on the aspects of the media coverage that make every story sensational...and they can often gloss over the motivational factors that make a crime compelling and interesting" (1997:13). Some support for Byrnes's conclusions is found in the

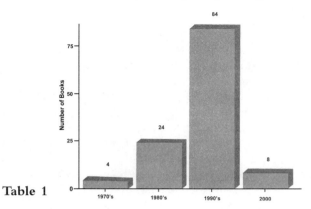

Table 1

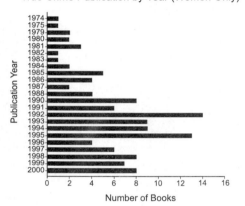

Table 2

content analysis of the covers of true crimes examined for this chapter. In an examination of the covers of over 100 true crime books, 35.8 percent did not include the motive for the crime.[2]

Byrnes' conclusions regarding insta-books in contrast to books such as Capote's *In Cold Blood* can be used to structure a continuum to classify true crime books. The continuum depicted in Figure 1 begins with Byrnes' classification, "insta-books" at the lower level and the classic literary true crime of Capote (1965) on the top level. "Historical true crime" (e.g., S*tarvation Heights,* 1997, and *Witch Hunt in Wise County: The Persecution of Edith Maxwell,* 1994) is the second level on the range of the continuum. The third level represents autobiographical/biographical accounts of true crime. Included in this category is *Crossed Over* (1992), Beverly Lowry's memoir about Karla Faye Tucker. Also, represented in this category are true crimes books such as those written by former district attorney Bugliosi (*Helter Skelter,* 1974) or about district attorney William Fitzpatrick's prosecution of Waneta Hoyt for serial infanticide in *Goodbye, My Little Ones* (1996). Popular true crimes that are well

researched and represent "the best true crime has to offer" (1997:13) are placed at the top level of "classic true crime."

A True Crime Continuum

It should be noted that Byrnes' assessment of what constitutes the "best true crime has to offer" is focused on true crime books as genre—on what appeals to readers of true crime and what true crime writers look for in a case they decide to write about—rather than criteria which would place "historical true crime" by historians and other scholars at the top level of the continuum. Historical non-fiction books about true crime are not necessarily about cases that tap into the public psyche and appeal to a wide readership. In fact, conventions such as the extensive use of endnotes and references may well mark such books as "scholarly" and make general readers hesitate to tackle them. Moreover, such books are usually shelved elsewhere—other than in the true crime section—in bookstores.

We should consider one other aspect of true crime books, one specifically intended to attract the reader to such books.

The Covers of True Crime Books

Weiner's (1993: 275) comments regarding the covers of true crime books:

> ... one cannot help but be assaulted by the book as object. With its sensational cover it calls out hysterically, begging the consumer to buy. The bold black and white cover suggests it will provide nothing but the facts which, ideally, might explain the gory photographs usually accompanying the title. The story is true, the book proclaims, and the author is most likely a noted journalist experienced in crime reporting ... Yet the bloody red gash slashed across the cover displaces information with sensation.

Weiner's (1993) statements are supported by the authors' content analysis of 120 true crimes books. Of these 120 books, 42.5 percent of the book covers

were black and 15 percent were white. 27.5 percent of the book covers were in primary colors of red (15 percent), blue (7.5 percent), and yellow (5 percent).

Can the images on book covers affect the reader's opinion about the character of women criminals and their role in a crime? No research exists to answer this question. One study of true crime magazine covers is discussed by profiler John Douglas in *Anatomy of Motive* (1999). Douglas (1999) cites and describes research by forensic psychiatrist Park Dietz and law professor Bruce Harry who "examined the covers, interior illustrations, and story contents" of these true crime magazines. Regarding the images displayed on the cover and inside the magazines, Douglas (1999) reports that Dietz and Harry's "greatest criticism was that the magazines routinely and relentlessly juxtaposed conventionally erotic images (such as beautiful, scantily clad women) and written descriptions of sexual acts with images of violence and helpless suffering of innocent victims" (Douglas, 88). Douglas states that the authors were concerned that the "continual juxtaposition of sexual and violent images might cause impressionable young men to begin associating the two in their own thoughts" (88). The authors point out that although the covers were graphic there was no proof that "detective magazines 'cause' sexual sadism or sadistic offenses" (88). However, Douglas (1999) reports that this article received much attention from law enforcement and forensic psychological communities, and magazine publishers changed the subject matter of many of their covers (88).

Inside the covers, true crime writers offer their readers narratives in which they probe the psyche of the protagonist. In doing so, the writers often include the statements, testimony, and opinions of the criminal justice experts involved in the case. The experienced true crime writer provides psychological analysis of the offender's motives, locating her in one of the categories that readers have come to recognize.

Classifying Women Who Kill

The next section of the chapter examines true crimes books about women who murder. Books about serial killers have been an important subgenre of true crime. However, the majority of these books have been about men. The classification schemes developed by criminal justice experts also used male offenders as the reference group. It has only been in recent years that researchers have attempted to classify women as serial killers. Since the 1990s, two female serial killers, Dorothea Puente and Aileen Wuornos, have been the subject of at least five true crime books.

Three books were published about Puente between 1990-1994. The first of these, *Human Harvest: The Sacramento Story* (1990), was written by Daniel J. Blackburn, a Sacramento journalist. Carla Norton, a true crime writer is the author of one of the other two books on Puente, *Disturbed Ground: The True Story of A Diabolical Female Serial Killer* (1994). The third book, by William P. Wood, *The Bone Garden: The Sacramento Boarding House Murders* was also published in 1994. One of the books about Wuornos—*Lethal Intent* (2002)—was written by Sue Russell, an author and internationally

syndicated journalist. But her book follows by a decade that of Dolores Kennedy, *On a Killing Day: The Bizarre Story and Trial of the First Female Serial Killer* (1992). When the book was released as a paperback in 1994, the subtitle was amended to add Wuornos's name.

In additional to the book about these two women, there are two anthologies featuring collected stories about female serial killers: *Deadlier Than the Male: Stories of Female Serial Killers* (1997) by Terry Manners, and Carol Anne Davis's *Women Who Kill: Profiles of Female Serial Killers* (2001). First published in Great Britain, Davis's book offers profiles of 14 women followed by discussion about classifying female serial killers and the theories about their crimes. Obviously, there has been some interest in female serial killers. However, earlier mass market anthologies about women killers also sometimes included the cases of women who had committed multiple murders (e.g., infamous "black widows") without labeling the women as "serial killers." As discussed below this term is a new one.

That said, the authors find that the use of serial killer typologies is not appropriate for many of the women murderers in the true crimes books examined here. The majority of the women who are the subject of the true crime books published since 1965 are not serial killers, i.e., they did not kill three people. This is a prerequisite of the serial killer definition created by profiler and former Los Angeles Police Detective Pierce Brooks. Moreover, examination of the serial killer classifications developed by profilers Holmes and DeBurger (1985, 1988), and Dietz (1986) reveals that these classification schemes cannot be applied seamlessly even with female serial killers.

It is relevant here to look at how the term "serial" was established and how the serial killer typologies developed. The term "serial killer," was coined in the 1980s by Pierce Brooks a homicide detective with the Los Angeles Police Department who was involved in serial killer investigations in California. Brooks was the mentor of profiler Robert Keppel (Keppel, 1997: 27). Robert Keppel, along with John Douglas, Roy Hazelwood, Ann Burgess, Robert Ressler, Park Dietz, Ronald and Steve Holmes, and DeBurger have interviewed and written about male serial killers since the 1980s. These researchers, as well as Steven Egger and Eric Hickey, have contributed works that are used by academics in classroom teaching and in research. However, attempts to study the motives of female serial killers did not occur until the last several years with the research of Kelleher and Kelleher (1998) and Laura Moriarty and Kimberly Freiberger (2000). Moriarty and Freiberger utilize the typologies of Holmes and DeBurger and Dietz and conclude by recommending five additional motives for the study of the woman serial killer.

Holmes and DeBurger (1985, 1988) include the following categories in their analysis of serial killers:

(1) **visionary serial killer** is motivated to kill because the killer hears voices or sees visions that direct him or her to kill;
(2) **mission serial killer** feels the need to eradicate a certain group of people;

(3) **hedonistic serial killer** is the lust or thrill killer who "has made a vital connection between personal violence and sexual gratification. A subcategory under **hedonistic** is the **comfort-oriented** serial murderer who kills for personal gain (e.g., professional assassin); and,
(4) **power/control serial killer** receives sexual gratification from complete domination of the victim.

Unlike the male killer, the female killer is rarely described as visionary, or as mission-oriented with the desire to kill certain types of people. However, like men, women are described as killing for hedonistic reasons that include the pleasure or sexual thrill of killing and the physical comfort acquired from insurance money or the acquisition of property. Recently, Moriarty and Freiberger examined the typologies of Holmes and DeBurger (1985) and of Dietz (1986) and concluded that these typologies only apply to one-third of the women's motives for killing. Consequently, Moriarty and Freiberger (2000) recommend including five other motives that may better explain women serial killers. These include attention, jealousy, frustration, cult killings and revenge.

As noted above, although most of the true crime books published about women criminals are about women who murder, the majority of these books are not about women who fit the definition of a serial murderer developed to describe male serial killers, many of whom are described as preying on strangers. When women do commit serial murder (3 or more individuals), these women are often killing intimates or acquaintances. Therefore, they have been ignored in the classification schemes developed to apply to male serial killers. Women who commit serial infanticide, who kill the people for whom they are caring in nursing homes, or who murder several lovers or husbands are not the killers that spring to mind with the use of the term "serial killer." Even a category such as "black widow" created to describe women who kill their mates is open to misinterpretation. In this study, most of the "black widows" have killed two husbands. This does not qualify them as serial killers because they have killed less than three. However, even those women who have killed more than three people may have killed people as varied as husbands, lovers, children, and people for whom they were caring (as in the case of Velma Barfield). Even Belle Gunness, who was alleged to have specialized in killing her gentleman suitors for their money, was also believed to have killed her husband and two of her children. Thus, the categories that might be applied to female killers are not neat and mutually exclusive.

In developing a classification to apply to women who murder, typologies from Holmes and DeBurger (1985, 1988), Dietz (1986), Kelleher and Kellerher (1998) were utilized along with the five motives that Moriarty and Freiberger (2000) recommended. It seemed, based on the work of these scholars, that as a group women may be more instrumental in their conceptualization of crime than men who may fantasize more about the crime before they commit it. Men, as a group, may also be more predatory than women (if predatory is taken to mean to seek out and kill strangers).

Scott (1996) indicates that there are no data that support that women serial killers fantasize about their crimes. Scott (1996) does report from Hickey's (1991) research that "interview data . . . [provide] tentative evidence linking women serial killers "with high rates of severe parental deprivation, childhood abuse, personality disorder, low self esteem, and a sense of personal inadequacy." Although limited research is available, Scott (1996) speculates that women who commit consecutive filicide and some women who commit murder in institutions may suffer from Munchausen Syndrome by Proxy (1996, p. 2 of e-text).

Keeney and Heide (1994) in an exploratory and descriptive study of 14 women serial killers reported that 13 of the women were "place specific killers" who operated in "one small area such as a city, often in a hospital or their own homes" (p. 5 of e-text). Forty-three percent of the victims were in custodial care of the women serial killers either as patients, or children with baby sitters. The second largest category of victims was family members (children, husbands, in-laws, fathers). Strangers, acquaintances, and non-spousal lovers made up the remaining 20 percent of the victim sample (p. 5 of the e-text). Keeney and Heide (1994) reported neither sexual assault, mutilation, or dismemberment nor evidence of victim torture. Poison was the weapon of choice for 57 percent of the women serial murderers, followed by 29 percent smothering, 11 percent firearm, and 3 percent by other methods (p. 6 of e-text). None of the 14 women serial murderers stalked their victims.

Seven of the women serial murderers' motives were instrumental goals (e.g., insurance benefits or other monetary gain) and the other seven had affective goals, i.e., "an emotional [benefit] upon the deaths of their victims" (Keeney and Heide, 1994, p. 6 of e-text).

Scott (1996) reports from previous studies of Hickey (1991), Dietz (1986), and Stross, Shasby, and Harlan (1976) that "female serial killers are more likely to report personal gain as a motive, carry out place specific murders (60%), and poison their victims (60%) . . . [W]omen mainly kill their husbands or relatives, while most male serial murderers kill strangers." The consecutive murder of women's own children is usually associated with mental disturbance. Scott continues that "a fifth of female serial killers murder people in hospitals or nursing homes where they are employed." When women are involved in "team killings," Scott (1996) states that "in two thirds of these 'team killings,' the man is the dominant partner." Women's involvement in the crimes "may range from awareness . . . to active participation in the abduction torture, and killings of victims" (p. 2 of e-text). However, Kelleher and Kelleher (1998) write that when the woman serial murderer works in a team with either other women or with men, the murders are more brutal and often sexual in nature. One-third of all female serial killers work in teams.

Although there is limited empirical research about the female serial murderer, the conclusions of the above studies are important for the content analysis of true crime books about the woman who kill multiple victims. From these publications, a classification scheme was developed to assist in the analysis

of true crime books about the woman murderer (serial or non-serial). This classification scheme proved useful in analyzing the narratives presented by true crime writers about women who kill. It was important in unraveling the depictions of women who kill in the over 100 true crime books examined by the authors. The eleven categories in this typology helped the authors to understand how true crime writers depict the ways in which the roles held by women in society shape how they choose to kill, or manipulate others to kill for them. That is, their roles such as mother, wife, or employee are presented as vital in the plan they develop to kill, or have others do it for them.

Eleven Classifications Depicting the Woman Who Kills

1. ***Infanticide*** includes mothers (biological and adoptive) who kill their children for reasons other than profit. Mothers who kill their children for profit (e.g., insurance) would be included under the women who kill for profit. The category infanticide includes women who murder children for attention or for sympathy from family members, friends, physicians, and others. This would include mothers who may suffer from Munchausen Syndrome by Proxy (separate from caretakers/nurses/child care providers who may suffer from Munchausen Syndrome by Proxy, and kill because of the attention they receive from the medical community). In this category are mothers such as those who kill their children because of inability to cope with the child's behavior (e.g., constant crying). This classification would include a mother who killed a child because she believed the child was not what the father wanted (e.g., a girl instead of a boy as in the case of Paula Sims) or mothers who kill their children because they believe they are a hindrance to their chances of remarriage (e.g., Susan Smith and Diane Downs).

2. The ***Black Widow*** is the classic category often used to refer to a woman who is portrayed as behaving like a black widow spider—mating then killing her mate. This can be applied to the woman who kills just once, although it is also used with the woman serial killer who kills three or more husbands. This category as used here applies exclusively to women who kill mates, generally for profit. The term "black widow" is not used here as in Kelleher and Kelleher (1998) to apply to a woman who kills anyone who is close to her, including husband/lovers, relatives, and children. Kelleher and Kelleher's definition requires that she kill 6-8 times.

3. ***Fatal Attraction*** describes those women who would say that they killed because of the way they were treated by a former lover/husband. Just as in the movie, *Fatal Attraction,* the "woman scorned" may either attempt to kill or kill the former husband/lover and/or his wife/lover. The motive is revenge because these women believe they have been used and pushed aside, or that they no longer have their

former allure and position without the man. Jealousy and frustration are a part of the motivation as well. Women such as Jean Harris, Betty Broderick, and Amy Fisher would fall into this category.

4. The **Team Killers** describes women who join someone else on a crime spree motivated by excitement, money, and valuables. These women may be a part of a team (male and female, or female and female) who display antisocial (psychopathic) personality disorder and reflect sexually sadistic tendencies. Karla Homolka and Carol Bundy are two women who were involved in the rapes and murders of young women.

5. *Caregivers/Nurses/Child Care Providers* include those women who work in nursing homes, hospitals, and other places where they have responsibility for the care of the infirm, elderly, or young. Their motives may include power and control ("angel of death"), or they may kill for the sexual thrill the physical act of killing gives them (serial murderers Graham and Wood), or for profit (serial murderer Dorothea Puente). Or, for example, a child's crying may result in the baby sitter's use of power and control to stop the child's cries (e.g., Christine Falling who "smothered" children in her care). Beverly Allitt, a newly-qualified state enrolled nurse on a children's ward who suffered from Munchausen's Syndrome and Munchausen's Syndrome by Proxy (see Manners, 1995), also killed children in her care.

6. The **Femme Fatale,** as in film noir, is the "instigator" who conceives the crime and then manipulates the person who is attracted to/sexually involved/in love with her to commit or join her in committing the crime. Similar to the characters in *The Postman Always Rings Twice,* and *Double Indemnity,* the generally male object of her attention is completely under the erotic spell of the woman who persuades him that he is the only person who can help her out of her present crisis. Just as in the movies, the femme fatale of true crime books uses her power/control to psychologically "motivate" others to kill. As the progenitor of the crime, the femme fatale does not have to actually kill; she may get others to do the deed for her.

 True crimes books include femme fatales from a variety of life roles. For example, Pamela Smart who encouraged her young boy friend to kill her husband for insurance; high school sweethearts, like Diane Zamora (*The Cadet Murder Case*) whose jealously led her to manipulate David Graham to kill her rival. Another teenage femme fatale, Marlene Olive, in the 1970s persuaded her boyfriend to kill her parents. And there was the teenager whose boyfriend fulfilled her request to *Kill Grandma for Me.*

7. **Family Ties** is a category created to include women who manipulate family members to kill for them. This category illustrates the strong hold that mothers have over their children. Like Jacob's mother, Rebekah, in the Bible who encourages him to deceive his father,

Isaac, in order to get the first-born birth rights of his brother, Esau, mothers in true crime books use similar strategies. As did Rebekah with Jacob, the mothers convince their children that it is appropriate to commit the crime that mother wants. True crime books with titles such as *Whatever Mother Says,* and *At Mother's Request,* offer narratives about mothers who persuaded their sons to kill family members. This category also includes sisters who manipulate their brothers to commit murder for them. For example, Toni Cato Riggs persuaded her brother Michael to kill her husband, Army Specialist Anthony Riggs, who returned home to Detroit in March 1991 only to be shot in front of Toni Cato's grandmother's home early the next morning after his return (see Pearson, 1997: 24-27).

8. ***Battered Woman/Sexual Assault*** classification is appropriate for the inclusion of true crimes about women who kill spouses/lovers not as a black widow but in self-defense after years of physical, emotional, and sexual abuse. These true crimes are about women who lived with domestic violence for many years and killed in order to save themselves. This classification is also appropriate for women like Joan Little who killed her jailer in self-defense.

9. The **Cult** motive of Moriarty and Freiberger, is combined with the **Disciple** category of Dietz (1986) because these two classifications are comparable in discussions related to the "Manson Girls" (Lynette "Squeaky" Fromm, Susan Atkins, Leslie van Houten, and Patricia Krenwinkel), and to Patty Hearst. Also, in order to maintain the methodology of including women who are not necessarily serial killers, but are murderers, it is important to include the Manson family who by definition were mass murderers, but may have continued to become serial murderers if they had not been apprehended after the second murders of the LaBiancas. Perhaps Cult might be used to classify both men and women members of Manson's "family." However, the Cult/Discipline motive does not explain Patty Hearst captivity completely. John Douglas describes Patty Hearst as more a victim than a compliant criminal on his continuum in *Anatomy of Motive* (1999). She has been described as experiencing "Stockholm Syndrome," and "Ritual Abuse Syndrome" (see Dershowitz, 1994). Also, the "Manson Girls" may be described as under the influence of a charismatic leader and "fit" the cult classification.

Perhaps Douglas' continuum explanation that he developed to describe the role of women who were involved in murders as part of a team/couple better explains the woman's role in the crimes. For example, Douglas states that Debra Denise Brown is an example of the compliant criminal who goes along with the wishes of the other more dominant team member, in Brown's case, Alton Coleman. In combination with John Douglas's continuum, "disciple" can be used to understand how Cinnamon Brown's father manipulated her to kill

her stepmother. The Douglas continuum is useful when discussing the Parker and Hulme case where two teenage girls in the 1950s in New Zealand murdered one of the girl's mother; and the Douglas continuum may be applied to understand how the court may have perceived Mary Bell as the more dominant criminal in the 1970s when two young girls killed two toddlers in England.

10. ***Murder for Profit*** includes women such as Eva Coo, Ellen Boehm and more recently Dana Sue Gray who murder strictly for profit. The expected profit is generally in the form of an insurance policy or other money or valuables that the woman expects to acquire with the victim's demise.

11. ***Venus Flytrap*** is used as a metaphor to describe women who either entice individuals into their care, or attract others (including lovers, friends, and children) into their "deadly trap" by their kindness or physical attractiveness. These women include Audrey Marie Hilley, Judias Buenoano, Velma Barfield, and Virginia McGinnis. These women are distinguished from the Femme Fatale because they are attracting victims rather than partners in crime. They are distinguished from the Black Widow because their victims are not confined to mates.

These eleven classifications are intended to "catalog" the woman criminal's behavior as a method to systematically describe her role in murders. This typology is intended to organize and certainly not intended as definitive, or as psychological explanations for the crimes.

The results of the eleven classifications used in the content analysis of the 120 true crime books are: caregivers, 8; infanticide, 17; black widow, 9; femme fatale, 9; fatal attraction 16; team killers, 33; cult/disciple, 5; battered woman, 10; murder for profit, 3; family ties, 5; and venus flytraps, 5.

Overall, the eleven classifications and their respective motives are similar to the nineteenth century women killers described by Judith Knelman in her book *Twisting in the Wind: The Murderess and The English Press* (1998). Similar to the women who are the subject of modern true crime books, Knelman's women—who perpetrated a minority of crimes—received a disproportionate amount of attention from the press, particularly if they killed their "superiors" (husbands, fathers, masters, mistresses). Most women in Knelman's study murdered for gain, rather than passion, although a substantial minority murdered out of anger, jealously, or lust.

Readers of true crime narratives often encounter stories of women with twisted motives involved in sensational crimes. However, the authors' analysis would suggest, true crime books as a genre fail to adequately reflect the spectrum of female killers. For example, only a scattered handful of true crime books are about women of color who kill. As with other media, readers who learn what they know about women who kill from true crime books will receive a somewhat distorted picture of who kills and under what circumstances.

Table 3. Crime Classifications & Women Criminals

INFANTICIDE	BLACK WIDOWS	FATAL ATTRACTION	TEAM KILLERS	TEAM KILLERS
Darlie Routier	Amy DeChant	Amy Fisher	Betty Wilson	Karla Faye Tucker
Debora Green	Arlene Caris	Bambi Bembenek	Bonnie Emily Heady	Karla Homolka
Diana Lumbrera	Barbara Stager	Betty Broderick	Candy Montgomery	Kelley Tibbs
Diane Downs	Blance Moore	Carolyn Warmus	Caril Ann Fugate	Mary Bell
				Melinda Loveless
Laurie Dann	Della Faye Hall	Christa Pike	Carol Bundy	Laurie Tackett
				Hope Rippey
				Toni Lawrence
Lindy Chamberlain*	Jill Coit	Jean Harris	Cindy Ray Campbell	Patricia Columbo
Lois Jurgens	Lisa Ann Rohm	Susan Cummings	Claudia Yasko	Rosemary West
Marie Noe	Susan Grund		Dee Casteel	Ruth Snyder
Marybeth Tinning			Diana Zamora	Sandra Stockton
Paula Sims			Elizabeth Haysom	Sante Kimes
Priscilla Phillips			Elizabeth Turpin	Sharon Green
Susan Smith			Janice Hooker	Sherry Sheets
Tanya Reid			Judith Neeley	Shirley Wolf
Waneta Hoyt			Juliet Hulme/Pauline Parker	
Andrea Yates				

CARETAKERS	FEMME FATALES	FAMILY TIES	BATTERED WOMAN	CULT/DISCIPLE
Anne Capute*	Gina Spann	Cinnamon Brown	Carol Aileen Wuornos	Leslie Van Houten
Catherine Wood/ Gwendolyn Graham	Mary Louise Thompson	Frances Schreuder	Charlene Gallego**	Lynette "Squeaky" Fromme
Dorothea Puente	Pam Smart	Theresa Cross Knorr	Francine Hughes	Patricia Krenwinkel
Genene Jones	Pat Taylor	Tina Cato Riggs	Ginny Foat	Patty Hearst
Olivia Riner*	Sharon Lynn Nelson	Virginia Larzelere	Jane Hurshman	Susan Atkins
	Wanda Ann Holloway		June Briand	
	Wendy Gardner		Kay Sandiford	
			Lorena Bobbit	

MURDER STRICTLY FOR PROFIT	VENUS FLYTRAPS
Dana Sue Gray	Audrey Marie Hilley
Ellen Boehm	Judias Buenoano
Eva Coo	Velma Barfield
	Virginia McGinnis

*Acquitted

**According to R. Barri Flowers' web page, Gallego was released in 1997 and claimed on the *Leeza Gibbons* show to be an innocent, but battered woman.

Summary

This chapter examined one genre of non-fiction literature that is available to and widely read by those who are interested in crime and justice. The chapter looked at the characteristics of the genre and the selection process applied by writers in choosing the protagonists who will be the subjects of their books. The chapter discussed the covers of true crime books. Then the chapter turned to the classification schemes developed by criminal justice experts for male serial killers and the applicability of those typologies to the women protagonists found in true crime books. The authors offered a modified typology that seems a better fit for many of the women who kill because it recognizes the circumstances in which they commit murder and their varied victims.

The next chapter focuses on fictional narratives of women who kill.

Exercises

1. Go to Amazon.com or Barnes and Noble.com and find a true crime book about a woman killer. Enlarge the cover image and describe how the crime or criminal is depicted. What colors are used? What words are used to describe the crime? The criminal?

2. Read the first chapter of a true crime book about a woman killer. How is the narrative presented? What techniques does the writer use to draw the reader into the story? What information is provided about the woman killer and her victim(s)?

Notes

[1] Using the internet sources, the average customer reviews for these two books in November 2000 were:

Helter Skelter
Amazon: 4.5 stars out of 5 stars
Barnes and Noble: 5 stars out of 5 stars

The Stranger Beside Me
Amazon: 5 stars out of 5 stars
Barnes and Noble: 5 stars out of 5 stars

[2] The true crimes books included in this analysis are those published after 1965 that were located from book stores (including used book stores), and university and public libraries. These true crimes are primarily those about women who are involved with murders (up to two), and the true crimes about the woman as serial killers (i.e., they murder 3 or more times). Because there is no published list of true crimes, the list of books was updated by a search of the true crime/biography section of book stores and libraries, and by doing a content analysis of Amazon and Barnes and Noble book listings on the Internet, and then cross-checking the true crime book list from the book stores and libraries against the true crime books acquired from the Internet. This was considered the most efficient way to locate books about the woman murderer. The examination of true crime books listed by Amazon was completed in May 2000 by graduate assistant, Michelle Weller, at Shippensburg University. She also verified the completed true crime book list with the Barnes and Noble Internet site. The 120 true crime books on woman criminals located for the content analysis is considered not as a sample of true crime books about women murderers and serial murderers, but rather as the population of publications about women murderers because of the exhaustive search utilized to develop the list. The authors do not have the exact percentages for books about women murderers from the Amazon site. The authors found that of the 1,823 true crime books available for purchase that 622 (34%) were about criminal homicide; 128 (7% were about serial killers). There was no breakdown provided for book titles by sex. In a more recent Barnes and Noble's Internet search (November 2000), the authors found that 2,153 true crime books had been published, and 896 (42%) were about criminal homicide; and 166 (8%) were about serial killers. Similar to the earlier Amazon search, the authors do not have exact percentages for books about women murderers.

Chapter 10
Women & Homicide in Literature, Music, & Films

Women Who Kill in Early Literature

Ballads

In *Weep Not for Me,* Symonds (1997) investigates the depiction of infanticide in folk ballads of early modern (17th and 18th centuries) Scotland. The most popular of these ballads is *Mary Hamilton,* which appears in twenty-nine different versions. In this ballad, the heroine kills her illegitimate child and is hanged. As Symonds notes, Mary Hamilton is "the quintessential ballad heroine. . . .She could speak, she could ride like a queen down from Edinburgh's Canongate, she could meet death with equanimity, and in her ballad she shares center stage with no one" (Symonds, 56). The early ballad singers placed the social location of Hamilton's crime in court society. In doing so, they ignored the contemporary reality of poor women who killed their illegitimate infants. Instead, they made *Mary Hamilton* a commentary on immorality in the royal court (Symonds, 56-57).

This particular ballad began to appear in ballad collections at a time when capital punishment was on the decline and after the old statute of 1690 had been replaced by the less harsh new statute of 1809. Symonds asserts that the old ballad allowed the singers to take seriously "the full tragic consequences of infanticide, and while the new law of 1809 saved women's lives, it did so at the cost of dismissing their actions and their children's lives as inconsequential" (Symonds, 66). *Mary Hamilton* offered a ballad heroine:

> who confronts her own death, and through that, the death of her child. Like the suicide note, itself a new object of interest in the eighteenth century, the ballad set the record straight, showing a murdered child and a young woman, pregnant and far from her parents, facing death (Symonds, 66).

As did Mary Hamilton, some other ballad heroines killed their intimates, including babies (e.g., *Cruel Mother*) and lovers. In the folk ballads of Great Britain and the Appalachian mountains of the United States, women such as *Bonnie Barbara Allen* and *Lord Randall's* beloved are fatal women who cast their spell over men and send them to their deaths. Sometimes this is accomplished, as in the ballad of *Barbara Allen,* simply by spurning a lovelorn suitor, who dies of lovesickness. But, some women, as does Lord Randall's lover, take more direct action with poison or other weapons. In another such ballad, the Brown Girl stabs *Fair Arnet,* the true love of the man she has married, when Arnet comes to her wedding. The bridegroom responds by killing his unwanted bride, and then himself. Conversely, another ballad heroine in *Cruel Youth,* defends herself against a killer. As she sends him to his watery grave, she tells him, "Six pretty maidens you drowned here, now go keep them company."

These ballads do not disappear with the appearance of mass media, but instead become the motifs (themes) of narratives of love, betrayal, and vengeance. One rather interesting example of the adaptation of the ballad form to a new medium occurs in an episode of the original *Twilight Zone*

television series. The episode is set in the Appalachian Mountains. A beautiful (but dark-haired and untamed) young woman goes to the cabin of an old woman to ask for a love portion to bind the man she loves to her side. The old woman, a witch, demands the young woman's immortal soul in exchange, and does not tell her that as a result of drinking the portion she will become a cougar on the prowl each night. As a cougar, the young woman is shot and killed. She returns to haunt and attempt to destroy the bride (fair-haired and steadfast) that the man she seduced has married. He finally vanquishes her by using the knowledge he has purchased (with coins, not with his soul) from the evil old woman. In keeping with its folk origin, a ballad singer provides the background music for this episode of the television show.

Fairy Tales

An even richer source of imagery of fatal women can be found in fairy tales, beginning with the 17th century tales concocted by Charles Perrault for an adult audience at the French court. Later, in the 19th century, these tales would be reworked and other stories would be added by the Brothers Grimm and by Hans Christian Andersen. In the 19th century, the fairy tales also would be made more appropriate for children by sanitizing the sex if not the violence. In the late twentieth century, this transformation of fairy tales to reflect contemporary social changes continued with the feminist re-telling of traditional fairy tales (see e.g., Zipes, 1983). But, in the earlier, non-feminist versions, fairy tales abound with wicked witches, evil queens, and heartless stepmothers.

Scholars of the fairy tale suggest that negative portrayals of stepmothers reflected a reality of the lives of many children in earlier eras. Because mothers often died in child-birth and fathers remarried, many children found themselves living with stepmothers. Logically, a stepmother might be expected to favor her own children rather than those of her predecessor. An additional source of conflict might be the matter of inheritance. Whatever was left by a deceased father would have to be divided among his children. Understandably, hostility might sometimes have existed within step-families. In addition, in narratives about family life, there was perhaps a psychological need to shift maternal neglect and abuse to a maternal figure other than the natural mother. Thus, in fairy tales, the stepmother appears in all her alleged wickedness. Her foes are the sweet, virginal daughter or the vulnerable young children.

In these "sinister stepmother tales," Gilmore (2001) finds that "animal transformations are prevalent. . .once against reflecting woman's ability to manipulate those near and dear and to turn people into beasts." The stepchildren are often turned into "wolves or lambs marked for slaughter and the family's dinner table" (72). But in other cases, the stepmother "may be an outright murderess (usually using poison)." The stepmother is also sometimes portrayed as forcing her stepchildren into destitution or, as a sexual predator, attempting to seduce her stepson and cuckold her husband (Gilmore, 72-73).

Because the stepmother is wicked, she must die so that everyone else can be happy. The father is either conveniently absent or blindly compliant as the

stepmother does her worst. But he too is rescued when the evil woman—the stepmother as witch and crone—is destroyed. The fairytales appear as animated interpretations of the originals in the Disney films that have brought these images quite vividly to life for several generations of children (see Warner, 1994; Zipes, 1997; and Laythe, 2002 on the real life case of accused stepmother Edna Mumbulo in 1930).

Other Early Literature

As discussed in Chapter 3, other images of women and death appeared in Medieval Christian literature. Aspects of these images became a part of secular literature. In the chivalric tradition of the medieval era, both women and the Devil played their roles. One important role of the woman in the narrative was to inspire the knight as he ventured forth on his sacred mission to overcome the Devil or infidels (de Bruyn (1979: 44). But at the same time, as discussed in Chapter 3, competing images associating women with evil and sin found their way into the works of secular writers. In a study of sixteenth-century literature, de Bruyn (1979) writes:

> In literature, as in life, the label 'witch' was sometimes attached to one's enemy. Hence Joan of Arc appears in Henry VI [Shakespeare] as a 'Foule Fiend of France, and Hag of all despight.' Any formidable enemy was looked upon with suspicion, but for a woman clad in armour, harassing the English troops, only one name was applicable (de Bruyn, 123).

Even closer to home, at his own hearth, a man might find a woman he considered a witch and a hag. Dolan (1994) examines representations of domestic crime in English literature (1550-1700). Ballads, sung and sold in written form, were the "most accessible" form of literature during this period (Dolan, 8). In early modern England, Dolan finds:

> Although accounts of petty treason usually focus on a wife-servant conspiracy—which reproduces the heterosexual couple even as it overturns domestic hierarchy—and almost never depict women plotting together, accounts of infanticide and witchcraft teem with women acting either alone or with other women (14).

However, in the literature of the sixteenth and seventeenth century, there are attempts in some texts to explain the behavior of women who kill their husbands by presenting the wife as a battered woman who "resorts to violence in despair and self-defense" (Dolan, 32).

Domestic Violence in Popular Music

In popular culture, songs about men who beat, rape, or kill women and children are found in lyrics that range across the spectrum from folk ballads to

Domestic Violence in Popular Music *Continued*

blues, pop, rock, punk, and rap. For example, one of the standard songs in the repertoire of pop icon Tom Jones is "Delilah." Audiences often sing along with the chorus as Jones relates the story of a man who witnesses his lover Delilah's meeting with another man, and then stabs her (see Porter, 02/01/2001). As he waits for the police to break down the door, he asks his dead lover, "Why?" Other durable popular songs about men and violence, include "Mack, the Knife" and "Tom Dooley."

There are far fewer songs about women who engage in violence. And, even when focusing on domestic violence, popular songs tend to deal with the experience of battering or of incest rather than the woman's response against her abuser. In fact, a recent episode raises the question of whether or not a double standard may apply when it comes to songs about women who use violence in response to violent men. When the female country trio, the Dixie Chicks, recorded "Goodbye Earl," they stirred controversy. Although the group won the best video award for their song about the murder of a wife abuser (and a second award for their album, "Fly") from the Country Music Association, they were criticized for treating a serious subject too lightly (Country awards embrace controversy, 10/05/2000). In the song, written by a man, a battered woman responds to years of abuse from her husband by poisoning his black-eyed peas. She and her friend then dispose of his body. Although the lead singer of the group, Natalie Maines, described "Goodbye Earl" as a "funny song and a funny video about a very serious topic" (Country awards, 10/5/2000), a reported 20 country stations out of 149 surveyed refused to play it (Williamson, 04/09/2000). One radio operations manager/program director in North Texas said in an interview that the reactions his station had received had been negative, with listeners expressing concern that the song "promotes violence" (Bourgoyne, 04/12/2000). But according to a Tampa, Florida music director, the song also produced another reaction. He reported that listeners were calling in to share their own experiences with domestic violence (Ferman, 11/02/1999).

Whatever other issues might be raised regarding a song about a battered woman and her lethal response to abuse, Linda Williamson of the *Toronto Sun*, wondered why the people who objected to the violence in "Goodbye Earl" hadn't raised the same objections a few years earlier to Garth Brooks' equally irreverent song "Papa Loved Mama." In Brooks' song, a jealous man kills his attractive wife and is sent to "the pen" for his crime. Aside from Brooks' song, Williamson noted that a three-CD set of "murder songs" by legendary country star Johnny Cash were due out the next month with liner notes written by *Pulp Fiction* director, Quentin Tarantino (Williamson, 04/09/2000).

Offering its opinion about the American controversy, the London newspaper *The Guardian* suggested that perhaps the Dixie Chicks and their hit

song created such controversy because of the politics of country music. The newspaper suggested that the country music industry always has been conservative in its views about women, preferring them in traditional stereotypical roles. These attitudes put the male-dominated industry at odds with the new breed of female artists. The newspaper goes on to suggest that the Dixie Chicks reflect a recent trend of assertiveness by female country singers. Their song, "Goodbye Earl" touched a nerve in spite of its comic touches (The Guardian, 04/06/2000).

The following songs are among those that deal with women who strike back, turning to violence in self-defense or to avenge their victimization:

"Independence Day"
Martina McBride (*The Way That I Am*), 1993 [Country]

"Janie's Got a Gun"
Aerosmith (*Pump*), 1989 [Rock/Pop]

"Lament"
Si Kahn and John McCutcheon (*Signs of the Times*), 1986 [Folk]

"Louisiana Air"
Angela Motter (*Pain and Pleasure*), 1999 [Folk/Funk]

"Love is Blind"
Eve: First Lady of the Ruff Ryders, 1999 [Rap]

"Shoot"
Sonic Youth (*Dirty*), 1992 [Rock]

"(The) Thunder Rolls"
Garth Brooks (*No Fences*), 1990 [Country]

"We Say No!"
Gerri Gribi (*Prince Charming Doesn't Live Here*), 1991 cassette

Source: http://creativefolk.com/abusesongs.html

Images of Lethal Women Since the 18th Century

By the late eighteenth century, there was a reading public in the United States eager for published accounts of true crime cases such as that of Elizabeth Wilson, who was tried and convicted of killing her twin infants. According to an account in *The Pennsylvania Journal* (1/5/1785), Wilson had been jailed in Chester after a traveler's dog went into the brush "and brought out the head of a child in his mouth." The traveler then discovered the bodies of two infants. The newspaper noted that "The head which the dog brought out had been cut off; and the woman was seen sucking the children near the spot but a little time before the bodies were discovered" (quoted in Williams, 1993:

148). When arrested, Wilson denied that she had killed the children, but maintained instead that she had left the infants by the roadside, hoping someone would find and care for them. She would not defend herself during her trial, but later identified her lover as the murderer of her children. Her brother was successful in obtaining a last-minute stay of her execution, but arrived too late to save her (Smith, 1999, 173).

The account of Wilson's trial and execution appeared in a longer and more embellished form two days after Wilson was put to death in a publication by a Philadelphia printer, *A Faithful Narrative of Elizabeth Wilson*. This chapbook contained "Wilson's final confessions and prayers, and an execution description" (Williams, 149). The publication quickly went through several editions, achieving greater distribution than such crime narrative had in the past (Williams, 149). The last edition appeared in Philadelphia in 1807, years after Wilson was dead. But the commercialization of Wilson's story took another turn with a "fictional treatment" of the case as *The Victim of Seduction! Some interesting particulars of the life and untimely fate of Miss Harriot Wilson* (1822). Although the author of the fictional account, published in Boston, changed the details of the case, the story seems to be based at least in part on the earlier true crime narrative (Williams, 151). Of the two accounts, one true crime and one fictional, Williams (1993) observes:

> Both "Elizabeth" and "Miss Harriot" were characterizations created to compete in literary marketplaces, and although the two share a number of similarities, including infanticide and execution, the differences between them reflect significant changes not only in textual perspectives but also in early American print culture. Exploiting the same basic series of events, the two texts were created according to different sets of genre conventions for two different audiences (Williams, 151).

One basic difference between the two narratives is that Elizabeth Wilson is presented as innocent of the crime for which she is executed in the true crime narrative. But in the fictional account, Miss Harriot, the victim of male seduction, is presented as having first been imprudent and then having compounded her sins with infanticide (Williams, 156). The story was published during an era of sensational and sentimental literature (Williams, 160; see also Davidson, 1986) and fit into the genre of the seduction tale. Of the true crime narrative about Wilson and how her case was later interpreted, Smith (1999) writes:

> Wilson was reborn as the ultimate eighteenth-century female victim. She was now seen as having been seduced, betrayed, and frightened into concealing her babies' bodies, but as innocent of their murder. Within the male court system, her fear and resultant silence rendered her insufficiently virtuous. In this transitional era, her execution was a reminder of past times when sinful women were publicly punished for moral transgressions...(Smith, 181).

Although Wilson had been a working class woman, she emerged as a good mother by middle-class standards. She had been unable to save her babies from their father, but there was evidence that she had given her babies a mother's care and nurturing. Smith observes, "In breast-feeding her babies, she enabled middle-class people to redeem her memory" (181). In the true crime narrative about her, Wilson emerged as the protagonist in a tragic tale of male betrayal.

However, during this era, there was another genre of sensational tale, in which women were the victimizer, not the victims, of men. In antebellum fiction involving "female fiends" the stories share certain common plot and character elements:

> ... the heroines are always white (although often endowed with a vaguely Spanish heritage), of ambiguous class status (although not desperately poor), and always young and attractive. Their adventures typically begin with the murder of a husband or lover; from there, the heroine heads straight down the slippery slope of crime, indulging in everything from sexual promiscuity, drinking, gambling, and dressing as a man to counterfeiting, robbery, infanticide, and serial murder (Keetley, 1999: 1).

Keetley describes these fictional tales as a "relatively unknown literary form that flourished in the United States in the 1840s and 1850s" (Keetley, 1). The two publishers of these pamphlets were located in the Northeast. Their pamphlets were distributed locally and by traveling salesmen (Keetley, 1).

Also appearing during the 19th century were the novels, short stories, and articles of mainstream writers such as Charles Dickens and Thomas Hardy in England and Nathaniel Hawthorne (discussed below) in the United States. The works of such writers presented images of women and death, sexuality and violence. For example, in *Great Expectations,* Dickens models a servant on a real life female killer. In Thomas Hardy's *Tess of the d'Urbervilles,* the female protagonist kills her seducer, the father of her dead child. She is executed.

In examining 19th century British sensational fiction, Tromp (2000) finds in the best-selling novels of Mary Elizabeth Braddon, "female characters... conspicuously enact or are associated with violence against men as retribution for cruel behavior on the part of husbands or fiancés" (102). Although in *Lady Audley's Secret* (1862), the title character is punished for her own transgressions, in *Aurora Floyd* (1863), the "dangerous woman" is left within the domestic sphere, now in a second marriage. Braddon describes the protagonist as being in a situation similar to that of the real-life Madeline Smith, who was suspected of killing her lover. As a transgressor against morality, Aurora, the suspected murderess, has symbolic links to the fallen woman. Tromp (2000) observes that in 1863 when the novel was published, Parliament "was generating a vision of the dangerous woman in the Contagious Diseases Act (C.D. Acts)." Tromp finds:

> the similarities between the rhetoric of the novel and the debate surrounding the repeal of the acts are stunning. In these acts, the

prostitute, like Aurora, was marked as murderess and the moral and social bane of the respectable family . . . Parliament believed that the acts had spawned "sensation literature" marked by "the grossest exaggeration," precisely the terms with which the critics characterized Braddon's novels and identified them as dangerous (Tromp, 107).

Tromp describes the "intensity of the response" to the C.D. Acts and to Braddon's novels as part of the same "cultural conversation" about the threat to the chastity of women and the impact of the "dangerous woman" (who was "Orientalized" in the Acts) on society (107).

In the "Darwinian slums worlds" created by authors such as George Gissing and Rudyard Kipling, Johnson (2001) finds that the women characters are envisioned as living in working class jungles "where the strong prey on the weak." In novels such as Gissing's *The Nether World* (1889), the "women evolve into naturally violent creatures, who compete with each other for men, and sometimes into monsters who are deadlier than the male." In Gissing's novel, his character Clementina Peckover "is the novel's most dangerous creature and is finally put on trial for attempting to murder her own mother" (Johnson, 134).

Among the American writers of the 19th century was George Lippard, a friend of Edgar Allan Poe. In his novel, *New York: Its Upper Ten and Lower Million* (1853), Lippard "created one of the most evil women and achieved one of the most grotesque combinations of sex and death in all literature" (Davis, 1957: 206). After she is forced by her father into marriage to a middle-aged and lecherous husband, Marion Merlin, a lovely, educated young woman, plans to commit suicide. Before she can carry out her plan, her husband drugs her and has sex with her. This event brings about her downfall. Her "moral sense" destroyed, Lippard has his heroine began a steady decline into sin and decadence—beginning with the moment when she pushes her husband into Niagara Falls. She continues her amoral career by seducing young men. After seducing a minister, she encourages another man to rape the minister's fiancé. Even after the minister strikes and almost kills her, Marion rallies from her catalepsy to seduce and ruin the doctor who is about to perform an autopsy on her (Davis, 176). As Davis asserts, this novel and other such works produced during this period reflected the fascination of writers (from those of sensational pulp fiction to more acclaimed purveyors of literature) with "the mysterious power of sex."

During this period there were also images of the "poisonous maiden," whose antecedents could be traced back as far as seventh century A.D. to the Indian political drama, *The Minister's Seal (Mudra-rakshasa)* (see Hoffman-Jeep, 282). These depictions usually present beautiful young women who are physically poisonous because they have knowingly or unknowingly imbibed small amounts of poison until they themselves are immune but they are lethal to others. This is true of the title character in Nathaniel Hawthorne's 1843 short story, "Rappaccini's Daughter." The story is set in Northern Italy where a

scientist has fed his daughter Beatrice toxic plants since she was a child. He keeps her in isolation, allowing her to tend the garden that is so toxic only she can enter. When a young medical student sees Beatrice and falls in love with her, the stage is set for tragedy. Rappaccini's scientific rival gives Beatrice's suitor what he tells him is an antidote for her toxicity. Instead, when she drinks it, she dies. Hoffman-Jeep (1996) observes, "With his poisonous garden, Rappaccini creates a kind of anti-Eden in which the highly-cultivated young woman is not created in order to reproduce but rather in order to destroy" (Hoffman-Jeep, 287).

The poisonous maiden has continued to appear in popular culture, including one of her more recent incarnations as "Poison Ivy" in the *Batman* comics and movies. Regarding the commercialization of this image, Hoffman-Jeep (1996: 291-292) describes as "misogynistic" the decision by Christian Dior to name a perfume *Poison* and to use an ad (which appeared in *Vogue* magazine in 1986) in which the pictured woman's message is "Poison is My Potion."

As discussed in Chapter 5, in the 19th century, images of real women who made poison their potion created anxiety among males. These women had their fictional counterparts in the novels and plays of the era. But it was general concern about "malice domestic" in the form of the murder of intimates by women that provoked media and public fascination with cases such as that of New England spinster Lizzie Borden.

The Borden murder case has been one of the more enduring in popular culture, inspiring articles, essays, short stories, novels, operas, ballets, plays, television episodes and movies, and an academic conference on the occasion of the 100th anniversary of the crime (see Ryckebusch, 1993). Nickerson (1999) finds that both mystery writer, Mary Roberts Rinehart (*The Album*) and African American writer Pauline Hopkins ("Talma Gordon") were among the authors (others include Gertrude Stein) who were inspired by the Borden case. Webster (1996) observes that, as have other true crimes, the Borden case has been adapted by writers to illustrate aspects of American culture. The focus of Borden-inspired works reflect both the changes occurring in American society and contemporary issues. Webster analyzes the differences in four Borden plays written and produced between 1934 and 1992. He finds, "The most salient theme in each of the plays is the notion of a "dangerous woman . . . Each of the four playwrights at least implicitly wrestles with the notion of a 'dangerous woman'" (Webster, 40).

Edith Maxwell and "Mountain Justice"

In 1935, Edith Maxwell, a 21 year old schoolteacher, was accused of the murder of her father. The case quickly attracted media attention. In the public debate that followed, the case was characterized by critics of the legal proceedings as illustrating the backward and patriarchal "hillbilly" culture of the Appalachian mountains. For their part, many of the citizens of Wise County, Virginia, the site of the case, resented the way in which the national press and other

Edith Maxwell and "Mountain Justice" *Continued*

outsiders located their narratives of the case in the stereotypical terrain created by a popular novel (John Fox's *The Trail of the Lonesome Pine*) and the comic strips featuring "L'il Abner" and "Snuffy Smith."

The death of Trigg Maxwell, Edith's father, had occurred during a family quarrel when she returned from an evening out. Accounts of the incident varied among the family members and the neighbors. What was at issue was whether Trigg Maxwell had died as the result of an lethal assault by his eldest daughter, Edith—perhaps with her high heeled slipper—or whether he had fallen and hit his head. If Edith had killed her father, had she been defending herself against an abusive parent?

Although the prosecution did not seek the death penalty, the charge was first degree murder. The prosecution argued that Edith Maxwell had acted with deliberation and malice. The jury found Maxwell guilty. She was sentenced to twenty-five years in state prison. In the aftermath, supporters of the young woman—who newspapers had portrayed as challenging the outdated morality of the mountains—rallied to her cause. The verdict in the case was described as a miscarriage of justice—symbolic, in fact, of the character of both mountain justice and Southern justice in general. Maxwell received support from women's groups, including the National Woman's Party, which raised money for her appeal. When Maxwell sold her story to the Hearst syndicate, newspapers across the country carried "sob sister" stories on Maxwell and the injustice of her trial and sentence.

In 1936, Maxwell was granted a second trial. This one received less media coverage because of competing events such as the abdication of England's King Edward VIII. However, to the satisfaction of some Virginians who had questioned the verdict of the first trial, the second process was seen by most who lived in the state as fair. And, again, Maxwell was found guilty. In that same year, 1936, production began on a movie inspired by press coverage of the case. In the movie, *Mountain Justice,* the father is seen beating his rebellious daughter with a mule whip. She kills him in self-defense.

In spite of the second defeat, Maxwell's supporters continued to work for her release. In 1937, First Lady Eleanor Roosevelt was persuaded to appeal to the Governor of Virginia. She wrote a letter on Maxwell's behalf. When the then incoming governor departed office in December 1941, he issued a conditional pardon to Edith Maxwell.

Source: R. Hamm (2003), "Edith and Her Pappy."

In the pulp fiction of the late nineteenth and early twentieth centuries, the femme fatale that would later be essential as an element of 1940s film noir begins to make her appearance. In 1930s detective fiction, she is the temptation that the tough guy detective must struggle to resist. In one of the classic pri-

vate eye novels of the era, Dashiell Hammett's *The Maltese Falcon*, private investigator Sam Spade turns his lethal lover over to the law. But in later hard-boiled novels, such as those of James M. Cain, both the man and the woman find it difficult to escape from the trap that they have created for themselves. Since many of Cain's novels were filmed, even those who never read his books became familiar with such femme fatales as Cora, the young wife of an older man in *The Postman Always Rings Twice,* and with the spoiled and homicidal daughter of the hard-working businesswoman *Mildred Pierce*. There is also the wife who teams with an insurance agent to kill her husband in *Double Indemnity*. As noted earlier the real-life Ruth Synder-Judd Gray murder trial in 1927 influenced such fictional images of murderous women.

"Miss Otis Regrets"

Composer Cole Porter was known for his witty and satirical lyrics. In the late 1930s, Porter wrote a song he titled "Miss Otis Regrets," for the never-produced show *Ever Yours*. In the song, a society woman sends her regrets—delivered by a servant—to the hostess who invited her to lunch. Miss Otis will not be present because the evening before she shot her philandering lover. She was dragged from the jail and lynched by a mob. Her last words were her polite expression of regret that she would not be able to join "Madame" for lunch. Porter's song was performed at parties by his friend Monty Woolley, including a party given by social hostess, Elsa Maxwell (McBrien, 1998: 238-240). It was also a standard in the repertoire of jazz stylist, Ella Fitzgerald.

In the post-World War II world of the 1950s, new attitudes were reflected in crime literature with regard to women. Unlike his earlier counterparts, hardened war veteran Mike Hammer, (best-selling writer Mickey Spillane's fictional PI) was not as inclined to gallantry as was Sam Spade. In *I, The Jury* stead of turning his homicidal lover over to the police, Hammer shoots her in the gut and takes some pleasure in during so. In fact, by the 1950s, the tough, smart women of the films of the thirties and forties had been replaced by sexy sirens. This is reflected in the popular literature of the period.

But in the aftermath of the women's movement of the 1960s-1970s, women began to appear in crime fiction as police officers and PIs. By the 1980s and 1990s, there were "tough gal" private detectives such as female private eyes created by Marcia Muller, Sara Paretsky, and Sue Grafton who were as capable as their male counterparts. At the same time crime writers such as Ruth Rendell and Minette Walters continued to offer powerful depictions of female killers in their books. By the late 20th century, crime fiction writers were providing more complex characterizations of both female heroes and female killers.

> **Nice (Or The Perils of Modern Dating)**
>
> In *Nice* (1998), mystery writer Jen Sacks' Edgar-award nominated novel, protagonist Grace has trouble letting her suitors down easy. She would rather not hurt men's feelings by rejecting them. She kills them instead. Then Grace meets Sam, who also knows something about homicide.
>
> In the first paragraph of the novel, Grace muses: "What is the definition of a sociopath? Could it be someone who's just a little more reasonable than most?"
>
> Source: Jen Sacks (1998) *Nice.* New York: St. Martin's Press.

In the modern era, feminist writers such as Margaret Atwood and Alice Walker use fiction as a vehicle for exploring issues that concern them. In doing so, these writers explore aspects of women and death as writers such as Zora Hurston (*Their Eyes Were Watching God*) and Ann Petry (*The Street*) did in an earlier period. Atwood, in particular, has made use of real life crime in her work. In *Alias Grace* (1997), the novelist examines the case of Grace Marks, a 16 year old Toronto serving girl, who in 1843 was convicted as an accessory in the murder of her employer, Thomas Kinnear, and his housekeeper/mistress, Nancy Montgomery. Mark's capital sentence was commuted to life in prison. Her alleged accomplice, James McDermott, the stableboy, was hanged (LeClair, 1996: 1). Atwood had first dealt with the case in 1970, when she published a book titled *The Journal of Susanna Moodie,* "a personal poem sequence" written from the point of view of Moodie, a legendary 19th-century pioneer who encounters Marks during a visit to the insane asylum (Moore, 1997: 1). Atwood later returned to the case to write about it in a novel. She recalls that as she was writing she considered "the number and variety of the stories" that had been told about Grace Marks. These narratives include the several versions of her own story that Marks had offered and that had been reported in newspapers and in Marks' "Confession." The other versions include several from McDermott; Moodie's account; and the narratives written by later commentators. Atwood concludes:

> For each story, there was a teller, but—as is true of all stories—there was also an audience; both were influenced by received climates of opinion, about politics, and also about criminality and its proper treatment, about the nature of women . . . and about insanity; in fact about everything that had a bearing on the case (Atwood, 1997: 20).

This basic truth that Atwood discusses—that there are multiple versions of an event such as homicide—shapes both real life courtroom trials and novels such as *Alias Grace.*

Libby Hatch, Murdering Mother

In Caleb Carr's novel, *Angel of Darkness* (1997) set in New York in 1897, Libby Hatch stands trial for the murder of her children. The prosecutor warns the jury that the defense will call her to the stand

> . . . to again tell her strange, unsupported story concerning a mysterious Negro assailant who attacked her children but not herself and then vanished into the night, never to be seen or detected again despite the most vigorous of searches (Carr, 525-526).

In the novel, reference is made to the real-life case of Lydia Sherman (known as the "Queen Poisoner"). Hatch's defense attorney in Carr's novel is the legendary real-life attorney Clarence Darrow. Another real person who figures in the novel is Elizabeth Cady Stanton, who is called by the defense and testifies because Hatch is accused of murdering her children. In real life, Stanton was both an activist on behalf of women's rights and a mother. In Carr's novel, the fictional Stanton asserts the strength of the maternal bond and argues that "if a woman did commit violence against her own child, it was either because she was insane or because the society of men had forced her into it somehow; probably both" (Carr, 605).

Source: Caleb Carr (1999) The Angel of Darkness. New York: The Ballantine Publishing Co.

Women and Violent Death in Hollywood Films

In her essay, "Women in Film Noir," Place (1998) writes:

> The dark lady, the spider woman, the evil seductress who tempts man and brings about his destruction is among the oldest themes of art, literature, mythology and religion in western culture. She is as old as Eve, and as current as today's movies, comic books and dime novel. She and her sister (or *alter ego*), the virgin, the mother, the innocent, the redeemer, form the two poles of female archetypes (Place, 47).

Some of the more potent images of women as destructive—as destroyers—are found on celluloid in Hollywood films. Sometimes these film women are innocently destructive, as in *Laura* (1944), a film noir classic. In this film, the heroine is the object of three men's desire—the hapless playboy with whom she thinks she is in love, the older mentor who becomes obsessed with her, and the tough police detective who falls in love with her portrait as he tries to solve her murder. Laura, herself, never kills. But murder is done because she is as she is—beautiful and an object of male desire. Or in *The Night of the Hunter* (1955), Willow, the naive, young widow, who has fallen under murderous Preacher Harry's spell and married him, confesses her sins at a camp meeting. As she tells the crowd, she "drove a good man [her first

husband] to murder" with her demands for fine things. Her first husband robbed and killed, and Willow has accepted the blame for that. Harry has convinced her that she is shameless (in her desire for sex) and sinful (in her desire for fine things). Of course, Harry, himself, has married Willow to find the money that her first husband stole.

Although Willow is eventually killed by Harry, other women in Hollywood films are allowed to be more plucky—and more deadly. Some who attract a homicidal male's gaze are forced to kill to protect themselves. This is often the outcome in modern "women in jeopardy" films such as *Jagged Edge* (1985), *Deceived* (1991), *Sleeping with the Enemy* (1991). On occasion, film women have been compelled to takes up arms or other weapons against an enemy that threatens not only their well-being but that of their people or country. They may be caught up in a war in films, such as *China* (1943) or *Dragon Seed* (1944), or in modern science fiction films, such as *Aliens* (1986), find themselves fighting for the survival of the human race.

On the other end of the continuum from these innocent and/or courageous females are the women who plot, scheme, and kill with malice aforethought. These women appear in film noir classics such as *Double Indemnity* (1944), *Out of the Past* (1947), *The Postman Always Rings Twice* (1946), *Portrait in Black* (1960) and in modern neo-noir films such as *Body Heat* (1981), *Fatal Attraction* (1987), and *Basic Instinct* (1992). Sometimes, as in *Basic Instinct* (1992), *Sea of Love* (1989), and *Body of Evidence* (1993), the question for the male hero—as a matter of survival—is whether or not the woman is guilty of the crimes of which she is suspected. Is she a beautiful, misunderstood woman caught in a web of circumstantial evidence? Or is she literally a *femme fatale*, a fatal woman? Hirsch (1981) writes:

> Sex in noir is usually poisoned, presented characteristically not in a romantic context but a psychotic one. Characters are enslaved, victimized by it. . . .sexually enflamed characters are often potentially dangerous, capable of acts of violence against themselves as well as others. Sexual interest fans psychosis. . . .(Hirsch, 186).

The fatal woman—the murderous lover, the scheming spouse—how can a man know with whom he is dealing? This question was posed in early film classics such as *My Cousin Rachel* (1952) and *The Dark Mirror* (1946). In the latter film, the hero, a psychiatrist, was required to determine which of two identical twins was a killer. If his science was up to the challenge, he would be able to detect the "bad" twin. He would rescue the "good" twin from her evil sister and have her for himself. Although the man of science is able to diagnosis the mental illness of the bad twin, his ability to tell them apart finally comes down to distinguishing between how they kiss. (Presumably the kiss of the bad twin is naughtier than that of her sister). Stables (1998) asserts that in films of the modern era, such earlier distinctions have become increasing blurred:

> Always a supra-real projection of 'woman', the *fatale* begins to border on caricature in 90s cinema. (The ultimate example here is

Catherine Trammel in *Basic Instinct,* constructed as an orphaned, homicidal maniac heiress who writes best-selling thrillers and flaunts her aggressively flexible sexuality.) . . . Long gone is the 'nurturing woman', representing a wholesome alternative in classic noir. Instead, the *fatale* is now surrounded by women who mirror and double her effects . . . Three of the four women in *Basic Instinct* are killers, linked by their unnatural blondeness . . . and their sexual or emotional relationships with one another . . . (Stables, 170)

In *Basic Instinct,* as in other films with women killers, madness lurks close to the surface. In fact, in Hollywood films, "mad" women—not just "bad" women—have long been a staple. In some of these films, madness is the product of aging and the lost of beauty. In one such film, *Sunset Boulevard* (1950), a former silent film star draws a young script writer into her fantasy about making a comeback. He narrates the film—as he floats face down (dead) in her swimming pool. As he relates in flashback, leaving Norma Desmond was not something he was allowed to do. This linking of aging—the decay of a woman's physical beauty—with madness also occurs in several films featuring the film stars of Hollywood's golden age. These films include *Hush. . .Hush, Sweet Charlotte* (1965) and *Whatever Happened to Baby Jane* (1962), in which Bette Davis, once a reigning Hollywood queen, glamorous and chic, is cast respectively as a demented Southern belle, who has lived for decades with accusations that she killed her lover, and as a grotesque former "child star," who taunts and tortures her crippled sister. But the twist in each of these two films is that the "good" woman who Davis is tormenting turns out to be the cause of her madness. The false good woman's homicidal and/or deceitful acts have made Davis what she has become. The revelation of this brings her peace. Of course, she does not escape the mental health or criminal justice systems. She has killed, and she must be taken away.

In other films, women lurk in attics ("the mad woman in the attic") as in *Jane Eyre* (1934), based on the novel by Charlotte Bronte, in which Mr. Rochester's first wife is the secret threat to the young governess, Jane. In some films, the women, though dead, leave the lingering odor of their evil, as in *Rebecca* (1940), based on the novel by Daphne du Maurier. Included in this category of Gothic madness and evil is the "granddaddy" of the "slasher films," *Psycho* (1960), in which Norman Bates' mother is there in both body (mummified) and spirit as she is implicated (in this film and its sequels) in her son's homicidal acts.

On occasion destructiveness is also associated with very young females. In *Taxi Driver* (1976), Iris, the 12 year old prostitute (played by Jodie Foster) becomes the object of Travis Bickle's (Robert De Niro) obsession. In the bloody climax, he kills three people to "rescue" her. The movie itself became an obsession of real-life, would-be assassin, John Hinckley, who tried to kill President Ronald Reagan. On the other end of the continuum, representing the destructive young females who plot and scheme and do their own killing, there is eight year old, Rhoda, intelligent, precocious, and a serial killer. As the

name of the movie, *The Bad Seed* (1956) implies, Rhoda is bad through and through. She has inherited her badness from her maternal grandmother, a notorious serial killer. Rhoda, in spite of her youth, is a psychopath who kills without conscience to obtain the objects she wants and to cover up her crimes. She confesses to her horrified mother (who somehow escaped the taint of her own mother's legacy). Rhoda explains her crimes with an air of reasonableness. She has pushed an old woman, a neighbor, down the stairs. She has caused a classmate to drown, and she has burned a nosy handyman up alive. In despair, her mother decides to kill both Rhoda and herself. Her mother almost dies from a self-inflicted bullet wound to the head, but Rhoda is rescued before she can die of the pills her mother gave her (disguised as vitamins). Because of the Motion Picture Production Code that was in effect when the film was made, Rhoda is not allowed to escape punishment as she does in the Maxwell Anderson play on which the film was based. In fact, God takes a hand. In a marvelous example of *deus ex machina*, Rhoda gets her comeuppance when she goes down to the pier during a storm and the pier is struck by lightning.

But as noted above, in modern films female badness most often appears in the form of a lethal woman not a homicidal little girl.

Deadly Dolls and Lethal Women

Holmund (1994) finds that in the last decade, "more deadly dolls have fueled Hollywood's—and our—imagination." These lethal females have often been presented as sexually ambivalent or overtly lesbian. Relevant to earlier discussion in this book, Holmund (1994: 38) observes that *Fried Green Tomatoes* (based on the novel) is one of the few films in this category "to broach the question of spousal abuse." Other films deal more directly with the issue of women as mothers. In such films as *The Hand That Rocks the Cradle* and *Fatal Attraction,* the good mother-wife is pitted against the bad "other woman" who seeks to punish and/or replace her (see e.g., Husting, 1999 on "anti-mothers" in films).

Scholars have proposed various descriptive categories for films featuring female protagonists who engage in violence. For example, Dole (2001) finds that films featuring female law enforcement officers fall into "three generations" with regard to treatment of the protagonist as woman and as professional. The first generation appeared in the late 1980s and early 1990s, and featured women police officers as the protagonists rather than in the role of partner to a male cop or his love interest (e.g., *Fatal Beauty* (1987) or *Blue Steel* (1990)). However, in these movies, the women displayed both "'female' motivations and weaknesses" and a tendency toward overcompensation. They seemed too much like "gun-toting women masquerading as men" (101). The second generation of films (e.g., The *Silence of the Lambs* (1991)) offered women who were more balanced, women who "combined traits from the masculine and feminine constellations to create a more integrated hero" (101). And finally, films such *Copycat* (1995) and *Fargo* (1996) "experimented with models of a specifically female heroism" (101). Dole asserts that Hollywood—recognizing "that consumers desire a change in old gender categories"—is

currently involved in a process of trying to create female heroes that will have audience appeal. She notes:

> The limited box-office returns of most female-dominated cop films suggest that while some audiences embrace the spectacle of the female action hero coming to the rescue of others, the ultraviolent heroine cannot draw the large audiences necessary to turn profits for high-cost action extravaganzas ... (Dole, 102).

Aside from the use of violence by women as law enforcement officers, other scholars have been interested in the range of movies in which women employ violence to avenge a wrong. Examining "rape-revenge" films, Read (2000) argues that rather than falling into a discrete subgenre, such films has their roots in early silent films, such as D. W. Griffith's *The Birth of a Nation* (1915), in romances, in film noir, and in westerns. Green (1998) in his examination of gender and ideology, asserts that in discussing the "women you don't mess with" in Hollywood films, attention should be given not only to the film noir femme fatales of the 1940s, but to the African Americans actresses such as Pam Grier and Tamara Dobson, who starred as tough gal protagonists during the era of "blaxploitation" films in the 1970s. A number of scholars (see e.g., Walters, 2001) also point to the violent women in the sensational films about women in prison that began to appear in the 1970s and continued to be made with variations into the 1980s and 1990s.

Finally, there are the films in which women are portrayed as "hard bodies." In these films, the female protagonists are physically fit and more than capable of dealing with opponents. Such films include *Aliens* (1986), *Le Femme Nikita* (1991), *Point of No Return* (1993), *Terminator 2* (1991), and more recently *Charlie's Angels* (2000), *Die Another Day* (2002), and *Kill Bill* (2003). This genre includes the marital arts films featuring Asian, and occasionally American, female stars. What has been a topic of debate is whether or not films in which women are modern day "warriors" are subversive to the gender status quo and thus serve to empower females in the audience, or whether they are instead only the most recent attempt by Hollywood to cater to the male gaze and/or a male perspective on violence (see Vares, 2001 on responses of female viewers to action heroines).

Summary

As Fryer (1996) observes in her analysis of public and media response to two trials involving women who killed, Anna George in 1899 and Francine Hughes in 1977, such events become "morality plays" which provide a focus for debate about "fundamental societal values." As the authors have observed throughout this book, narratives about women reflect fundamental societal conflicts about gender relations and gender roles. Images of women in their various roles are reflected, perpetuated, and challenged in literature and films. In these works of popular culture, we are able to trace evolving debates.

In Appendix A, the reader will find a list of literary works and films that deal with aspects of the social construction of women killers.

Chapter 11

Of Women, Sexuality, & Murder
Concluding Thoughts

Introduction

In her recent study of the legal treatment of female homicide defendants in England and Wales, Chan (2001: 22) writes:

> Given the rarity of women's use of fatal violence, societal reactions to women who kill have been drawn from long-standing myths and stereotypes about the nature of women to explain the homicide event. The bad, evil or manipulative woman of history is resurrected as a means of accounting for the contemporary presence of the women [sic] killer. Her use of violence is an element of her pathological being.

Chan goes on to note that this is in contrast to images of male violence "and the perceived normality of male aggression because violence 'is what men do'" (Chan: 22).

As discussed in the preceding chapters, historically violence by a woman has been seen as an aberration—a deviation from the naturally passive nature of women. Although those ancient female warriors, the Amazons, were respected as worthy opponents by Greek males, the Amazons were also constructed as "wild women" to be either killed or tamed (i.e., domesticated by marriage). In the same vein, from earliest times to the present, the explanations offered of female homicidal behavior have relied on narratives of "badness" or "wickedness" or "evil" on one hand or, on the other, "illness" or "madness" (both linked to dysfunctions of the female body). There seems to be much less middle ground for women in explaining violence than is allowed for men. If as Chan asserts there is a tendency toward the normalizing of male violence, then there is a parallel tendency to render female violence abnormal. Or, to quote journalist Caryl Rivers concerning the two "polar opposites" myths about women:

> —the Myth of Female Weakness and the Myth of Female Strength. In one, a woman is a sniveling, small-brained, hormone-wracked creature so filled with anxieties and chemical twitches it seems a miracle she can get out of bed in the morning. In the other, she's Wonder Woman and Medusa, all wrapped up in one, able to reduce men to irrational behavior, making them desert their senses and become besotted fools. And media coverage of women often bounces from one to the other like bumper cars gone mad (Rivers, 1996: 17).

In spite of these competing myths, feminists and other social and/or political activists have sometimes perceived homicides committed by women as violent resistance to various forms of oppression. Such characterizations of homicides as acts of resistance appear in feminist interpretations of the myths of Medea and Medusa. They also appear in readings of cases such as that of Virginia Christian, the African American washerwoman who engaged in fatal combat with her white female employer. A similar (albeit without race)

interpretation of class resistance to oppression was given to the case of the Papin sisters, the French servants who killed their two females employers. Simone Beauvoir and her peers saw the Papin sisters as mentally disturbed, but also as the products of a society that had created them by failing to address their needs because they were poor and unimportant in the scheme of things.

In the feminist description of the plight of all women, male oppression is described as both institutionalized and purposive. In her history of feminism, Freedman (2002) writes:

> Isolating women to control their sexuality preserved both male energies and male property. Fear of physical depletion underlays biblical depictions of Eve and Salome as sexually voracious temptresses, while the European myth of the vagina dentata imagined female genitalia devouring men. In addition, control over female sexuality has been critical to ensuring paternity. . .Female sexual control reinforced male dominance in patriarchal gender systems . . . (255)

In narratives of homicides committed by women, the events are often portrayed as disruptions of societal expectations about female roles, particularly those of wife and mother. It should again be noted that these societal expectations have been the expectations of males. Historically, women have been socialized into the roles assigned to their gender. Thus, the blatant deviation from those roles by women who kill looms large in the narratives that traditionally have been told by men. When the stories have been told by female narrators, particularly in the late 20th century, there has been a greater tendency both to question and to challenge the underlying assumptions about gender relations and the roles of women.

Still, because of the circumstances in which their acts occur, women who kill often are portrayed as unruly actors in domestic dramas. In a courtroom in present day California, Socorro Caro, who shot her three sons, was described by the prosecution as having killed three of her four children as they slept in a modern act of revenge. Prosecutor Cheryl Temple described Caro as lashing out at her husband. The children became "symbolic pawns" to be used against him (AP, California Mother). Although at first denying the allegations and even accusing her husband of the murders, Caro later pled innocent by reason of insanity (AP, California mother).

Whether insane or simply cold-blooded and calculating, women who kill their children and/or husbands subvert the social construction of ideal womanhood. Even in domestic violence cases in which battered women act in self-defense, the narratives of these women who kill their husbands to save their own lives are heard and interpreted alongside narratives of women as devious betrayers of their marriage vows. Pollock finds that in recent years, perhaps as a result of improved services for battered women, the number of women killing their partners has decreased (Pollock, 1999: 31). She observes:

Thus, the acceptance of the so-called "battered women's syndrome" as a legal defense to homicide has not resulted in an "open season" on husbands, as some dire predictions warned. In fact, the opposite has occurred. With the rise of battered women's shelters, more social support, and a recognition that domestic abuse is not the victim's fault, abusive male spouses are now less likely to be murdered (Pollock, 32).

However, the image of the woman who uses abuse—or allegations of abuse—as an excuse for killing her spouse or partner remains an important popular narrative about women who kill.

In a recent book which received much attention, journalist Patricia Pearson (1997), objected to the use by women of "victim status" to deny their autonomy and their responsibility for their acts. Of course, this debate about the attempt by alleged offenders to claim victim status is not limited to women. A few years ago, Ted Koppell's late evening news magazine *Nightline,* asked the question "Is Abuse An Excuse." The show was presented as a 90-minute forum in which legal experts and social scientists commented on high profile cases involving both male (e.g., the Menendez brothers) and female offenders who had suffered or claimed to have suffered physical, sexual, and/or psychological abuse. As the experts discussed, such claims are made in a society in which stories of victimization are heard more and more often. As a result, there may well be a backlash against what has been characterized as the "victimization excuse," or as attorney/law professor Alan Dershowitz (1994) puts it "the abuse excuse." Narratives by women who claim self-defense or who offer mitigating accounts of abuse in homicide cases are heard within this climate of suspicion.

Moreover, there continues to be concern about escalating violence by female offenders. Although this is clearly not the case, the images of these violent women loom large in articles such as the one from *Psychology Today* quoted in the Introduction. Recall that the author made the misleading assertion that rates of violence by women were skyrocketing, and then asked, "Have they [women] taken 'women's liberation' one step too far—or are they just showing their natural killer instinct?" (Yeoman, 1999: 54). Images of violent women remain pervasive. As discussed in the preceding chapter, portrayals of violent women have taken on new life in Hollywood films featuring "tough gals" and "hard-bodied women." Among these women are both heroes and villains. What they have in common is their willingness and ability to use violence instrumentally, as men traditionally have in films.

However, the real life narratives of women accused of homicide illustrate the complexity of the issue. The violent acts committed by women need to be examined within the context of not only gender, but race/ethnicity, class, and sexual orientation. The violent acts of women need to be considered within the contexts of societies in which: (a) laws traditionally have been man-made, and (b) narratives about women traditionally have reflected male perspectives about gender-appropriate behavior. Viewed within these contexts the stories of women now on death row in prisons across the country take on deeper meaning.

Women and the Death Penalty

The data about these women appearing in Table 1 reveals only the most basic information about them—name, race, age at time of crime, victim. What it does not provide is their life stories.

Table 1: Women on Death Row (June 30, 2004)

NAME	RACE	AGE (AT TIME CRIME)	VICTIM	WHEN SENTENCED
Alabama				
Patricia Blackmon	Black	29	Adopted daughter (2)	06-07-2002
Louise Harris	Black	34	Husband	08-11-1989
Shonda Nicole Johnson	White	28	Husband	10-22-1999
Arizona				
Debra Jean Milke	White	25	Son (4)	01-18-1991
California				
Maria Delrio Alfaro	Hispanic	18	Hispanic girl (9)	07-14-1992
Dora Luz Buenrostro	Hispanic	34	Her children (4, 8, 9)	10-02-1998
Socorro Caro	Hispanic	42	Her children (5, 8, 11)	04-05-2002
Celeste Simone Carrington	Black	30	Hispanic male (34) and White female (36)	11-23-1994
Cynthia Lynn Coffman	White	24	White female (20)	08-30-1989
Kerry Lynn Dalton	White	28	White female (23)	05-23-1995
Susan Eubanks	White	33	Her children (4, 6, 7, 14)	10-13-1999
Veronica Gonzalez	Hispanic	26	Her niece (4)	07-20-1998
Maureen McDermott	White	37	White female (27)	06-08-1990
Michelle Lyn Michaud	White	38	White female (22)	09-25-2002
Sandi Dawn Nieves	White	34	Her children (5, 7, 11, 12)	10-06-2000
Angelina Rodriguez	Hispanic	32	Husband	01-12-2004
Mary Ellen Samuels	White	40	Husband and Hired killer	09-16-1994
Catherine Thompson	Black	42	Husband	06-10-1993
Caroline Young	Hispanic	49	Her grandchildren (4 and 6)	10-27-1995

Table 1: Women on Death Row (June 30, 2004) *Continued*

NAME	RACE	AGE (AT TIME CRIME)	VICTIM	WHEN SENTENCED
Florida				
Virginia Gail Larzelere	White	38	Husband	05-11-1993
Georgia				
Kelly Renee Gissendaner	White	28	Husband	11-20-1998
Idaho				
Robin Lee Row	White	35	Husband, son (10), daughter (8)	12-16-1993
Indiana				
Debra Denise Brown	Black	21	Black female (7)	06-23-1986
Kentucky				
Virginia Susan Caudill	White	37	Black female (73)	03-24-2000
Louisiana				
Antoinette Frank	Black	24	White male police officer (25), Asian male (17), Asian female (24)	09-13-1995
Mississippi				
Michelle Byrom	White	43	Husband	11-18-2000
Nevada				
Priscilla Ford	Black	51	3 White females, 3 White males	04-29-1982
North Carolina				
Patricia JoAnn Wells Jennings	White	47	Husband	11-05-1990
Blanche Kisser Taylor Moore	White	56	White male (50)	11-16-1990
Carlette Elizabeth Parker	Black	34	White female (86)	04-01-1999
Christine Walters	Native American	19	2 White females (19 and 25)	07-06-2000
Ohio				
Donna Roberts	White	58	Husband	06-21-2003

Table 1: Women on Death Row (June 30, 2004) *Continued*

NAME	RACE	AGE (AT TIME CRIME)	VICTIM	WHEN SENTENCED
Pennsylvania				
Doneta Marie Hill	Black	23 and 24	Asian male (72), Black male (21)	04-09-1992
Carolyn Ann King	Black	28	Male (74)	11-30-1994
Beth Ann Markman	White	34	White (?) female (18)	2001
Delores Precious Rivers	Black	34	White Female (74)	03-16-1989
Michele Sue Tharp	White	29	Daughter (7)	11-14-2000
Tennessee				
Gail Kirksey Owens	White	32	Husband	01-15-1986
Christa Gail Pike	White	18	Hispanic female (19)	02-29-1996
Texas				
Suzanne Margaret Basso	White	44	Boyfriend (White male, 59)	09-01-1999
Kenisha Berry	Black	21	Son (newborn)	02-19-2004
Linda Anita Carty	Black	42	Hispanic female (20) and victim's infant son	02-31-2002
Cathy Lynn Henderson	White	37	White male (3 months)	05-25-1995
Brittany Marlowe Holberg	White	23	White male (80)	03-27-1998
Kimberly Lagayle McCarthy	Black	36	White Female (71)	11-1-2002
Francis Elaine Newton	Black	21	Husband, son (7), daughter (2)	11-17-1988
Darlie Lynn Routier	White	26	Son (5)	02-04-1997
Erica Yvonne Sheppard	Black	19	White female (43)	03-03-1995
Virginia				
Teresa Michelle Lewis	White	33	Husband, Stepson (26)	06-03-2003

Source: Streib, V. (2004)

In his on-going analysis of data about female offenders who have received the death penalty, Streib (2004) reports that as of June 30, 2004, fifteen women who had killed their husbands or boyfriends, and twelve women who had killed their children or grandchildren were on death row. These women represented twenty-seven of the forty-nine female offenders currently on death row. Of these 49 offenders, 26 (53%) were White; 16 (33%) were Black; 6 (12%) were Latin (Hispanic); 1 (2%) was Native American.

The question one might pose is why these women out of the total population of women accused of and tried for murder ended up on death row. When one reads the narratives of their crimes, the tales told are sometimes chilling. For example, Maria del Rosio Alfaro was sentenced to death for stabbing a nine year old girl 57 times during a burglary. Latasha Pullian, joined her boyfriend in sexually assaulting, torturing, and strangling her neighbor's six year old daughter. Blanche Moore was convicted of poisoning her boy friend. She probably committed five other murders as well, including the murder of her first husband. She attempted to poison her second husband, but he survived. These cases are the stuff of true crime books and television news magazine segments.

Then there is the case of Wanda Jean Allen, recently executed in the state of Oklahoma. An HBO documentary about the case focused on the effort by the attorneys handling Allen's appeal to obtain clemency for her based on the ineffectiveness of her trial attorney in failing to introduce evidence about Allen's mental dysfunctions. The attorneys handling her appeal pointed to a report written when Allen was fifteen years old and confined in a juvenile institution. The examining physician diagnosed her as borderline mentally retarded with cerebral damage and recommended further testing and treatment. Her attorneys argued that the state had failed in its responsibility to Allen by not following up on the report. In their comments on the case in the documentary, they also noted that in 1981 when Allen committed a similar crime (the killing of a friend), the state had plea-bargained the case to manslaughter, and she had served only four years. The attorneys suggested that this second homicide was an embarrassment to the state, and, therefore, there was less willingness to show leniency. They also asserted that the fact that Allen had killed a woman with whom she was involved in a lesbian relationship worked against her in the state of Oklahoma, in the "Bible belt." On the other side, the prosecuting attorney argued that Allen and her victim had been involved in a relationship that had been "turbulent" for some time. In that relationship, according to the prosecutor, Allen was "the dominant person." With regard to the defense contention that the killing had not been premeditated, but grew out of an argument, the prosecutor pointed out that under Oklahoma law, there need not be an extended period during which one has intent to kill—intent can be formed "in an instant."

This case of Wanda Jean Allen, an African American woman who killed her partner in a lesbian relationship, who apparently had cerebral damage (caused by being struck by a car, according to her brother), who had killed once, and then killed again, and who stood trial in a state that in 2001 executed three women, raises many issues about women who kill and those among that small group who are judged deserving of death. In fact, the stories of women on death row—women who killed husbands and/or children, who killed friends or neighbors, who hired hit men, who shot police officers, who committed (rarely) serial murders—raise questions about who our society chooses to put to death and why.

The Death of an Immoral Woman

In 1935, a case in which a woman was accused of greed and cunning ended with the execution of the accused. Like Ruth Snyder, Eva Coo died in the electric chair at Sing Sing Prison. Like Snyder, Coo was said to have killed for greed, for insurance money. She ran a roadside tavern and her alleged victim was Harry Wright, the handyman who had helped out around the place. According to the story told by the prosecutor, Coo and her partners in crime, had killed Wright and then attempted to make it look like a hit and run accident. In his summation to the jury, Donald Grant the prosecutor, described Eva Coo as a "tiger woman." After a deliberation of only two hours, the jury reached a verdict finding Coo guilty of murder in the first degree. The judge sentenced her to death. Her co-defendant, Martha Clift, who had driven the car in which they transported Harry Wright, and who had plea-bargained, received a sentence of twenty years in Bedford Hills Prison (Eggleston, 1997: 90-91).

On the surface, Coo's case seemed fairly straight-forward. Coo concocted a plan to kill the handyman on whom she had taken out insurance policies, and enlisted the help of her good friend and others in carrying out the crime. On the day of the murder, she and Clift obtained a car. That night, they drove Wright to an old deserted farm where they killed him. They were almost caught by the owners of the farm who appeared unexpectedly. But they talked their way out of the situation, concealing Wright's body under the car. Then they left the body in a ditch by the road where it was later found. However, in his analysis of the case, Eggleston (1997) suggests that Coo might have received a lesser sentence than death if she had not been considered a problem by the well-placed men who had enjoyed the hospitality of her roadhouse (and the girls who worked there) and who feared she might talk. He also raises questions about the adequacy of the counsel handling her appeal. At the suggestion of Lewis Lawes, the warden at Sing Sing Prison, Coo changed attorneys. However, Lawes and the other criminal justice participants in the case were involved in political feuding and one-upmanship that may have influenced their actions regarding Eva Coo (Eggleston, 1997). Still Lawes seemed to believe Coo had been the victim of a miscarriage of justice and that she should have received a lesser sentence. He recommended to the governor that her sentence be commuted. It was not (Eggleston, 108).

The Coo case was covered by Dorothy Kilgallen, one of the more famous women reporters of her day. In a chapter titled "Hootch, Whores, and Homicide" in her book, *Murder One* (1967), Kilgallen recalled the trial:

> The tenor of Prosecutor Grant's case was made crystal-clear in his opening remarks. He intended to prove that Harry Wright, a besotted town character, crippled by disease, was invited to live with Eva Coo after his mother's death for the sole purpose of setting him up for an insurance fraud. (Kilgallen, 121)

The prosecutor had the statement Coo had made implicating herself. He also revealed that Harry Wright had made a will naming Coo as his beneficiary.

In his counter-narrative, Coo's attorney, Jim Byard, raised the matter of the smooth-talking—and married—ex-furnace salesman who had come to live with Eva Coo. Byard suggested that there was something "sinister" about the fact that Harry Nabinger, Coo's lover, was being held in jail as a material witness under five thousand dollar bond when it was usually one hundred dollars. Then Byard accused the state of using third degree techniques to extract Eva Coo's confession. And, finally, he "thundered" at the jury: "We will show that Eva Coo, because she was notorious and feared by the very men she entertained, was made the victim of vicious persecution." Byard closed by arguing that although Coo had taken out the accident policies on Wright, she had not killed him. Wright, who was ill, had died of an internal hemorrhage. Coo, who was in need of money, had run over the body with the car and then set it up to look like an accidental death so that the policies would pay double indemnity (Kilgallen, 122-123).

These were the courtroom arguments to which Kilgallen listened. On the night of Coo's execution, she sought out Harry Nabinger, Coo's lover. He was in a tavern, drinking. Relating his own version of the murder, he told the reporter, "Eva was a tough baby. . .Don't let anyone tell you she wasn't. She killed Harry Wright, and I know it and you know it as well as you're setting there" (Kilgallen, 149). In her chapter on Eva Coo, Kilagellen concludes:

> Thus ended the case of Eva Coo, an evil, immoral, depraved human being who went to a terrible reward. But did she—no matter who or what she was—receive the kind of justice supposedly guaranteed every human being? I don't know. And Warden Lawes, who spent a lifetime dealing with criminals, had his doubt, didn't he? (150).

In a statement made after her execution, Warden Lawes said of Eva Coo:

> I don't know if she was innocent or guilty. But I do know that she got a rotten deal all around. Rotten. . .I suppose I ought not to say anything. My job was to kill that woman, not defend her. And I'm not defending her—she may be guilty as well, but she got a raw deal. Her trial attorneys—do you know what they did to help her lately? Know what? One of them wrote to me, saying he'd like four invitations to her execution. That's the kind of defense she had (quoted in Gillespie, 1997: 35-36).

Eva Coo died alone because she had refused to see the family from whom she had been estranged for years, preferring to see them again under better circumstances—after she was released from prison. She also refused a last meal, anticipating a last minute reprieve. It did not come. She died, leaving

behind unanswered questions about her death sentence (Gillespie, 35).

In the community near Cooperstown where she operated her roadhouse, Eva Coo is still remembered. In accounts of women who have been executed, she is discussed. But, unlike Ruth Snyder, Coo did not attract fever-pitch media coverage. Her trial took place in upstate New York. Shipman (2002) finds, "Public interest waned as the trial progressed. . ." (79). Even with a recent book (Eggleston, 1997) about the case, Eva Coo has not generated a great deal of contemporary interest. She was not a "murdering mother" or a "vengeful wife" or the female half of a pair of "adulterous lovers." She sits awkwardly on the mind as the protagonist in a case that was both banal and complex. Unlike Ruth Snyder, Eva Coo is not as usable in a social construction process that strives on catch phrases and tends toward oversimplification.

Unlike Ruth Snyder, there are fewer occasions to evoke Eva Coo's name.

The Culture of Memory

During the debate concerning Karla Faye Tucker's fate on death row, a reporter in Worcester, Massachusetts recalled the case of Bathsheba Spooner, "the last female executed in the Bay State." According to this staff reporter, the narrative of Spooner's trial and execution had all of the plot elements of a popular prime time melodrama ("Melrose Place"). The reporter notes that on the day of Spooner's execution, over 5,000 spectators arrived in Worcester, the town where it was to take place (*Telegraph & Gazette*, 02/04/1998). The tone of the article is more upbeat than one would expect about such a sober subject. The reporter seems to take some pleasure in relating this colorful slice of Worcester history. However, what is of interest here is the occasion on which this article appears. The name of Bathsheba Spooner and the legend of her death has been evoked in the midst of a debate about the execution of another woman. Regarding the journalistic use of collective memory, Edy (1999) writes:

> Many stories go out of date and cannot be used if there is not space in the news product for them in the day that they occur. However, stories about the past appear regularly in the news in three basic forms: commemorations, historical analogies, and historical contexts (74).

Commemorative stories are sometimes known as "anniversary journalism" (74) Historical analogies are used as "powerful symbolic resources that are pressed into service by various political actors" (78). And, the third, historical contexts "explain how we got here." Such news stories "trace the portions of the past that appear relevant" (80). Given these uses by journalists of stories from the past, some stories are more likely to be called into services

than are others. For example, an analysis of the media coverage of stories about women who are executed suggest that the women who were "the first" or "the last" to die appear often in stories about executions. Thus Velma Barfield, who was the first woman, executed in the post-Furman era is often mentioned in discussions about the death penalty. Or, in the story above the mention that Bathsheba Spooner was "the last female executed in the Bay State" makes it worthwhile to recall her story. Such stories are useful in providing historical context for discussion of other cases.

Of course, the Bathsheba Spooner case might also be evoked as historical analogy about the finality of the death penalty. Spooner was hanged, and then it was discovered that she was pregnant.

The cases of other women who kill are recalled whenever a crime of a similar nature occurs. When Andrea Yates killed her five children, the story of Susan Smith—an infamous "murdering mother"—was recalled. When Deanna Laney, the Texas mother who killed her two sons and injured a third, was arrested recently, the story of Andrea Yates was the one that was recalled. Such historical analogies to women who kill their children are a part of the social construction process that occurs in the print media and on television.

In the process of making such historical analogies, there is also the opportunity to turn to participants in past dramas for assistance. For example, during the Andrea Yates' case, CNN's Larry King interviewed Susan Smith's ex-husband. David Smith was asked to remember what he had thought and felt when he had experienced the loss of his own sons—first believing they had been taken by a carjacker, and then learning the shocking news that the boys had actually been drowned by their mother. King asked Smith how he felt about his ex-wife and what he thought of Russell Yates's announced support of his wife Andrea. King also asked Smith about his life with his new wife and baby. Clearly, the message was that Smith could speak as a father who had experienced the trauma of the loss of his children at the hands of their mother. But Smith had survived, and although he still felt a father's sadness at the loss of his sons, he had rebuilt his life. The implication was that Russell Yates, too, would eventually be able to get past the tragic loss of his children.

Such is the nature of historical analogies that connect the story of one woman who kills to that of another. But there are some stories that are "powerful symbolic resources" for other reasons.

A Symbol of Evil and Innocence Lost

When Myra Hindley, a child serial killer, died recently in prison, British journalists looked back at the impact of her crimes on British society. Although a few of the journalists made a gesture toward understanding the "Moor Murders" and Hindley in larger social context, often the tone of both editorials and articles was harsh. This was also the occasion for a volley in the newspaper wars by *The Sun,* which claimed credit for having helped to keep

Myra Hindley in prison, even as its liberal competitor supported her parole. In an article titled "Innocents Can Smile In Heaven," reporter John Troup interviewed the husband of Ann West. The Wests were the parents of one of the murdered children. West's husband told Troup that his late wife had credited his paper, *The Sun*, with keeping Hindley from getting out of prison (11/16/2002).

But beyond such self-praise, the journalists seemed to be expressing what they believed many of the public had felt about Myra Hindley, that she was evil beyond redemption. In an article in the *Sunday Mail* (SA) with the headline, "Death of a Moors Murderer; Monster takes dark secret to the grave," two reporters, Wright and Loudon, observed that with Hindley's death it became even less likely the mother of 12-year-old Keith Bennett would ever learn where her son's body had been buried. The reporters noted that there was some comfort for the mother in the fact that Hindley had never achieved her goal of gaining parole. Hindley had some support in her petition for release and some hope after she challenged the Home Secretary's right to keep her in prison for life. But she died before gaining her freedom and, in doing so, relieved the minds of many people who wanted her to stay in prison (Wright and Loudon, 11/17/2002).

Other newspapers focused more on why Hindley was hated. For example, the news editor of *The Star* (Sheffield) explained that for him as for many adults of his generation, what Hindley had done was give a face to nightmare. He noted that Hindley's compelling stare had chilled those who saw her. With their crimes, Hindley and Brady had robbed a generation of children and their parents of the sense of safety and security that they had known before the murders on the moors. After the murders, the British public knew more than it cared to about crimes against children. As did other journalists, this editor expressed the perception that because Hindley, a woman, helped to torture and kill children, she was more evil than Brady (Westerdale, 11/18/2002).

Few female killers have risen to Myra Hindley legendary status. Few females killers have been so hated. But Hindley's case illustrates many of the arguments made in this book. She was—still is—hated by many of the British public because in the society in which she lived Hindley did what no woman should ever have done. As a woman, she should have nurtured children and protected them. Instead, she lured them to their deaths. They came to her as a trusting mother figure. She revealed herself as an evil monster who devoured them. But not before she had taken pleasure in their cries for mercy. And then she buried the bodies of her innocent victims on the cold moors and left their parents to weep for their lost children. Brady was her partner in crime, yes. But it was Hindley who was the monster because she was so brazenly and unforgivably a violator of gender expectations.

In the social construction of women who kill, Myra Hindley represents an extreme. Most women who kill are not serial killers. Most do not kill the children of strangers. Most are not "team killers" who torture and abuse their

victims before killing them. Hindley represents an extreme, but for this reason she is much more memorable then the typical female killer. To label Myra Hindley as "monster" short-circuits any discussion about the social conditions and the individual characteristics that gave birth to her crimes. It is this short-circuiting with label—this explanation by reference to archetype—that is disturbing when we examine the social construction of women who kill.

On Social Science Narratives

The authors have not undertaken in this book the systematic examination of the impact present day social scientists have had on the construction of narratives about women who kill. Obviously, their roles may be numerous—classroom instructor, director of graduate student research, investigators on research projects, consultants to criminal justice agencies, public lecturers, authors of articles and books for both academic and mass market publishers, and—more visibly to the public—interactions with the media as experts on the topic. The concept of "newsmaking criminology" (i.e., the involvement of criminologists in demystifying images of crime and punishment and affecting public attitudes/policy, see Barak, 1995) as it applies to this topic merits further research. Such a project is beyond the scope of this book, but one that the authors hope to pursue in the future.

However, it seems to the authors that the greatest challenge faced by contemporary social scientists who study women offenders has been that of dismantling the stereotypes that entered mainstream discourse by way of the works of earlier theorists such as Lombroso, Freud, and Pollak. These theorists offered narratives of deviant and criminal women that supported the old images and offered new ones of women as inferior to men and defined by their physiology. Moreover, it seems to the authors that modern discourse about women who kill is deeply mired in gender politics. Therefore, even when a concept such as "the battered woman syndrome" makes its way into the mainstream it is subject to multiple constructions and to the backlash against feminism. This is not to argue that this is a new phenomenon. But it seems to the authors that in the present era, because there are so many unrestrained challenges to the status quo coming from so many different directions that the social construction of women who kill reflects cultural tensions that are much nearer the surface than in past eras.

As Appendix B indicates, women have been actively involved in criminal justice and related fields as scholar-practitioners and social science researchers since the 19th century. Historically, male social scientists have shown only limited interest in female offenders. Women activists and scholars have pointed out this neglect and been more prone then men to recognize and object to stereotyping. Women themselves have worked to address the issues of crime and justice that affect women. In recent decades, there has been more scholarship in the area of women and crime, with contributions in areas of both victimization and offending, and discussion of the nexus between being

a victim and becoming an offender.

The authors would encourage the reader to seek out the work of scholars such as Coramae Richey Mann, Carolyn Block, Rebecca Dobash, Joycelyn Pollock, and Joanne Belknap to become better acquainted with research on homicide and on women as victims and offenders. This short list is not by any means intended to be complete. The authors refer the reader to the other scholars cited throughout this book.

In Appendix C, the authors have included the responses of a number of other women professionals and practitioners who responded to a survey sent out by the authors. These women offer their observations about women who kill, and thoughts about women in the criminal justice system. The comments of these women provide fertile ground for further discussion. The reader will note that themes that appear throughout the book—such as the cultural tendency to normalize male violence while perceiving female violence as aberrant—are addressed by some of the women. Other topics are introduced or expanded on by the women. For example, there is some discussion here about women in prison. Another topic that is discussed by British writer/activist Angela Devlin is that of images of women in commercial advertising. She notes the use of images of aggressive women in British marketing campaigns. However, in her book *Deadly Persuasion* (1999), media scholar and documentary maker (*Killing Us Softly*), Jean Kilbourne downplays the importance of images of female aggression in advertising. She writes:

> Women are sometimes hostile and angry in ads these days, especially women of color who are often seen as angrier and more threatening than white women. But regardless of color, we know that women are far more likely than men to end up as roadkill—and, when, it happens, they are blamed for being on the road in the first place (280-281).

Clearly, Kilbourne is arguing that the portrayal of women as victims should be of more concern than images of aggressive women. The authors leave readers to debate this issue and the others raised by the women whose comments appear in Appendix C.

Finally,

This book has explored the social construction of women as killers. The authors have focused on the cultural resources that are drawn on in constructing legal and popular narratives about women who kill. The authors have looked at the roles of religion, mass media, and medicine as narrative sites in this process. The roles that women themselves have played in their own criminal justice dramas have been discussed.

The authors' frequent references to the uses made by various actors of "scripts," or recognizable stories, has not been intended as a moral judgment

of those actors. As the authors noted in the Introduction to this book, humans tell stories to each other. They tell stories that they hope will be recognizable by those with whom they are communicating and produce the desired response. But, as the authors have implied throughout this book, when stereotypes and erroneous assumptions become the cultural material used in the construction of these stories it becomes problematic for both storyteller and audience. Women who kill often have found themselves in the position of having to tell stories that must be scripted to fit certain stereotypical assumptions about gender. This has meant that some women have benefitted from their—or their defense attorney's—ability to tell a story well. Others, less articulate or poor or women of color, have been at a disadvantage because their narratives have been rendered suspect because of their inability to tell their stories fluently or because of their social status.

In the social construction process, the narrative of each woman who kills is shaped using cultural resources in existence at that historical moment. The stories told by and about each woman becomes a part of the lore that is available for use in future narratives. Thus, narratives about Susan Smith drew on cultural resources about murdering mothers from Medea to the moment when Smith committed her own crimes. In fact, when Smith was constructing her own story for the police, she drew on the cultural resources available and concocted a tale of a black assailant.

As discussed throughout this book, such contemporary high profile cases of women who kill provide forums for the exploration of social anxieties and for debates about social issues. Smith's case provided the opportunity not only for a discussion of women who kill their children but of racial hoaxes. Andrea Yates's case provoked debates about postpartum depression, feminist support of women criminals, and the responsibility of fathers (see Table 2 for examples). Karla Faye Tucker's appeals and execution occurred in the midst of debates about the death penalty (including gender bias and the international response to U.S. executions); religion and the possibility of redemption; media circuses and biases in reporting; and the interview faux pas of a presidential candidate (see Table 3 for examples).

Table 2: Selected Newspaper/Newsmagazine Headlines Andrea Yates Story (June 2001-November 2002)

NEWSPAPER	DATE	HEADLINE	SECTION OF PAPER
National Review	June 27, 2001	Mommy Dearest	National Review Online; NR Comment
New Statesman	July 9, 2001	Could you too be a killer mummy?	Not included

Table 2: Selected Newspaper/Newsmagazine Headlines Continued Andrea Yates Story (June 2001–November 2002)

NEWSPAPER	DATE	HEADLINE	SECTION OF PAPER
Sydney Morning Herald	Aug. 28, 2001	If A Hand Rocks The Cradle; It Must Bear The Blame	News and Features; Opinion
New Statesman	Mar. 11, 2001	A Nation of Old Testament Worshippers	Not included
The Weekly Standard	Mar. 14, 2002	Andrea Yates—Not a Woman's Issue	The Daily Standard
U.S. News & World Report	Mar. 18, 2002	Mothers and murder	Nation & World
Daily News (NY)	Mar. 19, 2002	Yates' Mom, Brother Rip Kid Killer's Hubby	News
Herald Sun (Melbourne)	Mar. 20, 2002	Killer's Husband Blamed	World
Star Tribune (Minneapolis)	Mar. 24, 2002	Russell Yates' Role	Variety
St. Petersburg Times	Mar. 26, 2002	Don't allow cartoon to distort new's concern	Editorial; Letters
The Columbus Dispatch	Apr. 1, 2002	Yates Case Threatens to Stigmatize Illness	Editorial & Comments
The Boston Globe	Apr. 6, 2002	No Run 4/6/2002 What Would Euripides Say?	Not included
Milwaukee Journal Sentinel	Apr. 7, 2002	Flood of e-mail makes postpartum blues starkly real	Lifestyle
Toronto Star (Ontario)	Apr. 20, 2002	Unrepentant in Yates tragedy	Religion
The Daily Telegraph (Sydney)	Apr. 30, 2002	Why mothers turn to murder	Local
Ottawa Citizen	May 12, 2002	The dark side of motherhood	The Citizens Weekly
Ottawa Citizen	June 21, 2002	Yates family "has to face the memories"	News
San Antonio Express-News	June 23, 2002	Yates' life in prison a lot healthier than her days as a wife	Insights
The Boston Globe	July 3, 2002	Deadly Violence Hits Boston	Metro/Region

Table 2: Selected Newspaper/Newsmagazine Headlines *Continued* Andrea Yates Story (June 2001–November 2002)

NEWSPAPER	DATE	HEADLINE	SECTION OF PAPER
The Plain Dealer	Aug. 17, 2002	"Helpful Mom" deals with postpartum depression	Metro
Daily News (NY)	Sept. 19, 2002	Lover Defends Mom Accused of Slaying Son	News
Newsweek	Oct. 7, 2002	Rusty Yates Moves On	Periscope
San Antonio Express-News	Oct. 20, 2002	Prosecutors find Another Inhumane Use for the Death Penalty	Insight
The Houston Chronicle	Oct. 28, 2002	Andrea Yates gets fan treatment on 'Mugshots: A Mother's Madness'	Houston
The Australian	Nov. 13, 2002	Let's get tough with killer mums	Features
Chicago Sun-Times	Nov. 17, 2002	More pregnant women taking Prozac	News Special Feature

Table 3: Selected Newspaper Headlines—Karla Faye Tucker Story (January 1998–March 2002)

NEWSPAPER	DATE	HEADLINE	SECTION OF PAPER
The Strait Times (Singapore)	Jan. 16, 1998	Will Texas Execute Repentant Woman Killer?	World
The Houston Chronicle	Feb. 1, 1998	Karla Faye's Last Chance; 'Other than the pickax, it wasn't that unusual...'	A
The Houston Chronicle	Feb. 1, 1998	Karla Faye's Last Chance; The world waits ... and watches	A
The Salt Lake Tribune	Feb. 4, 1998	Texas Executes Female Killer; The Beginning; Author Says She Won't Be Last; Author Says Tucker May Start Trend	Nation-World
The San Francisco Examiner	Feb. 4, 1998	Tears, Cheers Mark Tucker's Execution; Pickax murderer apologies to families	News

Table 3: Selected Newspaper Headlines—Karla Faye Tucker Story (January 1998–March 2002) *Continued*

NEWSPAPER	DATE	HEADLINE	SECTION OF PAPER
The Buffalo News	Feb. 4, 1998	Karla's Execution Confuses The Old Bargain - Control For Women, Death For Men	Editorial
Chicago Sun-Times	Feb. 5, 1998	Two women let media put pretty face on crime	News
Austin American-Statesman	Feb. 7, 1998	Texas' dirty linen? In Sweden, art exhibit protests executions	Metro/State
The Houston Chronicle	Feb. 7, 1998	Campaign '98; Mattox calls for life without parole in wake of Tucker case	A
Lewiston Morning Tribune	Feb. 7, 1998	Liberals wouldn't let Karla Faye live	Opinion
Ventura County Star (Ventura County, CA)	Feb. 7, 1998	Capital punishment and Christianity don't conflict	Editorials
Austin-American Statesman	Feb. 8, 1998	Looking in the mirror in Huntsville	Metro/State
The Denver Rocky Mountain News	Feb. 8, 1998	A Heartless Act The Size of Texas	Local
The Houston Chronicle	Feb. 8, 1998	Death Row After Karla	State
The Denver Post	Feb. 9, 1998	Vengeance be not proud	Denver & the West
The Houston Chronicle	Feb. 15, 1998	Karla Tucker gave death row a human face	Outlook
The Houston Chronicle	Mar. 15, 1998	Death penalty's support plunges to a 30-year low; Karla Faye Tucker's execution tied to Texans' attitude change	A
Austin American-Statesman	Mar. 21, 1998	Jesse Jackson asks to visit condemned woman; unlike Tucker before [Sheppard]	Metro/State
The Houston Chronicle	Mar. 28, 1998	Woman decides she will appeal death sentence [Sheppard]	A
Austin American-Statesman	Mar. 28, 1998	Texas woman, 25, gets death sentence [Holberg]	Metro/State
San Antonio Express News	Feb. 5, 1999	Death penalty issue turns into one more or less	A

Table 3 Selected Newspaper Headlines—Karla Faye Tucker Story (January 1998–March 2002) *Continued*

NEWSPAPER	DATE	HEADLINE	SECTION OF PAPER
The Deseret News (Salt Lake City, UT)	Aug. 12, 1999	Flippancy could haunt Gov. Bush	Opinion
The Houston Chronicle	Aug. 14, 1999	Talk Shows Third Side of Bush; Magazine captures governor's arrogance	A
Austin American-Statesman	Aug. 15, 1999	Not an issue flip-flop, just a miscommunication	News
Las Vegas Review-Journal	Aug. 22, 1999	The wise guy, frat boy side of contender George W. Bush	D
Denver Rocky Mountain News	Jan. 11, 2000	No Compassion for Karla Faye Tucker	Local
The Associated Press & Local Wire	Feb. 24, 2000	Media was the crowd at Beets execution	State and Regional
Austin American-Statesman	Feb. 25, 2000	Woman Executed for killing husband; Courts, governor reject argument [Beets]	Metro/State
The Houston Chronicle	Mar. 3, 2002	Dreary 'Crossed Over' is a waste	Television
Denver Rocky Mountain News	June 2, 2000	DNA and the Death Penalty	Editorial
San Antonio Express-News	May 20, 2001	Ghost of Karla Faye still hovers over death chamber	Insight
The Houston Chronicle	Jan. 6, 2002	Issues of Life and Death; Texas Jurors Say Capital Murder Cases Are Never Easy	Lifestyle
Houston Press	Mar. 21, 2002	Lethal Legacy; Yates isn't dying to prove the equity of Harris County executions	News/News

At other times, the occasions for remembering such cases provide opportunities for introspection and the application of hindsight. In 2002, the Court of Appeal was about to consider granting a pardon to Ruth Ellis (actually reducing her offense to manslaughter) almost forty-seven years after she was hanged. An article in *The Times* (London) bore the headline, "Ellis's life was wasted but we can learn from her death"(Macintyre, 02/23/2002). The reporter, Ben Macintyre, suggests that if Ruth Ellis had not been a

"peroxide blonde," she might not have received the death penalty. Commenting on appearances and justice in the Ellis case, Macintyre notes that Ellis's failure to take her attorney's advice and tone down her appearance played into the effort by the prosecution to portray her as a femme fatale. However, the review of Ellis's case provides an opportunity to "redefine" her conviction in the context of her mental instability. Macintyre notes that the Ellis case was instrumental in ending the death penalty in England, and perhaps now Ellis herself will receive justice (Macintyre, 02/23/2002).

What the Ellis case, and the others discussed in this book, illustrate is the power of the social construction process. It is important that we be aware of the myths and the stereotypes—the archetypes—that have shaped and continue to shape cultural perceptions of women and of their behavior. It is important that we attempt to hear the narratives of women who kill without allowing the cultural myths that configure women as the lethal "other" to bias our thinking. Medea was a myth. So was Medusa. Real women have their own stories, and those stories need to be heard without prejudice and with empathy.

Exercises

1. 1. On May 17, 2002, Cogun and Claffey, reporters for the *Daily News* (NY) recalled Amy Fisher's affair with Joey Buttafuoco. They observed that Fisher, her lover, and his wife would always be linked in popular memory. In December 18, 2003, when Joey Buttafuoco, now living in California, was charged with insurance fraud, newspapers across the country carried the story, routinely noting that Buttafuoco's claim to fame was his affair with Fisher, the "Long Island Lolita," who almost killed his wife. Examine the depictions of Fisher in these recent articles and discuss it in the context of journalistic use of collective memory.

2. Compared to men, very few women (only 1.3% of persons presently on death row) have been convicted of murder and sentenced to death (Streib, 2004). Why do you think this is so? Referring to newspaper and magazine articles, examine the lively national debate prior to the 1998 Texas execution of Karla Faye Tucker. The issues of gender, religion, and politics all played roles in this debate.

3. Watch either the film *I Want to Live!* (1958), based on the true-life story of Barbara Graham, or *Last Dance* (1996), in which the crime bears similarity to that of Karla Faye Tucker. Discuss this Hollywood depiction of a female death row inmate and the capital punishment debate.

4. Choose one of the death row inmates listed in Table 1 and do research on that woman's case. What were the competing narratives offered by prosecution and defense? In your opinion, does this woman deserve to die for her crime?

Appendix A

Suggested Reading & Viewing Lists

Literature

Below is a sampling of various works of literature that are relevant to issues of women and homicide. This list is intended only as an introduction to the topic.

Crime Fiction

Armstrong, Charlotte. *The Chocolate Cobweb* (1948)
Armstrong, Charlotte. *Mischief* (1950)
Armstrong, Raymond. *The Sinister Widow* (1951)
Biderman, Bob. *Judgement of Death* (1992)
Cain, James M. *Double Indemnity* (1935)
Cain, James M. *Mildred Pierce* (1941)
Cain, James M. *The Postman Always Rings Twice* (1934)
Carr, Caleb. *The Angel of Darkness* (1997)
Christie, Agatha. *Death on the Nile* (1937)
Christie, Agatha. *The Mirror Crack'd* (1962)
Christie, Agatha. *Murder on the Orient Express* (1934)
Conway, Jim C. *Deadlier Than the Male* (1977)
Cornwell, Patricia. *Point of Origin* (1999)
Craig, Philip R. *A Case of Vineyard Poison* (1995)
Cross, Amanda. *An Imperfect Spy* (1995)
Eddensen, A.E. *Murder on the Thirteenth Floor* (1992)
Eyles, Leonora. *They Wanted Him Dead* (1936)
Fairstein, Linda. *Final Jeopardy* (1996)
Freeling, Nicolas. *Aupres de ma Blonde* (1972)
Freeling, Nicolas. *Those in Peril* (1990)
Grafton, Sue. *"C" is For Corpse* (1986)
Graham, Mark. *The Killing Breed* (1998)
Graham, Pamela Thomas. *A Darker Shade of Crimson* (1999)
Green, Anna Katherine. *The Circular Study* (1902)
Hambly, Barbara. *Fever Season* (1998)
Hammett, Dashiell. *The Maltese Falcon* (1930)
Handberg, Ron. *Cry Vengeance* (1993)
Hastings, Laura. *The Peacock's Secret* (1994)
Holton, Hugh. *Windy City* (1995)
Hume, Fergus. *Hagar of the Pawn Shop* (1898)
Kadow, Jeannine. *Blue Justice* (1998)
Kaye, Marvin. *The Soap Opera Slaughters* (1982)
Kelly, Jack. *Line of Sight* (2000)
Law, Janice. *Backfire* (1994)
Lindsey, David. *Merry* (1991)
McBain, Ed. *Cop Hater* (1963)

McBain, Ed. *Mary, Mary* (1992)
McBain, Ed. *Lullaby* (1989)
McBain, Ed. *Tricks* (1987)
McCrumb, Sharyn. *I Should Have Killed Him When I Met Him* (1995)
Maron, Margaret. *The Bootlegger's Daughter* (1992)
Meade, L.T. *The Sorceress of the Strand* (1903)
Morrell, David. *Double Image* (1998)
Moyes, Patricia. *Season of Snow and Sins* (1971)
O'Donnell, Lillian. *A Good Night to Kill* (1989)
Perry, Anne. *The Cater Street Hangman* (1979)
Phillpotts, Eden. *Bred in the Bones* (1932)
Rendell, Ruth. *The Crocodile Bird* (1993)
Rohmer, Sax. *Nude in Mink* (1950)
Sacks, Jen. *Nice* (1998)
Sayers, Dorothy. *Gaudy Nights* (1936)
Shore, Viola Brothers. *The Beauty Mask Killer* (1930)
Skinner, Robert E. *Cat-Eyed Trouble* (1998)
Smith, Evelyn E. *Miss Melville Regrets* (1986)
Spillane, Mickey. *I, The Jury* (1947)
Walters, Minette. *The Ice House* (1992)
Walters, Minette. *The Sculptress* (1993)
Woolrich, Cornell. *Beware the Lady* (1953)
Woolrich, Cornell. *The Black Angel* (1943)
Woolrich, Cornell. *The Bride Wore Black* (1940)

General
Atwood, Margaret. *Alias Grace* (1996)
Braddon, Mary Elizabeth. *Lady Audley's Secret* (1862)
Braddon, Mary Elizabeth. *Aurora Floyd* (1863)
Bradfield, Scott. *What's Wrong With America* (1994)
Butler, Octavia E. *Dawn* (1987)
Cooper, James Fenimore. *The Ways of the Hour* (1850)
Dickens, Charles. *A Tale of Two Cities* (1859)
Dickens, Charles. *Great Expectations* (1860-1861)
Du Maurier, Daphne. *My Cousin Rachel* (1951)
Du Maurier, Daphne. *Rebecca* (1938)
Eliot, George. *Adam Bede* (1859)
Fitch, Janet. *White Oleander* (1999)
Flagg, Fannie. *Fried Green Tomatoes at the Whistle Stop Café* (1987)
Gissing, George. *The Nether World* (1889)
Hurston, Zora Neale. *Their Eyes Were Watching God* (1937)
James, Henry. *The Turn of the Screw* (1898)

Jones, Gayl. *Eva's Man* (1987)
King, Stephen. *Dolores Claiborne* (1992)
King, Stephen. *Misery* (1987)
King, Stephen. *Rose Madder* (1995)
King, Stephen. *The Shining* (1977)
Lippard, George. *New York: Its Upper Ten and Lower Million* (1853)
McCrumb, Sharyn. *The Ballad of Frankie Silver* (1998)
Maso, Carole. *Defiance* (1998)
Morrison, Toni. *Beloved* (1997)
Petry, Ann. *The Street* (1946)
Scott, Sir Walter. *The Heart of Midlothian* (1818)
Sheldon, Sidney. *Tell Me Your Dreams* (1998)
Stroker, Bram. *Dracula* (1897)
Wolf, Christa. *Medea* (1998)
Zahavi, Helen. *A Dirty Weekend* (1991)

Short Stories
Faulkner, William. *A Rose for Emily* (1930)
Glaspell, Susan. *A Jury of Her Peers* (1917)
Green, Jen, (Ed). *Reader, I Murdered Him: Original Crime Stories by Women* (1989)
— Dunlap, Sue. "A Burning Issue"
— McDermid, Val. "A Wife in a Million"
— Paretsky, Sara. "A Taste for Life"
McCrumb, Sharyn. *Foggy Mountain Breakdown* (1997)
— "The Luncheon"
— "Happiness Is a Dead Poet"
— "Not All Brides Are Beautiful"
— "A Predatory Woman"
— "A Snare as Old as Solomon"

Plays
Cristofer, Michael. *Amazing Grace* (1998)—about Velma Barfield
Glaspell, Susan. *Trifles* (1916)
Genet, Jean. *The Maids* (1947)
Jones, Leroi (Amiri Baraka). *The Dutchman* (1964)
Kesselman, Wendy. *My Sister in This House* (1981)
Kesselring, Joseph. *Arsenic and Old Lace* (1941)
Kreitzer, Carson. *Self Defense, or death of some salesmen* (2002)—inspired by Aileen Wuornos
Maugham, Somerset. *The Letter* (1927)
Miller, Arthur. *The Crucible* (1953)

O'Neil, Eugene. *Mourning Becomes Electra* (1930)
Shakespeare, William. *Macbeth* (1606)
Shaw, Bernard. *Saint Joan* (1923)
Shine, Ted. *Contribution* (1970)
Treadwell, Sophie. *Machinal* (produced on Broadway, 1928, revived 1999)—about the Ruth Snyder case
Watkins, Maurine Dallas. *Chicago* (1926)

Films
Memorable Quotes:

"It was Beauty killed the Beast."
King Kong (1933)
[Comment after the huge ape, King Kong, falls to his death from the Empire State Building, victim of his fatal passion for Fay Wray—and the planes that shot him down.]

"I may have killed him, yes. But not murder! Not that!"
Roxie Hart (1942)
[Testimony from a flashy dancer on trial for murder. One of the films based on the play, that was later a Broadway musical, and most recently the movie, *Chicago*.]

"There's a speed limit in this state Mr. Neff, 45 mph."
Double Indemnity (1944)
[Barbara Stanwyck to insurance agent Fred MacMurray, who is there to see her husband but really likes her ankle bracelet.]

"Yes, she was that sort of monster."
Leave Her to Heaven (1945)
[Cornel Wilde testifying about his dead wife, who killed herself—and framed her sister in the process.]

"The trouble is that I can't forget that I might die tomorrow. Suppose you got sore at me one morning for leaving the top off the toothpaste tube. Then there's Johnny. When a guy's pal is killed he ought to do something about it."
Dead Reckoning (1947)
[Tough guy Humphrey Bogart explaining to beautiful, but lethal Lizabeth Scott why they can't have a future together.]

"If I don't get out of here, I'll die. If I don't get out of here, I hope I die."
Beyond the Forest (1949)
[Rosa Moline again, still unhappy with Loyalton.]

"All a woman has to do is slip once, and she's a tramp."
Johnny Guitar (1954)
[Saloon-owner Joan Crawford complaining about the double-standard in

frontier western towns.]

"I've done a lot of things in my time, but not murder."
I Want to Live! (1958)
[Susan Hayward as Barbara Graham denying her involvement in the robbery and murder.]

"A boy's best friend is his mother."
Psycho (1960)
[Norman Bates to Janet Leigh as he is explaining why he stays with his annoying mother.]

"Being a nanny is based on trust."
The Nanny (British - 1965)
[Bette Davis to one of her former charges just before she kills her.]

"I want you to make love to me. Please. Please."
That Cold Day in the Park (1969)
[Sandy Dennis, frustrated spinster, to the young man she picks up and holds captive.]

"There's not much to know. I'm just an old-fashioned girl."
Ghost Story (1981)
[Vengeful ghost to the son of one of the men who killed her.]

"I only told you what you wanted to be true."
Prizzi's Honor (1985)
[Kathleen Turner to Jack Nicholson, husband and fellow hit person, about the things she didn't tell him.]

"Sinners deserve to die."
The Housekeeper (Canadian—1986)
[The housekeeper to her friend, the religious fanatic, before they began to kill the family who employs her.]

"What happens?"
"She kills him."
Basic Instinct (1992)
[Sexy serial killer Sharon Stone tells homicide detective Michael Douglas how her latest novel ends.]

"Don't worry, honey. We're going to get you good psychiatric help."
Serial Mom (1994)
[Bemused middle-class dentist husband to his wife when he learns the police suspect she is a serial killer.]

"I'm sorry I really am. This won't hurt a bit."

Daddy's Girl (Made for TV – 1996)
[Bad seed little girl apologizes to her victim before killing her.]

"You ever see something and know you just had to have it?"
U-Turn (1997)
[Hero as he plunges into the web of a dangerous woman.]

"Why are all the gorgeous women homicidal maniacs?"
Batman and Robin (1997)
[Batman bemoaning the fact Poison Ivy isn't a nice girl.]

"I guess you could say I'm a bit nutty."
Urban Legend (1999)
[The killer to the "last girl" (left alive) heroine as she explains why she's been doing all those nasty things to people].

Films About Women and Death

In the list below, are some of the films in which women are linked to death and destruction as killers or, occasionally, as the catalysts for murder. As noted in Chapter 10, in the 1980s and 1990s, women became more lethal in films such as *Aliens, Terminator 2, A View To a Kill, Sudden Impact,* and *Thelma and Louise* (see Innis, 1998; Green, 1998). Those films are included below. Also included are an occasional foreign-made film, such as *La Femme Nikita* (1990) in which a French waif who kills is then forced by a mysterious government agency to become an assassin, and *Romance* (1999) in which a woman kills her lover by turning on the gas to trigger an explosion in their apartment just before she leaves for the hospital to have their baby.

The Accused (1948)—Sexual Assault—professor defenses herself when student attacks her. She accidentally kills him, but then conceals the homicide.

Adam's Rib (1949)—Fatal Attraction—"screwball comedy" with husband and wife as attorneys on opposite sides in the trial of a woman charged with the attempted murder of her adulterous husband.

Agnes of God (1985)—Infanticide—novice nun apparently gives birth and kills baby; female psychiatrist sent to investigate.

Aliens (1986)—Defender—alien creature (mother) v. human female defending child.

Anatomy of a Murder (1959)—Sexual Assault—courtroom drama; jealous husband, an Army officer, kills the man he claims raped his wife [based on novel by Robert Traver].

Angel Face (1953)—Madness—beautiful but disturbed daughter of wealthy man kills to get what she wants.

Angel Heart (1987)—Noir/Horror—priestess of voodoo cult, PI in search of answers.

Arsenic and Old Lace (1944)—Venus Flytrap—two kindly old ladies who kill lonely men; raises issue of hereditary insanity.

Attack of the 50 Ft. Woman (1958)—Fatal Attraction—alcoholic and betrayed wife encounters aliens, becomes a giant, then seeks out her adulterous husband.

A Woman Scorned: The Betty Broderick Story (1992)—Fatal Attraction—Meredith Baxter, a former TV sitcom mom, stars as the raging Broderick.

Badlands (1973)—Team killers—young man and teenage girl on Midwest killing spree; inspired by Charles Starkweather and Caril Fugate case.

The Bad Seed (1956)—Venus Flytrap—perfect little girl who is granddaughter of female serial killer; includes a living room debate between journalist and crime writer about nature v. nurture (i.e., whether the genes for homicide can be inherited).

A Ballroom Tragedy (1905)—Fatal Attraction—a woman stabs her rival during a fancy dress ball. A production of the American Mutoscope and Biograph Company.

Bandit Queen (1994) [subtitles]—Sexual Assault—based on the true story of India folk hero Phoolan Devi, a woman who experienced brutality, including repeated rape while held hostage, and eventually escaped and joined a gang of bandits.

Basic Instinct (1992)—Femme Fatale—bisexual serial killer.

Batman and Robin (1997)— Poison Ivy has a kiss that is lethal

Bedelia (British - 1946)—Black Widow—woman marries and kills wealthy men [based on novel by Vera Caspary].

Beyond the Forest (1949)—Murder and self-induced miscarriage.

Big Bad Mama (1974)—Depression era— mother and her two daughters involved with male partners in robbery/kidnaping/murder.

The Big Heat (1953)—widow of corrupt cop who committed suicide uses the information he left behind; gangster's moll receives hot coffee in face and gets her revenge.

Blackmail (British—1929)—Sexual Assault—fiancée of Scotland Yard detective kills the artist who tried to rape her, conceals what she did, is blackmailed.

Black Cat (Asian—dubbed, 1991)—Assassin—Asian version of *La Femme Nikita,* woman recruited and trained as government assassin; problems when she falls in love.

Black Widow (1986)—federal agent investigates woman she suspects of being serial killer who assumes different identities.

Bloody Mama (1969)—Team killers—based on real life criminal, Ma Barker, and her outlaw gang (including her sons).

The Blues Brothers (1980)—Fatal Attraction—a scorned woman appears in a minor role.

Blue Steel (1990)—Woman in Jeopardy—female police officer kills felon and attracts dangerous admirer; she has father who abuses mother.

Blue Velvet (1986)—Sexual Coercion—a damsel in distress draws young man into danger.

Body Heat (1981)—Femme Fatale—a wife who wants to get rid of her husband and a man who wants to help; betrayal by the woman.

Body of Evidence (1993)—Femme Fatale—trial about murder with sex as the weapon; lawyer attracted to sexy client.

Bonnie and Clyde (1967)—Team killers—based loosely on life of the real outlaw couple.

Born to Kill (1947)—Fatal Attraction—married woman starts affair with killer, who then marries her sister; affair continues.

Bound (1996)—Femme Fatale—noir with a twist—female ex-con attracted to gangster's mistress; they decide to steal money belonging to mob.

The Bride Wore Black (French, 1968)—Avenger—woman tracks, seduces, brings about death of the five men responsible for her fiancé's murder.

Buffy the Vampire Slayer (1992)—Avenger—cheerleader becomes vampire slayer.

The Burning Bed (Made for TV—1984)—Battered woman kills her abusive husband—based on true story of Francine Hughes.

Burnt Offerings (1976)—Horror—demonic possession of wife and mother leads to murder.

Burn, Witch, Burn! (British—1962)—Horror—scientist's wife is reincarnation of witch.

Bury Me an Angel (1971)—Avenger—a female biker and friends set out to find the men who killed her brother.

Butterfly Kisses (1995)—Team killers—in Northern England, lonely woman meets female killer; they embark on romance and killing spree.

Captive Wild Woman (1943)—Fatal Attraction—mad scientist turns gorilla into beautiful woman.

Career Woman (1936)—Domestic Violence—female lawyer and her male colleague take on case of young and impoverished woman charged with murdering her sadistic father.

Carrie (1976)—Horror—shy teen with strange mother and telekinetic powers harassed by classmates; strikes back following humiliating episode at prom.

Cat People (1982)—Horror/Fatal Attraction—young woman and brother descended from human/panther cult; attraction leads to death.

Cauldron of Blood (Spanish-U.S.—1967)—Serial killer—murderous wife of artist.

Cherry 2000 (1988)—Sci Fi—futuristic female mercenary.

Chicago (2002)—an award-winning movie, based on the play.

Child's Play (1988)—Defender/Horror—mother protects son from lethal doll.

Chinatown (1974)—Noir/Femme Fatale—victim of incest and her daughter, wealthy father, PI.

Cleopatra Jones (1973)—Defender—government agent takes on drug dealers.

Cleopatra Jones and the Casino of Gold (1975)—Defender—government agent v. lesbian drug lord and her gang.

Cobra Woman (1944)—Evil Twin—sisters rivals to throne of island kingdom.

Coffy (1973)—Avenger—nurse takes on drug dealers when her 11 year old sister becomes an addict.

Color of the Night (1994)—Femme Fatale—victim of abuse who has retreated into split personality; psychiatrist becomes unknowingly involved with one of her personalities.

Consenting Adults (1992)—Femme Fatale—wife-swapping and a frame-up for murder.

Crazy in Alabama (1999)—Battered Woman—kills husband, leaves Alabama for Hollywood with husband's head along for the ride; set in mid-60s.

The Crying Game (British—1992) —IRA operative discovers woman left in his care by British soldier is not what he thought; female member of IRA involved in the bloody climax.

A Cry in the Dark (U.S.-Australian—1988)—Infanticide—based on true story of Lindy Chamberlain and her husband, suspected when baby disappeared from tent at campsite and they claimed taken by dingo (wild dog).

The Crucible (1996)—Supernatural—the witch trials of Salem.

Cujo (1983)—Defender—woman caught in affair by husband; then must protect son when trapped in car by rabid family dog.

Daddy's Girl (Direct to Video - 1996)—Serial killer—girl murders those who try to come between her and her father.

Daddy's Gone A-Hunting (1969)—disturbed former boyfriend tries to force now married woman to kill her child as revenge for abortion she had when they were together.

Dancing in the Dark (1986 - Canadian)—Woman has breakdown when she learns of husband's affair.

Dangerous (1935)—Fatal Attraction—alcoholic actress falls in love with architect, then tries to kill her husband and herself with tragic consequences.

The Dark Mirror (1946)—Evil Twin/Fatal Attraction—one of the sisters has killed the man they were dating..

Dead Calm (1989)—Sexual Assault/Self-Defense—couple take disturbed man on board; wife must distract man with sex in order to rescue husband.

Deadlier Than the Male (French - 1957)—Femme Fatale—a man takes in his dead ex-wife's daughter and discovers she is mentally unbalanced.

Dead Ringer (1964)—Evil Twin/Fatal Attraction—good twin had man she loved stolen by wicked sister who lied to snare him. Years later, he dies and good twin learns truth. She kills sister and takes her place in mansion.

Death and the Maiden (1994)—Avenger—woman tortures man she believes is doctor who experimented on/tortured her when she was prisoner.

Death of a Damsel (2002)—Serial Killer—independent film about Aileen Wuornos, based on written correspondence and telephones interviews of Wuornos by filmmaker/star.

Death on the Nile (1978)—Fatal Attraction/Murder for Profit—wealthy woman takes friend's boyfriend; the vengeful friend follows them on the honeymoon.

Deceived (1991)—Defender—deceived wife must protect herself and her child from her husband who faked his own death and was not what he seemed.

Dolores Claiborne (1995)—Battered Woman/Incest—woman kills husband who has battered her, molested daughter; years later accused of killing her employer.

Desperate Hours (1990)—Team Killers—lawyer helps client escape, joins in taking family hostage (contrast with the 1955 film, roles of women).

Detour (1945)—Femme Fatale—man led astray by greedy woman with a scheme in mind.

Diabolique (French - 1955/1996)—Team Killers—abused wife and mistress unite to kill husband.

Dick Tracy (1990)—Femme Fatale/Murder for Profit—beautiful but lethal nightclub singer.

Die Another Day (2002)—Defender—James Bond teams with American agent Jinx.

Dirty Mary Crazy Larry (1974)—Team Killers—outlaws who meet violent end.

Don't Look Now (1973—British)—Supernatural—strange happenings after drowning of couple's child [based on Daphne du Maurier novel].

Double Indemnity (1944)—Femme Fatale—insurance investigator and unhappy wife murder husband.

Double Jeopardy (1999)—Avenger—woman framed by husband for his faked murder plans to pay him back.

Dracula's Daughter (1936)—Horror—female vampire seeks female victims.

Dragon Seed (1944)—Defender—woman leads villagers against invading army.

Dressed to Kill (1980)—Fatal Attraction—a male psychiatrist with gender issues engages in cross-dressing and murder.

Duel in the Sun (1946)—Femme Fatale—a western with star-cross lovers and shoot-out between them.

Eating Raoul (1982)—Team killers—unusual couple who kill swingers and would like to own a restaurant.

Eve of Destruction (1991)—Sci Fi—beautiful android runs amok.

The Exorcist (1973)—Horror—young girl possessed by the devil.

Extremities (1986)—Sexual Assault/Avenger—woman turns the tables on man who tried to rape her; has him trapped; wants to kill him; debates matter with roommates.

Eye of the Needle (1981)—Espionage/Defender—lonely woman seduced by Nazi spy, must then defeat him [based on Ken Follett novel].

Eyes of Laura Mars (1978)—Fatal Attraction—female photographer who shoots fashion photos featuring violence begins to "see" through eyes of the serial killer who is stalking her friends.

The Fan (1981)—Woman in Jeopardy—famous actress is stalked by adoring fan who turns nasty.

Fatal Attraction (1987)—Fatal Attraction/Defender—woman scorned seeks revenge on the married man who takes their brief encounter too casually; his wife defends herself and her family when the woman turns homicidal.

The File on Thelma Jordan (1949)—Femme Fatale—an unhappily married man (an assistant DA) becomes involved with another woman.

Final Analysis (1992)—married woman, who experiences "pathological intoxication" when she drinks, becomes involved with sister's therapist; she has a jealous husband.

Flowers in the Attic (1987)—Child Abuse—mother and grandmother lock children away in the attic.

Foxy Brown (1974)—Avenger—streetwise woman goes after husband/wife drug dealers who murdered her boyfriend.

Frankie and Johnny (1936)—Fatal Attraction—woman scorned takes revenge.

Friday the 13th (1980)—Avenger—mother turns serial killer after son's drowning at summer camp.

Fried Green Tomatoes (1991)—Battered Woman—elderly woman in nursing home tells meek housewife the story of two women in the 1920s/30s and how they survived the bad marriage of one of them.

Fun (1993)—Team Killers—two troubled teenagers go on minor crime spree that ends in death of elderly woman; tabloid press and celebrity.

Ghost Story (1981) Avenger—ghost was victim of accidental homicide involving four young men who are now elderly. She has returned to pay them back.

Girls in Prison (1994)—produced as part of Showtime's "Rebel Highway" series; parody of "women behind bars" movies; set in the 1950s; three young women befriend each other and try to survive in midst of corruption and conspiracies.

Gloria (1980)—Defender—woman protects child from the mob.

Goldfinger (British—1964)—Espionage—Bond persuades pilot Pussy Galore to switch sides.

The Grifters (1990)—Con Artists—unusual mother-son relationship creates problems when son becomes involved with another woman.

Guest in the House (1945)—Fatal Attraction—unstable woman staying in her doctor's house falls in love with his married brother.

Gun Crazy (1949)—Team Killers—female sharpshooter teams up with man obsessed with guns.

Gun Crazy (1992)—Team Killers—abused teen corresponds with prisoner; he gets parole and gets into trouble; they take to the road.

Guilty as Sin (1993)—Woman in Jeopardy—lawyer deals with client who may have killed his wife and now is interested in her.

The Handmaid's Tale (1990)—Sci Fi—women used as bearers of children; one of them caught between man and his jealous wife [based on Margaret Atwood novel].

The Hand That Rocks the Cradle (1992)—Avenger—woman loses husband and unborn child, becomes psychotic nanny for couple that she blames for her tragedy.

Halloween: H20 (1998)—Defender/Horror—twenty years later sister still defending self and others against serial killer, her unstoppable brother.

Hannie Caulder (1971)—Avenger—western in which woman seeks men who killed her husband, raped her; gets training from a gunman.

The Haunting (2000)—Supernatural/Child Murder—woman defends herself and her children in haunted house, but there is an hidden family tragedy.

Heathers (1989)—Avenger—clique of popular girls paid back for nastiness.

Heavenly Creatures (1994)—Team Killers—based on true story of Pauline Parker and Juliet Hulme.

High Noon (1952)—Defender—classic western in which Quaker bride faced with dilemma when her new husband refuses to leave town before vengeful outlaw arrives on noon train [note the ballad sung by Frankie Laine about honor, duty].

The Hot Spot (1990)—Femme Fatale—man involved with boss's wife

The Housekeeper [aka *A Judgment in Stone*] (1986—Canadian)—Team Killers/Avengers—psychotic housekeeper meets religious zealot, kill employers.

The House on 56th Street (1933)—married woman is sent to prison for twenty years when she accidentally kills her former lover; years later tragic reunion with grown daughter in gambling hell.

House of Games (1987)—Fatal Attraction—psychiatrist/author is drawn to a man who turns out to be a con artist; she avenges his betrayal.

The Hunger (1983)—Horror—female vampire and female victim.

Hush (1998)—demented mother-in-law.

Hush. . .Hush, Sweet Charlotte (1964)—Fatal Attraction/Avenger—young woman has affair with married man, he is killed, she is suspected, years later truth comes out as her cousin and her lawyer scheme against her.

Inner Sanctum (1991)—invalid fears husband and nurse are plotting to kill her.

I Spit on Your Grave (1977)—Sexual Assault/Avenger—cult classic with brutal and graphic scenes of violence. City woman goes to small town; stalked and raped by four local men. She seeks them out one by one and kills them. Contains bathtub scene reminiscent of Lorena Bobbitt.

Ivy (1947)—Fatal Attraction—married woman poisons man who rejects her.

I Want to Live! (1958)—based on true story of Barbara Graham.

Jagged Edge (1985)—Woman in Jeopardy -- lawyer falls in love with man she defends for the murder of his wife.

Jane Eyre (1944)—Fatal Attraction—Young governess falls in love with employer; he has a mad wife in the attic.

Jaws, the Revenge (1987)—Avenger/Defender—the great white shark follows police chief's widow to island; showdown as she defends herself and family, avenges death of husband and son.

Jennifer (1978)—Avenger/Horror—girl who can command snakes has revenge on classmates at girl's school.

Jezebel (1938)—Old South belle loves married man, wears red dress to ball, nurses sick during yellow fever epidemic.

Joan of Arc (1948)—Defender—war with England.

Johnny Belinda (1948)—Sexual Assault—deaf/mute woman raped, becomes pregnant, kills rapist when he tries to take her son.

Johnny Guitar (1954)—Defender—western—showdown between female saloon owner and female vigilante rancher.

Kill Bill (2003)—Quentin Tarantino's homage to Asian martial arts films, a revenge tale.

Killing in a Small Town (1990—Made for TV)—Fatal Attraction - based on true crime, churchgoing wife and mother having affair with best friend's husband, kills her with ax.

King Kong (1933)—Femme Fatale—giant ape falls for beautiful woman and goes on rampage in New York City.

The Kiss (1988)—Horror—woman seeks to pass on her legacy to her niece.

Kiss Me Deadly (1955)—PI Mike Hammer; a blonde Pandora opens radioactive box and creates havoc.

Klute (1971)—call girl/actress stalked by killer. She is in therapy, but reacts violently when finds herself falling in love with small town cop.

Knights of the Round Table (1953)—Adulterous lovers Lancelot and Guinevere.

The Ladies Club (1986)—Sexual Assault/Avengers—police woman and rape victim team up with other women to target rapists.

The Lady From Shanghai (1948)—Femme Fatale—famous house of mirrors climax.

The Landlady (1998)—Madness—perfect wife snaps when husband has affair; kills tenants who break the rules.

Last Dance (1996)—Team Killers—male lawyer takes on case of woman on death row for double murder.

The Last Seduction (1994)—Femme Fatale—woman flees to small upstate New York town with money from her husband's drug deal; becomes involved with local man.

Laura (1944)—Noir—young woman attracts three men, including policeman who investigates her "murder" [based on Vera Caspary novel].

Leave Her to Heaven (1945)—Fatal Attraction—beautiful and obsessive woman kills to have husband to herself; commits suicide and makes it look like murder.

La Femme Nikita (French-Italian - 1990)—Defender—homicidal street urchin is unwillingly recruited and trained by secret government agency to be an assassin.

The Leech Woman (1960)—Supernatural—aging woman obtains secret of eternal youth, must kill to obtain secret ingredient; kills men, including her scientist/husband who wanted to use her as guinea pig.

The Legend of Billie Jean (1985)—Girl and brother on lam after shooting; become folk heroes.

Les Blessures Assassines (*Murderous Maids*) (2002)—Team Killers—acclaimed French film about the Papin sisters.

The Letter (1940)—Fatal Attraction—married woman has affair, kills her lover when he leaves her for his native wife.

Life Force (1985)—Sci Fi—space vampire as femme fatale.

The Little Girl Who Lives Down the Lane (1976—Canadian)—young girl alone in house has secret about her father's whereabouts.

Lipstick (1976—Sexual Assault/Avenger—fashion model is raped by younger sister's teacher, loses case in court, kills him when he comes back to rape her sister—then defended by the prosecutor (now defense attorney) who lost the first case.

The Locket (1946)—Madness—girl accused of theft as child grows up to become kleptomaniac and killer.

The Long Kiss Goodnight (1996)—Defender—Professional assassin loses her memory, happy as mother of daughter until past catches up with her.

Lost Highway (1997)—Femme Fatale—musician arrested in wife's murder finds himself with another identity and involved with gangster's wife.

Love and a .45 (1994)—Team Killers—two lovers on lam from robbery gone wrong become media celebrities.

Lovers (1991—Spanish)—Fatal Attraction—young man become involved with older landlady, he has a fiancée; based on true crime case from 1950s.

Macbeth (1948)—Team Killers—Shakespeare's play—Macbeth and wife kill to make him king.

Madame X (1929, 1937, 1966)—Woman forced to leave family; years later on trial for murder, defended by son who does not know she is his mother.

Mad Love (1995)—Awkward teenage boy meets manic depressive girl.

Malice (1993)—Arrogant surgeon rents room from college professor and pregnant wife.

The Maltese Falcon (1941)—Femme Fatale—PI Sam Spade must resist temptation.

Mandingo (1975)—Femme Fatale—Old South plantation—male slave has affair with his master's white wife, leads to his violent murder by husband after she gives birth to a black baby.

Marnie (1964)—Hitchcock film—wealthy man blackmails the beautiful new employee who tried to rob him into marriage—then sets out to unravel her past; has nosy and jealousy former sister-in-law [based on Winston Graham novel].

Mata Hari (1932)—Espionage/Femme Fatale.

Men of Respect (1991)—Team Killers—update of *Macbeth,* set among organized crime families.

Merci Pour le Chocolat (2000)—based on Charlotte Armstrong's mystery novel *The Chocolate Cobweb*—family secrets and drugged chocolate.

Midnight Lace (1960)—Murder for Profit—husband of wealthy woman and his married lover decide to dispose of her.

Mildred Pierce (1945)—Fatal Attraction—woman sacrifices all for daughter, tries to take the rap when daughter kills her step-father (with whom she was having an affair).

The Mirror Crack'd (1980)—Avenger—famous actress learns truth about tragic event in her life.

Misery (1990)—Fatal Attraction—obsessed fan of male romance writer holds him prisoner and makes him write the story she wants to read.

Mommie Dearest (1981)—Domestic Violence—actress Joan Crawford's adopted daughter recounts her life with her mother—scene in which Crawford tries to strangle her daughter during argument.

Mommy (1995)—the "Bad Seed" grown up—as mother, she kills teacher when daughter does not receive an award.

Monster (2003)—Serial Killer—award-winning performance by Charlize Theron as Aileen Wuornos.

The Morning After (1986)—Substance abuse—alcoholic actress wakes up with dead man.

Mortal Thoughts (1991)—Battered Woman—husband killed while trying to rape wife's friend; police investigate.

Mother's Boys (1994)—Fatal Attraction --estranged wife tries to turn children against the new woman in her husband's life.

Mountain Justice (1937)—Domestic Violence/Defender—girl from mountains escapes abusive father and goes to New York for nurse's training; but when she returns must defend her younger sister who is being forced into marriage.

Mrs. Soffel (1984)—based on true story; late 19th century Pittsburgh; warden's wife falls in love with convict.

Ms. 45 (1981)—Sexual Assault/Avenger—woman raped twice; becomes vigilante.

Murder by Natural Causes (1979)—Murder for Profit—cat and mouse game between professional mentalist and his wife who is having affair and wants him dead.

Murder in the Heart Land (TVM)—Team killer—two-part movie about Charles Starkweather and Caril Fugate.

Murder, My Sweet (1944)—Femme Fatale—PI tracks woman for ex-con and finds murder.

Murder on the Orient Express (1974)—Avengers—wealthy industrialist is killed, linked to kidnaping and murder of a child (recalls Lindbergh baby kidnap/murder case).

My Cousin Rachel (1952)—Femme Fatale—a beautiful woman who may have killed her husband.

Naked Killer (1994)—Hong Kong—lesbian assassins; martial arts film.

The Nanny (British - 1965)—Madness—nanny accidentally kills child in bathtub on day she finds out about her own illegitimate daughter's death [based on the novel by Evelyn Piper].

Natural Born Killers (1994)—Team killers on spree.

New Jack City (1991)—drug dealers include females with guns.

Niagara (1953)—Femme Fatale—disturbed war veteran's wife and her lover plot his murder at Niagara Falls.

Night of the Cobra Women (1972)—Horror—snake cult priestess drinks venom to stay young; mates with and kills young lovers.

Nocturne (1946)—Avenger—philandering composer is murdered; nightclub singer's sister among suspects.

Nuts (1987)—Madness—hooker arrested for murder of a client refuses to make an insanity plea.

Out of the Past (1947)—Femme Fatale—man escapes past and goes to small town, falls in love with good woman, then the bad woman and his former criminal associates find him.

The Paradine Case (1948)—Femme Fatale—woman on trial for murder of wealthy husband; married lawyer falls for her.

The Passion of Joan of Arc (1928)—Defender .

Peyton Place (1957)—Based on 1950s best-seller by Grace Metalious; affairs and murder in a small town.

Pitfall (1948)—Femme Fatale—married insurance man has brief affair and finds himself blackmailed.

Play Misty for Me (1971)—Fatal Attraction—a female fan becomes obsessed with a late night radio personality and invades his life, decides to eliminate his girl friend.

Point of No Return (1993)—Defender—American version of *La Femme Nikita*.

Poison Ivy (1992)—Venus Flytrap—sexy teenage girl befriends an awkward loner and invades her family, seducing the father and killing the invalid mother.

Portrait in Black (1960)—Femme Fatale—wife and doctor plot death of husband.

Possessed (1947)—Fatal Attraction—woman falls in love with husband of woman she is nursing.

The Postman Always Rings Twice (1946)—Femme Fatale—drifter and wife of a diner owner plot the husband's death.

Presumed Innocent (1990)—Fatal Attraction—lawyer has an affair with a femme fatale associate in firm. She is murdered, he stands trial [based on Scott Turow novel].

Prizzi's Honor (1985)—Two people with mob ties meet and fall in love.

Psycho (1960)—Madness—sweet, soft-spoken Norman Bates is actually a serial killer who assumes his mother's personality to murder women he is attracted to.

A Question of Silence (1982—Dutch)—three women, strangers to each other, kill a store owner when one of them is caught shoplifting.

A Rage in Harlem (1991)—Femme Fatale—1950s—mob leader's girlfriend flees Mississippi to Harlem; takes up with undertaker's assistant.

Ramrod (1947)—western—female ranch owner caught up in range war.

Rebecca (1940)—Fatal Attraction/Femme Fatale—shy second wife must cope with the lingering presence of her husband's beautiful first wife and a malevolent housekeeper who worshiped the woman.

Red Rock West (1993)—drifter mistaken for hit man, caught between husband and wife both willing to pay him to kill the other.

Rider on the Rain (1970—French)—woman kills rapist, disposes of body in sea; trouble when another man arrives looking for him.

Romeo is Bleeding (1994)—Femme Fatale—a corrupt cop falls for a Russian-born hit woman.

Rosemary's Baby (1968)—Supernatural—coven of witches, includes women, kill to ensure birth of satanic child.

Safe in Hell (1931)—prostitute thinks she killed client, flees, marries, years later man turns up alive, kills him accidentally, sent to gallows.

Samson and Delilah (1949)—Hollywood interpretation of the Biblical story.

Savage Streets (1983)—Avenger—woman goes after gang with crossbow after they rape her deaf-mute sister.

Scarlet Street (1945)—Femme Fatale—lonely married man has affair with woman who mistakes him for famous artist and connives with her con man lover.

Scream (1996)—Defender/Avenger—tongue in cheek tribute to the slasher movie formula; teenager recovering from her mother's rape/murder becomes target of stalker/serial killer; aggressive female journalist on the story.

The Selling of a Serial Killer (1992)—documentary about Aileen Wournos.

Serial Mom (1994)—Venus Flytrap—suburban housewife who kills people who annoy her.

Set It Off (1996)—Crime Caper—four young African American women become bank robbers.

Shadow of a Doubt (1943)—Defender—niece finds herself at odds with her favorite uncle when he comes to visit the family and is followed by police detectives who think he might be the serial killer they've been tracking.

She (1965)—Supernatural/Femme Fatale—mythical queen with the secret of eternal youth and lust for young explorer.

The Shining (1980)—Horror/Defender—woman must defend herself and her son when husband becomes homicidal in snowbound hotel.

The Silence of the Lambs (1991)—Defender—rookie FBI agent on the trial of serial killer.

Single White Female (1992)—Fatal Attraction—woman acquires homicidal roommate who wants to be like her.

Sister My Sister (1994—British)—Team Killers—servants kill their employers [based on *The Maids*].

Sisters (1973)—Evil Twin—separated Siamese twins, one of them is a killer.

Sleeping With the Enemy (1991)—Battered Woman—a woman escapes her husband by faking her own death, but he finds her.

Sophie's Choice (1982)—Child's Death—wartime—mother must choose between her children, haunted by her choice.

The Spanish Prisoner (1998)—Murder for Profit—a man falls victim to a team of con artists.

Species (1995)—Sci Fi—Deadly alien beauty who needs to mate.

Stage Fright (1950)—Femme Fatale—a famous actress is a suspect in a murder case.

Still of the Night (1982)—Femme Fatale—a psychiatrist attracted to a woman who might have killed one of his patients.

The Story on Page One (1959)—Fatal Attraction—lovers accused of killing husband.

Strait-Jacket (1964)—Madness—a paroled ax-murderess.

The Strange Love of Martha Ivers (1946)—a young woman kills her aunt and marries the man who helped her to cover it up, then the man she really wanted returns to town.

Straw Dogs (1971)—Femme Fatale/Sexual Assault—an American professor and his bored, unhappy wife return to her English village. She is sexually assaulted by men she knows. Violent climax when husband fights back.

Sudden Impact (1983)—Sexual Assault/Avenger—a woman and her younger sister were raped; she avenges the crimes.

Sunset Boulevard (1950)—Fatal Attraction—aging former movie queen meets young writer and wants to keep him.

The Terminator 2: Judgment Day (1991)—Defender—woman and cyborg fight to save humanity.

That Cold Day in the Park (1969)—Fatal Attraction—lonely woman brings young man to her apartment and holds him hostage.

Thelma and Louise (1991)—Sexual Assault—two women take a road trip and end up on the lam for murder after shooting a would-be rapist.

To Die For (1995)—Femme Fatale/Murder for Profit—a woman who wants a career in television kills to achieve her goal.

To Kill A Mockingbird (1962)—Battered Woman—a black man is put on trial for the rape of young white woman [based on Harper Lee novel].

Too Late For Tears (1949)—Femme Fatale—woman persuades husband to keep stolen money; kills him and teams up with PI.

The Unfaithful (1947)—Fatal Attraction—married woman shoots ex-lover to conceal affair.

The War of the Roses (1989)—Fatal Attraction—a marriage between an upper class couple disintegrates, with escalating violence.

Urban Legends (1998)—Madness—setting a college campus; the slasher is a woman.

U-Turn (1997)—Femme Fatale—a drifter avoiding collection agents gets involved with unhappy wife in small town.

Whatever Happened to Baby Jane (1962)—Madness—a crippled actress, once famous, is tormented by her sister, once a child star.

What Lies Beneath (2000)—Supernatural—a scientist's wife, who gave up her career as a musician to be a wife and mother, experiences "empty nest" syndrome when her daughter leaves for college—and finds herself haunted by a dead woman.

White Heat (1949)—Femme Fatale—a man and his mother lead gang until he is sent to prison. Then his wife and her lover conspire against him.

White Oleander (2002)—Fatal Attraction/Venus Flytrap—based on the novel by Janet Fitch about a woman, who killed her unfaithful lover, and her teenage daughter, who moves from one foster home to another while her mother is in prison. Michelle Pfeiffer as the poisonous mother.

Wide Sargasso Sea (1993 - US and Australia)—Jane Eyre told from the point of view of the woman who would become the "mad woman in the attic"; young Creole heiress marries Englishman named Rochester who takes her home and eventually locks her away [based on Jean Rhys novel].

Witness for the Prosecution (1957)—Fatal Attraction—Marlene Dietrich stabs the lover for whom she has perjured herself.

The Wizard of Oz (1939)—the wicked witch is killed by Dorothy.

You'll Like My Mother (1972)—a pregnant young widow is held hostage when she goes to visit her husband's mother.

Appendix B

Great Women in Criminology/Criminal Justice

APPENDIX B

*PRE-FEMINIST YEARS (1813-1839)	EARLY YEARS (1840-1869)	GOLDEN YEARS (1870-1919)	INTERMISSION (1920-1959)
Elizabeth Fry (1780 – 1845)	Eliza Farnham (1815-1864)	Myra Bradwell (1831 - ?)	Gertrude Rush (1880-1957)
Abby Hopper Gibbons (1801-1893)	Elizabeth Cady Stanton (1815-1902)	Frances Willard (1839-1898)	Augusta Fox Bronner (1881-1966)
Dorothea Lynde Dix (1802-1887)	Lucy Stone (1818-1893)	Julia Tutwiler (1841-1916)	Miriam Van Waters (1887-1974)
Mary Carpenter (1807-1877)	Susan B. Anthony (1820-1906)	Josephine Shaw Lowell (1843-1905)	Ida Leona Beane Rice (1895-1990)
	Elizabeth Blackwell (1821-1910)	Ida Tarbell (1857-1944)	Ruth Shonle Cavan (1896-1992)
	Belva Lockwood (1830-1917)	Martha Thomas (1857-1944)	Rhoda J. Milliken (1896-1992)
		Julia Lathrop (1858-1932)	Eleanor Glueck (1898-1972)
		Florence Kelley (1859-1932)	Edna Mahan (1900-1968)
		Jane Addams (1860-1935)	Gisela Piper Konopka (1910 -)
		Lola Baldwin (1860-1957)	Marguerite Q. Warren (1920 -)
		Katharine Bement Davis (1860-1957)	Martha Wheeler (1921-2001)
		Charlotte Perkins Gilman (1860-1935)	Constance Baker Motley (1921 -)
		Ida B. Wells (1862-1931)	Rose Giallombardo (1925 -)
		Nellie Bly (1864-1922)	Rosemary C. Sarri (1926 -)
		Sophonisba Breckenridge (1866-1948)	Carol Smart (1927 -)
		Jessie D. Hodder (1867-1931)	Lisa Richette (1928 -)
		Emma Goldman (1869-1940)	Joan McCord (1930 -)
		Frances Kellor (1873-1957)	Sandra Day O'Connor (1930 -)
		Mary Belle Harris (1874-1957)	Rita J. Simon (1931 -)
		Mary Bethune (1875-1955)	Erika S. Fairchild (1931-1992)
		Edith Abbott (1876-1957)	Coramae Richey Mann (1931 -)
		Kate O'Hare (1877-1948)	Cynthia J. Epstein (1933 -)
		Grace Abbott (1878-1939)	
		Georgia Bullock (1878-1957)	

MODERN MOVEMENT (1960-)

Melitta Schmideberg **	Mary Koss (1948 -)
June Morrison	Kathleen Daly (1948 -)
Ruth Bader Ginsburg (1933 -)	Christine Adler (1950 -)
Freda Adler (1934 -)	Elizabeth Stanko (1950 -)
Barbara Raffel Price (1934 -)	Angela Browne (1952 -)
Nicole Hahn Rafter (1934 -)	Susan Estrich (1952 -)
Sandra Harding (1935 -)	Marcia Clark (1953 -)
Ann Jones (1937 -)	Susan Caringella-McDonald (1954 -)
Karlene Faith (1938 -)	Marjorie Zatz (1955 -)
Maureen Cain (1938 -)	Anita Hill (1956 -)
Imogene Moyer	Marilyn Chandler-Ford
Edith S. Flynn	Linda Zupan
Josefina Figueira-McDonough	Marilyn D. McShane
Janet Reno (1938 -)	Helen Eigenberg
Diana E. H. Russell (1938 -)	Ann Goetting
Ruth Kornhauser	Mittie Southerland
Joann B. Morton	Joycelyn Pollock
Susan Ehrlich Martin (1940 -)	Alida Merlo
Dorothy Bracey (1941 -)	Laura Moriarty
Penny Harringtron (1942 -)	Lorraine Gelsthorpe
Lenore Walker (1942 -)	Angela Gover
Leslie Abramson (1943 -)	Patricia Pearson
Frances Heidensohn (1942 -)	Joanne Belknap
Rebecca Emerson Dobash (1943 -)	Candace Skrapec
Rosabeth Moss Kanter (1943 -)	Joan Petersilia
Doris Mackenzie (1943 -)	Mary Ann Wycoff
Lucie Duvall (1944 -)	Susan Brownmiller
Catharine MacKinnon (1946 -)	Pat Carlen
Merry Morash (1946)	Mary Eaton
Linda Fairstein (1947 -)	Allison Morris
Karen Silkwood (1946 – 1974)	Nancy Jurik
Phyllis Jo Baunach (1947 -)	Drew Humphries
Eileen B. Leonard (1947 -)	Mary Stohr
Estelle Freedman (1947 -)	Jill Leslie Rosenbaum
Beverly Smith	Kathleen Heide
Meda Chesney-Lind (1947 -)	Patricia Van Voorhis

* This list is not intended to include all the women who made contributions to the study of Women and Crime.
** Dates of birth/death are not available for all women.

Appendix C
Survey Responses of Women Professionals/Practitioners

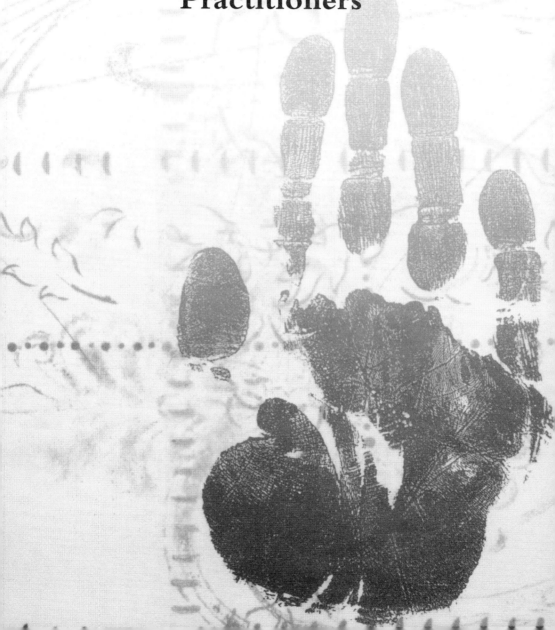

Methodology

The authors selected thirty-eight individuals who either work directly with women criminals as counselors/psychologists or who are forensic scientists, criminologists, attorneys, and/or writers. Each was sent a letter explaining that the authors were writing a book about the social construction of women criminals and asking the individual to complete and return a seven-question "interview" instrument to the authors. One woman (Medea Chesney-Lind) responded via e-mail. Eight other women completed and returned the surveys via regular mail. They were: Andrea Dworkin, Margaret Hagen, Ann Burgess, Andrea Devlin, Linda Fairstein, Karlene Faith, Lisa A. Richette, and Jaclyn Weldon White.

It should be noted that these are the verbatim remarks of the nine women who are in the fields of medicine, law, psychology, journalism/writer, and criminology.

The Survey Responses

Andrea Dworkin is a nonfiction writer and a political activist. With Catharine MacKinnon, she has done work on pornography and having it declared sexual discrimination against women.

1. **Do you think women who kill are perceived in the same way as men who kill?**

 "Women are never perceived in the same way as men are. Men are expected to be familiar with violence and to use aggression however moderated. Women continue to be victims of male aggression, especially in the home, and still have no realistic right legally or morally to self-defense in the face of assault or attempted rape. I was struck in Kathleen Barry's biography of Susan B. Anthony that Anthony was often accused in newspaper editorials of being violent because of the words she used in behalf of women's rights, or, for instance, for going to see a prostitute in jail."

2. **In your experience, what factors seem to come into play when people mentally construct images of women who kill?**

 "I think that the mental constructions usually have a sexual dimension to them, which is what makes the idea real. Fairy tales matter—the wicked witch and the evil stepmother; myths matter—Lilith, Kali, and so on; pornography matters—the dominatrix; but history rarely matters at all."

3. **What do you think of the mass media (newspaper, films, television, books, music) images of women and murder, particularly of women who kill? Are there issues that particularly concern you?**

"It's a cliché to say that media sensationalize but they do—and they simplify. It's probably the lack of complexity that most directly affects the lives of women. There is very little real information in the press about real women who kill. The role of sexual abuse is often acknowledged but little explicated or understood. The problem is, perhaps, that not nearly enough women do kill: we don't have heroic figures who use violence to avenge rape or battery or prostitution; we don't have women in situations of violent victimization retaliating as a matter of course or as if retaliation or violent self-defense were a right."

4. **What has been your own experience of women and murder?**

 "My own experience has been of the refusal to murder. I know huge numbers of women who have been beaten or raped or prostituted who have never used violence against those hurting them. The few women I know who have murdered and gone to prison should not be there. They murdered men who raped or tortured them."

5. **Do you think women who kill are somehow different from other women? If so, in what way?"**

 "I don't know."

6. **As a professional who deals with death in its more violent forms, are there any personal issues that you find yourself facing? Are there areas of stress?**

 "I can barely stand how little we are doing to stop men from using violence against women. The stress comes from the continued oppression of women, which includes me."

7. **Finally, do you have any other thoughts about the general subject of women and murder that you would like to share?**

 "Women who do kill in the face of sexual abuse should be supported politically."

Margaret Hagen has a Ph.D. in developmental psychology from the University of Minnesota and currently teaches at Boston University. She has written numerous books and articles including **Whores of the Court: The Fraud of Psychiatric Testimony and the Rape of American Justice** *(1997).*

1. **Do you think women who kill are perceived in the same way as men who kill?**

 "No. We expect a far greater capacity for anger, aggression, and loss of control from men than from women. Women who kill are seen as "unnatural.""

2. **In your experience, what factors seem to come into play when people mentally construct images of women who kill?**

"Expectations that derive from the traditional roles that women play in society-supportive wife, nurturant mother. Murdering women violate these expectations-rock foundations of society."

3. **What do you think of the mass media (newspapers, films, television, books, music) images of women and murder, particularly of women who kill? Are there issues that particularly concern you?**

 "The number of women who kill in the entertainment media exceeds by at least an order of magnitude for number who kill in real life. This fosters a perception of women as wolves in sheeps' clothing."

4. **What has been your own personal experience of women and murder?**

 "None."

5. **Do you think women who kill are somehow different from other women? If so, in what way?**

 "Yes and no. I think women are naturally less physically violent than men but I believe that individual life history and circumstances—as well as culture (witness Rwanda) can brutalize young women."

6. **As a professional who deals with death in its more violent forms, are there any personal issues that you find yourself facing? Are there areas of stress?**

 "I do not deal with it except to write about it."

7. **Finally, do you have any other thoughts about the general subject of women and murder that you would like to share?**

 "I think the murders of children and lovers by women are largely preventable by a more proactive social service system. And that includes everything from birth control to financial independence to getting hoodlum boyfriends out of the housing projects. The present system guarantees situations of intolerable stress for many women."

Ann W. Burgess is a Professor Emeritus, University of Pennsylvania, College of Nursing.

1. **Do you think women who kill are perceived in the same way as men who kill?**

 "No. Society has great difficulty with the fact that women (some) do kill. Women are supposed to inhibit aggression. Prison sentences are quite severe."

2. **In your experience, what factors seem to come into play when people mentally construct images of women who kill?**

"Many are horrified but others accept the behavior and motivation. Depends on the victim."

3. **What do you think of the mass media (newspapers, films, television, books, music) images of women and murder, particular of women who kill? Are there issues that particularly concern you?**

 "Women who kill infants receive great attention. Women killing batterers do not receive as much media attention now."

4. **What has been your own personal experience of women and murder?**

 'I have testified recently for defense on two cases. I find a wide range of motivation. I have interviewed other women who killed people who were barriers to their goal."

5. **Do you think women who kill are somehow different from other women? If so, in what way?**

 "Potential to kill is present in women and depends on motive. Self-defense as protecting a child is a big factor for some."

6. **As a professional who deals with death in its more violent forms, are there any personal issues that you find yourself facing? Are there areas of stress?**

 "All violent death has an impact. My management of my reaction is to try to understand the motivation in order to learn more about prevention and risk factors."

7. **Finally, do you have any other thoughts about the general subject of women and murder that you would like to share?**

 [Left blank by Ann Burgess]

Angela Devlin is the author of **Invisible Women** *(1998) an account based on interviews with prisoners and staff in 12 women's prisons. With her husband Tim Devlin, she is also the author of* **Anybody's Nightmare: The Sheila Bowler Story.**

1. **Do you think women who kill are perceived in the same way as men who kill?**

 "The woman who kills is regarded as 'deadlier than the male' in the sense that she is felt to have betrayed all the characteristics traditionally associated with the female: caring, mothering, 'being a good wife' etc. Girls who kill are regarded with particular horror—though they are often minorities in a predominantly male gang. A recent UK survey of 1000 mugging victims revealed that 96% of them reported being attacked by all-male gangs, 2% by mixed-sex gangs, and only 2% by all-

female gangs."

2. **In your experience, what factors seem to come into play when people mentally construct images of women who kill?**

"The general public (i.e., lay people rather than those who work in or with the criminal justice system) are statistically unlikely to have personal knowledge of a woman who has killed. Their only knowledge is likely to come via the media, which must influence the images they construct (see 3 below). Men will inevitably think of the women they know personally, usually in caring role—their mother, grandmother, partner, teacher—and will find it difficult to conceive that any of these could kill. The alternative image is some kind of she-devil, as far removed as possible from the carers. Women, unless they have personal experience of the kind of stresses that drove most female killers to commit their offense, are likely to say with a shudder that they simply can't imagine how a woman can kill—especially if she killed her child. So they too will regard the female killer as someone beyond the pale. Secretly most of us must realize we could kill, given the wrong circumstances, but it's something few of us will admit."

3. **What do you think of the mass media (newspapers, films, television, books, music) images of women and murder, particularly women who kill? Are there issues that particularly concern you?**

"In the UK the enduring media image is that of Myra Hindley, the Moors murderer, as an angry-eyed peroxide blonde-an image that has become the icon of female evil. Rarely does the media show Hindley as she is now—a greying middle-aged educated woman. She has now been incarcerated 30 years and successive Home Secretaries have said she is unlikely ever to be freed. She has become a political item: yet but for the continuing media image I believe she might have been quietly released years ago. The image of the deadly blonde predates Hindley: Ruth Ellis, the last woman to be hanged in Britain, was also portrayed as an evil blonde, and there are countless movies (e.g. "Sea of Love") which compound the image. There are plenty of current examples: last year Tracie Andrews was convicted of killing her boyfriend after claiming he was the victim of 'road rage': her image (dyed blonde hair, angry eyes) was similar to that of Ellis and Hindley. At present we have a new TV series, "Bad Girls", about a fictional women's prison. The main character is an inmate serving life: she again is portrayed as a hard-faced blonde.

An alternative image is that of the deranged female killer, probably more to be pitied than blamed—usually a mother who kills her child while under postnatal stress, or a jealous mistress or wife crazed by pre-menstrual tension. Such women are more likely to be

given the 'chivalry treatment' by male judges and may even escape a custodial sentence. So we are still stuck with a choice between the bad and the mad when it comes to female killers. The UK has just set up a new pilot project-the first special court to deal with domestic violence. This may change sentencers' perceptions of women who kill abusive partners, and a change in public perceptions may follow.

I am particularly concerned about a recent new development: the use by the advertising industry of images of violent, potentially murderous women to sell male products. Burton's, a nationwide chain of men's clothing retail stores, fairly recently covered their shop windows with images of an angry-eyed blonde, her mascara-ed eyes grotesquely streaked with tears of rage. I felt this was cashing in on media stories of women who slash their adulterous husband's suits as an act of revenge—which could be seen as the precursor to murder through jealous rage. We also have a TV car advertisement where a woman hurls her guy out of a high window and into the pool below as a punishment for borrowing her car—again a potentially murderous act: the voiceover says, 'Ask before you borrow it!' And a recent jeans ad showed a woman standing above a recumbent man with her stiletto heel pressing into his rear!"

4. What has been your own personal experience of women and murder?

"I have interviewed many women serving life sentences for murder—though the focus has not been on their crime because I was researching on two quite different issues: the conditions in women's prisons; and the links between educational failure and later criminal offending. Just recently my new book *Going Straight* was published; for that I interviewed male and female ex-offenders. One was a young woman who, under great stress, killed her boyfriend's mother in a frenzied knife attack. The boyfriend had left her and she was solely responsible for her 3 year old son. She went to the older woman for support, was called a whore and a slag who had ruined her son's life, and just snapped. She served 4 years of a 6 year sentence for manslaughter for killing her violent alcoholic husband. Through conversations with Sara and others I have come to understand the nature of abusive relationships."

5. Do you think women who kill are somehow different from other women? If so, in what way?

"I do not believe women who kill are different in any from other women. In most cases the murder is a one-off situational offence arising from domestic violence and other abuses of power, or extreme emotional distress arising from a particular set of circumstances. I think this even applies to Myra Hindley. Heinous as her crimes were (she was complicit in, if not the main perpetrator of, the torture and death of at least five young children), I believe she was at the time a young woman

fatally influenced by her lover, the psychopathic Ian Brady. A ex-prisoner who got to know Hindley in prison told me Hindley, from an impoverished background, said she fell in love with Brady because he was the first man she had ever met who had clean fingernails and read books. I find it interesting that Hindley is regarded with far greater public revulsion than Brady—also still alive and in prison.

Drugs are increasingly a factor with some women, particularly young women, jailed for life for a killing I honestly believe they were not aware of at the time. As far as I know this has never been used as a mitigating factor in a case, and I am not sure whether it should be.

6. **As a professional who deals with death in its more violent forms, are there any personal issues that you find yourself facing? Are there areas of stress?**

"I become angry with people who say that a woman in an abusive relationship should just 'walk away'. I can identify with women who say their only escape was to kill their abuser. I find it distressing speaking to young women facing life sentences, well past their potential child-bearing years. I identify them with my own adult daughters, happy with their children/careers. I also have problems with two life-sentenced prisoners whom I visit and correspond with regularly: both claim to be innocent victims of miscarriages of justice and I have no real way of knowing whether they are speaking the truth. I just try to concentrate on their present situation in prison rather than why they are there.

7. **Finally, do you have any other thoughts about the general subject of women and murder that you would like to share?**

"I guess I've said enough!"

Jaclyn Weldon White is the author of **Whisper to the Black Candle,** *a book detailing the 1958 Anjette Lyles murder case. She worked as a police officer for six years and has been employed as an investigator and administrator for a juvenile court for fifteen years.*

1. **Do you think women who kill are perceived in the same way as men who kill?**

 No. I believe society looks for deeper explanations when women kill. They expect to find excuses—such as domestic violence or mental aberration—to explain what has happened. Finally, probably due to movies and books, there is the perception that the killer is a scheming, manipulative, completely evil being with no redeeming features at all.

2. **In your experience, what factors seem to come into play when people mentally construct images of women who kill?**

I believe most people expect a woman who kills to be either a victim who finally turns on her victimizer or a textbook sociopath.

3. **What do you think of the mass media (newspapers, films, television, books, music) images of women and murder, particularly of women who kill? Are there issues that particularly concern you?**

 As stated above, the media tends to stereotype women who commit murder. They are either victims who have finally had enough and struck back or they are evil, unfeeling creatures who kill with no more concern than they'd express over killing a fly. My concern is that, unlike their male counterparts, women seem to be portrayed in only black and white. They are either good or bad. There is no shading.

4. **What has been our own personal experience of women and murder?**

 I researched and wrote the book, *Whisper to the Black Candle,* which is the story of Anjette Lyles of Macon, Georgia. In 1958, she was charged with poisoning to death two husbands, a mother-in-law and her nine-year old daughter over a six year period. I also worked as a police officer for six years—four of those as an investigator—and worked maybe ten murder cases. Only two of those cases involved women suspects. However, I have been with Gwinnett County Juvenile Court for fifteen years.

 During that time, I have been involved in cases of mothers killing their children. And, during the past two years, we've also seen an increase in violent acts committed by teenaged girls.

5. **Do you think women who kill are somehow different from other women? If so, in what way?**

 Certainly women with mental illnesses are different from other women. However, I don't believe, in most cases, that women who commit murder are physiologically or mentally different from other women. I think women who kill are much like their male counterparts—they don't see any other way to achieve what they need. They don't have the intelligence, the imagination, the financial means or the determination to achieve what they need through other avenues. I also believe that a percentage of these women, particularly the younger ones, are unduly influenced by the men with whom they are involved. I have seen this especially in cases where the girls are romantically involved with men who are gang members. Violence and killing are often used as ways for the girls to prove their allegiance to the man and the gang.

6. **As a professional who deals with death in its more violent forms, are there any personal issues that you finding yourself**

facing? Are there areas of stress?

Dealing with death, day in and day out, can certainly cause feelings of depression. The best antidote for that is making sure that you are involved in more positive areas of life as well. As a supervisor in Juvenile Court, I have often told employees to try and forget what they see here on a daily basis, to go home and spend time with their families, to do things that they enjoy and to develop outside interests.

A second danger in dealing with death and violence, whether in person or at a distance (as I do when researching and writing a book) is that you tend to become hardened to the terrible things people do to each other. Again, a remedy for this is staying in touch with your feelings for your family and friends.

7. **Finally, do you have any other thoughts about the general subject of women and murder that you would like to share?**

Only that I hope your book will help people see women who commit murder in a more realistic light. These women should be viewed, for good or bad, the same way we view men. They should not be deified or vilified just because of their sex.

Linda Fairstein has led the Sex Crimes Unit of the District Attorney's Office in Manhattan for more than two decades. She is the author of **Final Jeopardy** *and* **Likely to Die** *both fictional works. In 1994 her nonfiction book,* **Sexual Violence: Our War Against Rape,** *was the New York Times Notable Book.*

1. **Do you think women who kill are perceived in the same way as men who kill?**

 "No, I don't. They are generally thought to be more deranged and psychotic, rather than just intentionally evil or willful."

2. **In your experience, what factors seem to come into play when people mentally construct images of women who kill?**

 "Depends—on whether victim is a male partner; a child; or a stranger. Each conjures up a different image or problem."

3. **What do you think of the mass media (newspapers, films, television, books, music) images of women and murder, particularly of women who kill? Are there issues that particularly concern you?**

 "Generally hysterically overdrawn."

4. **What has been your own personal experience of women and murder?**

"As a professional, I have investigated and supervised the prosecution of some female murderers."

5. **Do you think women who kill are somehow different from other women? If so, in what way?**

 "I think men who kill are different from other men—and women who kill are, too. It's dysfunctional, aberrant behavior."

6. **As a professional who deals with death in its more violent forms, are there are any personal issues that you find yourself facing? Are there areas of stress?**

 "How much time do you have? Let's talk."

7. **Finally, do you have any other thoughts about the general subject of women and murder that you would like to share?**

 "In addition to my professional career, I also write a series of procedural crime novels. I have enclosed the first one—*Final Jeopardy*-because it features (as I spoil the surprise ending) a woman killer. Has lots of my thoughts on the subject."

Lisa A. Richette is Senior Judge for the First Judicial District of Pennsylvania, Court of Common Pleas in Philadelphia, Pennsylvania. She is the author of **The Throwaway Children.**

1. **Do you think women who kill are perceived in the same way as men who kill?**

 No.

2. **In your experience, what factors seem to come into play when people mentally construct images of women who kill?**

 Motivation—previous battering or lesbian jealousy.

3. **What do you think of the mass media (newspapers, films, television, books, music) images of women and murder, particularly of women who kill? Are there issues that particularly concern you?**

 No.

4. **What has been your own personal experience of women and murder?**

 I have been a homicide judge for 15 years.

5. **Do you think women who kill are somehow different from**

other women? If so, in what way?

Anger, control, drugs and alcohol abuse.

6. **As a professional who deals with death in its more violent forms, are there are any personal issues that you find yourself facing? Are there areas of stress?**

Concern for rehabilitative measure for women.

7. **Finally, do you have any other thoughts about the general subject of women and murder that you would like to share?**

I believe women who murder have had previous trauma in their lives, often not explained to the court or jury.

Dr. Karlene Faith is Professor of Criminology at Simon Fraser University. Her publications address the female offender and the media images of "criminal" women.

1. **Do you think women who kill are perceived in the same way as men who kill?**

No. It's more "out of character" so they're more readily demonized.

2. **In your experience, what factors seem to come into play when people mentally construct images of women who kill?**

Tough, aggressive, masculinist, evil, based on films.

3. **What do you think of the mass media (newspapers, films, television, books, music) images of women and murder, particularly of women who kill? Are there issues that particularly concern you?**

News: concern with reporting percentage increases based on low base numbers; heavy focus on every case of women accused of homicide, exaggerating the threat of women at large; Hollywood exploits the anti-feminist images.

4. **What has been your own personal experience of women and murder?**

Have worked with many. A book about Leslie Van Houten is coming out in April with NEU.

5. **Do you think women who kill are somehow different from other women? If so, in what way?**

No, although they are disproportionately middle class relative to in prison overall. They seem calmer than other prisoners. They've had their catharsis; they don't recidivate.

6. **As a professional who deals with death in its more violent forms, are there are any personal issues that you find yourself facing? Are there areas of stress?**

 Many women who have murdered are highly "virtuous," which raises questions re: good/evil dualities.

7. **Finally, do you have any other thoughts about the general subject of women and murder that you would like to share?**

 In my observation, and wardens/guards concur, women who have killed are usually the calmest and most cooperative prisoners. Women have described it to me as "catharsis."

Dr. Meda Chesney-Lind is Professor and Director of Women's Studies at the University of Hawaii—Manoa. She is the author of numerous publications regarding the woman criminal and the female delinquent.

1. **Do you think women who kill are perceived in the same way as men who kill?**

 Absolutely not. Male violence is not only normalized, it is often celebrated. Males who kill are often portrayed as heroic, particularly in the media. Boys are taught by childhood commercials that violence and aggression are often good and should be used to get what you want in life; in adolescence, they are surrounded by horribly violent video games, and by the time they are adults, they are watching movies with much the same message.

 Women who are violent, by contrast, are nearly always demonized. In general, there is little public discussion of aggression and violence; women are supposed to be passive. When women are "bad," to pull a quote out of Longfellow, "they are horrid." Patriarchy relies on constructions of femininity that render us without much agency, and so when we are seen on television, we are young, underweight, obsessed with our appearance and our relationships with men, and incapable of much of anything else except brooding about sex, even when we are supposed to [be] capable professionals. The occasional violent woman, is, by contrast, horrible beyond words. She's completely without remorse; cold blooded; and possibly not even heterosexual. I call this the Lizzie Borden syndrome. The intent of both the denial and demonization of women's violence is the same—to reinforce the sex-gender system that allows and celebrates male violence as normal and constructs women as victims.

2. **In your experience, what factors seem to come into play when people mentally construct images of women who kill?**

Again, I think that the construction of women as non-violent means that people flounder when they try to grapple with girls' and women's violence. If you remind people that hitting your sister was/is violent, people are often shocked. That's actually violence, and a lot of girls do it. Girls tend to get into fights with other girls; that, too, in the past was minimized as "girl fights." None of this societal knowledge, though, is consulted when women actually commit lethal violence, so people are confused. Rather than seeking to contextualize girls and women's violence, the media has always demonized it or denied it, so the general public has few places to go for more thoughtful treatments.

3. **What do you think of the mass media (newspapers, films, television, books, music) images of women and murder, particularly of women who kill? Are there issues that particularly concern you?**

 As I've said above, the media have done girls and women a terrible disservice. Films lead you to believe that when women are stalking or sexually harassing men, we are killing them. That's simply not true. The print media and television media are chiefly responsible for the hysteria around gansta girl menace that gripped the country in the last decade. This was a transparently racist and ageist "story" that simply wouldn't die. It was mythical and wildly inaccurate, but it was extremely hard to rebut, given the perennial appeal to the backlash journalist of the old notion that when girls and women seek better treatment (equality) there is a "dark" side to those demands, and that girls and women will seek "equality" in criminal pursuits.

4. **What has been your own personal experience of women and murder?**

 When I taught in prison, I met men who had killed women; I've also known women who were later killed. Finally, I've known women who have killed. None of these experiences have suggested that improving the status of girls and women would increase the likelihood that girls and women would participate in more lethal violence. I come away from all of these encounters with the strong belief that if we cared more about making childhood safe for girls and boys, if we kept men out of brutal conflicts abroad and extreme poverty and marginalization at home, if we made relationships safe for women, then we'd have a lower violent crime rate. Finally, if we removed the methods which make murder easy to accomplish with very little skill (guns), we'd have a far lower homicide and suicide rate.

5. **Do you think women who kill are somehow different from other women? If so, in what way?**

 I don't think there is any particular difference between their lives and

mine, with the possible exception of the fact that they could not escape their abusers or the poverty and racism of their situations. I was born into race and class privilege and my mother made a courageous decision to make me safe from abuse.

6. **As a professional who deals with death in its more violent forms, are there are any personal issues that you find yourself facing? Are there areas of stress?**

 Of course, there is stress when you worked with folks who have killed. You are always fearful that you are wrong and that they will kill again. Having lived through that experience (some one I was sure would never kill again, just did), I'm still sure that had he the supports when he was released from prison, had he been given the opportunity to finish college, and avoid homelessness, he would have been a wonderful, contributing member of our community. His stigma as a former prisoner and his race, took those possibilities from him.

7. **Finally, do you have any other thoughts about the general subject of women and murder that you would like to share?**

 Nope, said it all.

Bibliography

Abramson, P. L. (1990) *Sob Sister Journalism*. Westport, CT: Greenwood Press.

Accampo, E. A. (1996) The Rhetoric of Reproduction and the Reconfiguration of Womanhood in the French Birth Control Movement, 1890-1920. *Journal of Family History*, Vol. 21, No. 3, 351-371.

Acker, J. R. (1990) New York's Proposed Death Penalty Legislation: Constitutional and Policy Perspectives. *Albany Law Review*, Vol. 54, No. 3/4, 515-616.

Ackerman, D. (1994) *A Natural History of Love*. New York: Vintage Books.

Adams, A. (1776) Letter From Abigail Adams to John Adams, 31 March-5 April 1776. From Collection, Letters Between John and Abigail Adams. The Massachusetts History Society (online).

Alder, C. M. and J. Baker (1997) Maternal Filicide: More Than One Story to Be Told. *Women & Criminal Justice*, Vol. 9, No. 2, 15-39.

Adler, J. S. (2001) "Halting the Slaughter of the Innocents": The Civilizing Process and the Surge of Violence in Turn-of-the-Century Chicago. *Social Science History*, Vol. 25, No. 1, 29-52.

Adler, J. S. (2003a) "I Loved Joe, But I Had To Shoot Him": Homicide By Women In Turn-Of-The-Century Chicago. *The Journal of Criminal Law and Criminology*, Vol. 92, Nos. 3-4, 867-898.

Adler, J. S. (2003b) "We've Got a Right to Fight; We're Married": Domestic Homicide in Chicago, 1875-1920. *Journal of Interdisciplinary History*, Vol. 34, No. 1, 27-48.

Aiuto, R. (2004) *The Rosenberg Conspiracy*. Crime Library. Online at: www.crimelibrary.com/terrorists_spies/spies/rosenberg/1.html

Altick, R. D. (1970) *Victorian Studies in Scarlet*. New York: W. W. Norton.

American Academy of Pediatrics (2001) Committee on Child Abuse and Neglect. Shaken Baby Syndrome: Rotational Cranial Injuries – Technical Report. *Pediatrics*, July 2001; 108; 206-210 (online).

Amundson, M. (12/03/2001) Ann Rules has turned true crime into a diversified corporation. *Puget Sound Business Journal* (Seattle). Online (from 11/30/2001 print edition).

Anderson, P. (1995) *When Passion Reigned: Sex and the Victorians*. New York: Basic Books.

Anderson, W. (1999) Can Personality Disorders Be Used as Predictors of Serial Killers? *Futurics* 23: 34-43.

Aptheker, B. (1999) *Morning Breaks: The Trial of Angela Davis,* 2nd ed. Ithaca and London: Cornell University Press.

Archibald, E. (1997) Gold in the Dungheap: Incest Stories and Family Values in the Middle Ages. *Journal of Family History,* 133-149.

Aschkenasy, N. (1998) *Woman At the Window: Biblical Tales of Oppression and Escape.* Detroit: Wayne State University Press.

Ashe, G. (1990) *King Arthur: The Dream of a Golden Age.* London: Thames & Hudson.

Ashley, L. and B. Olson (1998) Constructing Reality: Print Media's Framing of the Women's Movement, 1966 to 1986. *Journalism & Mass Communication Quarterly,* Vol. 75, No. 2, 263-277.

Associated Press (2002) Mom Charged in Baby Deaths. *The Herald,* April (http://www.sharon-herald.com).

Associated Press (2002) *Nation: California mother who killed children sentenced to death.* The Nando Times. Online at http://www... com/national/story/346594p-2849261c.htm

Atkinson, C. W. (1991) *The Oldest Vocation: Christian Motherhood in the Middle Ages.* Ithaca and London: Cornell University Press.

Atwell, M. W. (2002) *Equal Protection of the Law?: Gender and Justice in the United States.* New York: Peter Lang.

Atwood, M. (1997) In Search of *Alias Grace:* On Writing Canadian Historical Fiction. Received as personal communication from author. (Published under same title by the University of Ottawa Press).

Auerbach, N. (1982) *Woman and the Demon: The Life of a Victorian Myth.* Cambridge: Harvard University Press.

Axtell, J. (1974) The Vengeful Women of Marblehead: Robert Roules's Deposition of 1677. *William and Mary Quarterly,* Vol. XXXI, No. 4, 647-652.

Bach, A. (1997) *Women, seduction, and betrayal in biblical narrative.* Cambridge: Cambridge University Press.

Baer, J. A. (1999) *Our Lives Before the Law: Constructing a Feminist Jurisprudence.* Princeton, NJ: Princeton University Press.

Bailey, B. (1989) *Hangmen of England: A History of Execution from Jack Ketch to Albert Pierrepoint.* New York: Barnes & Noble.

Bailey, F. Y. (2000) The Ballad of Frankie Silver. Paper presented at New York College English Association conference, Literature and Criminal Justice, Buffalo, NY.

Bailey, F. Y. and A. P. Green (1999) "Law Never Here": A Social History of African American Responses to Issues of Crime and Justice. Westport, CT: Prager.

Bakken, G. M. (1998) The Limits of Patriarchy: Women's Rights and "Unwritten Law" in the West. 1997 Presidential Address. *The Historian,* Vol. 60, No. 4, 702-716.

The Ballad of Frankie Silver (n.d.) Featuring Bobby McMillon. Delaplane, VA: Davenport Films.

Ballinger, A. (2000) *Dead Woman Walking: Executed Women in England and Wales* 1900-1955. Burlington, VT: Ashgate.

Ballinger, A. (1996) The Guilt of the Innocent and the Innocence of the Guilty. Pp. 1-28 in A. Myers and S. Wight, eds., *No Angels: Women Who Commit Violence.* San Francisco: Pandora.

Bandstra, B. L. (1999) *Reading the Old Testament: An Introduction to the Hebrew Bible.* Belmont, CA: Wadsworth.

Barak, G., ed. (1995) *Media, Process, and the Social Construction of Crime: Studies in Newsmaking Criminology.* New York: Garland.

Bardsley, M. (1999) Charles Starkweather & Caril Fugate. *Crime Library.* Online at www.crimelibrary.com/starkweather/starkmain.htm.

Barnes, R. and J. B. Eicher, eds. (1993) *Dress and Gender: Making and Meaning.* Providence, RI: Berg Publishers.

Barstow, A. L. (1994) *Witchcraze: A New History of the European Witch Hunts.* New York: HarperCollins.

Barton, B. (1998) Comment: When Murdering Hands Rock the Cradle: An Overview of America's Incoherent Treatment of Infanticidal Mothers. 51 *SMU L. Rev.* 591

Bassein, B. A. (1984) *Women and Death: Linkages in Western Thought and Literature.* Westport, CT: Greenwood Press.

Bauer, J.A. (1999) *Our Lives Before the Law: Constructing a Feminist Jurisprudence.* Princeton: Princeton University Press.

Bauman, R. A. (1992) *Women and Politics in Ancient Rome.* London and New York: Routledge.

Baxley, C. (07/22/1995) Smith hid her depression. *The Post and Courier,* A, pg. 1 (LexisNexis).

Beale, L. (2000) Attack of the Sexy-Tough Women. *Daily News* (online edition), Oct. 19.

Beale, L. (2000) The Ladies Who Punch. *Daily News* (online edition) Archives, Oct. 19.

Belknap, J. (2001) *The Invisible Woman: Gender, Crime, and Justice.* Belmont, CA: Wadsworth.

Bellhouse, M. L. (1999) Crimes and Pardons: Bourgeois Justice, Gendered Virtue, and the Criminalized Other in Eighteenth Century France. *Signs: Journal of Women in Culture and Society*, Vol. 24, No. 4, 959-1010.

Bennett, C. (2002) Review of *A Fool There Was* on DVD. Silent Era. Online at www.silentera.com/

Berenson, E. (1992) *The Trial of Madame Caillaux*. Berkeley: University of California Press.

Berger, P. L. and T. Luckmann (1966) *The Social Construction of Reality: A Treatise in the Sociology of Knowledge.* Garden City, NY: Doubleday.

Best, G. (1994) *Witch Hunt in Wise County: The Persecution of Edith Maxwell*. Westport, CT: Praeger.

Birch, H. (1994) If looks could kill: Myra Hindley and the iconography of evil. Pp. 32-61 in H. Birch, ed., *Moving Targets: Women, Murder and Representation*. Berkeley: University of California Press.

Bird, S. E. (1996) *CJ's Revenge: Media, Folklore, and the Cultural Construction of AIDS.* Critical Studies in Mass Communication, 13: 44-58.

Bitel, L. M. (1996) *Land of Women: Tales of Sex and Gender from Early Ireland.* Ithaca and London: Cornell University Press.

Bledsoe, J. (1998) *Death Sentence: The True Story of Velma Barfield's life, Crimes, and Execution*. New York: E. P. Dutton.

Blok, J. H. (1995) *The Early Amazons: Modern and Ancient Perspectives on a Persistent Myth*. Leiden, New York, and Koln: E. J. Brill.

Blumenthal, W. H. (1962) *Brides from Bridewell: Female Felons Sent to Colonial America.* Rutland, VT: Charles E. Tuttle.

Bobby, C. (2002) Infant Deaths Called Murder. *The Tribune Chronicle.* (http://www.tribune-chronicle.com).

Bommersbach, J. (1992) *The Trunk Murderess: Winnie Ruth Judd*. New York: Simon & Schuster.

Bourgoyne, J. E. (04/12/2000) Country Radio Says Goodbye To Violent 'Earl' Song. *The Times-Picayune* (Orleans) (LexisNexis).

Brandweek (01/21/2002) A House Lacking in Lactose? Intolerable! LexisNexis.

Brazil, J. R. (1981) Murder Trials, Murder, and Twenties America. *American Quarterly*, Vol. 33, Issue 2, 163-184.

Brennan, W. (1995) *Dehumanizing the Vulnerable: When Word Games Take Lives.* Chicago: Loyala University Press.

Breslaw, E. G. (1996) *Tituba, Reluctant Witch of Salem: Devilish Indians and Puritan Fantasies.* New York and London: New York University Press.

Briggs, L. (2000) The Race of Hysteria: "Overcivilization" and the "Savage" Woman in Late Nineteenth-Century Obstetrics and Gynecology. *American Quarterly,* Vol. 52, No. 2, 246-273.

Browder, C. (1988) *The Wickedest Woman in New York: Madame Restell, The Abortionist.* Hamden, CT: Archon Book.

Brown, B. (2000) Cop-Killer Lesbians Do Time Together. APB news.com. (May 16).

Brown, J. A. (1996) Gender and the Action Heroine: Hardbodies and the Point of No Return. *Cinema Journal,* Vol. 35, No. 3, 52-71.

Brown, K. M. (1996) *Good Wives, Nasty Wenches, and Anxious Patriarchs: Gender, Race, and Power in Colonial Virginia.* Chapel Hill and London: University of North Carolina Press.

Brown, R. H. (1987) *Society as Text: Essays on Rhetoric, Reason, and Reality.* Chicago and London: The University of Chicago Press.

Brown, S. (1998) The Princess of Monaco's Hair: The Revolutionary Tribunal and the Pregnancy Plea. *Journal of Family History,* Vol. 23, No. 2, 136-158.

Browne, A. and K. R. Williams (1993) Gender, Intimacy, and Lethal Violence: Trends from 1976 through 1987. *Gender & Society,* Vol. 7, No. 1, 78-98.

Bruhns, K. O. (1999) *Women in Ancient America.* Norman: University of Oklahoma Press.

Buchanan, K. M. (1986) *Apache Women Warriors.* El Paso: The University of Texas at El Paso.

Bugliosi, V. T. (1974) *Helter Skelter.* New York: Bantam Doubleday Dell. Reissued 1996 by Mass Market Paperback.

Burton, B. (1998) Comment: When Murdering Hands Rock the Cradle: An Overview of America's Incoherent Treatment of Infanticidal Mothers. *SMU Law Review* (51 SMU L. Rev. 591).

Busch, A. L. (1999) *Finding Their Voices: Listening to Battered Women Who've Killed.* Commack, NY: Kroshka Books.

Butterfield, F. (1997 [1995]) *All God's Children: The Bosket Family and the American Tradition of Violence.* New York: Alfred A. Knopf.

Byatt, A.S. (1999) Narrate Or Die: Why Scheherazade keeps on talking. *New York Times* online. (www.nytimes.com/library/magazine/millennium/m1/byatt.html).

Bynum, V. E. (1992) *Unruly Women: The Politics of Social and Sexual Control in the Old South.* Chapel Hill and London: The University of North Carolina Press.

Byrnes, T. (1997) *Writing Bestselling True Crime and Suspense.* Rocklin, CA: Prima Publishing.

Cahill, B. L. (1992) *Butterbox Babies.* Toronto, Canada: Seal Books.

Campbell, Nancy D. (2000) *Using Women: Gender, Drug Policy, and Social Issues.* New York: Routledge.

Capote, T. (1965) *In Cold Blood: A True Account of Multiple Murder and Its Consequences.* New York: Signet.

Carroll, L. (1865 [n.d. on this edition]) *Alice in Wonderland and Through the Looking Glass.* New York: Grosset & Dunlap.

Cavender, G., L. Bond-Maupin, and N.C. Jurik (1999) The Construction of Gender in Reality Crime TV. *Gender and Society,* Vol. 13, No. 5, 643-663.

Cecil, M. (1997-98, Winter) Justice in Heaven: The Trial of Ann Bilansky. *Minnesota History,* 350-363.

Chamberlain, A. (2000) The Immaculate Ovum: Jonathan Edwards and the Construction of the Female Body. *William and Mary Quarterly,* 3d Series, Vol. LVII, No. 2, 289-322.

Chambers-Schiller, L. (1999) Seduced, Betrayed, and Revenged: The Murder Trial of Mary Harris. Pp. 185-209 in M. A. Bellesiles, ed., *Lethal Imagination: Violence and Brutality in American History.* New York: New York University Press.

Chan, W. (1994) A Feminist Critique of Self-Defense and Provocation in Battered Women's Cases in England and Wales. *Women & Criminal Justice,* Vol. 6, No. 1, 39-65.

Chan, W. (2001) *Women, Murder and Justice.* New York: Palgrave.

Chesapeake Bay Program, *Black Widow Spider.* Online at www./cheaspeakebay.net/info/black_widow.cfm

Chesler, P. (1993) A woman's right to self-defense. *Off Our Backs,* Vol. 23, No. 6, 1-6, 12-15.

Chesney-Lind, M. (1988) Doing Feminist Criminology. *The Criminologist,* 13 (July-August) 1, 16-17.

Chesney-Lind, M. (1997) *The Female Offender: Girls, Women, and Crime.* Sage: Thousand Oaks.

Chollett, L. (2000) It's A Mystery: A New Short-Story Anthology Traces the Evolution of the Crime Genre. *Bergen Evening Record,* April 19.

Chrisler, J. C. (2000) Whose Body Is It Anyway? Psychological Effects of Fetal-Protection Policies. Pp. 377-380 in R. Muraskin, ed., *It's A Crime: Women and Justice.* Upper Saddle River, NJ: Prentice Hall.

Chudacoff, H. P. (1999) *The Age of the Bachelor: Creating an American Subculture.* Princeton: Princeton University Press.

Clarke, J. H. (1988) Africa Warrior Queens. Pp. 123-134 in I. Van Sertima, ed., *Black Women in Antiquity.* New Brunswick, NJ: Transaction Books.

Clover, C. J. (1993) Regardless of Sex: Men, Women, and Power in Early Northern Europe. *Representations,* No. 44, 1-28.

CNN (March 21, 2002) California couple guilty in dog mauling case. Online at http://www.cnn.com/2002/LAW/03/21/dog.mauling.trial/index.html

Cogun, D. and M. Claffey (05/17/2002) Ex Con Amy Turns Into Quiet Mom. *Daily News,* News, pg. 8 (LexisNexis).

Cohen, D. (1993) *Pillars of Salt, Monuments of Grace: New England Crime Literature and the Origins of American Popular Culture,* 1674-1860. New York: Oxford University Press.

Cohen, P. C. (1999) *The Murder of Helen Jewett.* New York: Vintage.

Cohen, P. C. (1993) The Mystery of Helen Jewett: Romantic Fiction and the Eroticization of Violence. *Legal Studies Forum,* Vol. 17, No. 2. Online, 1-13.

Cole, B. and A. Gealt (1989) *Art of the Western World: From Ancient Greece to Post-Modernism.* New York: Summit Books.

Cole, J. (1996) "A Sudden and Terrible Revelation": Motherhood and Infant Mortality in France, 1858-1874. *Journal of Family History,* Vol. 21, No. 4, 419-445.

Collins, D. (1996) The Myth and Ritual of Ezili Freda in Hurston's *Their Eyes Were Watching God.* Western Folklore, 55, 137-154.

Collins, J. (01/27/2003) Sentence upheld for mom accused of killing baby by taking cocaine. *The Associated Press State & Local Wire* (LexisNexis).

Collins, S. (1991) British Stepfamily Relationships, 1500-1800. *Journal of Family History,* Vol. 16, No. 4, 331-344.

Committee on Child Abuse and Neglect (2001) Distinguishing Sudden Infant Death Syndrome From Child Abuse Fatalities. American Academy of Pediatrics, 107, 437-441.

Committee on Child Abuse and Neglect (1993) Shaken Baby Syndrome: Inflicted Cerebral Trauma (RE9337). *American Academy of Pediatrics,* Vol. 92, No. 6, 872-875.

Cooper, B. (2000) "Chick Flicks" as Feminist Texts: The Appropriation of the Male Gaze in *Thelma & Louise*. *Women's Studies in Communication,* Vol. 23, No. 3, 277-305.

Conde, M. (1992) *I, Tituba: Black Witch of Salem*. New York: Ballantine Books.

Connell, R. W. (1990) The State, Gender, and Sexual Politics: Theory and Appraisal. *Theory and Society,* Vol. 19, No. 5, 507-544.

Corti, L. (1998) *The Myth of Medea and the Murder of Children*. Westport, CT: Greenwood Press.

Country awards embrace controversy (10/05/2000). *The Ottawa Citizen.* (LexisNexis).

Creery, D. and A. Mikrogianakis (2003) Sudden Infant Death Syndrome. *American Family Physician* 68(7): 1375-1376.

Crimmins, S., S. Langley, H. H. Brownstein, and B. J. Spunt. (1997) Convicted Women Who Have Killed Children: A Self-Psychology Perspective. *Journal of Interpersonal Violence,* Vol. 12, No. 1, 49-69.

Cuklanz, L. M. (1996) *Rape on trial: how the mass media construct legal reform and social change.* Philadelphia: University of Pennsylvania.

Culliver, C. C. (1993) Women and Crime: An Overview. Pp. 3-21 in C. C. Culliver, ed., *Female Criminality: The State of the Art.* New York and London: Garland.

Curtin, J. and D. B. Kates, Jr., (1978) Rape and gun laws: a second look. *Moving On: Monthly Magazine of the New American Movement,* March, pp. 3-4, 20.

Curtis, L. P., Jr. (2001) *Jack the Ripper and the London Press.* New Haven and London: Yale University Press.

D'Agostino, V. (2002) The Munchausen Syndrome by Proxy. (http: www.unice.fr/mdl/uk_works)

Dalarun, J. (1992) The Clerical Gaze. Pp. 15-42 in C. Klapisch-Zuber, ed. *A History of Women in the West: Silences of the Middle Ages.* Cambridge and London: The Belknap Press.

Danesi, M. (2002) *Understanding Media Semiotics.* London and New York: Oxford University Press.

Danton, E. R. (03/09/2003) Pop culture bubbles are quick to burst. *The Times Union* (Albany, NY), Arts, p. 11.

Dauphin, C. (1996) Brothels, Baths, and Babes: Prostitution in the Byzantine Holy Land. *Classics Ireland,* Vol. 3. Online at http://www.ucd.ie/~classics/96/Dauphin96.html.

Davidson, C. N. (1986) *The Revolution and the Word: The Rise of the Novel in America.* New York: Oxford University Press.

Davidson, J. W. and M. H. Lytle (1992) From Rosie to Lucy: The Mass Media and Images of Women in the 1950s. Pp. 303-328 in *After the Fact: The Art of Historical Detection,* Vol. II, 3rd ed. New York: McGraw-Hill.

Davidson, J. W. and M. H. Lytle (1992) The Visible and Invisible Worlds of Salem: Studying Crisis at the Community Level. Pp. 22-46 in *After the Fact: The Art of Historical Detection,* Vol. I, 3rd ed. New York: McGraw-Hill.

Davies, J. and C. R. Smith (1998) Race, Gender, and the American Mother: Political Speech and the Maternity Episodes of *I Love Lucy* and *Murphy Brown. American Studies,* Vol. 39, No. 2, 33-63.

Davis, N. Z. (1987) *Fiction in the Archives: Pardon Tales and Their Tellers in Sixteenth-Century France.* Stanford, CA: Stanford University Press.

Day, D. (1995) *The Search for King Arthur.* New York: Facts on File.

de Bruyn, Lucy (1979) *Woman and the Devil in Sixteenth Century Literature.* Tisbury (England): Compton Press.

De Jong, M. (1991) Dark-Eyed Daughters: Nineteenth-Century Popular Portrayals of Biblical Women. *Women's Studies,* Vol. 19, No. 3-4, 238-308.

de la Croix, H. and R. G. Tansey, revisers (1975) *Gardner's Art Through the Ages,* 6th ed. New York: Harcourt Brace Jovanovich.

Demand, N. (1994) *Birth, Death, and Motherhood in Classical Greece.* Baltimore and London: The John Hopkins University Press.

deMarrais, K. B., ed. (1998) *Inside Stories: Qualitative Research Methods.* Mahwah, NJ: Lawrence Erlbaum Associates.

Dershowitz, A. (1994) *The Abuse Excuse (And Other Cop-outs, Sob Stories, and Evasions of Responsibility.* Boston: Little, Brown and Company.

Dickson, G. (1999) Capote Novel Opened a New Literary Chapter. *Fort Worth Star-Telegram,* December 25, p. 1 of e-text.

Dietz, P. (1986) Mass, Serial and Sensational Homicides. *Bulletin of the New York Academy of Medicine,* 62: 477-491.

Dijkstra, B. (1998) *Evil Sisters: The Threat of Female Sexuality in Twentieth-Century Culture.* New York: Henry Holt.

Dolan, F. E. (1994) *Dangerous Familiars: Representations of Domestic Crime in England, 1550-1700.* Ithaca: Cornell University Press.

Dole, C. M. (2001) The Gun and the Badge: Hollywood and the Female Lawman. Pp. 78-105 in M. McCaughey and N. King, eds., *Reel Knockouts: Violent Women in the Movies.* Austin: University of Texas Press.

Donovan, J. M. (1991) Infanticide and the Juries in France, 1825-1913. *Journal of Family History*, Vol. 16, No. 2, 157-176.

Douglas, A. (1995) *Terrible Honesty: Mongrel Manhattan in the 1920s.* New York: The Noonday Press.

Douglas, G. (1999) *The Golden Age of Newspapers.* Westport, CT: Greenwood Press.

Douglas, J. and M. Olshaker (1999) *The Anatomy of Motive.* New York: Mindhunters, Inc.

Dow, B. J. (1997) Feminism, Cultural Studies, and Rhetorical Studies. *Quarterly Journal of Speech*, 83, 90-106.

Dowling, L. (1979) The Decadent and the New Woman in the 1890's. *Nineteenth-Century Fiction*, Vol. 33, No. 4, 434-453.

Dubinsky, K. and F. Iacovetta (1991) Murder, Womanly Virtue, and Motherhood: The Case of Angelina Napolitano, 1911-1922. *Canadian Historical Review*, Vol. LXXII, 505-531.

Duby, G. (1997) *Women of the Twelfth Century.* Chicago: The University of Chicago Press.

Duggan, L. (2000) *Sapphic Slashers: Sex, Violence, and American Modernity.* Durham and London: Duke University Press.

Dunn, J. L. (2002) *Courting Disaster: Intimate Stalking, Culture, and Criminal Justice.* New York: Aldine de Gruyter.

Dunn, M. M. (1978) Saints and Sisters: Congregational and Quaker Women in Early Colonial Period. *American Quarterly*, Vol. 30, Issue 5, 582-601.

Durham, A., H. Elrod, and P. Kinkade (1995) Images of Crime and Justice: Murder and the "True Crime" Genre. *Journal of Criminal Justice*, Vol. 23, No. 2, 143-152.

Dusinberre, J. (1996) *Shakespeare and the Nature of Women*, 2nd ed. New York: St. Martin's Press.

Dworkin, A. (1987) *Intercourse.* New York: Free Press.

Eagan, M. (2000) Mental help, not prison, for these moms. *Boston Herald*, June 1, News, p. 003.

Editorial (1998) Shaken babies. *The Lancet*, August 1, online.

Editorial (1999) Unexplained deaths in infancy. *The Lancet*, January 16, online.

Edy, J. A. (1999) Journalistic Uses of Collective Memory. *Journal of Communication*, Vol. 49. No. 2, 71-85.

Edwards, L. G. (1999) Joan of Arc: Gender and Authority in the Text of *The Trial of Condemnation*. Pp. 133-152 in In K. J. Lewis, N. J. Menuge, and K. M. Phillips, eds., *Young Medieval Women*. New York: St. Martin's Press.

Egger, S. (1998) *The Killers Among Us.* Upper Saddle River. NJ: Prentice-Hall.

Egginton, J. (1989) *From Cradle to Grave: The Short Lives and Strange Deaths of Marybeth Tinning's Nine Children.* New York: William Morrow.

Eggleston, N. (1997) *Eva Coo, Murderess.* Utica, New York: North Country Books.

Eigen, J. P. (1999) Lesion of the Will: Medical Resolve and Criminal Responsibility in Victorian Insanity Trials. *Law & Society Review,* Vol. 33, No. 2, 425-459.

Eisen, R. (June 21, 2001) Why Mothers Kill. Online at http://abcnews.go.com/sections/living/DailyNews/why motherskill010621.html

Emery, E. and M. Emery (1984) *The Press and America: An Interpretive History of the Mass Media,* 5th ed. Englewood Cliffs, NJ: Prentice-Hall.

Emmerichs, M. B. (2001) Getting away with Murder? Homicide and the Coroners in Nineteenth-Century London. *Social Science History,* Vol. 25, No. 1, 93-100.

Encyclopedia of World Crime (1990) George, Annie. Wilmette, IL: Crime Books.

Ennen, E. (1989) *The Medieval Woman.* Cambridge, MA: Basil Blackwell.

Erikson, K. (1966) *Wayward Puritans.* New York: Wiley.

Erenberg, L. A. (1981) *Steppin' Out: New York Nightlife and the Transformation of American Culture, 1890-1930.* Westport, CT: Greenwood.

Estes, D. C. (1993) Alice Walker's "Strong Horse Tea": Folk Cures for the Dispossessed. *Southern Folklore,* Vol. 50, No. 3, 213-229.

Evans, J. K. (1991) *War, Women, and Children in Ancient Rome.* New York: Routledge.

Ewing, C. P. (1997) *Fatal Families: The Dynamics of Intrafamilial Homicide.* Thousand Oaks, CA: Sage.

Executive Papers, Governor William Hodges Mann, 1912. In Archives of The Library of Virginia. Richmond, Virginia.

Exum, J. C. (1996) *Plotted, Shot, and Painted: Cultural Representations of Biblical Women.* Sheffield, England. Sheffield Academic Press Ltd.

Faith, K. (1993) *Unruly Women: The Politics of Confinement & Resistance.* Vancouver, B.C.: Press Gang Publishers.

Fantham, E., H. P. Foley, N. B. Kampen, S. B. Pomeroy, and H. A. Shapiro (1994) *Women in the Classical World: Image and Text.* New York: Oxford University Press.

Farr, K. A. (2000) Defeminizing and Dehumanizing Female Murderers: Depictions of Lesbians on Death Row. *Women & Criminal Justice,* Vol. 11, No. 1, 49-66.

Ferman, D. (11/02/99) 'Earl' Making A Killing For Quirky Dixie Chicks. *The Times-Picayune* (Orleans) (LexisNexis).

Ferrero, G. (1993) *The Women of the Caesars.* New York: Barnes and Noble Books.

Fessenden, T. (2002) Gendering Religion. *Journal of Women's History,* Vol. 14, No. 1, 163-169.

Fields, J. (1999) 'Fighting the Corsetless Evil': Shaping Corsets and Culture, 1900-1930. *Journal of Social History,* Vol. 33, No. 2, 355-385.

Fildes, V. (1988) *Wet Nursing: A History from Antiquity to the Present.* New York: Basil Blackwell.

Filetti, J. S. (2000) From Lizzie Borden to Lorena Bobbitt: Violent Women and Gendered Justice. *Journal of American Studies,* Vol.35, No. 3/4, 471-484.

Fisher-Giorlando, M. (1995) Women in the Walls: The Imprisonment of Women at the Baton Rouge Penitentiary, 1835-1862. Pp. 16-25 in B. Foster, W. Rideau, and D. Dennis in *The Wall Is Strong: Corrections in Louisiana,* 3rd ed. Lafayette, LA: The Center for Louisiana Studies.

Fishman, L. T. (2000) "Mule-Headed Slave Women Refusing to Take Foolishness from Anybody": A Prelude to Future Accommodation, Resistance, and Criminality. Pp. 31-52 in R. Muraskin, ed., *It's A Crime: Women and Justice.* Upper Saddle River, NJ: Prentice Hall.

Fitzmaurice, L. and K. Bankston (1994) Helping help mother nature with her own remedies: Environmental biotechnology is alive and well in Wisconsin. *Bioissues,* Vol. 5, No. 4. Online at http://www.accessexcellence.org/AB/IE/Helping_Heal_Mother_Nature.htm

Flock, J. (June 22, 2001). Chilling details of the Houston child killings. Online at http://www.cnn.com/2001/LAW/06/22/flock.otsc/

Flowers, R. B. (1995) *Female Crime, Criminals, and Cellmates: An Exploration of Female Criminality and Delinquency.* Jefferson, NC: McFarland.

Flynn, R. A. (1993) Lizzie Borden: 100 Years of Fascination in Fact and Conjecture. Pp. 293-301 in J. R. Ryckebusch, ed., *Proceeding Lizzie Borden Conference.* Portland, ME: King Philip Publishing.

Forbes, T. R. (1966) *The Midwife and the Witch.* New Haven: Yale University Press.

Foster, H. (1981) *The Dark Side of the Screen: Film Noir.* Oak Tree Publications.

Fox, K. M. (1985) Foreman of the Jury: Sidelights on the Trial of Winnie Ruth Judd. *The Journal of Arizona History,* Vol. 26, 295-305.

Francus, Marilyn (1997) Monstrous Mothers, Monstrous Societies: Infanticide and the Rule of Law in Restoration and Eighteenth-Century England. *Eighteenth-Century Life,* Vol. 21, No. 2, 133-156.

Freedman, E. B. (2002) *No Turning Back: The History of Feminism and the Future of Women.* New York: Ballantine Books.

French, K. (1998) Television preview. *Financial Times* (London), August 5, p. 17.

Freud, S. (1922) Medusa's Head. In J. Strachey, ed., (1999) *The Complete Psychological Works of Sigmund Freud.* W. W. Norton.

Fried, S. (1998) Cradle to Grave. Phillymag.com

Friedan, B. (1963 [1983]) *The Feminine Mystique.* New York: Dell Publishing.

Friedman, L. M. (1993) *Crime and Punishment in American History.* New York: Basic Books.

Fries, M. (1992) Female Heroes, Heroines, and Counter-Heroes: Images of Women in Arthurian Tradition. Pp. 5-17 in S. K. Slocum, ed., *Popular Arthurian Traditions.* Bowling Green, OH: Bowling Green University Popular Press.

Frost-Knappman, E. and K. Cullen-DuPont (1997) *Women's Rights on Trial.* Detroit: Gale.

Fry, S. (3/27/2001) Anderson's Attorney: Fame Cost Her Parole. *The Topeka Capital-Journal* (LexisNexis).

Fryer, S. B. (1996) Morality Plays at the Courthouse: The Celebrated Murder Trials of Anna George and Francine Hughes. *Proteus,* Vol. 13, No. 1, 33-38.

Frymer-Kensky, T. (1992) *In the Wake of the Goddesses: Women, Culture, and the Biblical Transformation of Pagan Myth.* New York: The Free Press.

Furneaux, R. (1955) The New Zealand girl murderers. *Famous Criminal Cases V2.* London: Wingate, 32-49. Online.

Gagne, P. (1998) *Battered Women's Justice: The Movement for Clemency and the Politics of Self-Defense.* New York: Twayne.

Gag order issued in case against mother accused of killing 5 kids (2001). Online at http://www.cnn.com/2001LAW/06/26texas.child.killings.index.html

Gates, B. T. (1988) *Victorian Suicide: Mad Crimes and Sad Histories.* Princeton: Princeton University Press.

Gavitt, P. (1990) *Charity and Children in Renaissance Florence.* Ann Arbor: The University of Michigan Press.

Genocide Perpetrated By Mother Nature (Feb. 8, 2001). Online at http://allafrica.com/stories/2001020800326.html

Geringer, J. (n.d.) Diane Downs: Her Children Got in the Way of Her Love. Online at http://www.crimelibrary.com/filicide/downs/3.htm

Getty, A. (1990) *Goddess: Mother of Living Nature.* London: Thames and Hudson, Ltd.

Gewirtz, P. (1996) Victims and Voyeurs: Two Narrative Problems at the Criminal Trial. Pp. 135-161 in P. Brooks and P. Gewirtz (eds.), *Law's Stories: Narrative and Rhetoric in the Law.* New Haven: Yale University Press

Gilbert, S. M. and S. Gubar (1979) *The Madwoman in the Attic: The Women Writer and the Nineteenth-Century Literary Imagination.* New Haven and London: Yale University Press.

Gibson, M. (2002) *Born to Crime: Cesare Lombroso and the Origins of Biological Criminology.* Westport, CT: Praeger.

Gillespie, L. K. (1997) *Dancehall Ladies: The Crimes and Executions of America's Condemned Women.* Lanham, MD: University Press of America.

Gilman, C. P. (1899 [1973]) *The Yellow Wallpaper.* New York: Feminist Press.

Gilmore, D. D. (2001) *Misogyny: The Male Malady.* Philadelphia: University of Pennsylvania Press.

Glass, N. (1999) Infanticide in Hungary faces stiffer penalties. *The Lancet,* February 13, online.

Gleick, E. (1996) Hell Hath No Fury. *Time Magazine,* Oct. 7, Vol. 148, No. 17. Online at www.time.com/time/international/1996/961007/cover.html.

Golden, J. (1999) "An Argument That Goes Back to the Womb": The Demedicalization of Fetal Alcohol Syndrome. *Journal of Social History,* 1973-1992, Vol. 33, No. 2, 269-298.

Golden, J. L. (1996) *A Social History of Wet Nursing in America: From Breast to Bottle.* New York: Cambridge University Press.

Gomez, L. E. (1997) *Misconceiving Mothers: Legislators, Prosecutors, and the Politics of Prenatal Drug Exposure.* Philadelphia: Temple University Press.

Goska, D. (1997) "Waking Up Less Than Whole": The Female Perpetrator in Male-Victim Kidney-Theft Legends. *Southern Folklore,* Vol. 54, No. 3, 196-210.

Gossage, P. (1995) La Maratre: Marie-Anne Houde and the Myth of the Wicked Stepmother in Quebec. *The Canadian Historical Review,* Vol. 76, Issue 4, 563-598.

Gowing, Laura (1997) Secret Births and Infanticide in Seventeenth-Century England. *Past and Present,* Vol. 0, Issue 156, 87-115.

Grabe, M. E. (1999) Television News Magazine Crime Stories: A Functionalist Perspective. *Critical Studies in Mass Communication,* Vol. 16, 155-171.

Graves, R. and R. Patai (1964) *Hebrew Myths: The Book of Genesis.* New York: Doubleday.

Green, E. C. (1999) Infanticide and Infant Abandonment in the New South: Richmond, Virginia, 1865-1915. *Journal of Family History,* Vol. 24, No. 2, 187-211.

Green, P. (1998) *Cracks in the Pedestal: Ideology and Gender in Hollywood.* Amherst: University of Massachusetts Press.

The Guardian (04/06/2000) [Dixie Chicks]. Guardians Features Page (LexisNexis)

Gurr, T. and H. H. Cox (1957) Death in a Cathedral City. *Famous Australasian Crimes.* London: Muller, 148-167. Online.

Haefeli, E. (1999) Kieft's War and the Cultures of Violence in Colonial America. Pp. 17-40 in M. A. Bellesiles, ed., *Lethal Imagination: Violence and Brutality in American History.* New York: New York University Press.

Haines, M. (1998) *Canadian Crimes.* New York: Penguin.

Halkias, A. (1999) From Social Butterfly to Modern Medea: Elizabeth Broderick's Portrayal in the Press. *Critical Studies in Mass Communication,* Vol. 16, No. 3, 289-307.

Hall, C. (1997) *Social Work as Narrative: Storytelling and Persuasion in Professional Texts.* Aldershot, England: Ashgate.

Hall, E., F. Macintosh, and O. Taplin, eds. (2000) *Medea in performance, 1500-2000.* Oxford: European Humanities Research Centre, University of Oxford.

Hallissy, M. (1987) *Venomous Woman: Fear of the Female in Literature.* New York: Greenwood Press.

Halttunen, K. (1998) *Murder Most Foul: The Killer and the American Gothic Imagination.* Cambridge, MA: Harvard University Press.

Hamilton, Edith (1942 [1999]) *Mythology: Timeless Tales of Gods and Heroes.* New York: Warner Books.

Hamm, R. (2003) Edith and Her Pappy. Chapter 4 in *Murder, Honor, and Law: Four Virginia Homicides from Reconstruction to the Great Depression.* Charlottesville: University of Virginia Press.

Hammer, J. (April 15, 2002) How Two Lives Met in Death. *Newsweek,* 18-25.

Hann, J. H. (1992) Heathen Acuera, Murder, and a Potano Cimarrona: The St. John's River and the Alachua Prairie in the 1670s. *Florida Historical Quarterly,* Vol. LXX, No. 4, 451-474.

Hansen, C. (1974) The Metamorphosis of Tituba, or Why American Intellectuals Can't Tell An Indian Witch From a Negro. *The New England Quarterly,* Vol. 47, 3-12.

Happe, K. (2000) Race Betterment and Class Consciousness at the Turn of the Century, or Why It's Okay to Marry Your Cousin. Pp. 166-186 in C. A. Stable, ed. *Turning the Century: Essays in Media and Cultural Studies.* Boulder, CO: Westview Press.

Harbage, A., ed. (1969) *William Shakespeare: The Complete Works.* Baltimore, MD: Penguin Books.

Harding, M.E. (1971) *Woman's Mysteries: Ancient and Modern.* New York: G.P. Putnam's Sons.

Hariman, R. (1990) Introduction and Chapter 1 (Performing the Laws: Popular Trials and Social Knowledge). Pp. 1-16 and pp. 17-30 in Hariman, R., ed. *Popular Trials.* Tuscaloosa and London: The University of Alabama Press.

Harrington, D. J. (1999) *Invitation to the Apocrypha.* Grand Rapids and Cambridge: Wm. B. Eerdmans.

Harris, C. C. (Aug. 1, 2001) Exploring Isis. *Tour Egypt Monthly.* Online at http://www.egyptmonth.com/magf5.htm

Harris, S. (1998) McCaughey Book Pulls No Punches In Women's Self Defense. Online at http://www.vt.edu:10021/ur/news/Archives/Jan98/98024.html.

Hart, L. (1994) *Fatal Women: Lesbian Sexuality and the Mark of Aggression.* Princeton: Princeton University Press.

Hartman, M.S. (1995[1977]) *Victorian Murderesses: A True History of Thirteen Respectable French and English Women Accused of Unspeakable Crimes.* Robson Books, Limited.

HBO documentary. *The Execution of Wanda Jean.* Broadcast 3/17/2002.

Hemphill, C. D. (1999) *Bowing to Necessities: A History of Manners in America, 1620-1860.* New York: Oxford University Press.

Henwood, D. (1997) Mary Rowlandson and The Psalms: The Textuality of Survival. *Early American Literature,* Vol. 32, 169-186.

Herman-Giddens, M. E., J. B. Smith, M. Mittal, M. Carlson, J. D. Butts (2003) Newborns Killed or Left to Die by a Parent. *JAMA,* Vol. 289, No. 11, 1425-1429.

Hewitt, N. A. (2002) Taking the True Woman Hostage. *Journal of Women's History,* Vol. 14, No. 1, 156-162.

Hickey, C., T. Lighty, and J. O'Brien (1996) *Goodbye, My Little Ones.* New York: Onyx.

Hickey, E. (1991) *Serial Murderers and Their Victims.* Pacific Grove, CA: Brooks/Cole.

Hill, F. (1995) *A Delusion of Satan: The Full Story of the Salem Witch Trials.* NY: Bantam Books.

Hinton, P. K. (1999) "The Unspeakable Mrs. Gunness": The Deviant Woman in Early-Twentieth-Century America. Pp. 327-351 in M. A. Bellesiles, ed., *Lethal Imagination: Violence and Brutality in American History.* New York: New York University Press.

Hirsch, F. (1981) *The Dark Side of the Screen: Film Noir.* New York: Da Capo Press.

Hobson, W. K. (1993) Lizzie Borden and Victorian America: Shifting Perspectives, 1892-1992. Pp. 167-190 in J. R. Ryckebusch, ed., *Proceedings Lizzie Borden Conference.* Portland, ME: King Philip Publishing.

Hodges, A. (3/03/2002) Dreary 'Crossed Over' is a Waste. *The Houston Chronicle,* Television; pg. 2 (LexisNexis)

Hoff, B. H. (1994) Bobbitt: Blaming the Victim. *M.E.N. Magazine.* Online at MenWeb. http://www.vix.com/menmag/bobbitt.htm.

Hoffer, P. C. and N. E. H. Hull (1981) *Murdering Mothers: Infanticide in England and New England, 1558-1803.* New York: New York University Press.

Hoffman-Jeep, L. (1996) Plotting a Misogynistic Path to Christian Dior's Poison. *Western Folklore,* 55, 281-96.

Hoff-Wilson, J. (1989) Women in American Constitutional History at the Bicentennial. *The History Teacher,* Vol. 22, Issue 2, 145-176.

Hollander, A. (1994) *Sex and Suits: The Evolution of Modern Dress.* New York: Alfred A. Knopf.

Holmes, R. and J. DeBurger (1985) Profiles in Terror: The Serial Murderer. *Federal Probation* 39: 29-34.

Holmes, R. and J. DeBurger (1988) *Serial Murder.* Newbury Park, CA: Sage.

Holmes, S., E. Hickey, and R. Holmes (1991) Female Serial Murderesses: Constructing Differentiating Typologies. *Journal of Contemporary Criminal Justice* 7: 245-256.

Holmlund, C. (1994) Cruisin' for a Bruisin': Hollywood's Deadly (Lesbian) Dolls. *Cinema Journal,* Vol. 34, No. 1, 31-51.

Horsley, K. and L. (1999) Meres Fatales: Maternal Guilt in the Noir Crime Novel. *Modern Fiction Studies,* Vol. 45, No.2, 369-402 (on-line).

Housekeeping Monthly (May 13, 1955) The good wife's guide.

Houston mom's prosecutors to seek death penalty (August 9, 2001). Online at http://www.cnn.com/2001/LAW/08/08mother.arrainged/index.html

Howard, C. (1999) The True Story of Barbara Graham. *The Crime Library,* online at http://www.crimelibrary.com/classics/graham1/2htm.

Huber, P. J. (1998) "Caught Up in the Violent Whirlwind of Lynching": The 1885 Quadruple Lynching in Chatham County, North Carolina. Vol. LXXV, No. 2, 135-160.

Hufton, O. (1996) *The Prospect Before Her: A History of Women in Western Europe, Vol. I, 1500-1800.* New York: Alfred A. Knopf.

Hull, N. E. H. (1987) *Female Felons: Women and Serious Crime in Colonial Massachusetts.* Urbana: University of Illinois Press.

Humbert, M. (1999) Amy Fisher granted parole after 7 years. *Times-Union,* Albany, New York, 05/06/1999, B13.

Humphries, D. (2000) Crack Mothers at 6: Prime-Time News, Crack/Cocaine, and Women. Pp. 117-128 in R. Muraskin, ed., *It's A Crime: Women and Justice.* Upper Saddle River, NJ: Prentice Hall.

Humphries, D. (1999) *Crack Mothers: Pregnancy, Drugs, and the Media.* Columbus: Ohio State University Press.

Husting, G. (1999) Abortion, Desert Storm, and Representations of Protest in American TV News. *The Sociological Quarterly,* Vol. 40, No. 1, 159-178.

Hustson, C. K. (1996) "Whackety Whack, Don't Talk Back": The Glorification of Violence Against Females and the Subjugation of Women in Nineteenth-Century Southern Folk Music. *Journal of Women's History,* Vol. 8, No. 3, 114-142.

Ide, A. F. (1993) *Battered and Bruised: All the Women of the Old Testament.* Las Colinas, TX: Monument Press.

Inness, S. A. (1999) *Tough Girls: Women Warriors and Wonder Women in Popular Culture.* Philadelphia: University of Pennsylvania Press.

In Search of History (11/18/1998) Joan of Arc: Soul on Fire. Produced by A& E, aired on both History Channel and A & E. (Available on video, 2000).

Introduction to Schizophrenia, An. Online at http://www.schizophrenia.com

Itnyre, C. J., ed. (1996) *Medieval Family Roles: A book of essays.* New York: Garland Publishing.

Jacobs, D. (2000) *Cold Killers.* New York: Kensington.

Johnson, P. E. (2001) *Hidden Hands: Working-Class Women and Victorian Social-Problem Fiction*. Athens: Ohio University Press.

Jonas, G. (1998) The ego versus the fetus. *The Ottawa Citizen,* News, June 17, A13.

Jones, A. (1980) She Had To Die! One of Ruth Snyder's Crimes Was Murder. *American Heritage,* Vol. 31, No. 6, 20-31.

Jones, A. (1996) *Women Who Kill*. Boston: Beacon Press.

Jones, L. C. (1982) *Murder at Cherry Hill: The Strang-Whipple Case, 1827*. Albany, NY: Historic Cherry Hill.

Jordan, B. L. (2000) Child's death stirred suspicions of murder. Atlanta Journal-Constitution, Nov. 9. Reprinted from *Murder in the Peach State*. Online, 1-4.

Jordan, R. A. and F. A. De Caro (1986) Women and the Study of Folklore. *Signs: Journal of Women in Culture and Society,* Vol. 11, No. 3, 500-518.

Joseph, N. (1986) *Uniforms and Nonuniforms: Communication Through Clothing*. New York: Greenwood Press.

Jourdan, T. (07/27/1998) The Ultimate Taboo. *The Scotsman,* pg. 9 (LexisNexis).

Jouve, N. W. (1994) An eye for an eye: The case of the Papin sisters. Pp. 7-31 in H. Birch, ed., *Moving Targets: Women, Murder and Representation*. Berkeley: University of California Press.

Just, R. (1989) *Women in Athenian Law and Life*. London and New York: Routledge.

Juster, S. (2000) Mystical Pregnancy and Holy Bleeding: Visionary Experience in Early Modern Britain and America. *William and Mary Quarterly,* 3d Series, Vol. LVII, No. 2, 249-288.

Karlsen, C. (1987) *The Devil in the Shape of a Woman: Witchcraft in Colonial New England*. New York: Vintage.

Kasinsky, R. G. (1994) Child Neglect and "Unfit" Mothers: Child Savers in the Progressive Era and Today. *Women & Criminal Justice,* Vol. 6, No. 1, 97-129.

Kasinsky, R. G. (1993) Criminalizing of Pregnant Women Drug Abusers. Pp. 483-501 in C. C. Culliver, ed., *Female Criminality: The State of the Art*. New York and London: Garland.

Kasson, J. F. (1990) *Rudeness and Civility: Manners in the Nineteenth-Century Urban America*. New York: Hill and Wang.

Katz, J. (1988) *Seductions of Crime: Moral and Sensual Attractions in Doing Evil*. New York: Basic Books.

Katz, M. A. (2000) A Review Essay: Sappho and Her Sisters: Women in Ancient Greece. *Signs,* Vol. 25, No. 2, 50-5-531.

Keeney, B. and K. Heide (1994) Gender Differences in Serial Murderers: A Preliminary Analysis. *Journal of Interpersonal Violence* Vol. 9, No. 3,: 383-398..

Keetley, D. (1999) Victim and Victimizer: Female Fiends and Unease over Marriage in Antebellum Sensational Fiction. *American Quarterly,* Vol. 51, No. 2, 344-384 (online).

Kelleher, M. P. and C. L. Kelleher (1998) *Murder Most Rare: The Female Serial Killer.* Westport, CT: Praeger.

Kellerman, A. L. and P. J. Cook (1999) Armed and Dangerous: Guns in American Homes. Pp. 425-239 in M. A. Bellesilles, ed., *Lethal Imagination: Violence and Brutality in American History.* New York: New York University Press.

Kennedy, K. (1998) Casting An Evil Eye on the Youth of the Nation: Motherhood and Political Subversion in the Wartime Prosecution of Kate Richards O'Hare, 1917-1924. *American Studies,* Vol. 39, No. 3, 105-129.

Kennedy, R. (1997) *Race, Crime, and the Law.* New York: Pantheon Books.

Kent, S. K. (1999) *Gender and Power in Britain, 1640-1990.* London and New York: Routledge.

Keppel, R. (1997) *Signature Killers.* New York: Pocket Books.

Kerber, L. K. (1976) The Republican Mother: Women and the Enlightenment—American Perspective. *American Quarterly,* XXVIII, 187-205.

Kidwell, C. B. and V. Steele, eds. (1989) *Men and Women: Dressing the Part.* Washington, D. C.: Smithsonian Institute Press.

Kilbourne, J. (1999*) Deadly Persuasion: Why Women and Girls Must Fight The Addictive Power of Advertising.* New York: The Free Press.

Kilgallen, D. (1967) *Murder One.* New York: Random House.

Kimmel, M. (1996) *Manhood in America: A Cultural History.* New York: Free Press.

King, M. and S. Ruggles (1990) American Immigration, Fertility, and Race Suicide at the Turn of the Century. *Journal of Interdisciplinary History,* Vol. 20, No. 3, 347-369.

King, W. (08/01/1975) Joan Little Prosecutors Contend Killing Was Part of Escape Plot. *The New York Times,* p. 28.

King, W. (07/15/75) Jury Selection Challenged by Joan Little's Lawyers. *The New York Times,* p. 20.

King, W. (08/02/1975) Lost Evidence at Slaying Scene Is Conceded at Joan Little Trial. *The New York Times,* p. 6.

Kinsley, D. (1989) *The Goddesses' Mirror: Visions of the Divine from East and West*. Albany: State University of New York Press.

Kitch, C. (1998) The American Woman Series: Gender and Class in The Ladies' Home Journal, 1897. *Journalism & Mass Communication Quarterly*, Vol. 75, No. 2, 243-261.

Kitch, C. (1997) Changing Theoretical Perspectives on Women's Media Images: The Emergence of Patterns in a New Area of Historical Scholarship. *Journalism & Mass Communication Quarterly*, Vol. 74, No. 3, 477-489.

Kitch, C. (2001) *The Girl on the Magazine Cover: The Origins of Visual Stereotypes in American Mass Media*. Chapel Hill & London: The University of North Carolina Press.

Klaits, J. (1985) *Servants of Satan: The Age of the Witch Hunts*. Bloomington: Indiana University Press.

Klapisch-Zuber, C., ed. (1992) *A History of Women in the West: Silences of the Middle Ages*. Cambridge and London: The Belknap Press.

Kleinbaum, A. W. (1983) *The War Against the Amazons*. New York: New Press.

Kline, W. (2001) *Building a Better Race: Gender, Sexuality, and Eugenics from the Turn of the Century to the Baby Boom*. Berkeley: University of California Press.

Knelman, J. (1998) *Twisting in the Wind: The Murderess and the English Press*. Toronto: University of Toronto Press.

Koslow, S. (1995) "How looked the Gorgon then..." The Science and Poetics of 'The Head of Medusa' by Rubens and Snyders. Published in *Shop Talk: Studies in Honor of Seymour Slive*. Cambridge, Mass., 1995, pp. 147-149. Online at: http://academic.brooklyn.cuny.edu/art/koslow/essays/medusa/text.htm.

Krause, J. C. (n.d.) Erzsebeth (Elizabeth) Barthory. Online at: www.abacom.com/~jkrause/bathory.html

Labarge, M. W. (1986) *Women in Medieval Life: A Small Sound of the Trumpet*. London: Hamish Hamilton.

Lane, B. and W. Gregg (1992) *The Encyclopedia of Serial Killers*. New York: Berkeley Books.

Lane, R. (1997) *Murder in America: A History*. Columbus: Ohio State University Press.

Langlois, J. L. (1985) *Belle Gunness: The Lady Bluebeard*. Bloomington: Indiana University Press.

Lansing State Journal (1997) What are Black Widows? July 9, Online at http://www.pa.msu.edu/~sciencet/ask_st/070997.html.

Laroux, N. (1992) What Is a Goddess? Pp. 11-44 in P. S. Pantel, ed. *A History of Women in the West: From Ancient Goddesses to Christian Saints.* Cambridge, MA: The Belknap Press of Harvard University Press.

Larson, J. (1995) *Greek Heroine Cults.* Madison, WI: The University of Wisconsin Press.

Laster, K. (1989) Infanticide: A Litmus Test for Feminist Criminological Theory. Pp. 151-164 in N. Naffine, ed., *Gender, Crime and Feminism.* Aldershot, England: Dartmouth.

LaRue, L.H. (1995) *Constitutional Law as Fiction: Narrative in the Rhetoric of Authority.* University Park, PA: The Pennsylvania State University Press.

Lavandera, E. (June 21, 2001) Houston community copes with children's deaths. Online at http://www.cnn.com/2001/US/06/21/lavandera.debrief/

Laythe, J. (2002) The Wicked Stepmother?: The Edna Mumbulo Case of 1930. *Journal of Criminal Justice and Popular Culture,* Vol. 9, No. 2, 33-54.

Law, J. (2000) The Politics of Breastfeeding: Assessing Risk, Dividing Labor. *Signs: Journal of Women in Culture and Society,* Vol. 25, No. 2, 407-450.

LeClair, T. (1996) Guilty Verdict (Book Review). *The Nation,* December 9, online.

Leeming, D. and J. Page (1994) *Goddess: Myths of the Female Divine.* New York: Oxford University Press.

Lefkowitz, M. R. (19896) *Women in Greek Myth.* Baltimore: The Johns Hopkins University Press.

Levin, J. and J. A. Fox (1993) Female Serial Killers. Pp. 249-261 in C. C. Culliver, ed., *Female Criminality: The State of the Art.* New York and London: Garland.

Levit, N. (1998) *The Gender Line: Men, Women, and the Law.* New York and London: New York University Press.

Lewis, J. (1987) The Republican Wife: Virtue and Seduction in the Early Republic. *William and Mary Quarterly,* Vol. 44, No. 4, 689-721.

LexXicon Interview. Betty Broderick. Online at www.lexXicon.com/betty.htm.

Lieberman, L. (1999) Crimes of Reason, Crimes of Passion: Suicide and the Adulterous Woman in Nineteenth-Century France. *Journal of Family History,* Vol. 23, No. 2, 131-147.

Light sentence for elderly woman who pleaded guilty to killing her children sparks outrage (June 29, 1999). http://www.courttv.com/trials/news/062999_noe_ctv.html

Lincoln, B. (1999) *Theorizing Myth: Narrative, Ideology, and Scholarship.* Chicago: The University of Chicago Press.

Liscio, L. (1992) *Beloved's* Narrative: Writing Mother's Milk. *Tulsa Studies in Women's Literature,* Vol. 11, No.1, 31-46.

Little, A. M. (1999) "Shee Would Bump His Mouldy Britch": Authority, Masculinity, and the Harried Husbands of New Haven Colony, 1638-1670. Pp. 43-66 in M. A. Bellesiles, ed., *Lethal Imagination: Violence and Brutality in American History.* New York: New York University Press.

Little, G. A. and J. G. Brooks (1994) Accepting the Unthinkable. *Pediatrics,* 94, 748-749.

Lombroso, C. and G. Ferrero (1958 [1895]) *The Female Offender.* New York: D. Appleton.

Loraux, N. (1998) *Mothers in Mourning.* Ithaca and London: Cornell University Press.

Loth, H. (1987) *Woman in Ancient Africa.* Westport, CT: Lawrence Hill.

Lowry, B. (1992) *Crossed Over.* New York: Knopf.

Lucal, B. (1999) What It Means to Be Gendered Me: Life on the Boundaries of a Dichotomous Gender System. *Gender and Society,* Vol. 13, Issue 6, 781-797.

Lyon, A., E. Hughes, and J. Thomas (2001) The People v. Juanita Thomas: A Battered Woman's Journey to Freedom. *Women & Criminal Justice,* Vol. 13 (1), 27-63.

MacDonald, M. (1988) Suicide and the Rise of the Popular Press in England. *Representations,* No. 22, 36-55.

Macfarlane, J. E. (1998) Note: Neonaticide and the "Ethos of Maternity": Traditional Criminal Law Defenses and the Novel Syndrome. *Cardoza Women's Law Journal* (5 Cardoza Women's L.J. 175).

Macintyre, B. (02/23/2002) Ellis's life was wasted but we can learn from her death. *The Times* (London). Features (LexisNexis).

MacKeen, D (1997) New Controversy Over SUDDEN INFANT DEATH SYNDROME Online at http://www.salon.com/sept97mothers/sids1970919.html

MacQuarrie, B. (2000) House Gives Initial OK to Legislation Tightening Au Pair Requirements. *The Boston Globe,* Metro/Region, June 26, B3.

Madriz, E. (1997) *Nothing Bad Happens to Good Girls: Fear of Crime in Women's Lives.* Berkeley: University of California Press.

Mahan, S. (1996) *Crack Cocaine, Crime, and Women: Legal, Social, and Treatment Issues.* Thousand Oaks, CA: Sage.

Mann, C. R. (1990) Female Homicide and Substance Use: Is There a Connection? *Women & Criminal Justice,* Vol. 1, No. 2: 87-95.

Mann, C. R. (1996) *When Women Kill.* Albany: State University of New York Press.

Manners, T. (1995) *Deadlier than the Male: Stories of Female Serial Killers.* London: Pan Books.

Margolin, L. (1999) *Murderess!* New York: Kensington.

Martin, K. A. (1993) Gender and Sexuality: Medical Opinion on Homosexuality, 1900-1950. *Gender & Society,* Vol. 7, No. 2, 246-260.

Martin, R.R. (1995) *Oral History in Social Work: Research, Assessment, and Intervention.* Thousand Oaks, CA: Sage.

Mason, J. D. (2001) "Munchausen Syndrome by Proxy" Online at www.emedicine/com/emery/topic830.htm

Mason, M. S. (01/25/2002) The Allure of Cleopatra. *The Christian Science Monitor,* Features, p. 13.

McBrien, W. (1998) *Cole Porter: A Biography.* New York: Alfred A. Knopf.

McCall, L. (1999) Armed and "More or Less Dangerous": Women and Violence in American Frontier Literature, 1820-1860. Pp. 171-183 in M. A. Bellesiles, ed., *Lethal Imagination: Violence and Brutality in American History.* New York: New York University Press.

McCaughey, M. (1997) *Real Knockouts: The Physical Feminism of Women's Self-Defense.* New York: New York University Press.

McCaughey, M. and N. King, eds. (2001) *Reel Knockouts: Violent Women in the Movies.* Austin: University of Texas Press.

McCormick, J., S. Miller, and D. Woodruff (1994) Why Parents Kill. *Newsweek,* National Affairs, November 14, p. 31.

McCrumb, S. (1998) *The Ballad of Frankie Silver.* New York: Signet.

McCullough, M. (1997) Experts Note Increase In Baby Killings By Young; Middle-Class Women. *The Buffalo News,* November 28, News, 4A.

McDaniel, M. (10/28/2002) Andrea Yates Gets Fair Treatment on 'Mugshots: A Mother's Madness.' *The Houston Chronicle,* Houston; pg. 6 (LexisNexis).

McDermott, M. J. and S. J. Blackstone (2001) Lilith in Myth, Melodrama, and Criminology. *Women & Criminal Justice,* Vol. 13, No. 1, 85-98.

McFarlane, J., J. C. Campbell, S. Witt, C. Sachs, Y. Ulrich, X. Xu (1999) Stalking and Intimate Partner Femicide. *Homicide Studies,* Vol. 3, No. 4, 300-316.

McLaurin, M. A. (1991) *Celia, A Slave.* New York: Avon Books.

McLaurin, M. A. (1999) On Infanticide, the Peculiar Institution, and Public Memory. (Review of Steven Weisenburger. *Modern Medea: A Family Story of Slavery and Child-Murder from the Old South*). *Reviews in American History* 27 (2) 250-253.

McLean, T. (1980) *Medieval English Gardens*. NY: Viking Press.

McNall, S. G. (1986) "It Was a Plot Got Up To Convict Me": The Case of Henrietta Cook Versus the State of Kansas, 1876. *Quantitative Sociology*, Vol. 9, Issue 1, 26-47.

Meyer, C. L., T. C. Proano, and J. R. Franz (2000) Postpartum Syndromes: Disparate Treatment in the Legal System. Pp. 91-106 in R. Muraskin, ed., *It's A Crime: Women and Justice*. Upper Saddle River, NJ: Prentice Hall.

Miccio, K. (1995) Symposium on Reconceptualizing Violence Against Women by Intimate Partners: Critical Issues: In the Name of Mothers and Children: Deconstructing the Myth of the Passive Battered Mother and the "Protected Child" in Child Neglect Proceedings. *Albany Law Review* (58 Alb. L. Rev. 1087).

Michels, D. L. (April 1996) Mother Nature Loves Breastmilk. *L.A. Parent Magazine*. Online at http://www.littlekoala.com/breastmilk.htm

Miles, J. (1991) Imaging Mayhem: Fictional Violence vs. "True Crime." *North American Review*, December, 57-64.

Millan, B. (1982) *Monstrous Regiment: Women Rulers in Men's Worlds*. Shooters Lodge (Great Britain): The Kensal Press.

Miller, A. (1954 [1964]) *The Crucible: A play in four acts*. New York: Viking Press.

Miller, J. C. (1999) Governing the Passions: The Eighteenth Century Quest for Domestic Harmony in Philadelphia's Middle-Class Households. Pp. 45-62 in C. Daniels and M.V. Kennedy, eds., *Over the Threshold: Intimate Violence in Early America*. New York: Routledge.

Miller, L. (1997) Sexuality, Reproduction, and Family Planning in Women with Schizophrenia. *Schizophrenia Bulletin* 23(4): 623-635.

Mims, N. C. (1963) *Devil in Petticoats, or, God's Revenge Against Husband Killing*. Edgefield, S. C. : s.n. , 1963.

Molloy, M. (1993) Science, Myth and the Adolescent Female: The Mazengarb Report, the Parker-Hulme Trial, and the Adoption Act of 1955. *Women's Studies Journal*, Vol. 9, No.1, 1-25.

Mooney, M. M. (1976) *Evelyn Nesbit and Stanford White: Love and Death in the Gilded Age*. New York: William Morrow and Co.

Moore, A. (1997) Review: A Mesmerizing Murderess. *Tucson Weekly*, January 16-22, online.

Moore, R. L. (1989) Religion, Secularization, and the Shaping of the Culture Industry in Antebellum America. *American Quarterly,* Vol. 41, Issue, 216-242.

Morgan, E. F. (2000) Women on Death Row. Pp. 269-283 in R. Muraskin, ed., *It's A Crime: Women and Justice.* Upper Saddle River, NJ: Prentice Hall.

Morgan, J. L. (1997) "Some Could Suckle over Their Shoulder": Male Travelers, Female Bodies, and the Gendering of Racial Ideology, 1500-1770. *William and Mary Quarterly,* 3d Series, Vol. LIV, No. 1, 167-192.

Moriarty, L. and K. Freiberger (2000) Classifying Female Serial Killers: An Application of Prominent Typologies. Pp. 417-428 in R. Muraskin, ed., *It's A Crime: Women and Justice,* 2nd Edition. Uppersaddle River, NJ: Prentice-Hall.

Morris, V. B. (1990) *Double Jeopardy: Women Who Kill in Victorian Fiction.* Lexington: The University Press of Kentucky.

Moskowitz, E. (1996) "It's Good to Blow Your Top": Women's Magazines and a Discourse of Discontent, 1945-1965. *Journal of Women's History,* Vol. 8, No. 3, 66-98.

Moten, D. E. (1997) *"A Gruesome Warning to Black Girls": The August 16, 1912 Execution of Virginia Christina.* Dissertation in American Studies, University of Iowa.

Mumby, D. K., ed. (1993) *Narrative and Social Control: Critical Perspectives.* Newbury Park, CA: Sage Publications.

Munchausen's Syndrome by Proxy. Online at http://bpcl.net/~agravels/msp.htm

Muraskin, R., ed. (2000) *It's A Crime: Women and Justice.* Upper Saddle River, NJ: Prentice Hall.

Muraskin, R. (2000) Remember the Ladies. Pp. 5-12 in R. Muraskin, ed., *It's A Crime: Women and Justice.* Upper Saddle River, NJ: Prentice Hall.

Murder of the Century (1995, 2003) American Experience (PBS documentary). WGBH Educational Foundation.

Myles, A. G. (2001) From Monster to Martyr: Re-Presenting Mary Dyer. *Early American Literature,* Vol. 36, No. 1, 1-30.

Nadelhaft, J. (1982) The Englishwoman's Sexual Civil War: Feminist Attitudes Towards Men, Women, and Marriage 1650-1740. *Journal of the History of Ideas,* Vol. 43, No. 4, 555-579.

National Institute of Health (2001) Women Hold Up Half the Sky: Women and Mental Health Research. Washington, D.C.: National Institute of Mental Health (http://nimh.nih.gov).

Navas, D. (1999) *Murdered By His Wife*. Amherst: University of Massachusetts Press.

Newsweek (April 15, 2002) Letters. Man's Best Friends Go Ballistic. [author of letter Kevin Burke], p. 13.

The New York Times (04/15/1927) Gray is Examined By Four Alienists, p.10.

The New York Times (07/29/1975) Joan Little Jury Is Told of Dead Jailer, p. 12.

The New York Times (02/109/1932) Mrs. Judd Guilty of First Degree Murder; Arizona Jury Orders Death for Trunk Slayer.

The New York Times (11/10/1931) Mrs. Judd Held For Trial, p.19.

The New York Times (02/25/1932) Mrs. Judd To Die On Scaffold May 11, p. 44.

The New York Times (04/16/1927) Mrs. Snyder Asks Women's Sympathy, p.17.

The New York Times (04/17/1927) Mrs. Snyder Breaks As Trial Day Nears, p. 8.

The New York Times (07/15/1975) Rosenbergs' Innocence Asserted In Sons' Suit to Open Case Files, p. 20.

The New York Times (04/01/1991) Teacher Says Her Conviction Was A Surprise. Section A, p. 11, Col. 1 (LexisNexis).

Nichols, R.C. (1990) Los Angeles newspaper coverage and dramatization of the Barbara Graham case. Unpublished doctoral dissertation. California State University, Northridge.

Nickerson, C. R. (1999) "The Deftness of Her Sex": Innocence, Guilt, and Gender in the Trial of Lizzie Borden. Pp. 261-281 in M. A. Bellesiles, ed., *Lethal Imagination: Violence and Brutality in American History*. New York: New York University Press.

Nickerson, C. R. (1998) *The Web of Iniquity: Early Detective Fiction by American Women*. Durham & London: Duke University Press.

Nilan, C. (1997) Hapless Innocence and Precocious Perversity in the Courtroom Melodrama: Representations of the Child Criminal in a Paris Legal Journal, 1830-1848. *Journal of Family History*, Vol. 22, No. 3, 251-285.

911 tape reveals unemotional Andrea Yates (January 26, 2002). Online at http://www.cnn.com/2001/US/12/10/yates.911/index.html

No Easy Answer (July 25, 2001). Online at http://abcnews.go.com/sections/us/DailyNews/five_dead010626.html

Nord, D. E. (1998) "Marks of Race": Gypsy Figures and Eccentric Femininity in Nineteenth-Century Women's Writing. *Victorian Studies,* Vol. 41, No. 2, 189-210.

Nord, D. P. (1990) Teleology and News: The Religious Roots of American Journalism, 1630-1730. *The Journal of American History,* Vol. 77, Issue 1, 9-38.

Norder, D. (1999) The Face in the Mirror. *MythologyWeb.* Online at http://www.mythologyweb.com/bloodymary.htm.

Norton, M. B. (1998) "The Ablest Midwife That Wee Knowe in the Land": Mistress Alice Tilly and the Women of Boston and Dorchester, 1649-1650. *William and Mary Quarterly,* 3d Series, Vol. LV, No. 1, 105-134.

Norton, M. B. (1987) Gender and Defamation in Seventeenth-Century Maryland. *William and Mary Quarterly,* Vol. 44, No. 1, 3-39.

Not without precedent (July 1, 2001). Online at http://www.chron.com/cs/CDA/story.hts/special/drownings/957431

Oglesby, C. (June 27, 2001) Postpartum depression: More than 'baby blues.' Online at http://www.cnn.com/2001/HEALTH/parenting/06/26/postpartumdepression

O'Hare, S. (forthcoming) Barbara Graham. In F. Bailey and S. Chermak (eds.) *Famous American Crimes and Trials.* Westport, CT: Praeger.

Olsen, G. (1997) *Starvation Heights.* New York: Warner Books.

Osherow, M. (2000) The Dawn of a New Lilith: Revisionary Mythmaking in Women's Science Fiction. *NSWA Journal,* Vol. 12, No. 1, 68-83 (online).

The Oxford English Dictionary, 2nd ed. (1989). Oxford University Press. Online version.

Parker, L. (2001) 'Psychotic,' but is Andrea Yates legally insane? Online at http://www.usatoday.com/usatonline/20010911/3618026s/htm

Parry-Giles, S. J. (2000) Mediating Hillary Rodham-Clinton: Television News Practices and Image-Making in the Postmodern Age. *Critical Studies in Media Communication,* Vol. 17, No. 2, 205-226.

Paton, N. (2000) Christine and Lea Papin: A Study in Criminal Psychology. Adapted from the unpublished book *The Monsters of Le Mans.* Online at wysiwg://61/http://www.geocities.com/neil404bc/christin.htm

Pauly, T. H. (1997) Introduction. Pp. vii-xxxii in M. Watkins, *Chicago,* M. Watkins. Carbondale and Edwardsville: Southern Illinois University Press.

Pearson, J. (1988) *The Prostituted Muse: Images of Women & Women Dramatists, 1642-1737.* New York: Harvester-Wheatsheaf.

Pearson, P. (1997) *When She Was Bad: Violent Women and the Myth of Innocence.* New York: Viking.

Pergament, R. (n.d.) Susan Smith: Child Murderer or Victim? Crime Library. Online at http://www.crimelibrary.com/filicide/smith/3.htm

Perkins, W. (1995) Perceptions of Women Criminals: The Case of Mme. De Brinvilliers. *Seventeenth-Century French Studies,* Vol. 17, 99-110.

Pershing, L. (10/31/1996) "His Wife Seized His Prize and Cut it to Size": Folk and Popular Commentary on Lorena Bobbitt. *NWSA Journal,* Vol. 8, No. 3, 1-25 (online).

Petry, A. (1964) *Tituba of Salem Village.* New York: Thomas Y. Crowell.

Phillips, G. and M. Keatman (1992) *King Arthur: The True Story.* London: Century Random House.

Phillips, O. C. (2000) Myra Hindley (1942-). P. 106 in Rafter, N. H, ed., *Encyclopedia of Women and Crime.* Phoenix, AZ: Oryx Press,

Pinker, S. (1997) Why They Kill Their Newborns. *The New York Times,* November 2, Section 6, p. 52.

Place, J. (1998) Women in Film Noir. Pp. 47-68 in E. A. Kaplan, ed. *Women in Film Noir* (rev. and exp.). London: British Film Institute.

Pollak, O. (1950, reprint 1978). *The Criminality of Women.* Westport, CT: Greenwood Press.

Pollock, J. M. (1999) *Criminal Women.* Cincinnati, OH: Anderson Publishing.

Pomeroy, S. B. (1976) A Classical Scholar's Perspective on Matriarchy. Pp. 217-223 in B. A. Caroll, ed. *Liberating Women's History: Theoretical and Critical Essays.* Urbana: University of Illinois Press.

Pomeroy, S. B. (1997) *Families in Classical and Hellenistic Greece: Representations and Realities.* Oxford: Clarendon Press.

Pomeroy, S. B. (1995) *Goddesses, Whores, Wives, and Slaves: Women in Classical Antiquity.* New York: Schocken Books.

Porter, N. (02/01/2001) Six Nations Special: Why, Why, Why I've A Ticket To The Game. *The Mirror* (LexisNexis).

The Post and Courier (10/07/2003) Pregnancy to Prosecution: McKnight Timeline. Section A; p. 9A (LexisNexis).

Potter, C. B. (1995) "I'll Go The Limit And Then Some": Gun Molls, Desire, and Danger in the 1930s: [Part 3 of 3]. *Feminist Studies,* Vol. 21, No. 1, 41+ (online).

The Press, (Weekend) (1991) Murder Without Remorse, October 5, p. 5. Online.

The Press, (Weekend) (1994) Solved: Hulme's greatest secret. August 6, p. 4. Online.

Price, M. L. (2002) Imperial Violence and the Monstrous Mother: Cannibalism at the Siege of Jerusalem. Pp. 272-298 in E. Salisbury et al., eds., *Domestic Violence in Medieval Texts*. Gainesville: University Press of Florida.

Proser, M. W. (1965) *The Heroic Image in Five Shakespearean Tragedies*. Princeton, NJ: Princeton University Press.

Pulitzer, L. B. (2000) The Truth about True Crime. *Writer's Digest*, July, 30-32+.

Purkiss, D. (1999) Classical Greek Themes in Contemporary Law: The Children of Medea: Euripides, Louise Woodward, and Deborah Eappen. *Cardoza Studies in Law and Literature*, Vol. 11, Issue 1, 53-64.

Purkiss, D. (1996) *The Witch in History: Early Modern and Twentieth-Century Representations*. New York: Routledge.

Queen Ruffles Feathers (11/21/2000) ABC News.com. From Wire Reports.

Quigley, P. (1989) *Armed and Female*. New York: St. Martin's Press.

Rafter, N. H. (1997) *Creating Born Criminals*. Urbana and Chicago: University of Illinois Press.

Rand, D. C. (1997) The Spectrum of Parental Alienation Syndrome (Part I) (Cont.). *American Journal of Forensic Psychology*, Vol. 15, No. 3. Online at http://www.deltabravo.net/custody/rand02.htm.

Ransom, Rev. R. C. (n.d.) Deborah and Jael B Sermon to the I. B. W. Woman's Club. In *The African American. . .1850-1920/Reverdy C. Ransom Collection*. Online at http://dbs.ohiohistory.org/africanam/page.cfm?ID=13905&Current=F1.

Rasche, C. E. (1990) Early Models for Contemporary Thought on Domestic Violence and Women Who Kill Their Mates: A Review of the Literature from 1895 to 1970. *Women & Criminal Justice*, Vol. 1 (2), 31-53.

Read, J. (2000) *The New Avengers: Feminism, femininity and the rape-revenge cycle*. Manchester and New York: Manchester University Press.

Reagan, L. J. (1991) "About to Meet Her Maker": Women, Doctors, Dying Declarations, and the State's Investigation of Abortion, Chicago, 1867-1940. *The Journal of American History*, Vol. 77, No. 4, 1240-1264.

Reagan, L. J. (1997) *When Abortion Was a Crime: Women, Medicine, and Law in the United States, 1867-1973*. Berkeley: University of California Press.

Reis, E. (1997) *Damned Women: Sinners and Witches in Puritan New England*. Ithaca and London: Cornell University Press.

Rennison, C. M. and S. Welchans (2000) Intimate Partner Violence. Bureau of Justice Statistics Special Report. U.S. Department of Justice (online version, revised 1/31/02).

Reston, J., Jr., (1977) *The Innocence of Joan Little: A Southern Mystery*. New York: Time Books.

Reuters (Nov. 21, 2000) Shocking Deaths, Woman Accused of Killing Children to Appease Goddess. Online at http://abcnews.go.com/sections/world/DailyNews/kali001121.htm

Rivers, C. (1996) *Slick Spins and Fractured Facts: How Cultural Myths Distort the News*. New York: Columbia University Press.

Roberts, A. (2002) The "Homicidal Women" Stories in the *Roman de Thebes, the Brut Chronicles,* and Deschamps's "Ballade 285." Pp. 205-222 in E. Salisbury et al., eds., Domestic Violence in Medieval Texts. Gainesville: University Press of Florida.

Robb, G. (1997) Circe in Crinoline: Domestic Poisoning in Victorian England. *Journal of Family History,* Vol. 22, No. 2, 176-190.

Robb, G. (1996) Out of the Doll's House: The Trial of Florence Maybrick and Anxiety Over the New Woman. *Proteus,* Vol. 13, No. 1: 29-32.

Roberts, D. (1997) *Killing the Black Body: Race, Reproduction, and the Meaning of Liberty*. New York: Vintage Books.

Robinson, L. S. (1991) Killing Patriarchy: Charlotte Perkins Gilman, the Murder Mystery, and Post-Feminist Propaganda. *Tulsa Studies,* Vol. 10, No. 2, 273-285.

Rohde, D. (April 13, 2002) Bomber was young woman. *Rocky Mountain News* [from the *New York Times*], 6A

Rosenman, E. B. (1996) Spectacular Women: *The Mysteries of London and the Female Body. Victorian Studies,* Vol. 40, No. 1, 31-64.

Ross, L. (1998) *Inventing the Savage: The Social Construction of Native American Criminality*. Austin: University of Texas Press.

Roth, R. (2001) Child Murder in New England. *Social Science History,* Vol. 25, No. 1, 101-147.

Roth, R. A. (1999) Spousal Murder in Northern New England, 1776-1865. Pp. 65-93 in C. Daniels and M. V. Kennedy, eds., *Over the Threshold: Intimate Violence in Early America*. New York: Routledge.

Rowbotham, S. (1997) *A Century of Women: The History of Women in Britain and the United States*. New York: Viking.

Ruddick, J. (2002) *Death at the Priory: Love, Sex and Murder in Victorian England*. New York: Atlantic Monthly Press.

Ruggiero, K. (1992) Honor, Maternity, and the Disciplining of Women: Infanticide in Late Nineteenth-Century Buenos Aires. *The Hispanic American Historical Review,* Vol. 72, Issue 3, 353-373.

Rule, A. (1988) *Small Sacrifices.* NY: Signet.

Rule, A. (1980) *The Stranger Beside Me.* New York: Penguin. Reissued 1996, Mass Market Paperback.

Russell, K. K. (1999) *The Color of Crime: Racial Hoaxes, White Fear, Black Protectionism, Police Harassment and Other Macroaggressions.* New York: New York University Press.

Russell Yates bides farewell to his 5 children (June 28, 2001). Online at http://www.cnn.com/2001/US/06/27/funeral.time/

Ryckebusch, J. R. (1993) *Proceedings: Lizzie Borden Conference.* Portland, ME: King Publishing.

Sacks, P. H. (01/04/2000) Revisiting a crime; Author has new insights into Bathsheba Spooner trial. *Telegram & Gazette,* People, pg. C1 (LexisNexis).

Saint Joan of Arc Center. A Short Biography of Saint Joan of Arc. Online at: http://www.stjoan-center.com

Salgado, G. (1977) *The Elizabethan Underworld.* London: J.M. Dent & Sons.

Sanders, A. (1995) *A Deed Without A Name: The Witch in Society and History.* Oxford and Herndon, VA: Berg Publishers.

Sauer, R. (1978) Infanticide and Abortion in Nineteenth-Century Britain. *Population Studies,* Vol. 32, Issue 1, 81-93.

Savage, S. (1996) Woman Who Kill and the Made-For-TV Movie: The Betty Broderick Story. Pp. 113-129 in A. Myers and S. Wight, eds., *No Angels: Women Who Commit Violence.* San Francisco: HarperCollins.

Scandura, J. (1996) Deadly Professions: Dracula, Undertakers, and the Embalmed Corpse. *Victorian Studies,* Vol. 40, No. 1, 1-30.

Schafer, S. (1998) Between Parental Rights and the Dangerous Mother: Reading Parental Responsibility in Nineteenth-Century French Civil Justice. *Journal of Family History,* Vol. 23, No. 2, 173-189.

Scheffler, J. (1990) Ethel Rosenberg's Prison Letters: An Example of Women's Prison Literature in Transition. *Women & Criminal Justice,* Vol. 2, No. 1, 19-39.

Schuetz, J. (1994) *The Logic of Women on Trial: Case Studies of Popular American Trials.* Carbondale: Southern Illinois University Press.

Schulte, R. (1994) *The Village in Court: Arson, Infanticide, and Poaching in the Court Records of Upper Bavaria, 1848-1910.* New York: Cambridge University Press.

Schutte, A. J. (1985) "Such Monstrous Births": A Neglected Aspect of the Antinomian Controversy. *Renaissance Quarterly,* Vol. 38, Issue 1, 85-106.

Schutzman, M. (1999) *The Real Thing: Performance, Hysteria, and Advertising.* London: Routledge.

Scott, G. F. (1996) Shelley, Medusa, and the Perils of Ekphrais. Pp. 315-332 in F. Burwick and J. Klein, eds. *The Romantic Imagination: Literature and Art in England and Germany.* Online: *theRomanticCircles*.http://www.rc.umd.edu/editions/shelley/medusa/gscott.html

Scott, J. (1996) Serial Homicide. *British Medical Journal* 312: 2-3.

Scully, D. and P. Bart (1973) A Funny Thing Happened on the Way to the Orifice: Women in Gynecology Textbooks. *American Journal of Sociology,* Vol. 78, Issue 4, 1045-1050.

Sealey, G. (10/04/Oct. 4, 2000) Drug Testing on the Docket. ABC News.com Online at : http://abcnews.go.com/sections/us/DailyNews/scotus_pregnant001003.htm

Selden, S. (1999) *Inheriting Shame: The Story of Eugenics and Racism in America.* New York: Teachers College Press.

Sellnow, D. D. (1999) Music as Persuasion: Refuting Hegemonic Masculinity in "He Thinks He'll Keep Her." *Women's Studies in Communication,* Vol. 22, No. 1, 66-84.

The Sentinel (March 16, 2002) Jury spares Yates, Page A1.

The Sentinel (February 18, 2002) Testimony to begin in Andrea Yates' trial, Page A3.

Shadron, V. (1983) State and Local Records as Women's History Sources: The Case of Edna Perkins Godbee. The Proceedings and Papers of the Georgia Association of Historians.

Shaheen, N. (1999) *Biblical References in Shakespeare's Plays.* Newark: University of Delaware Press.

Shapiro, A. (1996) *Breaking the Codes: Female Criminality in Fin-de-Siecle Paris.* Stanford, CA: Stanford University Press.

Shapiro, A. (1999) "Stories more terrifying than the truth itself": narratives of female criminality in *fin de siecle* Paris. Pp. 204-221 in M. L. Arnot and C. Usborne, *Gender and Crime in Modern Europe.* London: UCL Press.

Shipman, M. (2002) *"The Penalty Is Death": U.S. Newspaper Coverage of Women's Executions.* Columbia and London: University of Missouri Press.

Sims, C. (11/26/1999) For Chic's Sake, Japanese Women Parade to the Orthopedist. *The New York Times.* Online at www.nytimes.com/library/style/112699japan-fashion.html

Sklar, E. S. (1992) Throughly Modern Morgan: Morgan le Fey in Twentieth-Century Popular Arthuriana. Pp. 24-35 in S. K. Slocum, ed., *Popular Arthurian Traditions*. Bowling Green, OH: Bowling Green State University Popular Press.

Skrapec, C. (1994) The Female Serial Killer: An Evolving Criminality. Pp. 241-268 in H. Birch, ed., *Moving Targets: Women, Murder, and Representation*. Berkeley: University of California Press.

Smith, J. (1989) *Misogynies: Reflections on Myths and Malice*. New York: Fawcett Columbine.

Smith, M. D. (1991) *Breaking the Bonds: Marital Discord in Pennsylvania, 1730-1830*. New York: New York University Press.

Smith, M. D. (1999) "Unnatural Mothers": Infanticide, Motherhood, and Class in the Mid-Atlantic, 1730-1830. Pp. 173-184 in C. Daniels and M. V. Kennedy, eds., *Over the Threshold: Intimate Violence in Early America*. New York: Routledge.

Smith-Rosenberg, C. and C. Rosenberg (1973) The Female Animal: Medical and Biological Views of Woman and Her Role in Nineteenth-Century America. *The Journal of American History*, Vol. 60, Issue 2, 332-356.

Snyder, S. (2001) Personality Disorder and the *Film Noir Femme Fatale*. *Journal of Criminal Justice and Popular Culture*, Vol. 8, No. 3, 155-168.

Solinger, R. (2000) *Wake Up Little Susie: Single Pregnancy and Race before Roe v. Wade*. New York and London: Routledge.

Spinelli, M. G. (2001) A Systematic Investigation of 16 Cases of Neonaticide. *American Journal of Psychiatry*, 158, 811-813.

Spivack, C. (1992) Morgan Le Fay: Goddess or Witch? Pp. 18-23 in S. K. Slocum, ed., *Popular Arthurian Traditions*. Bowling Green, OH: Bowling Green State University Popular Press.

Srebnick, A. G. (1995) *The Mysterious Death of Mary Rogers: Sex and Culture in Nineteenth-Century New York*. New York: Oxford University Press.

Stables, K. (1998) The Postman Always Rings Twice: Constructing the Femme Fatale in 90s Cinema. Pp. 164-182 in E. A. Kaplan, ed., *Women in Film Noir* (rev. and exp.). London: British Film Institute.

Staiger, J. (1995) *Bad Women: Regulating Sexuality in Early American Cinema*. Minneapolis: University of Minnesota Press.

Stammer, L. B. (07/31/1999) Catholic groups take a new look at role of Mary Magdalene. *The Ottawa Citizen*, News; A11 (LexisNexis).

Stanley, A. (01/20/2001) Cleopatra, Career Woman. *The New York Times*, Section B, p. 9.

Starling, S. P., J. R. Holden, and C. Jenny (1995) Abusive Head Trauma: The Relationship of Perpetrators to Their Victims. *Pediatrics,* 95, 259-262.

The Star Sun (Christchurch, New Zealand) (08/23/1954) Two Teenagers Face Charge of Killing Woman, p. 1 (e-text).

Steffensmeier, D. and C. Streifel (1993) Trends in Female Crime, 1960-1990. Pp. 63-101 in C. C. Culliver, ed., *Female Criminality: The State of the Art.* New York and London: Garland.

Stevens, K. (02/23/2003) Fetal-drug prosecution ignites debate in S.C.; State stands alone in arresting women who engage in risky behavior during pregnancy. *The Post and Courier,* Section A, p. 1A.

Stevenson, L. L. (1991) *The Victorian Homefront: American Thought and Culture, 1860-1880.* New York: Twayne.

Stokes, M. (1998) Someone's in the Garden with Eve: Race, Religion and the American Fall. *American Quarterly,* Vol. 50, No. 4, 718-744.

Stormer, N. (2001) Why Not? Memory and Counter-memory in 19th Century Abortion Rhetoric. *Women's Studies in Communication,* Vol. 24, No. 1, 1-29.

Stowers, C. (1/09/2003) Sisters in Crime; Female authors find a lucrative trade in Texas lawlessness. *Dallas Observer,* News/News (LexisNexis).

Strange, C. (1992) Wounded Womanhood and Dead Men: Chivalry and the Trials of Clara Ford and Carrie Davies. Pp. 149-188 in F. Iacovetta and M. Valverde, eds., *Gender Conflicts: Essays in Women's History.* Toronto: University of Toronto Press.

Streib, V. L. (2004) Death Penalty For Female Offenders, January 1, 1973, Through June 30, 2004. Available electronically at http://www.law.onu.edu/faculty/streib

Stross, J., D. Shasby, and W. Harlan (1976) An Epidemic of Mysterious Cardiopulmonary Arrests. *New England Journal of Medicine* 295: 1107-1110.

Sudden Death (February 25, 1999). Online at http://www.bbc.co.uk/science/horizon/suddendeath.shtml

Sudden Infant Death—SIDS Alliance. Online at http://sidsalliance.org/

Surette, R. (1998) *Media, Crime, and Crime Justice: Images and Realities,* 2nd ed. Belmont, CA: Wadsworth.

Sussman, G. D. (1982) *Selling Mother's Milk: The Wet-Nursing Business in France, 1715-1914.* Urbana: University of Illinois Press.

Sweet, J. H. (1997) The Iberian Roots of American Racist Thought. *William and Mary Quarterly,* 3d Series, Vol. LIV, No. 1, 143-166.

Symonds, D. A. (1998) Reconstructing Rural Infanticide in Eighteenth-Century Scotland. *Journal of Women's History,* Vol. 10, No. 2, 63-84.

Symonds, D. A. (1997) *Weep Not for Me: Women, Ballads, and Infanticide in Early Modern Scotland.* University Park, PA: The Pennsylvania State University Press.

Tavener, J. (2000) Media, Morality, and Madness: The Case Against Sleaze TV. *Critical Studies in Media Communication,* Vol. 17, No. 1, 63-85.

Telegraph & Gazette (02/04/1998) Bathsheba Spooner met her fate in Worcester.

Testimony of Ethel Rosenberg. Online at:
http://www.law.umkc.edu/faculty/projects/ftrials/rosenb/ROS_TETH.HTM

'That wasn't her,' says father of slain children (June 21, 2001). Online at http://www.cnn.com/2001/US/06/21children.killed/index.html

Thernstrom, M. (07/13/1998) Child's Play. *New York,* pp. 19-23 and 84.

Thomasset, C. (1992) The Nature of Woman. Pp. 43-69 in C. Klapisch-Zuber, ed. *A History of Women in the West: Silences of the Middle Ages.* Cambridge and London: The Belknap Press.

Thrush C. and R. H. Keller, Jr. (1995) "I See What I Have Done": The Life and Murder Trial of Xwelas, A S'Klallam Woman. *Western Historical Quarterly,* Vol. XXVI, No. 2, 168-183.

Tiersma, P.M. (1994) *Legal Language.* Chicago and London: The University of Chicago Press.

Time-Life Books (eds.) (1997) *What Life Was Like at the Dawn of Democracy: Classical Athens 525-322 B.C.* Alexander, Virginia: Time-Life.

Titus, M. (1991) Murdering the Lesbian: Lillian Hellman's The Children's Hour. *Tulsa Studies,* Vol. 10, No. 2, 215-232.

Tobin, E. (1993) Law and Literature: Imagining the Mother's Text: Toni Morrison's Beloved and Contemporary Law. *Harvard Women's Law Journal* (16 *Harv. Women's L. J.* 233).

Tolnay, S. E. and E. M. Beck (1995) *A Festival of Violence: An Analysis of Southern Lynchings, 1882-1930.* Urbana: University of Illinois Press.

Tokyo Journal, New York Times online at www.nytimes.com/library/style/112699japan-fashion.html.

Tomes, N. (1990) Historical Perspectives on Women and Mental Illness. Pp. 143-171 in R. D. Apple, ed. *Women, Health, and Medicine in America: A Historical Handbook.* New Brunswick, NJ: Rutgers University Press.

Toufexis, A and D.Bjerklie (1994) When is Crib Death a Cover for Murder? *Time* 143:15.

Towler, J. and J. Bramall (1986) *Midwives in History and Society.* London: Croom Helm.

Treneman, A. (1998) A Life Too Brief. *The Independent (London).* August 2, Features, pp. 4, 5.

Tromp, M. (2000) *The Private Rod: Marital Violence, Sensation, and the Law in Victorian Britain.* Charlottesville and London: University Press of Virginia.

Troup, J. (11/19/2002) Innocents Can Smile in Heaven. *The Sun* (LexisNexis).

Ullman, O. (07/28/00) Facing Mother Nature's Fury. Online at http://www.usatoday.com/weather/hurricane/2001beachboom/wpart2a.htm

Ulrich, L. T. (1991) *Good Wives: Image and Reality in the Lives of Women in Northern New England, 1650-1750.* New York: Vintage Books.

Valentis, M. and A. Devane (1994) *Female Rage: Unlocking Its Secrets, Claiming Its Power.* New York: Carol Southern Books.

Valkenburg, P., H. A. Semetko, C. H. De Vreese (1999) *The Effects of News Frames on Readers' Thought and Recall.* Communication Research, Vol. 26, No. 4, 550-569.

Vares, T. (2001) Action Heroines and Female Viewers: What Women Have To Say. Pp. 219-243 in M. McCaughey and N. King, eds. *Reel Knockouts: Violent Women in the Movies.*

Veyne, P. (1987) The Roman Empire. Pp. 5-234 in P. Veyne, ed., *A History of Private Life From Pagan Rome to Byzantium.* Cambridge, MA: Belknap Press of Harvard University.

Walker, B. G. (1985) *The Crone: Woman of Age, Wisdom, and Power.* New York: HarperCollins.

Walker, L. (1979) *The Battered Woman.* New York: Harper & Row.

Walker, L. (1984) *The Battered Woman Syndrome.* New York: Springer.

Walkins, C. E. (2000) *Postpartum Feelings: Major Depression or Just the Blues?* Baltimore, MD: Northern County Psychiatric Associates.

Walters, S. D. (2001) The (R)evolution of Women-in-Prison Films. Pp. 106-123 in M. McCaughey and N. King, eds. *Reel Knockouts: Violent Women in the Movies.* Austin: University of Texas Press.

Warnes, K. (forthcoming) Mary Dyer. In F. Bailey and S. Chermak, eds., *Famous American Crimes and Trials.* Westport, CT: Praeger.

Warner, M. (1994) *From the Beast to the Blonde: On Fairy Tales and Their Tellers.* New York: Farrar, Straus, and Giroux.

Watkins, M. (1927 [1997]) *Chicago.* Carbondale and Edwardsville: Southern Illinois University Press.

Webster, S. W. (1996) "Lizzie Borden Took An Axe": Representations of American Culture in Plays about the Lizzie Borden Murders and Trial. *Proteus,* Vol. 13, No. 1: 39–47.

Wehrwein, P. (1998) Scientific review on shaken-baby syndrome undermines legal defense. *The Lancet,* News: Science and Medicine, June 27, online.

Weiner, M. J. (1990) *Reconstructing the criminal: Culture, law, and policy in England, 1830-1914.* New York: Cambridge University Press.

Weiner, S. (1993) True Crime: Fact, Fiction, and the Law. *Legal Studies Forum,* Vol. 17, No. 3, 275–289.

Weis, A. (1998) The Murderous Mother and the Solicitous Father: Violence, Jacksonian Family Values, and Hannah Duston's Captivity. *American Studies International,* Vo. 36, Issue 1, 46–65.

Weisenburger, S. (1998) *Modern Medea: A Family Story of Slavery and Child-Murder from the Old South.* New York: Hill and Wang.

West, R. (1993) *Narrative, Authority & Law.* Ann Arbor, MI: The University of Michigan Press.

Westerdale, B. (11/18/2002) Myra — I'm not glad she's dead, I just wish she'd never been born... *The Star* (Sheffield) (LexisNexis).

Westerkamp, M. J. (1993) Puritan Patriarchy and the Problem of Revelation. *Journal of Interdisciplinary History,* Vol, 23, Issue 3, 571–595.

Wheelan, J. (12/13/1998) True-crime author scores again with "Death Sentence," TV Movie. *Associate Press,* State and Regional (LexisNexis).

Wheeler, L. A. (2000) Rescuing Sex from Prudery and Prurience: American Women's Use of Sex Education as an Antidote to Obscenity, 1925-1932. *Journal of Women's History,* Vol. 12, No. 3, 173–195.

White, J. W. (1999) *Whisper to the Black Candle: Voodoo, Murder, and the Case of Anjette Lyles.* Macon, GA: Mercer University Press.

Williams, D. (2001) Postpartum psychosis: A difficult defense. Online at http://www.cnn.com/2001/LAW/06/28/postpartum.defense/

Williams, D. E. (1993) Victims of Narrative Seduction: The Literary Translations of Elizabeth (and "Miss Harriot") Wilson. *Early American Literature,* Vol. 28, 148–170.

Williams, E. (1967) *Beyond Belief: A Chronicle of Murder & Its Detection*. New York: Random House.

Williams, J. K. (1955) White Lawbreakers in Ante-Bellum South Carolina. *The Journal of Southern History*, Vol. 21, No. 3, 360-373.

Williams, M. N. and A. Echols (1994) *Between Pit and Pedestal: Women in the Middle Ages*. Princeton, NJ: Markus Wiener Publishers.

Williamson, L. (04/09/2000) Song Boycott A Cryin' Shame. *Toronto Sun* (Lexis Nexis).

Wilson, C. and P. Pitman (1961 [1962]) Lafarge, Marie. *Encyclopedia of Murder*. New York: G. P. Putnam's Sons, 340-342.

Wilson, N. K. (2000) Taming Women and Nature: The Criminal Justice System and the Creation of Crime in Salem Village. Pp. 13-30 in R. Muraskin, ed., *It's A Crime: Women and Justice*. Upper Saddle River, NJ: Prentice Hall.

Wilson, S. (1988) Infanticide, Child Abandonment, and Female Honour in Nineteenth-Century Corsica. *Comparative Studies in Society and History*, Vol. 30, Issue 4, 762-783.

Wolf, C. (1998) *Medea: A Modern Retelling* (Introduction by Margaret Atwood). New York: Doubleday.

Wolf, J. H. (1999) "Mercenary Hirelings" or "A Great Blessing"?: Doctors' and Mothers' Conflicted Perceptions of Wet Nurses and the Ramifications for Infant Feeding in Chicago, 1871-1961. *Journal of Social History*, Vol. 33, No. 1, 97-120.

Wonders, N. and P. Rector (2003, forthcoming) The Intersecting Identities of Being Black, Crack-Addicted and Pregnant. In C. T. M. Coston, ed., *Victimizing Vulnerable Groups: Images of Especially High-Risk Crime Targets*. New York: Praeger Press.

Wood, B. (1994) The trials of motherhood: The case of Azaria and Lindy Chamberlain. Pp. 62-94. In H. Birch, ed., *Moving Targets: Women, Murder and Representation*. Berkeley: University of California Press.

Wood, M. (1989) Introduction. Pp. viii-xx in B. Cole and A. Gealt, eds. *Art of the Western World: From Ancient Greece to Post-Modernism*. New York: Summit Books.

Wright, M. E. (1987) Unnatural Mothers: Infanticide in Halifax, 1850-1875. *Nova Scotia Historical Review*, Vol. 7, No. 2, 13-29.

Wright, S. and A. Loudon (11/17/2002) Death Of A Moors Murderer; Monster takes secret to the the grave. *Sunday Mail* (SA), News, p. 5.

Yalom, M. (1997) *A History of the Breast.* New York: Alfred A. Knopf.

Yalom, M. (2001) *A History of the Wife.* New York: HarperCollins.

Yellis, K. A. (1969) Prosperity's Child: Some Thoughts on the Flapper. *American Quarterly,* Vol. 21, Issue 1, 44-64.

Yeoman, B. (1999) Bad Girls. *Psychology Today,* Vol. 32. No. 6, 54-57, 71.

Young, C. (2000) Sexism and the death chamber: Chivalry lives when a woman must die. *Salon Mothers Who Think.* Online at salon.com/mwt/feature/2000/05/04/death/index.html.

Young, P. D. (1998) *The Untold Story of Frankie Silver.* Asheboro, N. C.: Down Home Press.

Zedner, L. (1991) *Women, Crime, and Custody in Victorian England.* Oxford: Clarendon Press.

Zelizer, V. A. (1985) *Pricing the Priceless Child: The Changing Social Value of Children.* New York: Basic Books.

Zipes, J. (1997) *Happily Ever After: Fairy Tales, Children, and the Culture Industry.* New York and London: Routledge.

Zipes, J. (1983) *The Trials and Tribulations of Little Red Riding Hood: Versions of the Tale in Sociocultural Context.* Massachusetts: Bergin & Garney.

Author Index

Abramson, 110
Accampo, 97-98
Ackerman, 22, 23, 41, 55
Adams, 68
Adler, C. M., 194
Adler, J.S., 124-126
Aiuto, 157
Altick, 90, 91
Amundson, 200
Anderson, 121
Aptheker, 159, 160
Archibald, 26
Aschkenasy, 33-34
Ashe, 37
Atkinson, 41-42
Atwood, 227
Auerbach, 110
Axtell, 59

Bach, 32, 33
Baer, 188, 189
Bailey, B., 84
Bailey, F., 74, 76, 77, 93
Bakken, 105
Ballinger, 84, 85, 86, 147, 148, 155-156, 162
Bandstra, 32
Barak, 246
Bardsley, 154
Barstow, 46, 48, 49, 50-51
Barton, 194
Bassein, xiv
Bauer, ix, xiv
Bauman, 23-24
Baxley, 180
Belknap, iii, 170-171
Bennett, 110-111
Berenson, 127, 128, 199
Berger, iii
Betzig, 39
Bird, vi
Bitel, 55
Bledsoe, 176
Bommersbach, 136-137
Bourgoyne, 219
Brazil, 130
Breslaw, 65
Browder, 96
Brown, R.H., xiv

Brown, S., 82
Browne, 169
Busch, 170
Butterfield, 82
Bynum, 75
Byrnes, 198, 201-202

Cahill, 164
Capote, 200
Carr, 228
Carroll, 84
Cecil, 100
Chambers-Schiller, 92, 93
Chan, 51, 234
Chesler, 178-179
Chudacoff, 94, 95
Clarke, 22, 29
Clover, 55
Cogun, 253
Cohen, D., 66, 81
Cohen, P. C., 95
Cole, 4
Collins, 190
Conde, 65
Connell, vii
Corti, 14
Crimmins, ix
Cuklanz, vi
Curtin, 167
Curtis, 88, 89

Dalarun, 40, 41
Danton, 134
Davidson, J. W., 60, 64, 65
Davis, C. A.,
Davis, 223
Davis, N. Z., v, 169
Day, 35-36
de Bruyn, 218
de la Croix, 77
deMarrais, xiv
Demand, 20, 21
Dershowitz, 210, 236
Dickson, 200
Dietz, 205, 206, 207, 210
Dijkstra, 111, 113
Dolan, 45, 51, 218
Dole, 231-232
Donovan, 99
Douglas, A, 132
Douglas, G. 129
Douglas, J. 204

Dowling, 105
Duby, 38
Dubinsky, 140
Duggan, 103
Dunn, 60, 170
Dupont, C., 100, 101, **102-103**, **106**
Durham, 201
Dusinberre, 53
Dworkin, 47

Edwards, 47, 55
Edy, 243
Eggleston, 241, 243
Eigen, viii
Emery, 129, 130
Erenberg, 110
Erikson, 64
Evans, 25
Ewing, 171, 182
Exum, 32

Faith, 69, 81
Fantham, 13, 18, 19, 24, 25, 26, 29
Farr, 174-175
Ferman, 219
Ferrero, 23-24
Fessenden, 73
Fields, 109
Fisher-Giorlando, 76
Flowers, 164
Forbes, 49-50
Francus, v
Freedman, 235
French, 194
Friedan, 145
Friedman, 121
Fries, 37
Frost-Knappman, 60, 61, 62, 64
Fry, 196
Fryer, 232
Frymer-Kensky, 32
Furneaux, 152, 153

Gavitt, 42-43
Gealt, 4
Geringer, 180-181
Gerwitz, vi
Getty, 7-8
Gibson, 112
Gilbert, 34
Gillespie, 242
Gilman, 91

Gilmore, 5, 217
Golden, J., 187-188, 189
Golden, J. L., 78-79, 82
Gomez, x
Graves, 34
Green, E. C., 98
Green, P., 232, 261
Gregg, 243, 244, 249
Gurr, 153

Haefeli, 59, 60
Halkias, 173
Hall, C., xiv
Hall, E. F., 14
Hallissy, 91
Halttunen, 66-67, 72, 73, 81, 95
Hamilton, 5, 7, 12, 16, 29
Hann, 81
Hansen, 65
Happe, 119
Harbage, 43
Harding, viii, 8
Harlan,
Hariman, v-vi
Harris, 167
Hart, 178
Haskins, 281
Henwood, 59
Herman-Giddens, 194
Hickey, 207
Hill, 65
Hinton, 116, 117,
Hirsch, 229
Hobson, 102
Hodges, 196
Hoffer, 81
Hoffman-Jeep, 224
Holmes, 205, 206
Holmund, 231
Howard, 146
Huber, 93
Hull, 52, 58
Humbert, 173
Humphries, 189
Husting, 231

Ide, 26-27, 34-35
Innis, 261
Itnyre, 42

Johnson, 223
Jonas, 187

Jones, A., 118, 133, 140, 161, 162
Jordan, 149, 150
Jourdan, 194
Jouve, 137-138
Just, 19, 29

Karlsen, 64
Kasinsky, 189-190
Kasson, 105
Katz, J., xiv
Katz, M.A., 18
Keeney, 207
Keetley, 222
Kelleher, 205, 206, 207, 208
Kennedy, K., 164
Kennedy, R., 93
Kent, 98
Keppel, 205
Kerber, 81
Kilbourne, 247
Kilgallen, 241, 242
Kimmel, 108
King, 161
Kinsley, 9
Kitch, 108, 111
Klaits, 47-48
Klapisch-Zuber, 32
Kline, 120
Knelman, 85, 87, 211
Krause, 140

Labarge, 38-39
Lane, B., 155, 159, 178
Lane, R. 98, 106, 158, 159
Langlois, 117, 118
La Rue, xiv
Laster, 86
Law, 192
Laythe, 218
Lebsock, 199
LeClair, 227
Leeming, 8
Lefkowitz, 13
Levine, 121
Levit, iii
Lewis, 81
Lincoln, 5, 6
Little, 68-69
Lombroso, 112, 193
Loraux, 6
Loth, 24, 113
Luckmann, iii

Lyon, 172

Macfarlane, 194
Macintyre, 252, 253
MacKeen, 183
Madriz, 166-167
Mann, 194
Manners,
Margolin, 129, 131, 133
Martin, xiv
McBrien, 226
McCall, 168
McCaughey, 167
McCormick, 182
McCrumb, 74
McCullough, 194
McDaniel, 196
McDermott, 34
McFarlane, 170
McLaurin, 75
McLean, 39
McNall, 100
Miccio, 194
Miles, 200
Milicia, 185
Millan, 22-23
Miller, 69, 70
Mims, 72
Molloy, 143, 153
Mooney, 109
Moore, A., 227
Moore, R. L., 72
Morgan, 82
Moriarty, 205, 206
Morris, 88, 89, 90
Moskowitz, 143
Moton, 115, 116
Mumby, xiv
Muraskin, iii
Myles, 62-63

Nadelhaft, 81
Naffine, 140
Navas, 71-72
Nickerson, 101, 102, 224
Nord, 63
Norton, 64, 81

Oglesby, 182
O'Hare, 146-147

Paton, 137, 138
Pauly, 134
Pearson, J., 53, 210
Pearson, P. 236
Perkins, 81
Petry, 65
Phillips, 36, 37
Phillips, O.C., 201
Pinker, 194
Place, 228
Pollak, 148-149
Pollock, 235
Pomeroy, 9, 18, 19, 20, 29
Porter, 219
Proser, 44
Purkiss, 50, 191-192

Quigley, 166

Rafter, 119
Rasche, iv-v
Read, 232
Reagan, 96, 97, 143-145
Rennison, 169
Reston, 160
Rivers, 49, 234
Robb, 87, 88, 89, 90
Roberts, x, 77, 190, 191
Roth, 70
Ruddick, 89, 199
Russell, 179
Ryckebusch, 335

Sacks, 199
Salgado, 46, 52
Sanders, 55
Scheffler, 157-158
Schulte, 106
Schutte, 61, 62, 63
Schutzman, 91
Scott, 207
Selden, 119, 120
Shadron, 140
Shaheen, 53
Shapiro, iii-iv, 90
Shipman, 176-177, 243
Sklar, 55
Skrapec, 178
Smith, 69, 221, 222
Solinger, 144
Spivak, 55
Srebnick, 96

Stables, 230
Stammer, 40
Starling, 194
Stevens, 190
Stevenson, 105
Stokes, 114
Stormer, 97
Stowers, 199
Strange, 122-124
Streib, 239, 253
Stross, 207
Symonds, 81, 216
Surette, xii
Sweet, 82

Thernstrom, 186-187
Thomasset, 40
Thrush, 82
Tiersma, vi
Tolnay, 93
Treneman, 194
Tromp, 222-223

Ullman, 8
Ulrich, 58-59, 81

Valentis, 11
Valkenburg, vii
Vares, 232
Veyne, 24-25, 29

Walker, B.G., 10
Walker, L., 170
Walters, 232
Warnes, 62
Warner, 218
Watkins, 133-134
Webster, 224
Wehrwein, 194
Weiner, M.J., 203
Weiner, S.,
Weisenburger, 77
West, xiv
Westerdale, 245
Westerkamp, 63
Wheelan, 199
White, 150, 151
Williams, J.K., 106
Williams, M.N., 40, 42, 43, 47
Williams, D. E., 220, 221
Williamson, 219
Wolf, C., 35

Wonders, 194
Wood, 4
Wortman, 97
Wright, 98, 105, 245

Yalom, 13, 73
Yeoman, iii, 236
Young, xiv, 74

Zelizer, 79, 86-87
Zipes, xiv, 46, 47, 217, 218

SUBJECT INDEX

Abortion, 49, 95-97, 104, 105, 106, 126, 143-145, 147, 150, 186, 188, 191; criminalizing, 96-98; full birth, 186; therapeutic, 144 (See also American Medical Association; Restell, Madame)
Abuse, as an excuse, 236; of husband, 69; of wife, v, 69, 70, 74, 75, 124-125, 142, 162; physical, 125, 140, 148, 164; psychological, 75; sexual, 27, 164, 282; verbal, 69
Acquittal, 94, 102, 123, 125, 128, 130
Adam, 34, 48
Adams, Abigail, 67-68
Adams, John, 67
Addams, Jane, 94
Adoption, 144
Adultery, 20, 24, 29, 37, 72, 88, 105, 118, 127, 130,133, 140, 142
Advertising, images of women, 8, 11, 12, 108, 142, 224, 247, 286 (See also Magazines, illustrators)
Africa, 8, 13, 113
Aggression, 282, 283, 291; male, 292
Agrippina, 23
AIDS, 8, 121, 136
Alcoholism, 111, 188
Alice in Wonderland (Carroll), 84, 105
Alienists, 131-132
Amazons, 10, 13, 15, 24, 53, 113, 234 (See also Warriors, women as)
Allen, Wanda Jean, 177, 240 (See also Executions)
American Medical Association (AMA), 96-97, 103 (See also Physicians)
Amulet, 35, 42
Anatomy, female, 20-21
Andersen, Hans Christian, 217
Anderson, Maxwell, 231
Angels, 34, 46; of Death, 36
Anthony, Susan B., 281
Antony, Marc, 22, 23
Aphrodite, 6, 8, 16

Archetypes, 253
Arsenic, 88, 176 (See also Poisoning)
Art, 4, 11, 18, 34, 77, 100, 148 (See also Magazines: illustrators)
Arthurian Romances, 35-36
Ashtart, 33
Assassination, of Lincoln, 92
Athena, 9-10
Atwood, Margaret, 227

Baal, 33
Baby-farmers, 79, 85-87, 118
"Bachelor culture," 94
Ballads, 63, 73-74, 118, 216-217, 218
Banishment 60, 69
Bara, Theda, 110-111, 114, 117 (See also Vamps)
Barfield, Velma, 175-176, 198-199, 206, 211, 243
Bartlett, Adelaide, 88
Bates, Norman, 230
Bathory, Erzsebet (Elizabeth), 140 (See also Stoker, Bram)
Bathsheba, 33-34
Battered Woman Syndrome, 162, 170, 193, 236, 246
Battered women who kill, 170-172, 287
Beck, Martha, 154-155
Belli, Melvin, 136
Beloved (Morrison), 258 (See also Garner, Margaret)
Bible, wicked women in, 32-35
Biological defect model, iv
Biologically determined, 19
Birth control, 97, 283
Births, 39, 41, 58, 60, 62-63
Black arts, 36
"Black Death," 42
"Black widow," xii, 22, 175, 205, 206, 208, 210, 211
Bledsoe, Jerry, 175-176, 198-199
Bobbitt, Lorena, vi
Borden Lizzie, 101-102, 103, 118, 224, 292
Borgia, Lucrezia, 88
"Born criminal," female, 112-113
Bowlby, John, 143
Bravo, Florence, 88
Breasts: breast-feeding, 25, 43, 44, 77, 78, 79 191-192, 222; breast milk, frozen; 191-192 (See also Mother, and murder; Eappen, Deborah; Lady Macbeth; Wet nurses)
Broderick, Betty, 172-173; 209
Brooks, Pierce, 205
Brothels, 94 (See also Prostitution)
Brunhilda (See Queens)
Buenoano, Judias, 174-175, 211
Bugliosi, Vincent, 200, 202
Bundy, Ted, 179. 198
Burgess, Ann W., 283-284
Buttafuoco, Mary Jo, 173, 253
Byrnes, Tom, 198, 201-203

Caillaux, Madame, 126-128, 199
Capital punishment, xiv, 72, 74, 85, 86, 154, 160, 161, 174-178 (See also Executions)
Capote, Truman, 200, 201, 202, 204
Carew, Edith, 88
Caro, Socorro, 235
Carter, Jimmy, 160
Carter, Landon, 78
"Catharsis," 291, 292
Celia, 74-75, 177
Chapman, Lucretia, 73
Chastity, 18, 27, 39, 123, 223
Chesney-Lind, Meda, 292-294
Chicago, 133-134
Childbearing, curse of painful, 35, 40
Childbirth, 18, 24-25, 49, 91
Child endangerment, 173
Children: abandonment, 98-99; as "assets," 42; mercy killing of, 126; value of, 86-87 (See also Fetal protection; Infanticide; Sudden Infant Death Syndrome)
Chivalric code, 124
Chivalry, xi, 73, 80, 121, 124, 147, 218, 285; theory, 121
Chloroform, 89 (See also Poison)
Christianity, x, 26-27
Christian, Virginia, 114-116 (See also Capital punishment)
Circe, 12, 14, 55
Cisterian monks, 35-36
Civil War, 92-93, 94
Class, 74; middle-class families, 142-143
Cleaver, June, 145
Clemency, 175-176
Cleopatra, x, 22-23, 28, 29
Clytemnestra, 13
Cold War, 156
Colonialism, 113
Coo, Eva, 211, 241-243
Cook, Henrietta, 100-101
Cotton, Rebecca ("Becky"), 72-73
Courtly love, 37-38
"Crack moms," x (See also Drugs, use of; Fetal protection)
Crime of passion, iv (See also Caillaux, Madame)
Criminality, female, iii-iv (See also by topic)
Crone (See Kali Ma; Medusa)
Cross-dressing, 27, 47, 122-123
Cult, 39, 158, 210
Culture: Appalachian, 74; French, 128; mass, iv; popular, 69, 142, 162 (See also Art; Ballads; Fairy tales; Films, Media)

Dance halls, 94
"Dangerous woman, the," 112, 222-223, 224
Darwin, Charles: slum worlds, 223; theory of evolution, 112 (See also Social Darwinism)
Davis, Angela, 159-160
Davis, Bette, 142, 163

"Deadlier than the male," 284
Dean, James, 153 (See also Starkweather, Charles)
Death penalty, women and, 135, 150-151, 158-159
Death row, 174-177, 237-239 (See also Executions; Capital punishment)
de Beauvoir, Simone, 137-138, 235 (See also Papin Sisters)
Degeneracy, 119
Delilah, 32, 219
Delinquency, juvenile, 151-154; girls and violence, 292-295 (See also Parker, Pauline; Fugate, Caril)
Demeter, 7, 29
Dershowitz, Alan, 236
Deviance, 94
Devil, the, 40, 43, 48, 49, 66, 182; devil's disciple, 111; "in petticoats," 73
Devlin, Angela, 284-287
Dickens, Charles, 85, 222
Disney, films, 218 (See also Films)
Dixie Chicks, The, 219-220
Domesticity, 146, 151, 162
Dorothy (See *Wizard of Oz, The*)
Douglas, John, 204, 205, 210-211
Downs, Diane, 189-181, 198, 208
Dracula (Stoker), 110 (See also Vamps)
Drugs, use of, 109, 146, 188-191, 194, 290
Dugdale, Richard, 119 (See also Degeneracy)
Dunston, Hannah, 58-60, 168
Dworkin, Andrea, 281-282
Dyer, Amelia, 85-86
Dyer, Mary, 61-63, 80

Eappen, Deborah, 191-192 (See also Breasts and Wet-Nursing)
Earth Mother, 7
Eaton, Anne, 68-69
Eleanor of Aquitaine, 38, 39
Electra, 13
Ellis, Ruth, 147-148, 252-253
Emerson, Elizabeth, 58-59, 81
Esther, 32
Etiological perspectives, iv-v
"Eugenic criminology," 119
Eugenics, 108, 119-120
Euripides, 13-14
Eve, 34-35, 49, 55, 113-114, 235
Evil, 36, 49, 55, 63, 73, 86, 142, 156, 179, 217, 222, 234, 242, 285
Evolution (See Eugenics; Social Darwinism)
Excommunication, 60
Executions, 72, 84-85, 99, 129-130, 145-146, 151, 157, 242, 254, 287, 288, 289, 291-292; media portrayals of condemned women, 174-175; sermon, 58 (See also Capital Punishment)

Fairstein, Linda, 289-290
Fairy tales, xiv, 46, 217-218, 281
Faith, Karlene, 291-292

"Fallen woman," 95, 98, 120, 124
Family: "fitter," 119; middle class, 142, 156 (See also Eugenics; Mother)
Female Offender, The (Lombroso and Ferrero), 112
Feme covert, 52, 64
Feme sole, 64
Feminine Mystique, The (See Friedan, Betty)
Feminist movement, 50, 81, 97-98, 161-162, 235
Femme fatale, 77, 96, 147, 173, 209, 211, 229-230, 253
Fertility, 42, 97
Fetal Alcohol Syndrome (FAS), 187-188
Fetal protection, ix, 189
Films: 133, 134; "bad" twin, 229; "deadly dolls," 231; female police officers in, 231-232; "hard bodies," 232; madness in, 230-231; neo-noir, 133; noir, 133, 228-229; rape-revenge, 232; spousal abuse in, 232; "women in jeopardy,"229; women in prison, 232 (See also Appendix A)
Fisher, Amy, vi, 173
Flapper, 108, 133
Floradora Girls, 109
Folie a deux, 138, 152, 153
Folklore, 34, 36, 63, 245
Fool There Was, A, 110-111, 114 (See also Bara, Theda)
Foreign immigration, (See also Urbanization)
"Foreign milk," 192 (See also Breasts)
Forensic: chemistry, 87
Freud, Sigmund: theories of, 11, 108, 139, 246
Friedan, Betty, 143, 145
Fromm, Lynette, (See also Manson, Charles)
Fugate, Caril, 153-154
Funeral rites, 18-19

Gallows confessions, xi
Gallows sermon, 58, 66-67, 81, 198 (See also Executions)
Garcia, Inez, 162
Garner, Margaret, 77
Gender: conflict, 63, 111; disorder, 92; equity, 176; politics, vii, 143, 162; relations, 108, 124, 129; roles, 43, 69; women as, 128
Geoffrey of Monmouth, 36, 37
GI Bill, 142 (See also World War II)
Gibson, Charles D., 108-109
Gibson Girl, 108-109, 118 (See also Magazines; Nesbit, Evelyn)
Gilman, Charlotte Perkins, 91
Girls, and gangs (UK), 284
Good, Sarah, 65
Gothic horror, 72
Graham, Barbara xi, 145-147, 163, 254
Greek mythology, 4-16
Greenfield, Gloria, 185
Grossberg, Amy, 185-187
Guinevere, 37 (See also Arthurian Romances)
Gunness, Belle, 116-118, 139, 206 (See also Serial killers)
Gun ownership, 149, 166-169, 193

Hagen, Margaret, 282-283
Hair, "hank of," 110; Samson's, 32; victims', 102; women's, 27, 41, 55, 146-147, 150, 175, 230, 252-253, 285 (See also Medusa)
Hall-Mills murder case, 129-130 (See also Media)
Hardy, Thomas, 85
Harris, Clara, vii
Harris, Mary, 92-93
Hartung, Mary Koehler, ix
Hawkins, Jane, 63
Hawthorne, Nathaniel, 59, 66, 222, 223-224
Hearst, Patricia, 160, 210
Heavenly Creatures, 152, 163 (See also Delinquency, juvenile)
Hebe, 35
Helen of Troy, 16
Hera, 5, 6, 16
Heresy, xi, 46, 63 (See also Dyer, Mary; Hutchinson, Anne; Joan of Arc)
Hindley, Myra, 154, 155-156, 201, 244-246, 286-287
Homicide: by women, iii-v, 51; defendants, 234; research on, 124; spousal, 87, 169 (See also Murder; Serial Killers)
Homolka, Karla, 209 (See also Team Killers)
Homosexuality, 19-20 (See also Lesbians)
Honor, and women, 92-93, 105, 127, 128
Hoover, J. Edgar, 157
Hopkins, Pauline, 224
Howard, Frances, 52
Hoyt, Waneta, 183-184, 202
Hughes, Francine, 232
Hulme, Juliet, 152-153 (See also Delinquency, juvenile)
Hunt, Mary Ann, viii
Hutchinson, Anne, 60-61, 79-80
Hysteria, 91

Illiad, The (Homer), 5
Incest, 26, 36 (See also Papin Sisters)
Infanticide, v, ix, 29, 49, 52, 58, 66, 81, 98-99, 104, 106, 125-126, 194, 206, 208, 220-222
"Info-tainment," xii
Insanity, insane asylum, 176; temporary, 92-93, 109, 170-171; psychosis, 151 (See also Sickles, Daniel)
Isis, 9

Jack the Ripper, 90 (See also Serial Killers)
Jael, 58
Jails, Southern, in popular culture, 164 (See also Little, Joan)
Jane Eyre (Bronte), 230
Jewett, Helen, 94-95 (See also Prostitution; Urbanization)
Jezebel, 33
Joan of Arc, 27, 46-47, 55
Journalism: "jazz," 129; "yellow," 129; investigative reporter, 135 (See also Media)
Judd, Winnie Ruth, 134-137
Judith, 32-33
Justice, repressive, 64
Juveniles: and sexual scandals, 153; as consumers, 151 (See also Delinquency, juvenile)

Kali Ma, 10-11, 281
Kilgallen, Dorothy, 241-242
"Killer instinct," iii
"Killer pairs," 154
King, Larry, 244
Kinsey, Alfred, 143
Kipling, Rudyard, 110, 223
Knorr, Frances, 86

Lady Macbeth, 27, 43-45, 53, 54, 55, 77
La Llorona, 12
Laney, Deanna, 244
Law, women and, 50-51
Leopold and Loeb, 152, 153
Lesbians, ix, 103, 137, 146, 153, 177, 178-179, 194, 230, 240, 290 (See also Homosexuality)
Lilith, 34-35, 48, 281
Literature: crime, 66-67, 72, 118; early, 218; frontier, 168; mystery novels, 225-226, 227; sensational, 72, 222-223 (See also Appendix A)
Lincoln, Abraham, 92
Little, Joan, 160-161
Little Red Riding Hood, xiv (See also Fairy tales)
Lombroso, Cesare, 111-113, 117, 118, 138, 193, 246
Lowell, Josephine Shaw, 119 (See also Eugenics)
Lyles, Anjette, 149-151, 163, 288
Lynching, 93, 103

Macbeth (Shakespeare), 43-46, 54
Mad woman, 101; "in the attic, the, "230 (See also Films)
Maenads, 29
Magazines, covers, 204; illustrators, 108; Eugenic theories in, 119; *Women & Guns*, 116; women's, 142-143 (See also Media)
Magic (See Witchcraft)
Male gaze, 229
"Malice domestic," ix, 45, 87, 224 (See also Poisoning)
Malleus Maleficarum (Kramer and Sprenger), 48, 49 (See also Witch trials)
Manning, Mrs., 85
Manson, Charles, 200; "The Manson Girls," 249
Marks, Grace (See Atwood, Margaret)
Marriage, iii, 14, 29, 92, 109, 125, 127, 130, 132
Martyrs, Christian, 26 (See also Joan of Arc)
Mary Magdalene, 40
Mary, Virgin, 27, 39-40
Masculinity, "crisis in," 108; meaning of, 128
"Maternal deprivation," 143, 153
Maternity homes: Ideal Maternity Home, 164
Mather, Cotton, 58, 60, 66, 168
Maxwell, Edith, 224-225
Maybrick, Florence, 88-89
McCrumb, Sharyn, 74
Medea, x, 13-14, 55, 77, 192, 234 (See also Garner, Margaret; Smith, Susan)
Media: ads in newspaper, 116; news coverage, vi-vii, xi-xii, 87, 89, 92, 94-95, 102, 103, 106, 117,

122, 126-128, 129-139, 140, 144, 150, 152, 160, 174, 176-177, 185, 187, 196, 220-221, 224-225, 244-246, 248
Medusa, 9-11, 12, 234
Melodramas, romantic, 123
Memory, collective, 243; culture of, 243-244
Menstruation, viii, 40, 93, 96, 105, 128
Michelangelo, 34, 48
Midwives, x, 20, 42, 48-49, 50, 55, 71, 81, 117
Minstrel shows, 122
Misogyny, 32
Mitchell, Alice, 103
Morgan Le Fay, 35-36, 55
Morte d' Arthur, The (Malory), 37
Mothers, and murder, v, 125-126, 179-187, 228; as career woman, 191-192; protecting children, 194 (See also Breasts; Fetal protection; Infanticide; Medea; Smith, Susan; Yates, Andrea)
Mother Nature, 8 (See also Advertising)
Munchausen Syndrome, 182, 183, 208, 209
Murder, iv, v, vii, ix, 49, 58-59, 67, 73, 75, 81, 88, 89-90, 94, 95, 100-101, 102, 103, 114, 117, 119, 122, 123, 125, 126, 128—133; "as mystery," 67 (See also Homicide)
Music, domestic violence in, 218-220
Myth: definition of, 4
Mythology (See Greek, mythology)

"Nanny" case (See Eappen, Deborah; Woodward, Louise)
Narratives, iii-xiv, 27, 58, 67, 72, 74, 114, 196, 201-203, 220-221, 234, 235, 236, 247-248; historical, 199; legal (trial), vi-vii, xiv, 66-67, 92-93, 115, 122-124, 130-131, 241-242; social science, 246-247
Natural selection (See Eugenics)
Neonaticide, ix, 185, 187, 194 (See also Grossberg, Amy)
Nesbit, Evelyn, 109-110
Newark Custodial Asylum, 119
News coverage (See Media)
"Newsmaking criminology," 246
"New Woman," 105, 108, 138, 139
Noe, Marie, 184
Norman, Judy, 171-172

Ocuish, Hannah, 67
Odysseus, 12-13
Osbourne, Sarah, 65
"Overlaying," 76

Pandora, 34
Papin Sisters, Christine and Lea, 137-235
Parker, Pauline, 152-153, 163
Passions, 115
Perry, Anne, 152, 164 (See also Hulme, Juliet)
Petty treason (petit treason), 51, 70
"Physical feminism," 167
Physicians, coroner's office, 126; drug-addicted, 136; female, 25; male, 20-21, 40, 42, 70, 71, 78, 96, 97, 144, 188, 240 (See also American Medical Association; Midwives)
"Plea the belly," 52, 82 (See also Spooner, Bathsheba)

Poe, Edgar Allen, 95, 223
Poisoning, Poison, 14, 52, 87-91, 100, 101, 118, 131, 217, 223-224, 228, 240
"Poison Ivy," 224
Police, reform, 96, 125-126; undercover, 146
Pollak, Otto, 148-149, 246
Pope Joan, 41-42
Pornography, 281
Porter, Cole, 226
Postpartum depression, viii, 182 (See also Yates, Andrea)
Pregnancy, 105, 134, 140, 147 (See also Infanticide; Mothers; Neonaticide; Spooner, Bathsheba)
Premenstrual stress (PMS), viii, 285
Pre-patriarchal period, 7-9, 15
Prisons, 149; Albion Correctional Facility, 173; Baton Rouge, 76; Bedford Hills, 183; Sing Sing, 241; Women's (UK), 286-287
Prostitution, 18, 19, 93, 94, 98, 120-121, 140, 145, 146, 179, 222-223, 230
Psyche, 16
Psychopathology, iv
Pulp fiction, 225
Puritans, 58-66, 168

Queens: Brunhilda, 36; Catherine de Medici, 53; Elizabeth I, 52, 53; Elizabeth II, 194; Isabella, 38-39; Mary, Queen of Scot, 51-52, 53; Mary Tudor, 53; Victoria, 84 (See also Cleopatra; Eleanor)
Quickening, 52 (See also Pregnancy; Spooner, Bathsheba)

Race, 29, 74-78, 120; racial stereotyping, 122-123; suicide, xi, 97, 120 (See also Christian, Virginia; Eugenics; Social Darwinism; Women, African American, Native American, Slaves)
Racial hoaxes, 179
Rage, xiv, 109, 285, 286 (See also Hera; Medusa; Mother Nature)
Rape, 10, 47, 65, 75, 93, 103, 109, 123, 155, 162, 223, 282; gang, 27; statutory, 173 (See also Films, rape-revenge)
Reasonable man standard, 162
Rebecca (du Maurier), 230
Religion, iii; rituals, 18 (See also Christianity)
Restell, Madame, 79, 95-96 (See also Abortion)
Revenge, 208, 286 (See also Broderick, Betty; Ellis, Ruth; Films, rape-revenge; Woman, scorned)
Richette, Lisa A., 290-291
Riggs, Christina Marie, xiv
Rinehart, Mary Roberts, 224
Rodgers, Esther, 66-67
Rogers, Mary, 95-96 (See also Poe, Edgar Allan)
Roman, empire and women, 22-27
Rosenberg, Ethel, 156-158
Rule, Ann, 198, 199, 200

Sacco and Vanzetti, 133
Salome, 33, 235
Sappho, 18
Satan, 49 (See also Eve; Devil, the; Witches)
Seduction/Seductive, 32, 35, 63, 95
Self-defense, v, 74, 124-126, 160, 162, 210, 235 (See also Battered Woman Syndrome; Gun

ownership; Literature, frontier)
Self-presentation, 102
Semiotics, viii
Seneca, tragedies of, 53
Serial killers, xii, 204-208, 230-231 (See also Gunness, Belle; Wuornos, Aileen)
SIDS (See Sudden Infant Death Syndrome)
Sex/Sexuality, 27, 32-33, 34, 63, 97, 110, 129, 131, 148, 229, 235 (See also Femme Fatale; Films)
Sexual assault, 122, 160 (See also Rape)
Shaken Baby Syndrome, 191, 194 (See also Woodward, Louise)
Shakespeare, 23, 39, 53 (See also Lady Macbeth; *Macbeth*)
Shoplifting, 102
Sickles, Daniel, 105
Silver, Frances ("Frankie"), 73-74, 75
Simpson, O. J., 102, 201
Sirens, the, 12
Slaves, 74-75, 76-78, 93 (See also Women, African American)
Smart, Pamela, 173-174, 209
Smith, Madeline, 88, 90-91
Smith, Susan, x. 179-180, 201, 208, 244, 248
Social constructionists, iii
Social Darwinism, 113, 139
Snyder, Ruth, 129-133, 242-243
"Spectral evidence," 65 (See also Witch trials, Salem)
Spencer, Herbert, 113
Spooner, Bathsheba, 70-72, 173, 199, 243-244
"Sporting culture," 94
Stalking, 170, 293
Stanton, Elizabeth Cady, 72
Starr, Belle, 193
Steinem, Gloria, 161
Stepmothers, 101, 103, 217-218, 281
Stoker, Bram, 110, 140 (See also Vamps)
Strychnine, 100 (See also Poisoning)
Sudden Infant Death Syndrome (SIDS), 181, 182-183, 184, 185
Suffocation (See "Overlaying")
Suicide, 27, 44, 95, 223
Sumner, William, 113
Surratt, Mary, 92, 93
Syphilis, 119, 121, 136

"Team Killers," 209, 246
Television, sit-coms, 142, 163; images on , 217, 292; "Twilight Zone," 216-217
Terrorists, 50, 159
Theogony (Hesiod), 4
Thomas, Juanita, 172
Thurber, James, xiv
Tinning, Marybeth, 181-182
Tituba, 64-65
Torture, 155
Tuberculosis, 79, 136
Treason (See Petty treason; Rosenberg, Ethel)
True crime, xii, 129, 196, 198-214, 220

"True woman," 128, 169
"True womanhood," xi, 72, 73, 108
"Trunk murderess" (See Judd, Winnie Ruth)
Tucker, Karla Faye, vi, ix, 174, 196, 202, 248, 250-252, 254

"Unwritten law," and women, 124-125
Urbanization, 94
Urban environment: dangers of, 94; streets, etiquette of, 105

Vagina dentate, myth of, 235
"Vampire, The" 111 (See Bara, Theda)
"Vamps," 111, 114 (See also Magazines, illustrators)
Venereal disease, 82, 98; syphilis, 79, 121, 136
Venus, 7, 16, 39
"Victim status," 236
Victorian: men and passion, 110; moral sensibilities, 109
Violence: female, iii-v, ix, 59, 60; male, iv, v, ix, 281, 292; slave, 76 (See also Abuse; Homicide; Murder)
Virginity, 5, 10, 19, 39, 109, 132, 140, 217, 228 (See also Mary, Virgin; Martyrs, Christian)
Virility, African American males, 120
Virtue, 92, 113
Vivien, 55

"Wandering womb," 21, 28 (See also Anatomy, female)
Wanrow, Yvonne, 162
War on drugs, iii, 189 (See also Women, African American)
Warriors, women, 22-23, 24, 29, 55 (See also Amazons; Joan of Arc)
Weems, Parson Locke, 72, 73
Wells, Ida B., 103
Wet nurses, x, 25-26, 42-43, 76, 77-78, 82
White, Jaclyn Weldon, 287-289
White, Stanford, 109-110
Wicca, 54
Wilson, Elizabeth, 220-222
Winthrop, John, 61, 62, 63
"Wise blood, " 11 (See also Kali Ma; Medusa; Menstruation)
Witches/Witchcraft, xi, 12, 14, 45-50, 54, 63
Witch trials, x, 48; Salem, 64-66
Wives, images of, 58, 69
Wizard of Oz, The, xiv, 231
Womanhood: "cult of true,"xi, 108
Woman scorned, 208 (See also Revenge)
Women: African, 182; African American, 99, 125, 149, 151, 166, 172, 177, 232, 240; "as wolves in sheep's clothing," 283; in Criminology/Criminal Justice, 277-279; Latina, 166; Native American, 59, 60, 81, 82, 188; roles, v, 81 (See also by topic)
Women's liberation, iii, 236
Woodward, Louise, x, 191-192
World War II, 120, 142, 151, 162, 226
Writers, women, 53, 112, 222-223, 224
Wuornos, Aileen, 178-179

Yates, Andrea, vii, 180, 196, 244, 248-250

Zamora, Diana, 209
Zeus, 4, 5-6, 15